701.1 ART-CENTRAL

★ KT-489-140

Art-general

The Visual Experience

The Visual Experience

Jack Hobbs & Richard Salome

Davis Publications, Inc. Worcester, Massachusetts

Preface

Have you ever wondered about the world of art? Have you ever been stimulated, or turned off, by an artwork? Have you ever liked an artwork, but didn't know why? Did you know that artworks come in all sizes and shapes? Some works are as big as buildings. Some are small enough to fit in the palm of your hand. Some are as new as today. Some are thousands of years old. If you follow the news, you know that some are very expensive. A painting by Van Gogh, for example, recently sold for nearly \$53,000 a square inch!

Art is much more than just sensational facts and figures, however. If you stop to think about it, art—at least certain kinds of art—is part of your daily life. Consider, for example, the effects of graphic or applied art on your life. Magazine illustrations stimulate you to like everything from clothes to compact discs; movies provide you with fashionable role models that are hard to resist; television lures you to crave everything from pizzas to sunglasses; music video informs you about what is "in" in all kinds of things—music, celebrities, clothes, hairstyles, and much more.

Many people are very critical of commercial imagery. They believe that much of it is so poor in visual quality that it lowers public taste. They disapprove of its content, believing that it sends the wrong messages about what is truly important in life. The authors feel that there is both good and bad in commercial imagery. But the point is: *images are powerful*. They can and do influence people's attitudes and desires.

Art images are also powerful, yet they do not try to

persuade you to buy products or convince you to be fashionable. They do say things about life, however. Some artworks celebrate modern society, others criticize it; some works arouse our anxieties about life in general, others reassure us. Still other works delight us by their high standards of originality and visual quality. Did you know that the styles of advertisements and commercials often follow the styles of art?

The pages of this book will introduce you to all kinds of art and ways to look at it, analyze it, judge it, and even make it. Part I, Introduction, provides some basic ideas about what art is and the ways we experience it. Part II, What to Look For, provides explanations and examples of the visual elements – the "building blocks" of art. This part also introduces you to the skill of describing a work of art. Part III, How Is It Organized?, explains the principles of design - the ways artists put the visual elements together to make a picture or sculpture. This part also introduces you to the skill of analyzing composition. Part IV, What Is It Made Of?, presents various two-dimensional and threedimensional media - the materials and techniques artists use to make art. You will be amazed at how many kinds of media there are. This part also has a chapter on careers in art. Part V, What Is It Saying?, discusses examples of art from many times and places. It also introduces you to the skill of interpreting art. Part VI, In the Final Analysis, explains how you can put together all the pieces presented in the earlier chapters and do art criticism. In addition to providing examples of criticism, this part explains some of the criteria used to judge a work of art.

4-25 Kazuaki Tanahashi, *Heki*, 1965. Ink on paper, $36'' \times 28''$ (92 \times 71 cm). East-West Center, Honolulu.

The pages of this book are filled with diagrams, illustrations, maps, graphics, and color reproductions. Some pages also include brief descriptions of things to do, called *Suggestions* and *Challenges*.

The Suggestions are easy and fun. Studio equipment is not required, and most Suggestions can be done by you in the classroom, around the school, or at home. A Suggestion may ask you to make a list of things that you see or know, or to search for something outdoors or at home to bring to class. Although a Suggestion can be performed by you alone, your teacher may want to use it as a point of departure for the whole class to discuss.

If studio facilities are available in your classroom, the Challenges are also enjoyable. Most Challenges require supplies and some work space. Although designed to help you understand the ideas in the book, the Challenges are regular studio projects. Depending on how your class is organized and the plans of your teacher, you and the other students may work at the same project, or you may be allowed to work on some of them independently.

After using this book, you will definitely know more about art. But we sincerely hope that you *never* stop wondering about it.

Copyright 1991 Davis Publications, Inc. Worcester, Massachusetts, U.S.A.

All rights reserved. No part of this publication may be reproduced or transmitted in any form or by any means, electronic or mechanical, including photocopying, recording, or any storage and retrieval system now known or to be invented, except by a reviewer who wishes to quote brief passages in connection with a review written for inclusion in a magazine, newspaper, or broadcast.

Managing Editor: Wyatt Wade
Design: Douglass Scott and Janis Capone
Production Editor: Nancy Dutting
Copyeditor: Marilyn Prudente
Photographic Acquisitions: Victoria Hughes
Line Art: Carol Keller
Maps: Julia Hänsel
Biographies: Martha Phillipa Siegel
Printed in the United States of America

Library of Congress Catalog Card Number: 90-080630

ISBN: 0-87192-226-6

10 9 8

Front Cover: Robert Hudson, *Drawing #26*, 1975. Mixed media on paper, $30\frac{1}{2}$ " \times 25 $\frac{1}{2}$ " (77 \times 65 cm). From the collection of Jan Perry Mayer, Denver, Colorado.

Back Cover: Lawrence Beck, Punk Walrus Spirit (Poonk Aiverk Inua), 1987. Mixed media, $10'' \times 17'' 16'' (25 \times 43 \times 41 \text{ cm})$. Photograph: Garry Sutto.

Contents

Part I Introduction

1 Seeing, Wondering, Enjoying 3

The Variety of Art

2 When Is It Art? 10

Philosophy of Art
Artworks as a Class of Objects:
What Do They Have In Common
The Aesthetic Experience
Intentions and Art
The Art World

Part II What To Look For

3 Describing What You See 20

Description Knowing What To Look For Vocabulary The Elements of Art

4 Visual Elements: Line 26

Descriptive Lines Implied Lines Expressive Use of Lines

5 Visual Elements: Shape and Form 40

Visual Elements: Value and Color 57 Light and Dark Value

page 305

7 Visual Elements: Space 74

Space in Our Environment
Space in Three-Dimensional Art
Space in the Picture Plane
Representing Three-Dimensional Space in
Two-Dimensional Art
Three-Dimensional Space in Abstract Painting
Framing

8 Visual Elements: Texture and Movement 92

Texture Movement

Part III How Is It Organized?

9 Analyzing What You See 110

Composition

10 Design 116

Unity Variety Dominance Rhythm and Movement Balance

Part IV What Is It Made Of?

11 Introduction To Media 130

12 Two-Dimensional Media 134

Drawing
Painting
Mosaic
Printmaking
Photography and Film
Video Art
Computer Art
Mixed Media

13 Three-Dimensional Media 158

Sculpture Environmental Art Ceramic Pottery, Jewelry, Fibers, and Glass

14 Careers in Art 186

Architecture
Interior and Display Design
Graphic Design
Industrial Design
Fashion Design
Illustration
Film and Television
Art Education
Fine Art
Crafts

Part V What Is It Saying?

Photography

15 Interpretation: There Is More To It Than Meets The Eye 200

Interpretation and Meaning Art History

page 137

16 Non-Western Art I 206

Introduction

India

Southeast Asia

China

Japan

17 Non-Western Art II 224

Islam

Africa

Pre-columbian

North America

Conclusion

18 Islands of Time I 244

The Ice Age

2500 B.C. Egypt

Classical Greece

First and Second Century Rome

Through the Dark Ages to Charlemagne

Medieval Crusades and Pilgramages

The Renaissance in the 1400's

The High Renaissance

19 Islands of Time II 274

The 1600's and the Baroque Style

The Enlightenment, Rococo, and Neoclassicism

Romanticism, Realism, Impressionism, and

Post Impressionism

The Industrial Revolution

Architecture: Frame Construction

Art of the First Half of the Twentieth Century

Architecture of the First Half of the Twentieth

Century

Art of the Second Half of the Twentieth Century

Architecture of the Second Half of the Twentieth Century

Postscript: The Post-Modern Era

Part VI In the Final Analysis

20 Criticism and Critics 308

Professional Criticism Nonprofessional Criticism

21 A Critical Method 312

Using the First Three Stages of the Critical Analysis Model Evaluation Conclusion

Pronunciation Guide 322

Glossary 324

Bibliography 332

Index 334

Acknowledgements 340

Chapter 1 Seeing, Wondering, Enjoying Chapter 2 When Is It Art?

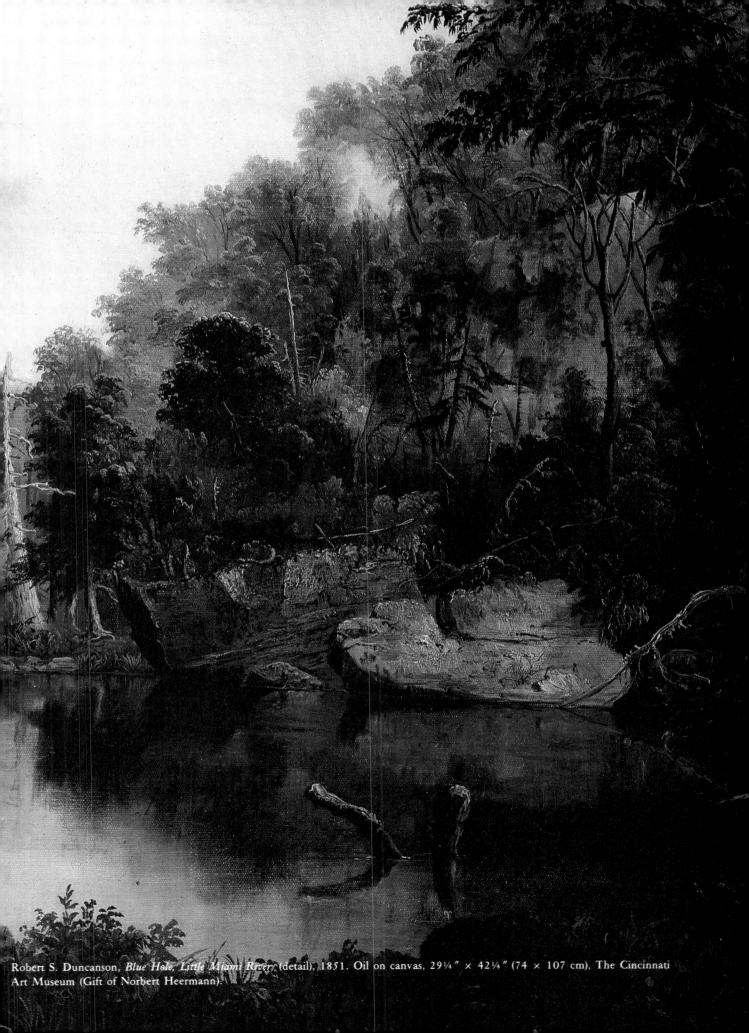

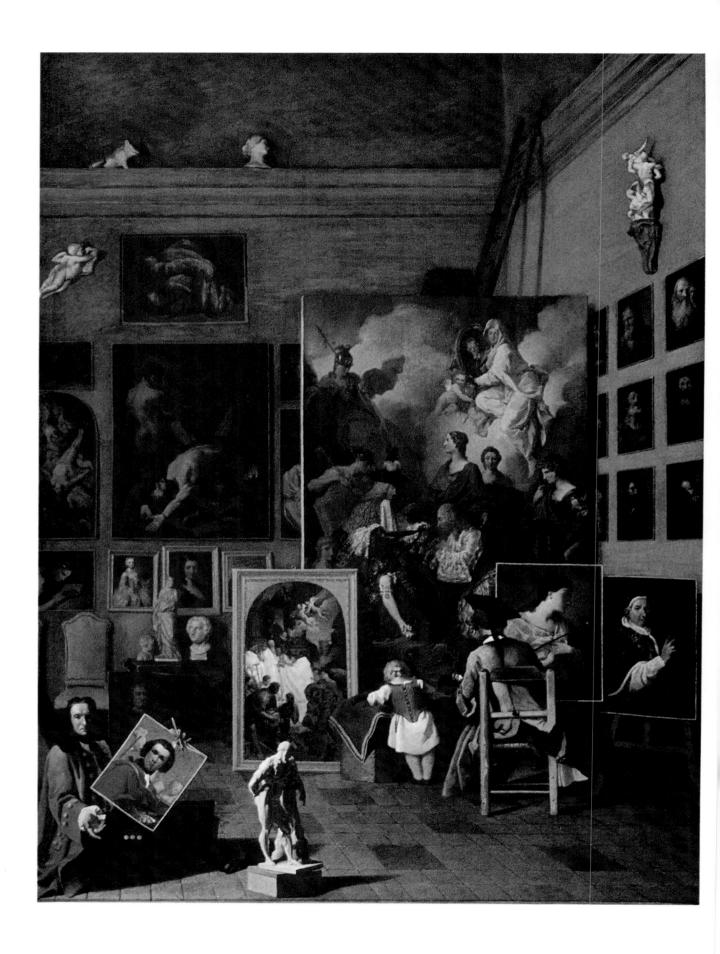

Chapter 1 Seeing, Wondering, **Enjoying**

What does the word art mean to you? Does it remind you of paintings and sculptures - objects commonly called works of art or artworks? (In a minute or two, you will have a chance to test your knowledge about these kinds of objects.) Does it make you think of an art gallery or art museum where these objects are displayed? Or does art bring to mind a classroom full of special supplies and equipment where you and your classmates create artworks and talk about them?

If you thought of those kinds of objects and places in relation to art, you were correct, but art is more than that. It is also people: artists who make art, viewers who visit galleries and museums, teachers who talk about art, and students like you who study it. All of these people are involved in seeing, wondering, and enjoying.

Art obviously involves seeing. But effective seeing of art is a special skill, a skill that will be discussed in this book. If you know how to see art, it is apt to fill you with wonder, a word that implies curiosity, amazement, or even astonishment. And, finally, art is apt to provide enjoyment, not just because the experience of seeing art is pleasant, but because it is meaningful and worthwhile.

A good place to begin this book is with the artwork itself. What is an artwork? What sets it apart from other objects? No doubt you already have some ideas about this subject.

Suggestion:

List some examples of artworks that you have seen or know of. (If you do not know the title of a work, simply describe it in three or four words, for example, "a painting of yellow flowers," "a wood carving of a head," and so forth.) If you have the opportunity, compare your list with that of a friend or classmate.

1-0 This is a painting about being an artist - a painting about paintings. The artist tells his own life story through works he painted at various times in his career. Early in his life, he painted with his young daughter at his side (can you see her?); an older self may be seen at the bottom left, holding a portrait. What does a painting like this tell you about art's importance? How many different ways to remember a time, a place or a person can you see here? How important is his art to this artist? Pierre Subleyras, The Artist's Studio, Fine Arts Academy, Vienna.

The Variety of Art

Test your ability to recognize an artwork by taking the quiz on this page. You will not be graded on this. You can score it yourself for your own information.

Art Quiz

There are ten photographs on this page. Look at each one and decide whether or not it is a work of art by answering "yes" or "no." (Put your answers on a separate sheet of paper.) The answers for this quiz appear on the next page.

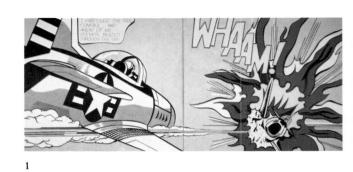

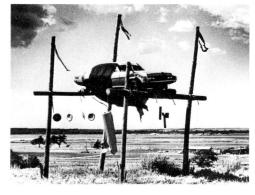

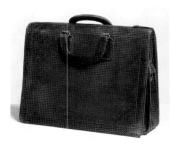

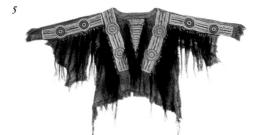

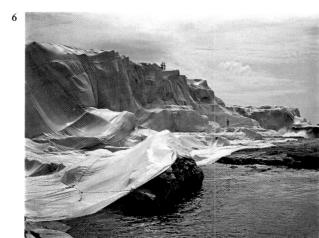

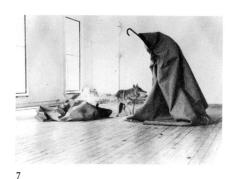

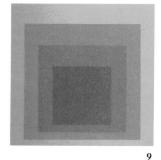

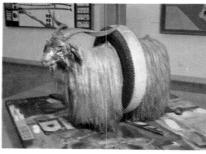

10

All the answers to the art quiz were "yes." (To score yourself, use the following scale: ten yes's = 100%, nine = 90%, eight = 80%, and so forth.)

In the following list, each of the works is identified by the kind of artwork it is, the name of the artist or the culture in which it was made, and its date.

- 1. Acrylic painting by Roy Lichtenstein, 1963.
- 2. Oil painting by Robert S. Duncanson, 1851.
- 3. Construction by Ron Anderson, 1984.
- 4. Ceramic sculpture by Marilyn Levine, 1985.
- 5. Buckskin shirt by an American Indian, early nineteenth century.
- 6. Environmental piece by Christo, 1969.
- 7. Performance piece by Joseph Beuys, 1974.
- 8. Painting on a cave wall by members of the Ice Age culture in western France, around 15,000–10,000 B.C.
- 9. Lithograph by Joseph Albers, 1967.
- 10. Construction by Robert Rauschenberg, 1959.

Were you surprised that all of the answers were yes? If you answered no to some, you may have thought that artworks were mostly just pictures and statues. You probably did not think that they came in so many different forms and materials.

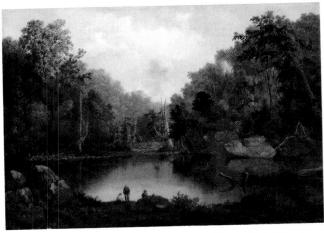

1-1 Robert S. Duncanson, *Blue Hole, Flood Waters, Little Miami River*, 1851. Oil on canvas, 291/4" × 421/4" (74 × 107.6 cm). The Cincinnati Art Museum (Gift of Norbert Heermann).

Probably you and everyone in your class answered yes to artwork 2, the painting of a landscape (fig. I–I). It is very *traditional*, meaning that its form, style, and subject matter are familiar as art.

Most of you probably answered yes to artwork 8, the cave painting (fig. 1–2), even though this kind of art is not easy to see in its original state. Cave paintings were painted directly onto cave walls; therefore, they are not available to view in museums. However, reproductions of them are found in many art books. This ancient art has been very popular ever since it was discovered about a century ago, and then brought to our attention by art historians.

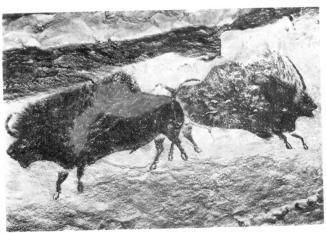

1-2 Painted in a cave near Lascaux, France around 15,000 years ago, these images of animals are the oldest paintings known to us. Although we have theories about this art and the people who made it, it is still a mystery. Chapter 18 will discuss some of those theories and the mystery. Cave painting, Lascaux, ca. 15,000 – B.C. Dordogne, France.

Probably fewer of you said yes to artwork 5, the Indian shirt (fig. 1–3), because it is neither a painting nor a

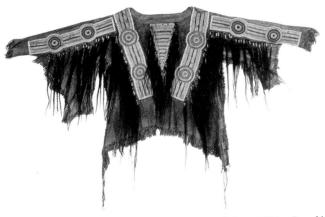

1-3 This is neither a painting nor a sculpture. Is it art? Shirt, Broulé Sioux, early nineteenth century. Buckskin with quillwork, beads, and hair locks, 58 "(147 cm) arm spread. Museum of the American Indian, Heye Foundation, New York.

1-4 Might people in A.D. 3990 be interested in "junk" like this? Do you think they would put any of it in a museum?

sculpture. Yet objects like this - especially if they are from an old culture or a tribal culture - are found in many museums. Not only items of clothing, but masks, banners, water jugs, spoons, tools, and even weapons from older cultures are often looked upon as art.

One hundred years ago you probably would not have found such objects in an art museum. At that time, people in this country and Europe had a very narrow idea about art, an idea limited largely to paintings, sculptures, and the styles of certain kinds of public buildings, called architecture. In order to be considered an artwork, a painting, sculpture, or building had to be from the Western civilization; that is, it had to be produced in styles that developed in classical Greece and spread gradually through Europe and into the Americas.

Now the idea of art has become much broader. It can include many different kinds of objects from anywhere in the world, from any type of society, and from any time in history. In fact, almost any object has a good chance of being considered art if it is from a different culture or is very old or both.

Can you imagine some people from a society two thousand years from now digging in the rubble (fig. 1-4) and discovering objects from our present society? Suppose they found your radio. Would it be considered a work of art? Of course the answer depends on the abilities and interests of those future people. They might not recognize the object as a two-thousand-year-old radio. Even if they did, they might not find it interesting enough to save, much less call a work of art

Suggestion:

Look around you and imagine what things will survive and be of interest to a culture in the distant future. Make a list of those things. If you have the opportunity, discuss them with your classmates to discover the variety of objects that you and your classmates thought of. Imagine how any of these objects would look to someone who had never seen them before.

Objects that survive or are preserved from the past are often called relics. Scientists who explore ancient cities and villages to discover, identify, and catalog relics are called archaeologists (ark' kee ol' o jist).

Archaeologists (fig. 1-5) provide many things of interest to museum directors and art historians - people who collect and study art of other times and places. Museum people and art historians provide us with a great variety of things to see, wonder about, and enjoy.

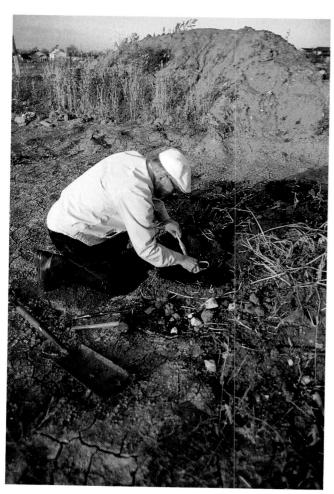

1-5 Archeologists excavate to discover relics in places called "digs."

Let us go back to the test to look at artworks 1, 3, 4, 6, 7, 9, and 10. These works are called contemporary because they were done in our own day and age. You probably identified artwork 9 (fig. 1-6) as an example of abstract art – art that does not resemble things in real life. Artwork 2 (fig. 1-7) is not abstract and does not employ unusual materials. Because of its style, you may have thought it was a comic strip. Were you fooled by art-

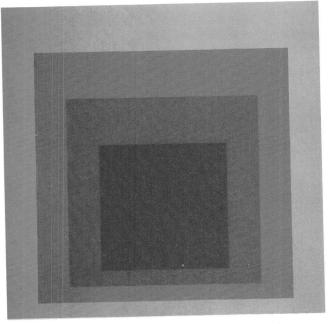

1-6 Josef Albers, Homage to the Square: Glow, 1966. Acrylic on fiberboard, 48 " \times 48 " (122 \times 122 cm). Hirshhorn Museum and Sculpture Garden, Smithsonian Institution (Gift of Joseph H. Hirshhorn, 1972).

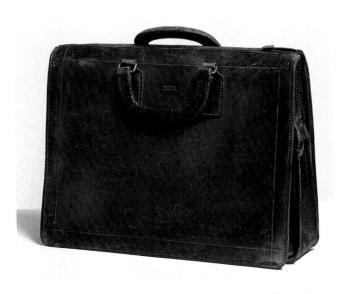

1-8 Marilyn Levine, H.R.H. Briefcase, 1985. Clay and mixed media, handbuilt (slab constructed), 16 $^{\prime\prime}$ \times 17 ½ $^{\prime\prime}$ \times 6 ¾ $^{\prime\prime}$ (41 \times 44 \times 17 cm). Courtesy O.K. Harris Works of Art, New York.

work 4, the ceramic sculpture (fig. 1-8)? Ceramic (se ram'ik) refers to baked clay, a material that has been used for thousands of years for making pottery. Until quite recently ceramic artists limited themselves to making useful objects such as plates, bowls, jars, and vases. Now, although some continue that tradition, many artists feel free to make anything out of clay, even including fake

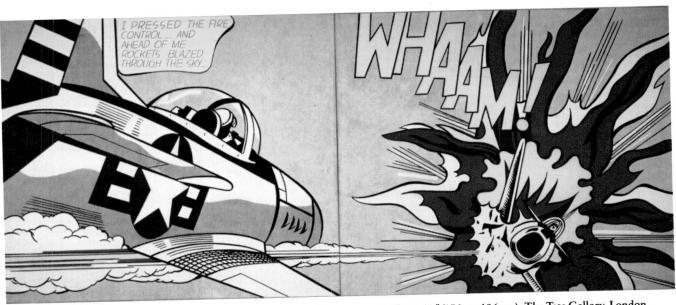

1-7 Is this art or a comic? Roy Lichtenstein, Wbaam!, 1963. Acrylic on canvas, 68" × 160" (173 × 406 cm). The Tate Gallery, London.

briefcases. You may have been misled by artworks 3, 6, 7, and 10 because you found it difficult to think of used cars on scaffolds (fig. 1–9), wrapped coastlines (fig. 1–10), stuffed goats (fig. 1–11), and performances (fig. 1–12) as art.

Years ago, people had a difficult time accepting even abstract paintings as art. The artists of the early twentieth century who first experimented with abstract art nevertheless made paintings on canvas that could be framed and hung on a wall. Many of today's artists, however, do not feel limited by such restrictions. They are apt to make art out of almost any material and shape it into almost any form, or even perform their art, as Joseph Beuys does. Not only that, new technologies have stimulated some artists to experiment with neon lights, photography, film, video,

1-9 Ron Anderson, *The Killing of a '69 XR-7*, 1984. Mercury Cougar with wood, cloth, glass, rawhide, feathers, mixed media. Copyright 1984 *The Daily Oklaboman*.

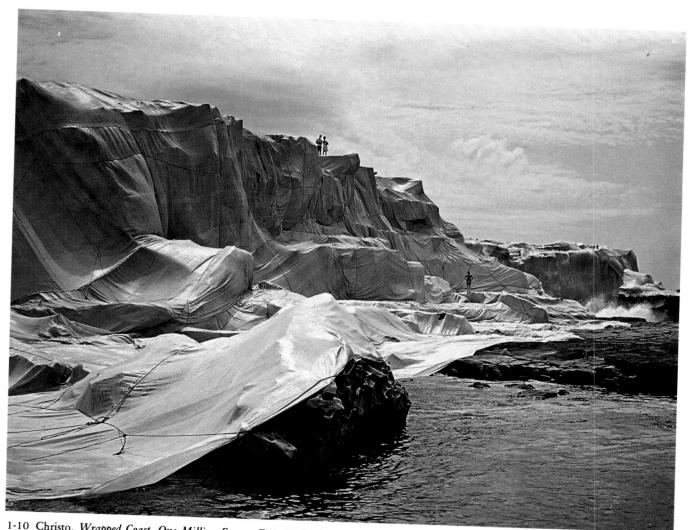

1-10 Christo, Wrapped Coast, One Million Square Feet, Little Bay Australia, 1969. Erosion control fabric and 35 miles of rope. Photograph: Harry Shunk. Copyright Christo, 1969.

and computers, to mention just a few materials. Some of this new art employs techniques that would not have been available even thirty years ago. Perhaps the amount of variety caused by this new freedom and technology fills you with some wonder already. Because of this variety, however, questions are being raised about the definition of art, questions that will be explored in the next chapter.

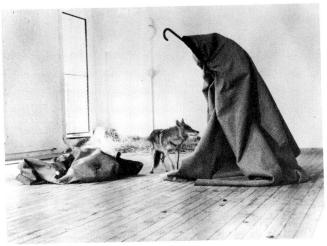

1-12 The artist, Joseph Beuys, was actually involved in this "performance art" for three days. Joseph Beuys, Coyote — I Like America and America Likes Me, 1974. Copyright 1974 Caroline Tisdall, Courtesy Ronald Feldman Fine Arts, Inc., New York.

Summary

Typically, when the word art is mentioned, one thinks of artworks, museums, and galleries. Art, however, is also people: artists, viewers, art historians, archaeologists, teachers, and students.

Although you have covered just one chapter in this book, you have already learned that today's art comes in an incredible variety of forms. This situation did not exist in the past when art objects consisted only of paintings, sculpture, and public buildings made primarily in Europe or the United States. Because today's artists have produced new kinds of art, art historians have uncovered previously undiscovered art from the past, and archaeologists have unearthed objects from other cultures, the idea of what art is and can be has broadened considerably.

One of the purposes of this book is to introduce you to some of the rich variety of today's art - a world of objects, places, and people for you to see, wonder about, and enjoy.

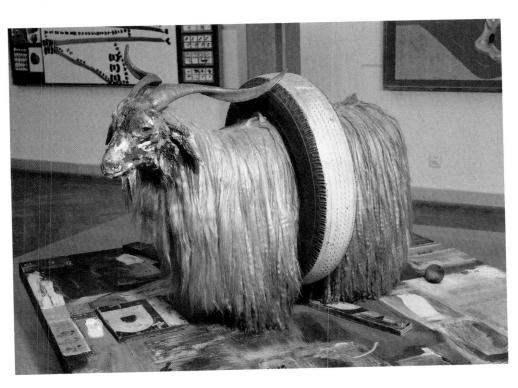

1-11 An assemblage by Robert Rauschenberg that can be hung on a wall. How would you feel about hanging an artwork like this in your room? Robert Rauschenberg, Monogram, 1959. Construction, 48" × 72" × 72" $(122 \times 183 \times 183 \text{ cm})$. Collection, Moderna Museet, Stockholm.

Chapter 2 When Is It Art?

In Chapter 1 we saw a variety of things called art – from a stuffed goat to a ceramic briefcase, and from a wrapped coast to an Indian shirt. The fact that art in our time has such variety makes it exciting. But this fact also raises questions: Can anything be art? Are all stuffed goats and all Indian shirts art?

These questions are part of the larger question, What is art? Long ago, this question was easy to answer. If something was a painting, sculpture, or an architectural monument, it was art. But recently, with so many new objects added to the list of things called art, this question has become difficult to answer. If you saw an Indian shirt or a stuffed goat in a shop window, would you know whether or not it was art?

There are more ordinary examples than Indian shirts and stuffed goats that raise the same question. For example, there are millions of photographs in the world. Some of them are art; they are shown in art galleries and discussed in art magazines. But many more are not art. Thousands appear daily in newspapers and magazines to

2-1 Photographs like this are printed in newspapers everyday. They are not usually thought of as works of art. Other photographs hang in art museums, and are called works of art. What is the difference?

document the news, to portray celebrities and politicians, or to advertise products (fig. 2–1). They are called newsphotos or advertisements, not art. Other photographs, called snapshots, are the kind you take at family gatherings and store in an album or a drawer. If you saw a photograph in a shop window, would you know whether or not it was art?

Perhaps a better question to ask is: When is it art? Under what conditions do things like used cars, stuffed goats, Indian shirts, and photographs become art? What are the requirements for something, anything, to be called an artwork? Are there any principles that apply in all cases?

Philosophy of Art

Raising serious, difficult questions and then trying to find answers to those questions is called philosophy. Raising and answering the kinds of questions posed in the previous paragraph is called philosophy of art. Identifying questions-good questions-is often more important than finding the answers. Philosophical questions often have many answers. Some cannot be answered at all, but provoke people to think in more creative ways.

Suggestion:

Are you a philosopher (fig. 2-2)? Are there aspects of astronomy, prehistoric life, geography, animals, or just life in general

2-2 Photograph by Barbara Caldwell.

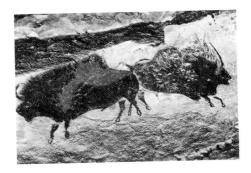

2-3

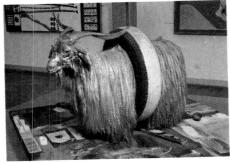

2-4 Is the relationship between the goat and the tire logical and harmonious? Is this construction a work of art? Are the animals in the cave painting arranged haphazardly? Is the painting a work of art?

that intrigue you? Do you ask questions about them? Make a list of questions that you think are really important. List questions that you think are important about art.

Philosophers of art are interested in all kinds of questions about art. They are concerned not only with what art is, but how it can be evaluated, how people respond to it, and how it relates to personal and social values.

Artworks as a Class of Objects: What Do They Have in Common?

A philosopher may attempt to answer questions about art by focusing on artworks themselves as a particular group, or class of objects. He or she might ask what all these objects, as a class, have in common. Based on what we saw in Chapter 1, the answer would seem to be nothing, since art can be made out of anything from cars to stuffed animals. Furthermore, some artworks, like Joseph Beuys's performance piece, are not even objects in the usual sense of the word. Thus it is obvious that the physical materials and form of an artwork are not what artworks have in common.

There may be another, more important trait to consider besides materials and form. A philosopher might suggest that all artworks have good design. Good design can be defined as a logical and harmonious relationship among all of the parts of an artwork. The opposite of good design is chaos. Good design seems to be a very important factor. Young people studying to be artists are taught the principles of design. Artists apply these principles in order to make their art better. Knowing these principles can help you to appreciate art more. (The principles of design are reviewed in Chapter 10 of this book.) Now, look again at some of the examples introduced in Chapter 1.

You might question the fact that all of them have good design. Is the relationship among the animals in the cave painting (fig. 2-3) logical and harmonious? Their locations are haphazard; some animals are smaller than others for no particular reason; some are not even finished. Furthermore, what is logical or harmonious about the combination of a tire and a stuffed goat (fig. 2-4)? Does a ceramic briefcase (fig. 2-5A) have better design than a real briefcase (fig. 2-5B)?

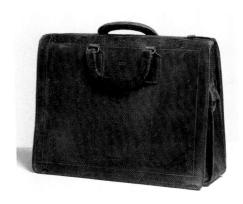

2-5a

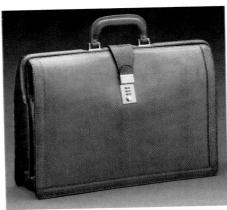

Does a ceramic briefcase have a better design than a leather one? Is the leather briefcase a work of art? 2-5a Marilyn Levine, H.R.H. Briefcase, 1985. Clay and mixed media, handbuilt (slab constructed), 16" \times 17½" \times 6¾" (41 \times 44 \times 17 cm). Courtesy of O.K. Harris Works of Art, New York. 2-5b EC28 Lawyer's Briefcase. Courtesy of Hartmann Luggage Co.

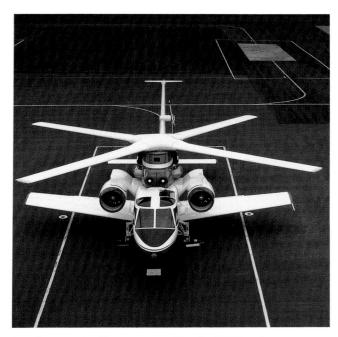

2-6 Can you identify some ways a Sikorsky X Wing plane demonstrates high standards of unity and balance? Is it a work of art? Photo courtesy United Technologies.

The example of the fake briefcase points out the fact that many things besides artworks are considered to have good design. In the world of manufactured products, we admire the design of anything from real briefcases to Japanese cameras to military planes (fig. 2-6). In nature,

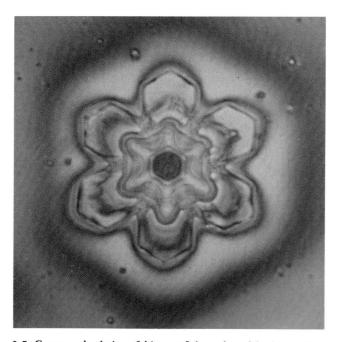

2-7 Compare the design of this snowflake to that of the Mystic Circle (fig. 2-8). Is the snowflake a work of art? Photomicrograph of a snowflake. Copyright Roger J. Cheng.

we admire the design of trees, flowers, crystals, rocks, snowflakes (fig. 2–7) – the list seems endless.

Even though good design may be important for many works of art, it is not necessarily a trait that can be found in all works of art. Moreover, many objects that are not art - whether manufactured or natural - display logical and harmonious relationships among their parts.

Many philosophers of art are now saying that there are probably no special traits that all artworks have in common. Thus it would be difficult for you to be certain that an object was an artwork on the basis of its materials, form, or design.

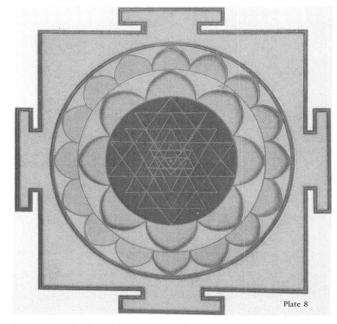

2-8 Mystic Circle, Sri Yantra, late eighteenth century, Rajasthan. Burnaby Gallery, British Columbia.

The Aesthetic Experience

If a philosopher of art admits that artworks as a class of objects have little or nothing in common, he or she may attempt to determine if an object is art by focusing on the experience it gives a person. As a general rule, the purpose of an artwork is to provide viewers with an aesthetic (esthe 'tick) experience. Philosophers have struggled with this concept for centuries, but most tend to agree that an aesthetic experience has to do with enjoying something for its own sake. So, unlike most objects - which are made to be used in certain ways - artworks are made to be seen and enjoyed for their own sake. Some artworks, like pottery, jewelry, and weaving, are meant to be used and to provide aesthetic experiences. The Indian shirt, which was made

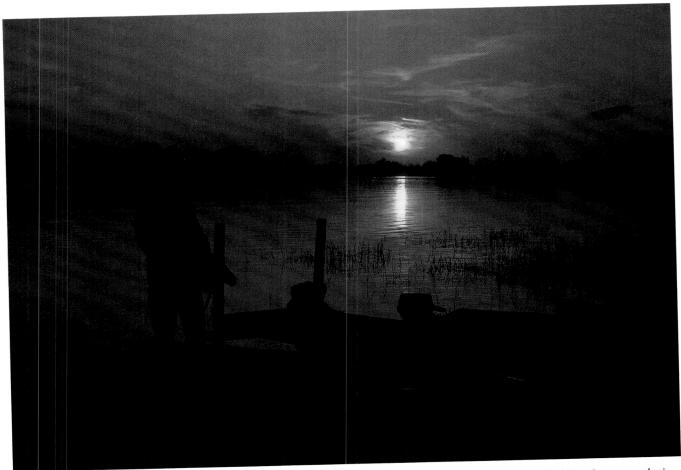

2-9 One of these scenes is quiet and contemplative; the other (fig. 2-10) is noisy and festive. Which do you prefer? Could you have an aesthetic experience in response to either?

to be worn as well as admired for its beauty, is a good example of this kind of art.

However, many situations besides viewing art provide aesthetic experiences. For example, have you ever enjoyed watching a sunset (fig. 2-9), cheered at a parade, smelled roses, or blown seeds off a dandelion ball? When you do things like this, you are not trying to impress friends, earn money, or get a good grade. Instead, you do them for their own sake, in other words, because you like the colors of an evening sky, the smell of roses, or the sight of dandelion seeds floating lazily on a gentle breeze.

You also like to watch sports, especially when a team from your high school is involved (fig. 2–10). But watching your own team is not always aesthetic. For example, when your school plays another school in football you are usually too concerned about who is winning to have much of an aesthetic experience. However, if you did not care about the score, and simply enjoyed the game for the movements of the players and the drama of competition (regardless of who won), you would have an aesthetic experience.

2-10 Which is more important – the drama of the action or the final

Suggestion:

Recall some events that have occurred in your community, such as fairs, parades, festivals, and concerts. Also recall some things you have done with family or friends: celebrations, picnics, hiking, nature walks. Have you taken any trips recently? Have you been to the beach?

Which of these recollections seems particularly vivid? Did you enjoy any of these events purely for their own sake? Make a list of them. If you have the opportunity, describe one or two events that seem to have been an aesthetic experience to a friend or classmate.

As you have discovered, many situations besides viewing art are capable of providing aesthetic experiences. If this is so, you will not be able to tell if something is an artwork just because it gives you an aesthetic experience.

On the other hand, would it be possible to tell if something is *not* an artwork because it does *not* give you an aesthetic experience? No. In reality, artworks do not always succeed in providing aesthetic experiences for everyone. It is not so much the quality of the artwork as it is the *attitude* or *mood* of the person who sees it that matters. We all have our personal feelings, and sometimes these change. If you saw Joseph Beuys's performance piece, *I Like America and America Likes Me* (fig. 2–11), and were bored by it, this would not mean that others would not enjoy it. Indeed, on a different day, you might enjoy it yourself. The point is this: your personal likes and dislikes on any given day are not very reliable for telling you when something is a work of art.

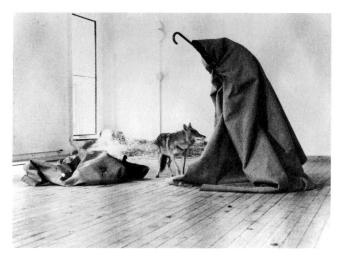

2-11 Would seeing a Beuys performance be an aesthetic experience for you? Why? Joseph Beuys, Coyote — I Like America and America Likes Me, 1974. Copyright 1974 Caroline Tisdall, Courtesy Ronald Feldman Fine Arts, Inc., New York.

Intentions and Art

Today, many philosophers of art say that *buman intention* is a necessary factor in determining whether or not something is art. People who make paintings, for example, "intend" them to be art. When Robert Rauschenburg attached an old tire to a stuffed goat, mounted them to a canvas, and smeared them with paint, he *intended* the whole thing to be a work of art. The museum director *intended* the Indian shirt (fig. 2–12) to be a work of art when he or she put it in the Museum of the American Indian—even though the Indians themselves may not have intended it to be art. If you saw a piece of driftwood on the beach (fig. 2–13), you probably would not call it art. But if you saw it mounted on a wall in someone's home, you probably would. The person mounting the driftwood *intended* it to be seen as art.

The principle of human intention seems to be the answer to our question, When is it art? Perhaps this principle explains all of the examples presented in Chapter 1.

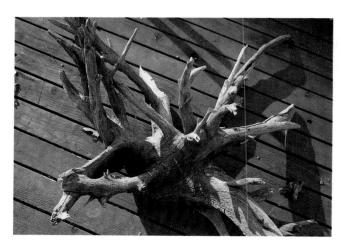

2-13 Under what conditions would this piece of driftwood be a work of art? Photograph by Barbara Caldwell.

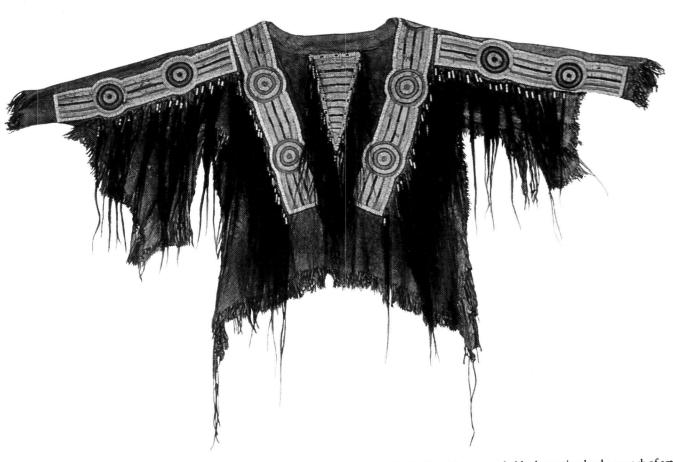

But does it answer all the questions? Who is to do the intending: just artists and museum directors? Can anyone-you, for example-intend something, anything, to be art? Suppose you wrapped your house with bedsheets. Would other people consider it a work of art-or a mess (fig. 2-14)? Would your neighbors appreciate it? Would your art teacher praise you for it? Suppose, like Joseph Beuys, you wrapped yourself in felt and walked around a room with a coyote. Would anyone take you seriously?

2-12 This Indian shirt was probably determined to be a work of art by a board of directors of a museum. Shirt, Broulè Sioux, early nineteenth century. Buckskin with quillwork, beads and hair locks, 58 " (147 cm) arm spread. Museum of the American Indian, Heye Foundation, New York.

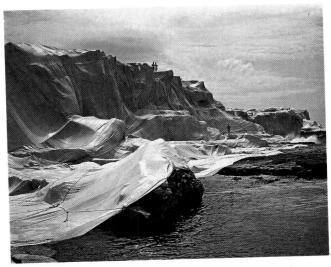

2-14 What do you think your dad would say if you wrapped your garage in "plastic-wrap." Would he consider it a work of art? Christo, Wrapped Coast, One Million Square Feet, Little Bay, Australia, 1969. Erosion control fabric and 35 miles of rope. Photo: Harry Shunk. Copyright Christo 1969.

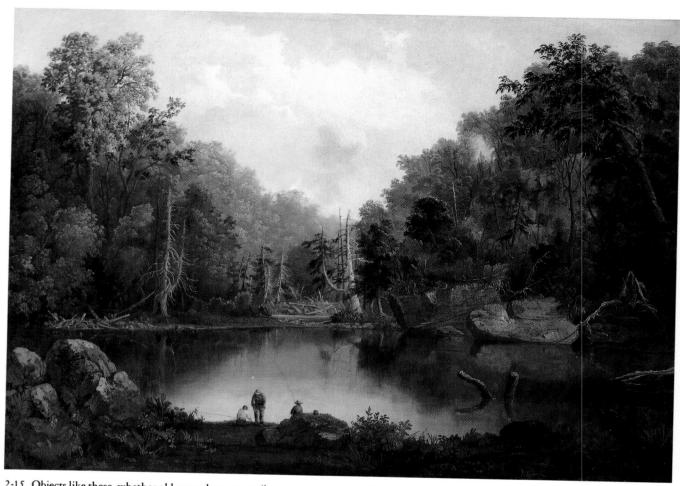

2-15 Objects like these, whether old or modern, are easily recognizable as art. Why are they so easy to recognize? These examples, along with those that are less traditional, including the Indian shirt, the stuffed goat, the wrapped coast, and even the Beuys performance, belong to a world of things called *fine art*. Can all of these be found in museums or galleries? Where can we find pictures of these things? Robert S. Duncanson, *Blue Hole, Flood Waters*, *Little Miami River*, 1851. Oil on canvas, 29½ " × 42½ " (74 × 107 cm). The Cincinnati Art Museum (Gift of Norbert Heermann).

The Art World

Some art is ancient like the cave paintings; some is traditional like Duncanson's (fig. 2–15); some is modern like Albers' (fig. 2–16). Regardless of their styles, we have no trouble telling that these objects are art. The kinds of art that often raise questions are utilitarian objects from old or tribal cultures, like the Indian shirt, and experimental forms, like the ceramic briefcase, used car, wrapped coast, stuffed goat, and performance piece.

In the final analysis, there is no perfect method for determining when things like these are art. Human intention is necessary; good design and the aesthetic experience are important. But ultimately, determining when something is art seems to be a matter of judgment.

Who makes the judgments in these matters? People like artists, dealers, collectors, art critics, museum direc-

tors, and art teachers, all of whom make up what is known as the art world—just as players, coaches, managers, umpires, and team owners make up the sports world. These people are involved not only in the production of art, but in selling it, collecting it, displaying it, writing about it, and teaching it. Because of their training, experience, and commitment, they have the expertise to make judgments. Do these people ever make bad judgments? Yes. Some utilitarian objects should have stayed in history museums; some examples of experimental art should have been forgotten. But there are also many traditional paintings and sculptures that were misjudged by experts in the past. Most of those works now are out of sight, gathering dust in museum basements.

Art of the kind that you see in art galleries and art museums—the art that is reproduced and written about in newspapers, art magazines, and art books like this one—is called *fine art*. Unless you have original art in your home,

or are a member of the art world, fine art is something you will see only on special occasions, as when visiting an art gallery or museum, or reading an article about it in a newspaper or magazine. Sometimes the term fine art is used to contrast it with folk art, art produced by amateur or untrained artists, and with commercial art, the kind of art that you experience on an everyday basis, usually in the newspapers or on television.

Summary

Difficult questions about art - one of which has to do with the definition of art-are dealt with by philosophers of art. Defining art by looking for traits that all artworks have in common is almost impossible to do. Most works possess good design, but not all do. Furthermore, many things besides art possess good design. Artworks are intended to provide an aesthetic experience, a personal experience that involves appreciating something for its own sake. But many things besides art can be experienced this way.

Therefore, neither good design nor the aesthetic experience is a complete test of something being a work of art.

Human intention is common to all art: traditional paintings and sculptures, ancient objects, experimental forms of art, and even pieces of mounted driftwood. Beyond that, it is the art world that makes judgments about what is to be called art - or more precisely, fine art, the kind we see in art galleries and museums, and that is written about in major newspapers and art magazines.

Challenge 2-1:

Select an object from home that you can defend as an artwork according to conditions listed in this chapter. Is it old or new? Is it art? Bring it to school. If others in your class have also brought in objects, they can be displayed and discussed. Defend your object as art. What reasons would you give? Can you prove that something, anything, is art?

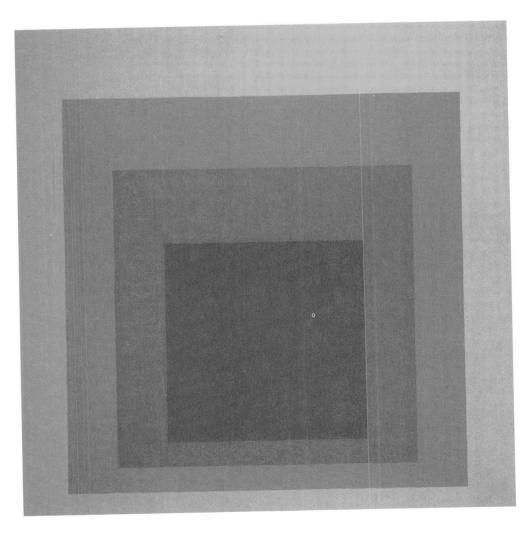

2-16 Josef Albers, Homage to the Square: Glow, 1966. Acrylic on fiberboard, $48'' \times 48''$ (122 × 122 cm). Hirshhorn Museum and Sculpture Garden, Smithsonian Institution (Gift of Joseph H. Hirshhorn, 1972).

Chapter 3 Chapter 4 Chapter 5 Chapter 6 Chapter 7 Chapter 8

Describing What You See
Visual Elements: Line
Visual Elements: Shape and Form
Visual Elements: Value and Color
Visual Elements: Space
Visual Elements: Texture and Movement

Chapter 3 **Describing What You See**

One way to open ourselves to art is by taking the time to look at an artwork. Our world is so full of images – advertisements, illustrations, billboards, and photographs that we get into the habit of glancing and not really looking. This is unfortunate, especially when good pictures are involved.

To make sure that we are looking, and not just glancing, at a picture, we should try once in awhile to describe it.

Description

According to the dictionary, describe means "to tell or write about, to give a detailed account of." If you were to describe a work of art, first you would *look* at it closely, and second you would tell or write about what you saw. This kind of telling or writing is called *description*.

When writing a description you must stick to the *facts*. Include things like the objects, people, shapes, and colors that you and others can see. Do not include opinions, such as: "The man is wearing a stupid hat," "That is a pretty color," or "This picture is about people having a lot of fun." Such statements are opinions that may be true for you but not for others. They are not facts.

How well can you describe a painting? Look carefully at and write about *Luncheon of the Boating Party* (fig. 3–1) by Renoir. To make the job somewhat more challenging, allow yourself no more than fifteen minutes to write your description. (Do not continue reading until you have finished the description.)

Did you feel that you needed more time to describe the picture? If you said yes, you are right.

Your description probably indicated that there are a number of young adults, both men and women, gathered on what appears to be a deck. Some are sitting, some are standing. Several seem to be talking to one another. You probably also recorded the table, the food and drink on the table, the young woman at the table holding a little dog, the railing behind the table, the people leaning on the railing, the awning overhead, and the leafy foliage beyond the deck. Did you have time to note the people's clothes, their hats, or what they are doing? Did you notice the sailboats in the distance?

If you mentioned all those things, you did quite well, but that is only a *beginning*. A good description would have pointed out several more things about the people: that some are nearer to the viewer than others; that those on the left seem spread apart, while those on the right seem crowded together; and that some are looking to the right, some to the left, some toward the viewer, and some away from the viewer.

A good description would have called attention to the fact that both the table and the railing are on the left side of the picture, but that both lead your eye to the right.

If you said all of these things, you did very well, but even so, your description would have recorded only the people and objects in the painting. It would have left out some of the most important things – namely, the various lines, shapes, colors, and textures.

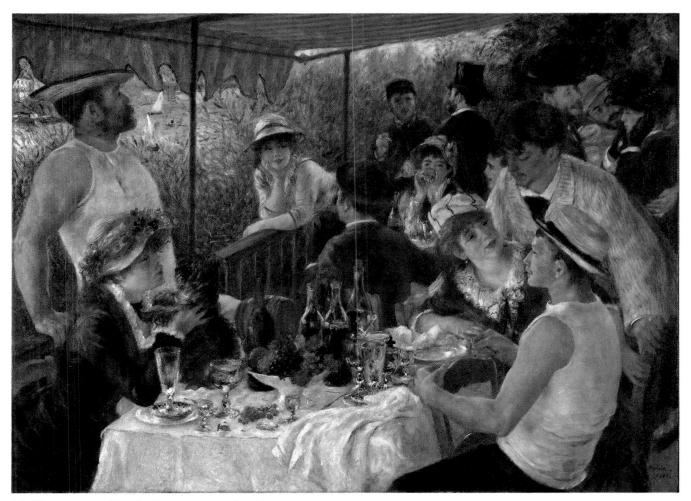

3-1 There are many things in this painting: people, objects, colors, and textures, even a puppy. Pierre Auguste Renoir, *Luncbeon of the Boating Party*, 1881. Oil on canvas, 51 " × 68" (130 × 173 cm). Phillips Memorial Gallery, Washington, DC.

Pierre Auguste Renoir 1841-1919

Warm red and yellow colors fill a tranquil scene of carefree vacationers gathered at an afternoon meal. Bold brushstrokes define faces and figures leisurely mingling in the summer sun. Pierre Auguste Renoir developed a reputation for his talent in portraying lighthearted scenes like Luncheon of the Boating Party.

As one of five children of a tailor from Limoges, France, Renoir had to save every penny he earned as a porcelain painter to attend the School of Fine Arts in 1862. There he became friends with other aspiring artists, including Claude Monet, and Alfred Sisley. These men influenced each other's painting, and began to work in similar styles, using brilliantly colored dabs of paint and often painting outdoors. These techniques were considered unique and revolutionary. Later, this group of artists and friends became known as the Impressionists.

Renoir soon attained great status as a portrait painter. Underneath this success, however, he was often dissatisfied with his work. He was also selfconscious about being a member of the working class and not a part of the middle class group who were the subjects of his paintings. But the public adored him. In his lifetime Renoir was paid to paint over two thousand portraits of wealthy art lovers

Why did he paint such joyous scenes when he was really unhappy? "There are enough ugly things in life for us not to add to them," he once said. The happy images Renoir painted contrasted with his emotions.

From delicate work on porcelain and drawing from models in an art class, Renoir learned the techniques necessary to paint on canvas. Using these skills, Renoir presented colorful scenes filled with happiness and untroubled ease, a world he envisioned with paint and brush.

3-2 What are some colors that you see in this "white" table cloth? Pierre Auguste Renoir, Luncbeon of the Boating Party (detail), 1881. Oil on canvas, $51'' \times 68''$ (130 × 173 cm). Phillips Memorial Gallery, Washingtion, DC.

3-3 What other colors besides green do you see in this section of foliage? Pierre Auguste Renoir, Luncbeon of the Boating Party (detail), 1881. Oil on canvas, $51'' \times 68''$ (130 × 173 cm). Phillips Memorial Gallery, Washington, DC.

We hope you said something about color. But did you note that the white tablecloth (fig. 3-2) is not a single color of white, or that the foliage (fig. 3-3) is not a single color of green? Did you point out that some colors are lighter (or darker) and that some are brighter (or duller)?

As you can see, if you were to write a good description, you would need a great deal of paper and a lot of time. It is not something that can be done in fifteen minutes.

Even if you had been given one hundred minutes, you probably would have left out many important things. To describe a work of art, you need more than just enough time, you also need to know what to look for and to have the appropriate vocabulary - the right words to describe what you do see.

Knowing What to Look For

You may be able to see normally, that is, you may see as much as, and as clearly as, the average human being. But being able to see normally does not mean that you are going to see all of the things you should in a work of art. To see properly requires some knowledge about what you are looking at. It also requires some practice.

The Sunday comics (fig. 3-4), television cartoons, and other pictures that you see all the time are very simple compared to Renoir's painting. Leaves are usually one shade of green, skies are blue, clouds are white and puffy shaped, houses have pointed roofs, and Santa Claus always has a round body and a red suit. Colors are plain and shapes are simple in this kind of everyday art.

3-4 Comic strip art is obviously not very demanding of your ability to describe shapes and colors. Rex Morgan, M.D., DiPreta, 1988 King Features Syndicate, Inc. Reprinted with special permission of NAS, Inc.

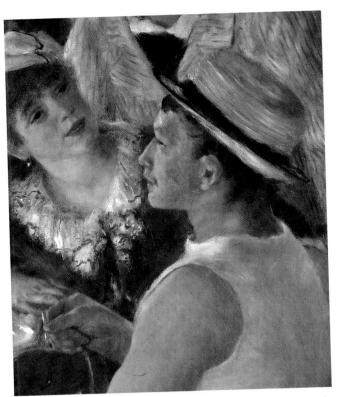

3-5 Can you name all the different colors in just this little section of Renoir's painting? Pierre Auguste Renoir, Luncbeon of the Boating Party (detail), 1881. Oil on canvas, 51" × 68" (130 × 173 cm). Phillips Memorial Gallery, Washington, DC.

As you can see, the shapes in Luncheon of the Boating Party are very complicated. The colors are even more so (fig. 3-5). For example, every item of clothing, whether it is a white shirt, a blue dress, or a brown suit, consists of different shades of white, blue, or brown. The leafy foliage consists of not only different shades of green, but also bits of yellow, blue, white, and brown. All of the colors in this painting come in different degrees of lightness and darkness and brightness and dullness.

Colors not only are more complicated in Luncheon of the Boating Party, but they have more purposes than simply to describe objects; they play an important role in providing unity and balance and contributing to the mood. The ways in which colors do this will be explained in later chapters. The point to be made now is that you should give more attention to color (and also line, shape, texture, and space) than you usually do when looking at everyday pictures.

Vocabulary

Probably the easiest thing for you to talk about in a picture is the *subject matter*, namely, the people and objects. It may be more difficult for you to deal with such things as colors and textures, because you have not learned the right vocabulary for talking about art. For example, you may be able to recognize the color orange without knowing that it is a "secondary" color and how such a color relates to other colors. You may already be aware of the texture of a painting without having the words to describe it. On the other hand, you may not be aware of these things at all, until you first learn the words for them.

The Elements of Art

The place to begin building knowledge about art and the vocabulary to apply to that knowledge is with the *elements of art:* line, shape, form, value, color, space, texture, and movement.

In a particular work of art, some elements may be less emphasized than others. For example, color probably plays a less important role than shape in the wrapped coastline pictured in the first two chapters. But it is still there. All of the elements are present to a greater or lesser degree in all works of visual art.

Learning the elements will help you to see things that you may not have noticed before and to provide words for those things.

Suggestion:

Save your description of Luncheon of the Boating Party. You may want to add to it as you learn more about art in the following chapters.

Write a description of art from memory. Look at a picture for a few minutes and then do not look at it while writing. After you have finished, look at it again and compare your description with the real thing.

Summary

Describing is telling about what you see. A description of an artwork should stick to the facts.

It is not easy to describe a painting like Luncheon of the Boating Party. There are many things to look for in terms of both its subject matter—the people and objects—and its visual elements—lines, shapes, colors, textures, and space. The visual elements will be discussed in the next five chapters. Knowledge of these elements should help you see things in art that you did not see before, and also provide you with words for those things.

Challenge 3-1:

Produce a description of Grant Wood's American Gothic that includes things which can be seen, named and decribed with certainty. Consider such things as line, color, value, etc.

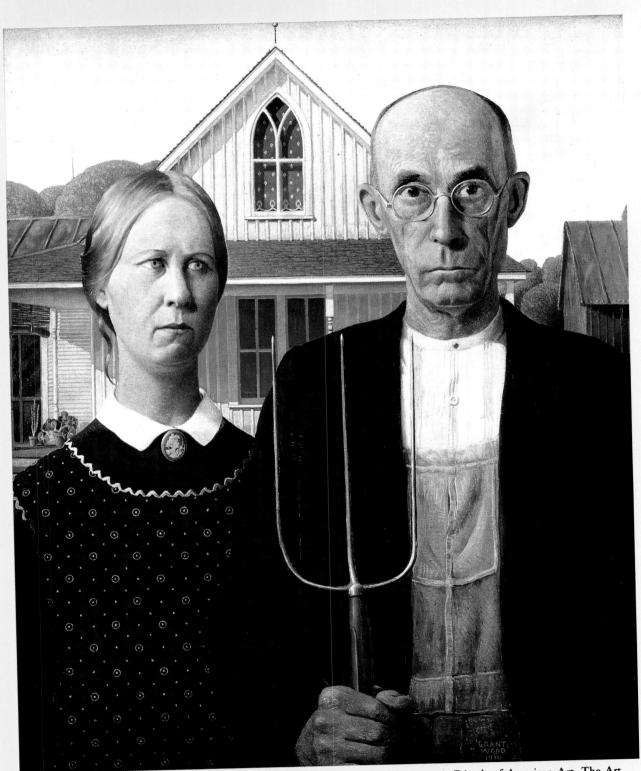

Grant Wood, American Gotbic, 1930. Oil on beaver board, 30" × 25" (76 × 63 cm). Friends of American Art, The Art Institute of Chicago.

Chapter 4

Visual Elements: Line

The word *line* is one of the longest entries in Webster's dictionary. Think of some of the different ways in which *line* can be used: *line* a ball in baseball, hit the *line* in football, memorize *lines* for a play, avoid being last in *line* at the cafeteria, and apply for a *line* of credit. Even when the meaning of line is narrowed to things that resemble "long thin marks," we are left with a great variety of examples of usage.

Lines can be found in nature in such things as the veins of a leaf (fig. 4–1), the branches of a winter tree (fig. 4–2), and the wind-etched sands of a desert (fig. 4–3). Lines are also plentiful in the manufactured environment. If you looked up on your way to school you probably saw electric power and telephone lines stretched between poles (fig. 4–4); if you looked down you probably saw the cracks of the sidewalk.

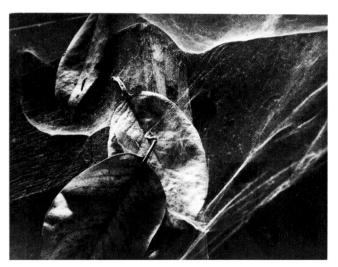

4-1 Wynn Bullock, *Leaves and Cobwebs*, 1968. Silverprint, $7\frac{1}{2}$ " × $9\frac{1}{4}$ " (19 × 24 cm). The Detroit Institute of the Arts.

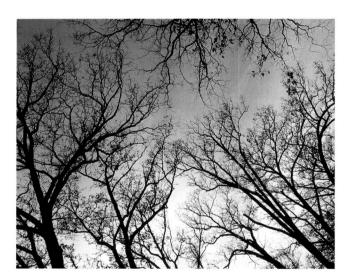

4-2 Photograph by Barbara Caldwell.

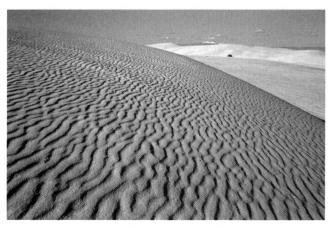

4-3 White Sands National Monument, New Mexico. Photo courtesy U.S. Dept. of the Interior, Washington, DC.

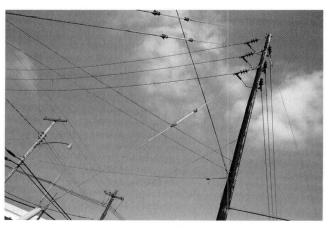

4-4 Photograph by Barbara Caldwell.

In fact, the printed letters and numbers you are reading right now are shapes made with lines—either curved or angled. Some, like c, s, and s, are made with single lines that are open at the ends; some, like s, and s, are made with lines that cross; some, like s and s, are made with open lines that are connected in places. Many, like s, s, s, s, s, s, and s, are made with lines that are partly open and partly closed. Of course, at least two—s and s—are made of single lines with no open ends. Isn't it amazing how many letters and numbers can be created by arranging or rearranging a few straight and curved lines (and dots to make s and s)?

Suggestions:

Look at other alphabets, such as Greek, or Russian, to see if you can find new kinds of letters. Some alphabets, like Arabic, Hebrew, and Japanese, are very different from English. Perbaps you can create your own alphabet.

Another example of lines is a road map. Lines and shapes on a map are usually called *symbols*—various marks that stand for other things. On a map of northern Illinois, for example, the long lines stand for roads, highways, interstate highways, and rivers (fig. 4–5). On the road and highway lines are dots (a little circle surrounded by a line) that stand for small towns. On Interstates 80 and 39 are little squares that stand for exits and interchanges. The wandering line that parallels Highway 6 is the Illinois River.

Lines in art come in at least as many varieties as those in nature or in books and maps. Many lines in art are the result of the movement of some tool such as a pencil, charcoal stick, pen, or brush. Did you know that lines can even be made with light (fig. 4–6)?

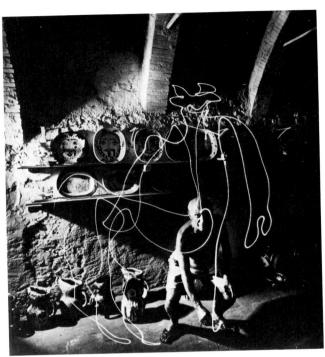

4-6 Gjon Mili, A Centaur Drawn with Light — Pablo Picasso at the Madoura Pottery in Vallauris, France. Photograph. Copyright 1984. Sotheby Parke Bernet, Inc., New York.

4-5 Courtesy of Rand McNally.

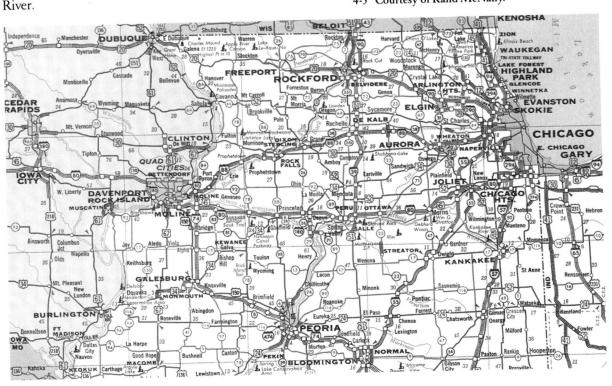

Challenge 4-1:

Produce five different kinds of line with each of five different drawing tools: crayons, pencils, felt-tip pens, ball-point pens, drawing pens, sticks and brushes. Now that you know what kinds of line can be produced with these drawing media, use several of the tools to make an interpretive drawing of fall weeds (see fig. 4-1-B, C).

b. Student work.

c. Student work.

Descriptive Lines

You have been making lines since the first time you picked up a pencil. At first you probably made scribbles. Eventually your lines turned into recognizable pictures. This use of lines—whether by a child or an artist—is called *descriptive*. Descriptive lines come in many varieties.

Outlines

The most basic kind of descriptive line is an outline, that is, a line that joins itself to surround a shape. We have seen examples of outlines in alphabet letters and map symbols. In school you use outlines to make letters and symbols, and you also use them to make pictures. Like you, comic strip artists use outlines to create all kinds of imaginary objects and people, including such memorable characters as Charlie Brown and Snoopy (fig. 4–7). The lines of an outline drawing usually are the same thickness throughout. Because of this, and the fact that only the outer edges of its shape are defined, an outline drawing seems to have little depth. Charlie Brown and Snoopy are almost as flat as cutouts.

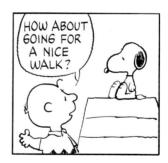

4-7 Charlie Brown and Snoopy, 1973. United Feature Syndicate. Charles M. Schulz.

Contour Lines

Contour lines also define edges, but unlike outlines, they vary in thickness and darkness, and they also define the edges of shapes within a form. Because of their variety, these lines are not only more interesting, they are more descriptive, and they impart a greater sense of depth to the objects they describe. Lines in drawings by professional artists are often called contour lines rather than outlines. Notice how the contour lines in the Persian drawing APortly Courtier (fig. 4-8) smoothly trace the man's rotund form and even some of the folds in his clothes. Contrast the Persian artist's "relaxed" lines with the intense, scratchy lines of Ben Shahn's Dr. J. Robert Oppenbeimer (fig. 4-9). Diego Rivera used ink and brush to create lines that describe an Indian mother carrying her child (fig. 4-10). Some are narrow, some are quite wide; some, like the one that shows the underside of the mother's arm, are both narrow and wide. Compare Rivera's two people to Charlie Brown and Snoopy. Which pair seems to you to be the most solid, the most three-dimensional? Which of the two pictures has the most variety in its lines? When you draw, which kinds of lines do you use mostly: outlines or contour lines?

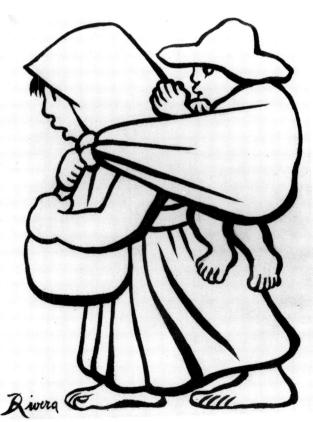

4-10 Diego Rivera, *Mother and Child*, 1936. Ink on paper, 12" × 9¹/₄" (30 × 23 cm). San Francisco Museum of Modern Art (Albert M. Bender Collection, Gift of Albert M. Bender).

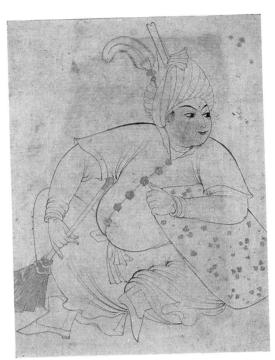

4-8 A Portly Courtier, Persian Safavid, Tabriz, ca.
1535. Ink and gold on paper, 13" × 9"(34 × 23 cm).
Courtesy The Arthur M. Sackler Museum, Harvard
University, Cambridge, Massachusetts (Gift of Mr.
Henry B. Cabot, Mr. Walter Cabot, Mr. Edward W.
Forbes, Mr. Eric Schroeder, and the Annie S. Coburn
Fund).

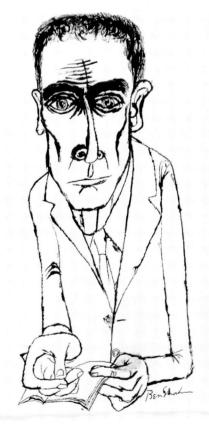

4-9 Ben Shahn, *Dr. J. Robert Oppenbeimer*, 1954. Brush and ink, 19½ " × 12¼ " (50 × 31 cm). Collection, The Museum of Modern Art, New York (Purchase).

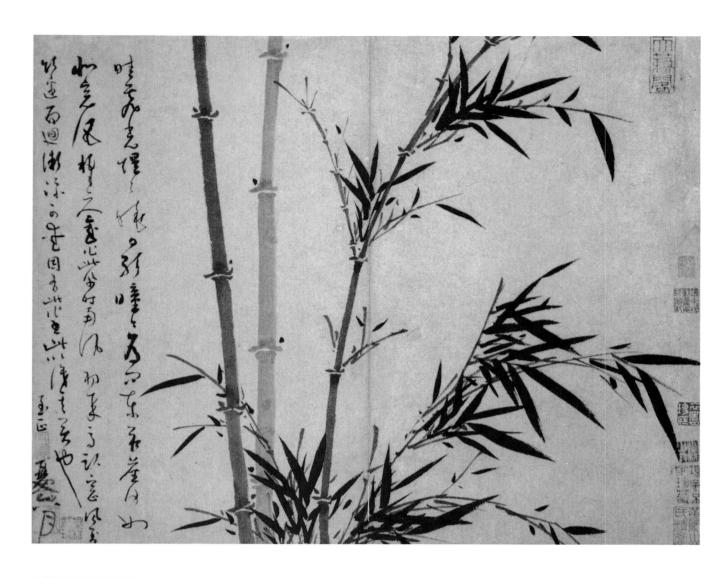

4-12 Wu Chen, Bamboo, Yuan dynasty, A.D. 1350. Album leaf, ink on paper, 16 $'' \times 21$ '' (41 \times 54 cm). Collection of the National Palace Museum, Taipei, Taiwan, Republic of China.

Individual Lines

Just as a single line can represent the letter S or a highway on a map, it can describe an individual strand of hair, as in the closeup of a painting by Andrew Wyeth (fig. 4–11). Wu Chen used single strokes of an ink-loaded brush to describe the stalks and leaves of a bamboo plant (fig. 4–12). He also used individual strokes for each symbol of the Chinese writing—called *calligraphy*—on the left side of the picture.

4-11 Andrew Wyeth, *Braids* (detail), tempera. Copyright 1986 Leonard E.B. Andrews.

Challenge 4-2:

Produce a drawing using contour lines that describe the three-dimensional characteristics of an object.

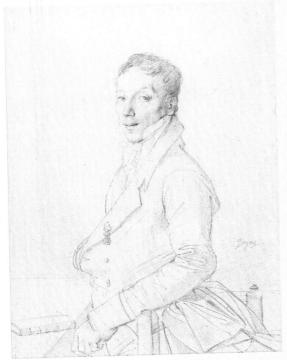

a. The lines in this contour drawing accurately and sensitively describe the edges of forms, and the details and folds of the coat found within the major forms. Jean Auguste Dominique Ingres, *Portrait of a Young Man*, ca. 1815. Pencil, (290 × 220 mm). Museum Boymans—van Beuningen, Rotterdam.

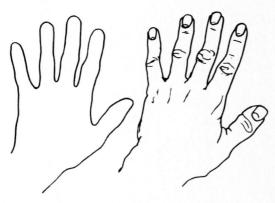

b. The outline of a hand is accurate, but appears flat and lacks information when compared with the contour drawing on the right.

Hatching

David Levine used contour lines to make a humorous drawing of a public person (fig. 4-13). But notice in the face and coat of the person that he also used many thin, closely spaced, parallel lines called batching. Hatching lines that cross, like those on the lower part of the head, are called crossbatching. In hatching, the black lines are so thin and close together that they blend with the white of the paper. When this happens, they appear gray rather than black on white. This effect is called optical mixing (because the mixing of black and white happens in the eye). In Levine's picture, the hatching lines are optically mixed (in your vision) to produce a variety of grays that in turn help to describe the forms of the face - especially the nose, cheeks, chin, and jowls. The use of lighter and darker grays to make a form seem three-dimensional is known as shading, a subject that will be explained further in the chapter on value and color.

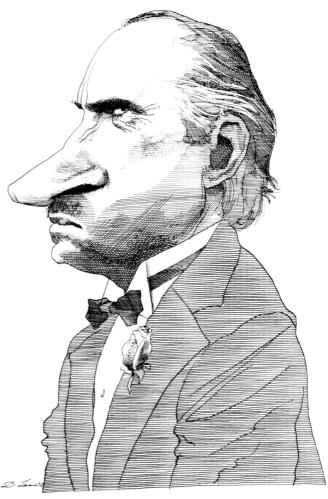

4-13 David Levine, Nixon as The Godfather, 1972. Reprinted with permission from The New York Review of Books. Copyright 1972, Nyrev, Inc.

Challenge 4-3:

Use pen and ink, black ballpoint pen, or pencils to practice batching and crossbatching in a variety of drawings. Try to achieve a wide range of lights and darks.

b. Student work.

c. Student work.

a. Hatch and crosshatch techniques.

Implied Lines

The lines we have seen so far are just that: seen lines. They are visible. They have width as well as length. Some lines are not seen, at least not in the usual way. They are implied; that is, they are indicated indirectly. Have you ever implied that you were hungry by looking at your watch or checking the oven around meal time? The presence of hunger on your part was suggested by your actions. Likewise, the presence of lines can be suggested by things that are not lines.

Edges

A line can be implied by an edge. In a picture where outlines are not used, an edge exists where one shape ends and another begins. Although no line is there, the points of contact between the shapes are seen as a line. For example, there are no outlines or contour lines in Renoir's painting of a boating party (fig. 4–14). Nevertheless, lines are

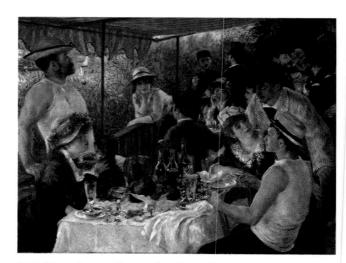

4-14 Pierre Auguste Renoir, Luncheon of the Boating Party, 1881. Qil on canvas, $51'' \times 68'' (130 \times 173 \text{ cm})$. Phillips Memorial Gallery, Washington, DC.

implied by various edges: the edge of the railing on the left, the edge of an arm leaning on the railing, the edge of the man's back on the right, even the water's edge where it

touches the riverbank in the distance.

In a sculpture, an edge exists where the sculpture ends and the space around it begins, or where parts of the sculpture project. Such an edge, of course, is never indicated with a real line. But it can suggest a line. The edges of Elizabeth Catlett's carving of Mother and Child #2 imply many graceful lines (fig. 4-15). The outside line of the form almost describes the contour of a rounded parallelogram. The edges of the mother's arms are echoed by the inner lines that form similar angles. The curve of her hand is repeated in the circle of the infant's head.

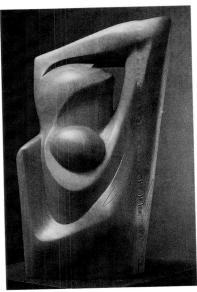

4-15 Elizabeth Catlett, Mother and Child #2, 1971. Walnut. 38" (97 cm). Collection of Alan Swift. Photograph courtesy Samella Lewis.

4-17 Skidmore, Owings and Merrill, Sears Tower, 1974. Chicago, Illinois.

The edges of a building can also suggest lines. Typically, these lines occur at the outer edges of the building or where flat planes meet, as at the roofline. But lines also are suggested by the edges around window and door openings, and the edges of overhangs, ledges, balconies, railings, posts, and trim. In the Japanese villa (fig. 4–16), most of the lines are horizontal, emphasizing the width of the building rather than its height. Horizontal lines also tend to relate to the flat ground, thereby symbolizing restfulness and stability - qualities associated with home. By contrast, most of the lines of the Sears Tower (fig. 4-17) are vertical, stressing its enormous height, and symbolizing the strength of a powerful corporation.

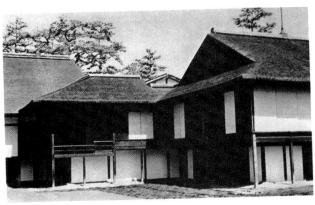

4-16 The Shoin, Katsura Imperial Villa.

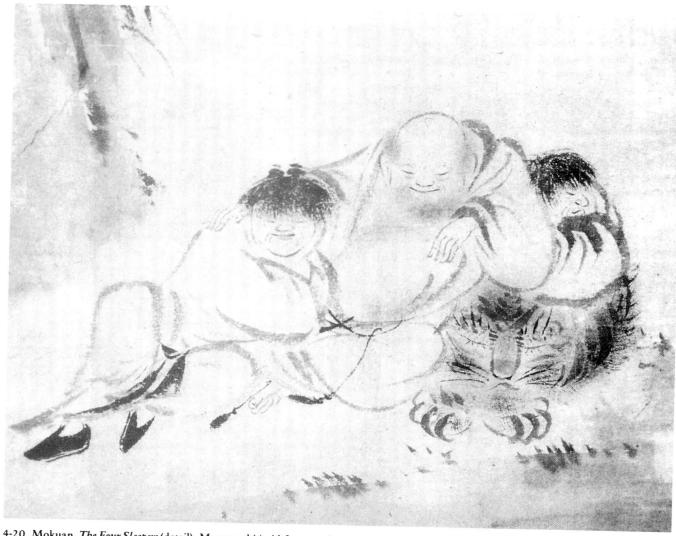

4-20 Mokuan, The Four Sleepers (detail). Muromachi (mid-fourteenth century). Ink on paper, 28 " \times 14" (70 \times 36 cm). Maeda Ikutokukai Foundation, Tokyo.

Closure

Lines can even be implied by a simple arrangement of dots. For example, there are no lines in figure 4–18. Nevertheless this arrangement of dots is seen as a square rather than simply as four separate dots. The dots are connected by lines in the "mind's eye" (fig. 4–19). The tendency of people to connect marks this way, or to "see" lines where none exist, is called closure.

4-19

Closure is required to connect the loosely drawn and delicate lines in Mokuan's The Four Sleepers (fig. 4-20). Can you see the four sleepers? Would you agree that the loss of clarity in Mokuan's picture is offset by a gain in interest and humor? Why?

Closure is required even for viewing a photograph, especially when the photograph provides limited "information," as in figure 4–21. The student and the teacher are formed by just a few areas of black and white. The teacher's face below the hair has almost no outline or any other lines except a mouth.

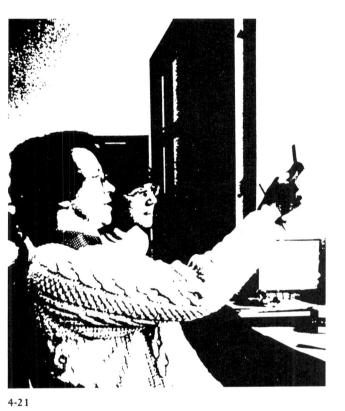

Lines of Sight

In your description of Renoir's Luncheon of the Boating Party, did you mention the lines of sight—the implied lines along which people look? Following a line of sight is a natural tendency. How often have you looked up when someone else looked up? Following a line of sight between two people—as between two merrymakers in Renoir's painting (fig. 4–22)—is also natural. It is similar to the process of closure. Artists often use lines of sight as a device to connect different parts of a picture. Which of the many lines of sight do you think are the most important in Luncheon?

Expressive Use of Lines

We have seen that artists use lines as symbols to describe shapes or forms, and to indicate shading. We have also seen some ways that painters, cartoonists, sculptors, and architects utilize implied lines. In addition to these uses, artists also employ lines to convey, or *express*, feelings and ideas. Although the discussion so far has not focused on expression, some examples of the expressive qualities of lines have been mentioned. Recall the "relaxed" lines of the Persian drawing (fig. 4–8), the "intense, scratchy" lines of Shahn (fig. 4–9), the "graceful" lines of the Catlett sculpture (fig. 4–15), and how the lines of the Japanese villa suggest "restfulness and stability" (fig. 4–16), while the lines of the Sears Tower suggest "power and strength" (fig. 4–17). Lines—whether descriptive or implied—seem to have their own "personalities."

Abstract Lines

Abstract lines typically are found in abstract (nonrepresentational) art. Unlike descriptive lines, abstract lines are not used to symbolize, to outline, or to look like shading. Although descriptive lines can be both descriptive and expressive, abstract lines are limited primarily to expression. As a viewer, you have little choice but to see abstract lines for what they are: lines.

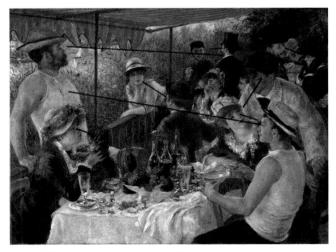

4-22 Which lines of sight do you think are the most important? Pierre Auguste Renoir, *Luncbeon of the Boating Party*, 1881. Oil on canvas, 51 " × 68" (130 × 173 cm). Phillips Memorial Gallery, Washington, DC.

4-23 Jose Roberto Aguilar, *The Brazilian Myth (O Mito Brasileiro)*, 1981. Acrylic on canvas, $7' \times 13'$ (213 \times 396 cm). Collection Kim Esteve, São Paulo, Brazil.

Suggestion:

Look at the examples of abstract art (figures 4-23, 4-24, 4-25, and 4-26). Try to come up with a word or two to describe the feeling that each work seems to express. If you have the opportunity, compare your set of words with your neighbor's. If you do not want to make up your own words, use those in the following list and match them with the works of art. Again, see if your choice of words agrees with your neighbor's. Possible words to match with the artworks:

aggressive	energetic	savage
awkward	explosive	soft
balanced	delicate	strong
blunt	graceful	swift
bristling	nervous	timid
brutal	powerful	unstable
calm	rbythmic	weak
chaotic	restless	

4-25 Kazuaki Tanahashi, *Heki*, 1965. Ink on paper, 36 $''\times$ 28 '' (92 \times 71 cm). East-West Center, Honolulu.

4-24 Ibsen Espada, El Yunque, 1985. Oil and ink on paper applied to canvas. $53\frac{1}{4}$ " \times 63" (135 \times 160 cm). Rundy Bradley, Houston.

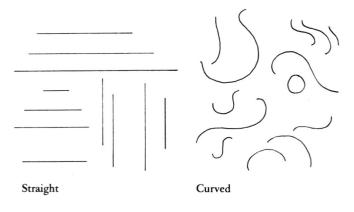

4-27

Line Personalities

We said earlier that lines have personalities. If you did the Suggestion, you matched abstract lines with adjectives: aggressive, calm, energetic, and so forth. Could you match people—say, friends of yours—with these adjectives?

How does a line acquire a personality? There is no single answer to this question. One theory is that we associate lines with other things in our experience. Some generalizations can be made about this theory under the headings of shape, movement, and direction.

Shape. Straight lines remind us of things like buildings that are strong or powerful. Curved lines remind us of people, animals, or plants that are soft, delicate, or graceful. Jagged lines suggest objects like broken glass, sawteeth, or lightning that are bristling, aggressive, or savage.

Movement. A line, as we explained, is often the record of real movement. We associate lines with the movements of animals, people, or even our own bodies. Straight lines may seem rigid or swift, curved lines seem relaxed or graceful, and jagged lines seem nervous or awkward.

Direction. If a line has movement, it also has direction. Lines that move in vertical directions seem strong; horizontal lines seem calm or stable; and diagonal lines seem unstable (fig. 4–27).

Always keep in mind that these descriptions are *generalizations*. The effect of a particular line may be due to its shape, movement, and direction. But this effect can also be influenced by the line's surroundings, or *context*. The context consists of shapes, colors, textures, and even other lines in a work of art. (The visual elements of shape, color, and texture are discussed in later chapters.)

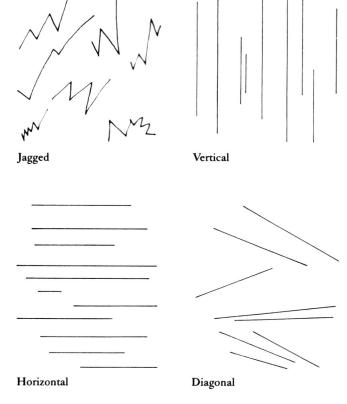

Summary

There are many varieties of lines. They exist in both the natural and manufactured environments. Lines are especially numerous on paper, as on the pages of a book, maps, even musical scores.

Lines in art also come in various forms. In this chapter the different kinds of lines are discussed under the headings of descriptive, implied, and abstract. Descriptive lines are created with a variety of tools, and can be outlines, contour lines, single lines, or hatching. On the other hand, lines can be implied by the edges of forms in paintings, sculptures, and buildings, by the process of closure, and by lines of sight. Abstract lines, unlike descriptive lines, usually do not symbolize or represent anything except themselves.

All lines—whether descriptive, implied, or abstract—have the ability to express ideas and feelings. Lines can be said to have personalities through associating their qualities with our daily experiences of shape, movement, and direction. Regardless of how we describe the expressive qualities of lines, these qualities are an important part of the aesthetic experience.

Challenge 4-4:

Artists use a variety of drawing media in order to create lines that are appropriate for communicating particular ideas and feelings. Van Gogh's drawing of cypress trees shows how line can express spiraling

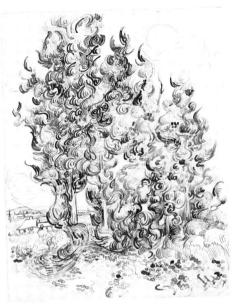

a. Vincent Van Gogh, *Grove of Cypresses*, 1889. Pen and ink over pencil on paper, 24" × 18" (61 × 46 cm). The Art Institute of Chicago, Illinois (Gift of Robert Allerton).

c. Match these words with the line drawings above. Timid, aggressive, strong, graceful, nervous.

rhythm and energy. Compare Van Gogh's tree with that of Leonardo DaVinci. How do the lines in the two drawings differ? Describe the different feelings that are suggested by the two drawings.

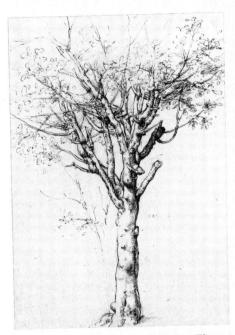

b. Leonardo da Vinci, Study of a Tree. The Royal Library, Windsor, England.

d. Create abstract drawings in which lines communicate ideas or feelings.

Chapter 5 Visual Elements: Shape and Form

Shape

A shape is a two-dimensional area with a recognizable boundary. When you draw or paint on paper you are making shapes. When you cut something out of paper you are making a shape.

As you can see, there is a relationship between lines and shapes. Lines, particularly outlines, describe shapes. On the other hand, the edge of a shape implies a line.

Here is a quiz for you to test your knowledge about shape. Choose the response that identifies the following figures:

Shape Quiz I

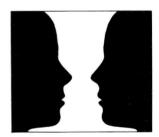

- 1. a. a vase
 - b. two faces
 - c. either a or b

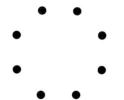

- 2. a. eight dots
 - b. a circle
 - c. two squares
 - d. any of the above

- 3. a. a black and white pattern
 - b. a locomotive
 - c. either a or b

All of the shapes in the quiz can be seen in more than one way. Look again at the illustration for question 1 (fig. 5–4). It provides a good example of the tendency to see a pattern as two kinds of shapes: figure and ground. A figure appears to stand out, to be "on top of" a ground. A ground, on the other hand, appears to be underneath and surrounding a figure. The white shape in the illustration is the figure and the black shape around it is the ground if you see the pattern as a vase. However, the black shapes are figures and the white is the ground if you see the pattern as two identical faces looking at each other. Try to see it either way. Such a pattern can be "read" in two different ways, but not both ways at once. You can reverse the figure and ground. Artists use the term positive shape to refer to figure and negative shape to refer to ground.

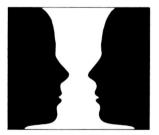

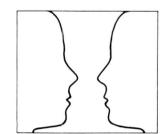

5-4 When you took the quiz, which did you see first: The vase or the faces? Did you see both? Can you see both at the same time? Does it matter whether the shapes are solid or outlined?

Circle Limit IV by M. C. Escher (fig. 5–5) is an excellent example of figure–ground, or positive–negative, reversal in an artwork. Which is figure: black or white? Can you see it either way? Can you see it both ways simultaneously?

Answers: 1. (c), 2. (d), 3. (c).

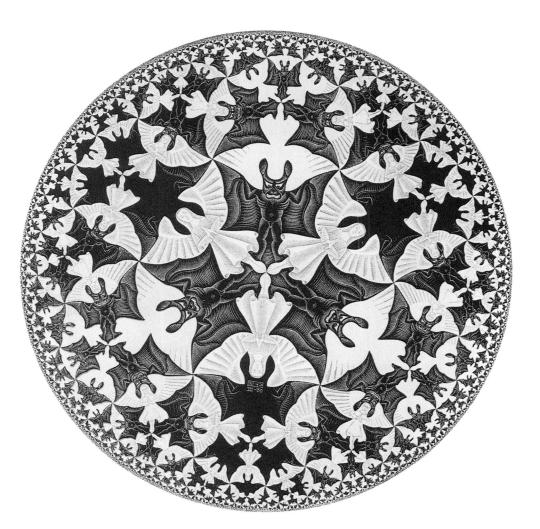

5-5 What are the reversible figures in this print by Escher? In what ways does the meaning change when the figures are reversed? M.C. Escher, Circle Limit IV, 1960. Woodcut in two colors, diameter 131/2" (417 cm). Copyright 1989 M.C. Escher Heirs / Cordon Art-Baarn-Holland.

Maurits C. Escher 1898-1972

Devils link together and the spaces between them form angels. Or, do the spaces between the angels form devils? Maurits Cornelis Escher experimented with many repeating patterns similar to the one in Circle Limit IV, in which the edges of one object help to form the shape of another.

Escher's fascination with the repetition of geometric shapes is just one aspect of the art which he created. An accomplished and technically masterful printmaker, Escher first became interested in art in his high school in the Netherlands. There he learned to create designs by rolling ink on the textured surface of a carved linoleum plate, and imprinting this inked surface onto paper. This printmaking process could be

repeated to produce multiple copies of a single

Formal training in graphic arts at college enabled Escher to perfect his printmaking technique and freed him to experiment with a range of subject matter for his prints. Early imagery included Escher's observations of the real world, especially scenes he recorded from visits to Italy and Spain. His interest in nature and reality gradually gave way to an obsession with invented landscapes - dreamy worlds filled with strange creatures and impossible perspectives.

Like the multiple patterns of devils and angels in Circle Limit IV, there are multiple levels on which to look at this artist: as a master printmaker, a master drawer, and as a man with a masterful sense of imagination and creativity.

Return again to the quiz. Questions 2 and 3 involve closure, a visual tendency discussed in the previous chapter. You probably saw the eight dots of question 2 as a circle (fig. 5–6). With some effort you could connect the dots to see them as forming two separate squares (fig. 5-7), although this would be an unusual reading. The simplest shape (in this case, a circle) is always the one that works best for closure. Did you see question 3 as a random pattern of white shapes or as a locomotive (fig. 5-8)? At first you may not have seen the locomotive because your mind's eye failed to connect the shapes. But once it does, the locomotive image is almost impossible to avoid.

The *Harper's* cover was influenced by early twentiethcentury art, such as Picasso's *Three Musicians* (fig. 5–10). Did it take you a while to see all three musicians? Although it is not a reversible figure, this painting can be read either as an image (in this case, of three musicians) or as an abstract pattern of shapes. In fact, Picasso probably intended you to appreciate the pattern more than the image, which is primarily humorous. The shapes of this painting are so cleverly assembled that it is difficult to distinguish between figure and ground, or between positive and negative. What kind of music would this painting be appropriate for as a design on an album cover?

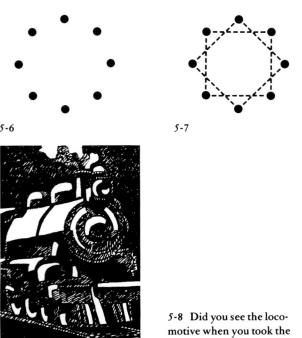

quiz?

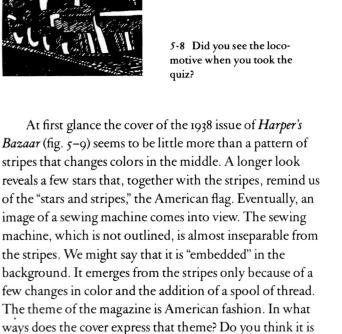

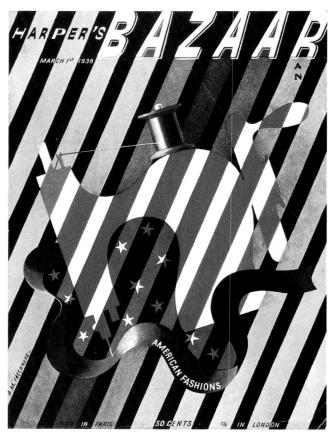

5-9 A.M. Cassandre, Harper's Bazaar magazine cover, March 1938, U.S.A. (Private collection).

successful? Explain your answer.

5-10 Pablo Picasso, Three Musicians, 1921. Approx. 6'7' × 7'3¾"(201 × 223 cm). Collection Museum of Modern Art, New York (Mrs. Simon Guggenheim Fund).

Challenge 5-1:

Produce an outline drawing in which figure and ground are reversible.

Student work.

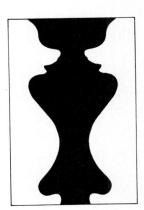

Challenge 5-2:

Create a reversible pattern by alternating the positive and negative shapes of an abstract figure cut out of construction paper.

Student work.

Form

Most of the things we encounter in everyday life are threedimensional shapes, often called forms. A form has height, width, and depth. The chair you are sitting on and the desk you are working at are good examples of forms that have height, width, and depth.

Forms in Pictures

In this section we will be concerned with forms in pictures, that is, the representation of three-dimensional objects on a twodimensional surface.

Try this second quiz on shape. Answers to this quiz follow.

Shape Quiz II

- 1. a. an ellipse
 - b. a football
 - c. a top of a pop can
 - d. any of the above

- a. a trapezoid
- b. a blade of a knife
- a side of a truck
- d. any of the above

You probably guessed that the answer for both questions was (d), any of the above. Like the examples used in the first quiz, these illustrations can be seen in different ways.

The example in question 1 is an *ellipse* (fig. 5–13), a curved shape that is longer in one dimension than it is in another.

But, in a picture, an ellipse can also represent a threedimensional ellipsoid (fig. 5-14), a type of form. A football is an ellipsoid. (Did you ever kick an ellipsoid? Do ellipsoids bounce differently than round balls, or spheres?) An ellipse can also represent the top of a pop can seen from an angle (fig. 5-15). But as you know, the true shape of a pop can top is a circle (fig. 5-16).

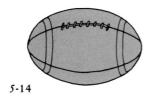

You may think of the pop can top as being the shape of a circle, even when seeing it from an angle, which is an example of *shape constancy* – the tendency to see a shape as unchanging regardless of the viewing angle.

The artist who drew the ellipse wanted you to see it as a circle at an angle. He or she also wanted you to see the whole image as a form, specifically, a three-dimensional cylinder - or a pop can as it might be seen on a table in front of you. To make it seem this way the artist deliberately shortened the height of the top in comparison to its width (fig. 5-17). Notice that the artist also curved the bottom edge of the can to match the curve of the ellipse at the top. Making a three-dimensional object in a picture appear to be seen at an angle by shortening one or two of its dimensions is called foreshortening.

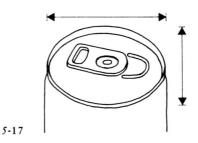

Now look at the shape in question 2 of the quiz (fig. 5-18). It is a trapezoid with four straight sides, two of which are parallel. A trapezoid can easily be used to represent the flat blade of a utility knife (fig. 5-19). It can also represent the side of an eighteen-wheel truck that is coming toward you (fig. 5-20). Compare the foreshortened view of the truck with its full view (fig. 5-21). Because of shape constancy, you think of it as being the same truck.

5-19

The use of foreshortening to make objects appear three-dimensional is very common in traditional paintings. Virtually every item in Dirk Bouts's The Last Supper (fig. 5-22) has been foreshortened. Identify as many items as you can. Some of these have been diagramed to show how they appear in the picture as it is, and how they would appear if not foreshortened (fig. 5-23).

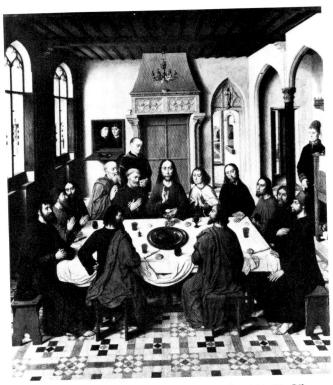

5-22 Dirk Bouts, The Last Supper (center panel), 1464-68. Oil on wood, $6' \times 5'$ (183 × 152 cm). St. Peter's Louvain.

5-23 Details of Last Supper.

Not foreshortened

Foreshortened

So far, we have seen examples of foreshortening in objects: pop cans, trucks, windows, and even floor tiles. Foreshortening can also be applied to people. Parts of Charles White's *Preacher* (fig. 5–24) are clearly foreshortened: the lower part of his right arm, the upper part of his left arm, the palm and fingers of his right hand, and even his head. Notice how complicated the foreshortening is in both hands.

5-24 Charles White, Preacher, 1952. Ink on cardboard, 213/8 " × 29% " (54 × 75 cm). Collection of The Whitney Museum of American Art (Purchase).

In Mary Cassatt's *The Bath* (fig. 5-25), both objects and people are foreshortened. This technique is readily seen in the forms of the basin and the pitcher. The effect of foreshortening is even more pronounced in the forms of mother and child. You may have noticed that their upper bodies, compared to their legs, are quite short. However, the most extreme effect of foreshortening occurs in their faces. Observe how close together the eyes and the mouth are in both faces.

Mary Cassatt 1844-1926

Ignoring the objections of her parents, in 1861 Mary Cassatt boldly enrolled at the Pennsylvania Academy of Fine Arts. With a strong independent nature and financial support she was able to complete four years of work at this prestigious art school at a time when art was frowned upon as an occupation for women. Rather than remain quietly at home, Mary preferred a life full of adventure and art.

Her avid desire to learn brought Mary to Paris, the center of the art world in 1865. There she was able to pursue her studies of the great masters of the past, while meeting and working with the new and influential Impressionist artists. Mary learned unfamiliar artistic techniques from her new friends such as printmaking and the use of colorful pastels to create soft images. She also explored Europe, enjoying museums and attending gallery exhibitions of international art, from as nearby as Italy to as far away as Japan.

Inspired by what she saw, Mary began to create paintings and prints with renewed enthusiasm. Her explorations on the subject of mother and child were numerous. The gentle caress of the mother as she washes her child in The Bath is just one example of the hundreds of maternal images which Mary created during her lifetime.

Throughout her travels, her years living in Europe, and those when she returned to the United States, Mary remained an independent woman. She never chose to marry or have children. Rather, Mary Cassatt focused her life on the pursuit of technical expertise in painting and printmaking, and on achieving a beauty in her life and art which is uniquely her own.

5-25 Mary Cassatt, The Bath, ca. 1891-92. Oil on canvas, 391/2" \times 26" (100 \times 66 cm). The Art Institute of Chicago (Robert A. Waller Fund).

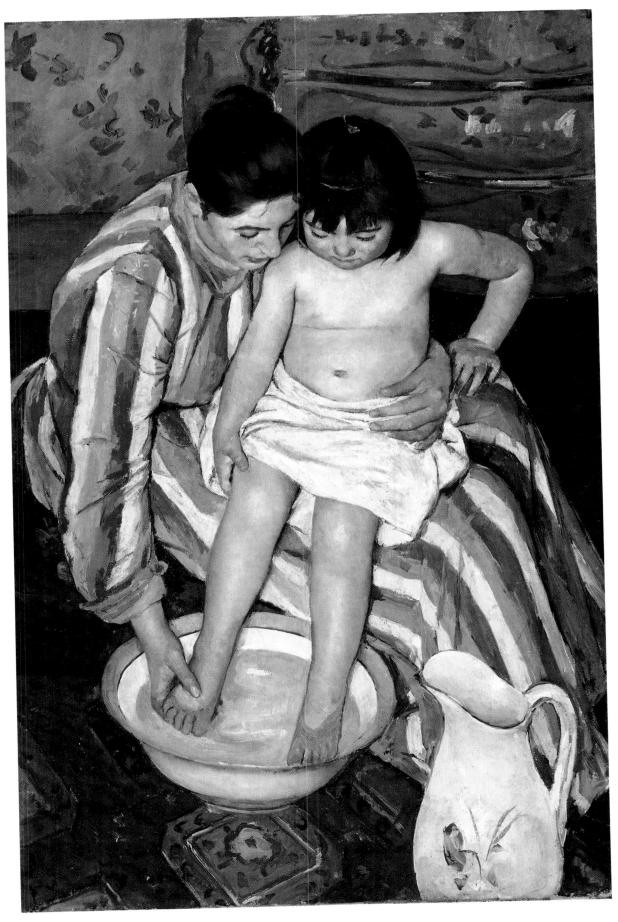

Returning briefly to the illustration of the fore-shortened truck (fig. 5–26): did you notice that the back of the truck is shorter than the front? This is because the back is farther away. To represent something being farther away in a picture, the artist makes it smaller. To represent something close, the artist makes it larger. We tend to think of an object's size as unchanging no matter how close or far away it is. This tendency is called *size constancy*. An illustration of size constancy can be seen in a picture of utility posts (fig. 5–27). The artist drew the farthest away post twice—once on the left-hand side and again on the right-hand side at the foot of the nearest post. Were you surprised to learn how small the image of the farthest away post is?

5-26

5-27

Challenge 5-3:

Create foreshortened shapes in drawings of geometric forms using ellipses and trapezoids cut from paper as patterns.

Challenge 5-4:

Determine the effects of distance on the size of objects by tracing an outdoor scene on a windowpane to see how small the images are compared to what you know the size of the objects to be. Then trace the drawing and use ruled lines and shading to enhance the illusion of depth.

5-28 Alexander Calder, The Arch, (three views) 1975. Steel painted black, 56' high. Storm King Art Center, Mountainville, New York (Purchase and by exchange).

Real Forms

So far we have been talking about three-dimensional forms in pictures. Technically, all the pictures in this book, even the photographs, have only two dimensions – height and width-even though they may represent depth. However, you are surrounded by real forms: you, the other students and the teacher, as well as tables, cupboards, equipment, and books. Almost everything in the room and the room itself has height, width, and depth.

Three-dimensional art comes in many varieties: sculpture, pottery, metalwork, and architecture, to name some of them. Professional sculptors use these materials in addition to wood, stone, metal, and plastics. Regardless of the material used, when a person makes a sculpture, he or

she is making a real form, not the picture of a form. If you were to make a sculpture of a truck, for example, you would not foreshorten the side to make it seem long. You would make it long in reality.

Unlike looking at a painting, looking at a sculpture usually requires the viewer to move around it in order to see its different sides (fig. 5-28). The many-sided form of a sculpture does not have to be viewed just by the eyes. It can also be "viewed" by hands moving across its different surfaces, edges, and corners.

Suggestion:

Look around your classroom for a small object with an interesting shape — a tool, bottle, wood scrap, or small sculpture. Have a classmate do the same. Do not show your objects to one another. Conceal them in paper bags, and study each other's object using only the sense of touch. After "viewing" the objects with your hands, draw pictures of the objects before actually seeing them.

Challenge 5-5:

Model a clay sculpture with the clay concealed in a paper bag (or while blindfolded) to experience developing a mental image of a form on the basis of touch.

Expressive Qualities of Shapes and Forms

Chapter 4 pointed out the importance of expressive qualities in lines. Different lines were described as relaxed, excited, energetic, strong, and unstable, among others. Expressive qualities of shapes and forms are also important. Artists typically classify shapes and forms as organic or geometric (sometimes called biomorphic or rectilinear) and closed or open.

Organic versus Geometric

Organic shapes and forms (fig. 5-29) are found throughout nature: earth, water, clouds, plants, animals, and people. Organic shapes tend to be irregular. Sometimes their edges are relatively straight, but never perfectly so. Sometimes their surfaces are relatively flat, but they are never perfect planes. Sometimes they are curved, but never perfectly round like a circle or a sphere.

5-29 Organic Shapes and Forms.

Geometric shapes and forms (fig. 5–30) are typically found in things made by people, such as buildings, bridges, factories, and office machines (although some natural things, such as ice crystals and snowflakes, have geometric shapes). Unlike organic forms, geometric forms are very regular. Their edges and surfaces are straight or perfectly curved.

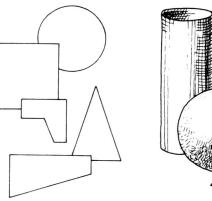

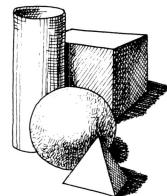

5-30 Geometric Shapes and Forms.

The forms of *The Mill* (fig. 5–31), a famous landscape painting by Rembrandt, are primarily organic. Even the few human-made objects - such as the mill and the rampart wall below the mill - show the effects of natural weathering and erosion. Notice that the edges of the forms are rather irregular.

Compare this painting to House by the Railroad (fig. 5-32), a landscape, or "townscape," by Edward Hopper, in which the forms are primarily geometric. Except for the somewhat irregular lines of the roof and windows, the rest of the lines are fairly regular and straight. Note the verticals of the sides of the house; the horizontals of the eaves, the porch overhang, and the railroad track; and, finally, the diagonal line of the shadow.

5-31 What do the geometric forms used in this painting seem to be expressing? Are the forms open or closed? Rembrandt van Rijn, The Mill, ca. 1650. Oil on canvas, 34½ " \times 41½ " (0.88 \times 1.06 m). National Gallery of Art, Washington, DC (Widener Collection).

5-32 As in the Rembrandt, can you tell what the geometric forms in this painting express? Are the forms open or closed? Edward Hopper, House by the Railroad, 1925. Oil on canvas, $24" \times 29"$ (61 × 74 cm). Collection, The Museum of Modern Art, New York (Given anonymously).

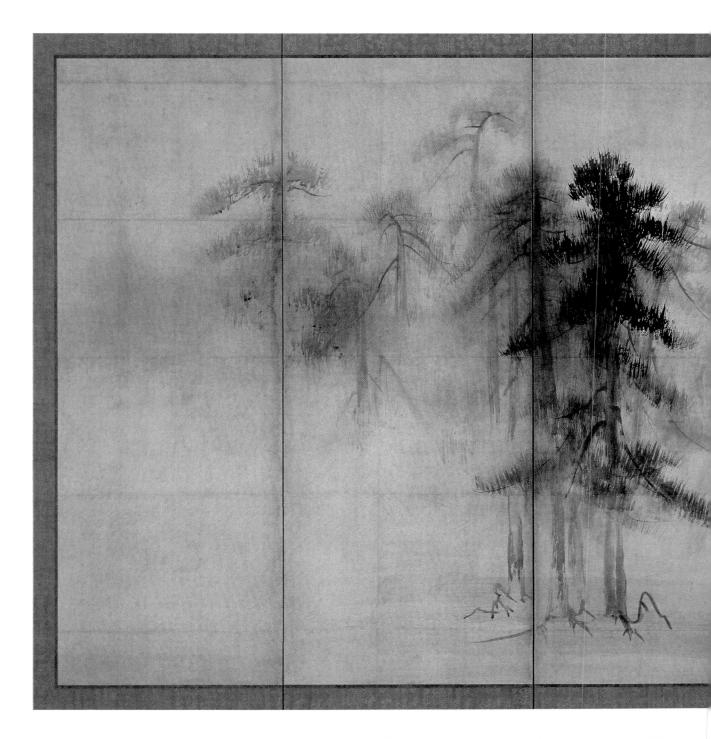

Closed versus Open

The scenes by Rembrandt and Hopper are similar in that both consist of single forms set against a broad expanse of sky. Both express loneliness, although the loneliness in House by the Railroad is "starker" because of its geometric forms. Furthermore, the forms in both paintings are closed rather than open. Few openings, or negative shapes, are allowed to penetrate. This has the effect of making the mill and the land it rests on seem massive, that is, solid and heavy. Even though the house by the tracks has a few windows, it seems as heavy and dense as the forms in The Mill.

Open shapes and forms, on the other hand, allow space to penetrate. Notice the forms in the landscape Pine Trees (fig. 5-33) by Hasegawa Tohaku. Unlike the forms of Rembrandt and Hopper, the Tohaku trees are so open they almost float. Indeed, space penetrates the entire landscape, as the pines are surrounded by acres of mist and light. How do the ideas and feelings expressed in the Tohaku compare with those in the Rembrandt? the Hopper?

5-33 Hasegawa Tohaku, *Pine Trees*, Momoyama Period, Japan, 1539–1610. Ink on paper, 61 " (155 cm) high. Tokyo National Museum. (Photo courtesy of the International Society for Educational Information, Inc.).

5-34 Isamu Noguchi, Great Rock of Inner Seeking, 1974. Basalt, $128'' \times 63'' \times 35'' (325 \times 160 \times 89 \text{ cm})$. National Gallery of Art, Washington, DC. (Gift of Arthur M. Sackler, M.D. and Mortimer D. Sackler, M.D.).

The classifications of organic or geometric and closed or open apply to abstract art as well. The abstract sculpture in figure 5–34 by Isamu Noguchi is organic and closed. Although abstract art does not represent things we see, it does express ideas. In your opinion, does Noguchi's piece relate to the idea suggested by its title, Great Rock of Inner Seeking? Explain your response. Why did the artist use an organic form? a closed form? Like the Noguchi piece, Untitled (fig. 5-35) by Doris Leeper is abstract. Whereas Noguchi's is organic and closed, however, Leeper's is geometric and open. Even though it is open, does it seem as light as Tohaku's pines?

5-35 Doris Leeper, Untitled, 1984. Epoxy over aluminum, 15'3" \times 13 '3 " \times 12 '9 1/4. Barnett Centra, West Palm Beach, Florida. Photograph: David Zicki. Courtesy of the artist.

Suggestion:

On a piece of paper, write short statements to describe the ideas and feelings you think are expressed by Tobaku's Pine Trees, Noguchi's Great Rock of Inner Seeking, and Leeper's Untitled. Compare your statements. Explain how the ideas and feelings expressed in these works are affected by the types of forms – organic or geometric, closed or open – used in each.

Summary

Shapes, like the letters and pictures in this book, have height and width but no depth. Forms, on the other hand, have height, width, and depth. Most of the things in this world, like ourselves, are forms.

This chapter discussed many tendencies to see shapes in certain ways, including figure-ground, closure, shape constancy, and size constancy. Figure-ground and closure often occur when looking at pictures or simple twodimensional patterns. Shape and size constancy affect what one sees when looking at both real forms and pictures of forms.

When trying to represent three-dimensional objects in a picture, an artist often uses foreshortening. Furthermore, an artist will make an object larger or smaller in a picture depending on whether it is supposed to appear closer or farther away.

Artists who make sculptures or pottery, and who design buildings or interiors, deal with real forms. To be seen in its entirety, a three-dimensional artwork such as a sculpture requires a viewer to see its many sides. A sculpture can also be appreciated through the sense of touch.

Finally, it is possible to classify shapes and forms as organic or geometric and as closed or open. Organic shapes and forms are typical of forms found in nature. With the exception of the planets and stars in the sky, and some crystals on the earth, geometric forms are almost always human-made. Closed forms tend to be dense or massive. Open forms are penetrated with negative shapes or space.

Suggestion:

Now that you have learned more about shape, go back to your description of Renoir's Luncheon of the Boating Party. Can you see in the painting any examples of foreshortening? Are some of the forms of people larger than others? Why? Which forms are organic? Which, if any, are geometric? Which are closed? Which are open?

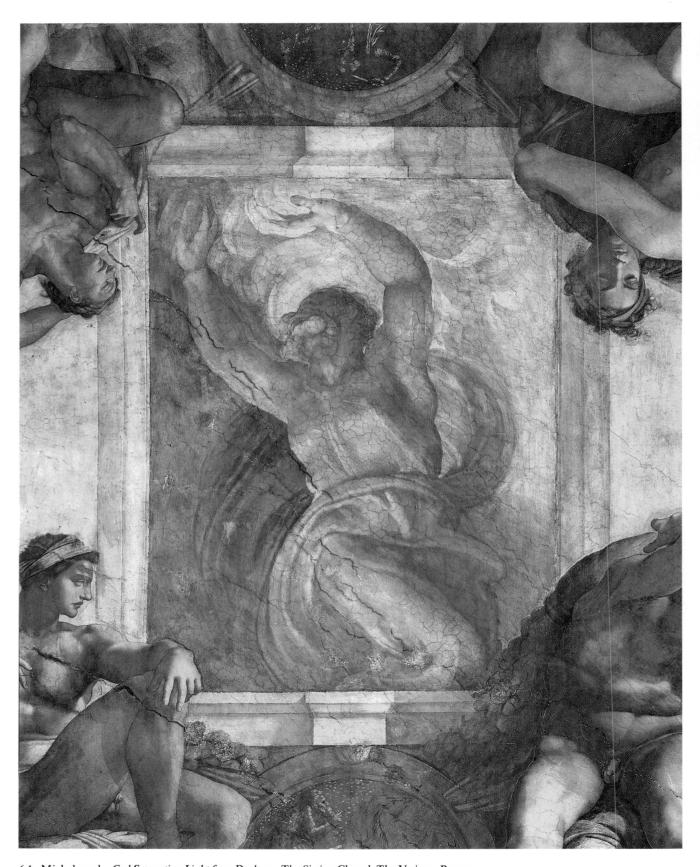

6-1 Michelangelo, God Separating Light from Darkness, The Sistine Chapel, The Vatican, Rome.

Chapter 6 **Visual Elements:** Value and Color

Light and Dark

Without light you and I could not see lines, shapes, forms, or any objects. In fact, unless it is a source of light itself, an object is visible only to the extent that it reflects light.

In addition to being important in vision, light, along with its opposite, dark, appears in the legends of most cultures. Among the episodes illustrated on the Sistine

Chapel ceiling by Michelangelo is the separation of light and dark (fig. 6-1). Light is often used to symbolize truth, hope, and new life. On the other hand, dark is often associated with evil, the fear of the unknown, and death. Have you ever experienced the onset of a storm when light turns to dark (fig. 6-2)? Light and dark are also important in art.

6-2 Light colors colliding with contrasting dark colors produce drama in a picture. Cynthia Stanton, A Wild and Wicked Sky near Remus, Michigan, August 16, 1988. Photo courtesy Weatherwise, Heldref Publications, Washington, DC.

Value

Imagine the possible extremes of light and dark in this world. One extreme might be looking directly at the noonday sun; the other might be experiencing the black void of a deep cave. But in daily life the range of light and dark is much less dramatic than that.

The range of light and dark in the context of a given artwork (seen under normal light conditions) is known as *value*. Typically, values are represented on a nine-step scale (fig. 6–3) with white at one extreme and black at the other.

9/ White 8/ 7/ 6/ Value 5 4/ 3/ Black

Imagine a world with only the colors of the gray value scale. You would be able to distinguish different objects because of their different values. You see examples of this situation in "black-and-white" reproductions (fig. 6–4) in which everything consists of different values.

The lightness or darkness of a particular value is *relative*, depending on its context. In other words it is light or dark in comparison to its surroundings. For example, the banjo face in Henry O. Tanner's *The Banjo Lesson* (fig. 6–5) appears light when compared to the shadows around it. But compared to the light values in the background, it appears rather dark.

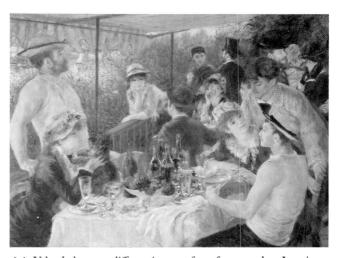

6-4 Value helps us to differentiate one form from another. Imagine what the world would be like if nothing had color. Pierre Auguste Renoir, *Luncbeon of the Boating Party*, 1881. Oil on canvas, $51\text{ "}\times68\text{ "}(130\times173\text{ cm})$. Phillips Memorial Gallery, Washington, DC.

6-3 A value scale.

6-5 Henry O. Tanner, *The Banjo Lesson*, 1893. Oil on canvas. $4'1/2'' \times 3'11''$ (123 × 119 cm). Hampton University Museum, Virginia.

Further, a value in a picture seems lighter or darker because of what it represents. You see the egg in figure 6–6 as being very light—the color of either white or off-white. Now, cover the upper half of the egg with your hand, and you see that the lower half of the form is not very light (or white) at all. Reflected light causes the difference in value in the picture between the top and bottom halves of the egg. In this case, the reflection is stronger on the top.

6-6 What is the color of the egg: white or dark gray?

Artists often take the situation of reflected light into consideration when making pictures, especially when they want a form to look solid. Notice how the artist caused the polyhedron (fig. 6–7) to look very three-dimensional by making some surfaces darker than others. The technical term for the practice of using lighter and darker values to make something in a picture appear three-dimensional is *chiaroscuro*, an Italian word that literally means light–dark. Another, more familiar, term is *shading*. Earlier, in Chapter 4, you saw an example of shading done by the method of hatching and crosshatching to make the caricature of a celebrity look more three-dimensional (fig. 4–13).

6-7 How many values did the artist use to make this polyhedron appear solid?

Suggestion:

Cut a small hole (1/2" square) out of the middle of a piece of paper and lay the paper over the drawing of the polyhedron. If you move the paper around, you will easily see through the small viewing area that the values differ from very light to very dark. Do the same with the photograph of the egg.

Challenge 6-1:

Create a black and white tempera painting of a still life illuminated by directed light. Use variations in value to suggest a mood and to make the objects appear three-dimensional.

a. Student work.

b. Student work.

Value and Artistic Expression

Shading is important to the artist who wishes to represent the effects of reflected light. But that is only one purpose for value. This visual element is very effective for establishing mood.

Recall the notions about light and dark standing for good and evil. These representations stem both from our culture and our own experiences. The artist should be able to capitalize on these notions when he or she uses value, which is certainly possible. You should know, however, that light and dark in art are not always synonymous with good and evil. Remember the two examples in Chapter 5: Hopper's House by the Railroad (fig. 5-33) where light seems oppressive, and Rembrandt's The Mill (fig. 5-32) where darkness seems peaceful.

In A Woman in White (fig. 6-8), Picasso used mostly the middle range of the value scale, and kept the contrasts of light and dark to a minimum. The whole picture seems bathed in a bright, but soft light that expresses a serenity echoed in the peaceful expression and relaxed position of the woman herself. Here, light seems to play a positive

6-8 Pablo Picasso, Woman in White, 1923. Oil on canvas, 39 $^{\prime\prime}$ \times $31\frac{1}{2}$ " (99 imes 76 cm). The Metropolitan Museum of Art, New York (Rogers Fund, 1951, Lizzie P. Bliss Collection).

role. Do you think that it was meant to symbolize something positive about womanhood? Why?

The artist used mostly the dark end of the value scale in Mademoiselle Charlotte du Val d'Ognes (fig. 6-9). However, very light values were used in places. The painting is a scene in which a single source of light illuminates one side of a subject, leaving the rest of the picture in relative darkness. The use of dark shading and strong contrast to create drama or establish a mood was very popular in the 1600's and 1700's. Like Picasso's woman, Mademoiselle Charlotte seems relaxed, though perhaps more solemn. Here, dark contributes to a somber mood, but not necessarily an evil one.

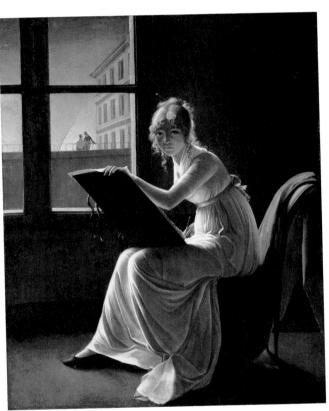

6-9 Unknown French Painter, Mademoiselle Charlotte du Val d'Ognes. The Metropolitan Museum of Art, New York (Bequest of Isaac D. Fletcher, 1917. Mr. & Mrs. Isaac D. Fletcher Collection).

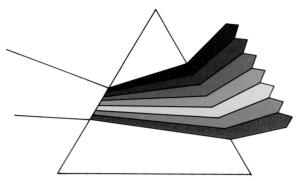

6-10 The visible spectrum.

Color

Of all the visual elements, color is the most fascinating and puzzling. Because of its effects on people, color has been studied more than any of the other elements. To analyze color, we must return to the discussion of light.

In a famous experiment over three hundred years ago, Isaac Newton demonstrated that light is more complicated than people had originally believed. He also showed that color is a property of light. When passed through a glass object, called a prism, a beam of light divides into the seven colors of the rainbow (fig. 6–10). Each of these colors represents a different ray of light. All seven rays—a small fraction of the total number of light rays—make up what is known as the *spectrum*. Newton demonstrated that white light includes all of the spectrum colors. For reasons still not fully understood, only the rays of the spectrum are visible to the human eye, and each ray is visible as a different color. Newton proposed that the spectrum colors be represented in a color circle (fig. 6–11), the ancestor of the color wheel (fig. 6–15).

6-12 A lemon absorbs all the colors of light except yellow.

The average person thinks of color as belonging to objects. Strictly speaking, this is not true. There is a difference between light, the real source of color, and *reflected* light, the kind of light given off by objects. According to

6-11 Newton's Color Wheel, from Isaac Newton, Optice, 1706. The British Library, London.

color theory, when white light strikes a red apple, the apple looks red because it *absorbs* every color of light *except* red, which it reflects. A lemon absorbs all the colors except yellow (fig. 6–12). When light is totally absorbed by an object, the object appears black.

Newton's theories, important as they were to the science of color, refer to only one dimension of color: hue. Color is best understood as having three dimensions: hue, value, and saturation.

Hue

Hue identifies a color as blue, yellow, red, or green, and so on, as seen in the spectrum or the color wheel. People with normal vision not only see different hues, but have names for many of them.

6-13 Primary and secondary hues in lights.

6-14 Primary and secondary hues in pigments.

In addition to those of the spectrum, an infinite number of hues can be created through intermixing. At this point, however, a distinction must be made between colored light and *pigment*, the coloring matter found in such things as inks, crayons, paints, dyes, and glazes. Mixing colored lights is an *additive* process. When all colors are combined, the result is white (fig. 6–13). Mixing pigments, on the other hand, is *subtractive*. Pigments behave the same way as the surfaces of lemons or apples; they absorb all the colored rays except those we see. So, combining more and

6-15 Color wheel.

more pigmented colors creates increasingly darker results—as you know if you've ever mixed paints. Theoretically if all three primaries are combined in the correct proportions, the final result would be black (fig. 6–14). A black surface absorbs all the spectrum colors. Since almost all artworks involve the use of pigments, the following discussion will focus on the behavior of pigment hues.

Three hues—red, yellow, and blue—are called *primary colors*. Supposedly you can make any other hue with just these three, if you know how to mix them properly. Mixing two primary colors produces one of the *secondary colors*: orange, green, or violet. Yellow and red make orange, yellow and blue make green, and red and blue make violet. Notice that on the color wheel (fig. 6–15), each secondary color is placed midway between the

primary colors that produced it. Lying between the primaries and secondaries are the *intermediate colors*: yellow-orange, yellow-green, blue-green, blue-violet, red-violet, and red-orange. These are made by unequal mixing of primaries; for example, approximately two parts yellow mixed with one part red produces yellow-orange.

Hues directly opposite each other on the color wheel are called *complementaries*: red and green, orange and blue, yellow-orange and blue-violet, and so on (fig. 6–16). In addition to being opposite geographically, they are exactly opposite in hue. For example, yellow, a primary color, has nothing in common with its complement, violet, which is composed of red and blue. Complementaries play a role in both *saturation* and *color barmonies* (discussions follow).

6-16 Complementary colors are opposite in hue and are also opposite each other on the color wheel.

Challenge 6-2:

Mix red, yellow, and blue tempera to paint a picture using only secondary and intermediate colors.

Next try making a bue that lies between a secondary and an intermediate bue, such as bluish green (between green and blue-green).

Can you think of some fancy names – turquoise, aqua – for these in-between bues? Can you invent some new colors?

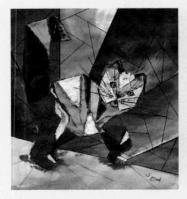

a. Student work.

b. Student work.

Value

Value was discussed previously as a separate element. In that discussion, value was associated with black, white, and gray—colors that are sometimes called *neutrals*. Unlike spectrum colors, black, white, and gray have no identifiable hues. However, value is also a dimension of color. Every color has a normal value that is shown on the wheel. The value, the lightness and darkness of a color, can be altered by adding white or black to the color. Different values of red (fig. 6–17), for example, can be displayed on a scale just as they can for gray. Lighter values of a color are called *tints*, the darker values, *shades*. Artists sometimes create *monochromatic* (one-color) paintings, using tints and shades of one color.

6-17 Value scale of red. What color should be added to make a tint of red?

Saturation

Saturation (sometimes called *intensity*) describes the relative purity—the brightness and dullness—of a color. A color's saturation can be represented on a scale from bright to gray (fig. 6–18). All of the hues on the color wheel are bright (or as bright as the printer was able to make them).

6-18 A saturation or intensity scale.

When you paint a picture and use a yellow, blue, or red straight from the bottle, the color will be bright. Mixing any two of the primaries, as you saw earlier, produces a new color—a secondary or intermediate hue. But if you mix a color with its *complement*, the resulting color will be a duller one, because each color subtracts from the other. If you mix complementaries in the right proportions, not necessarily in equal amounts, the result may be a neutral gray (fig. 6–19).

Challenge 6-3:

Produce a monochromatic painting using a color and black and white. Use at least five values of the color you chose.

a. Student work.

b. Student work.

6-19 Mixing a color with its complement can produce a neutral gray.

Colors of low saturation that have identifiable hues can be just as beautiful as bright colors. Most of the colors in nature are of this type: the olive greens and forest greens of spring and summer, and the golden yellows, burnt oranges, and brown-reds of fall (fig. 6-20).

The colors of clothes are not always bright. Look at your friends' clothes; some probably consist of dulled reds, greens, and blues, as well as browns. The colors of woodwork also tend to be of low saturation: mahogany (deep reddish brown), oak (brownish yellow), and maple (brownish yellow-orange).

Challenge 6-4:

Use tempera paint to mix a color with its complement to produce a nine-step saturation scale, with a pure color at one end, three saturation changes, gray in the middle, three saturation changes, and the second color at the other end.

6-20 Which of the colors are saturated? Which are of low saturation? Photograph by Barbara Caldwell.

Challenge 6-5:

Mix paint to match the colors of found materials such as pieces of fabric, leaves, colored papers, labels, photographs, wrappers, etc.

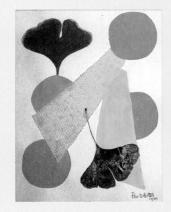

Student work.

Color Interactions

Colors rarely appear in isolation. Therefore the artist and the viewer should also understand how one color is affected by other colors. A particular color—when placed side-by-side or on top of another color—is apt to have either its hue, value, or saturation affected, depending on the combination. Some examples of these effects are illustrated.

Hue Interaction. A patch of yellow-orange appears more orange on top of a square of yellow. On top of a square of orange, it appears more yellow (fig. 6–21).

6-21 Which of the smaller squares appears more yellow? Why?

Value Interaction. A tint appears much darker on white than it does on black (fig. 6–22).

6-22 A tint appears much darker on which field of color?

Intensity Interaction. A medium bright blue will appear brighter on top of a neutral than it does on top of a bright blue (fig. 6–23).

6-23 Which of the smaller squares appears to be of brighter intensity?

Color Harmonies

Color harmonies are combinations of colors that are considered satisfying, or that produce certain effects. Knowledge of these combinations is particularly useful to the designer.

6-24 A triad scheme.

In the discussion of bue, you learned some color groups: secondaries, complementaries, and so on. These, along with other combinations, can also be thought of as types of color harmonies, sometimes called color schemes.

Triad harmonies consist of three equidistant hues on the color wheel, for example, the primaries, the secondaries, or three of the intermediates (fig. 6-24). Because of their mutual dissimilarity, a triad of the primary colors would be the most daring combination. Like strangers in a

6-25 Helen Frankenthaler, Cravat, 1973. Acrylic on paper. 621/2' \times 58 ½ " (159 \times 149 cm). Collection Mr. and Mrs. Gilbert H. Kinney. Courtesy of Andre Emmerich Gallery.

room together, they are apt to react negatively to each other. Secondary or intermediate hues, on the other hand, are apt to be more agreeable, because of their shared colors. Perhaps this is what Helen Frankenthaler had in mind when she poured diluted colors of violet, green, and orange onto a white canvas (fig. 6-25).

Complementary colors, as we have seen before, are opposite colors. Therefore, a *complementary combination* would provide the strongest contrast, the greatest possibility of a color "collision." For this reason, some designers prefer a *split complementary* scheme, in which one hue is combined with hues on either side of its complement (fig. 6–26). This brings two of the colors closer together and tends to tone down the "violence" somewhat. The trim colors in Paris architect Jean Satosme's living room (fig. 6–27) pit red against a variety of yellow-greens and blue-

6-26 Split complementary scheme.

greens (split complementaries of red). The neutral tones of the walls help to soften the contrast even further.

Analogous harmonies consist of adjacent hues on the color wheel, for example, yellow, yellow-green, green, and blue-green (fig. 6–28). Because of their strong "family resemblances," these kinds of hues are very agreeable, yet different enough to provide interest. If necessary, contrast can be strengthened by varying the values. The inlaid colors decorating the balcony pillars of a music palace (fig. 6–29) by architect Llúis Domenech i Montaner range be-

6-28 An analogous scheme.

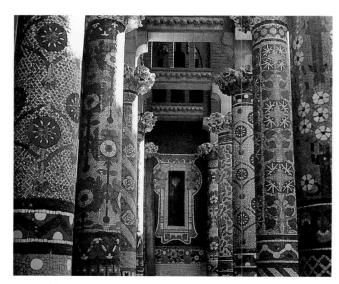

6-29 Llúis Domnechi i Montaner, Balcony of the Palace of Catalan Music (Palau de la Musica Catalana), Barcelona.

6-27 How do the neutral tones help soften the contrast in this interior?

tween red and blue-violet. The colors, along with Sr. Montaner's robust patterns, contribute significantly to the overall splendor.

Monochromatic combinations consist of tints and shades of a single hue (fig. 6-17). Of all the combinations, this harmony is made up of colors that coexist most easily, because all are the same hue. But the gain in agreeableness is offset by a loss in boldness. A monochromatic scheme, being the least daring, risks being uninteresting. The label of uninteresting does not apply to Picasso's The Old Guitarist (fig. 6-30), however, a painting that is largely monochromatic (except for the subdued browns in the guitar). Because of the subject, the colors are particularly appropriate, and they contribute to the dominant mood, which, of course, is sad.

6-30 Pablo Picasso, The Old Guitarist, 1903 . Oil on panel .48 $^{\prime\prime}$ \times $32\frac{1}{2}$ " (123 imes 83 cm). The Art Institute of Chicago (Helen Birch Bartlett Memorial Collection).

Expressive Qualities of Color

Why is blue appropriate for a picture with a sad mood? Imagine The Old Guitarist painted in tones of red, yellow, or orange. Given these alternatives, blue clearly seems to be the best choice. But this is not to say that blue always expresses sadness. In other contexts, blue can suggest such qualities as serenity, dignity, and elegance.

Color and its effects on people have been the subject of more research (and guesswork) than any other visual element. Red is said to raise blood pressure, while blue lowers it. Pink, a tint of red, has been shown to have a calming effect on violent children. In one experiment, factory workers thought that the building temperature had been raised after the colors of the walls were changed from blue and grey to red and brown. In fact, the temperature had remained at 70 degrees.

Artists are aware of the power of color-whether they have read the research or not. To take account of the effects of color, artists divide colors into warm and cool categories. Reds, oranges, and yellows (the colors on the left side of the wheel) are considered warm colors. Blues, greens, and violets (the colors on the right) are considered cool colors (fig. 6-31). Perhaps this distinction is made because reds and yellows make us think of such things as blood, fire, and the sun, while blues, greens, and violets remind us of sky, water, trees, grass, and shade. Whatever the reasons, the use of warm colors in a design is likely to excite us, while cool colors are likely to have a quieting effect.

6-31 Color wheel.

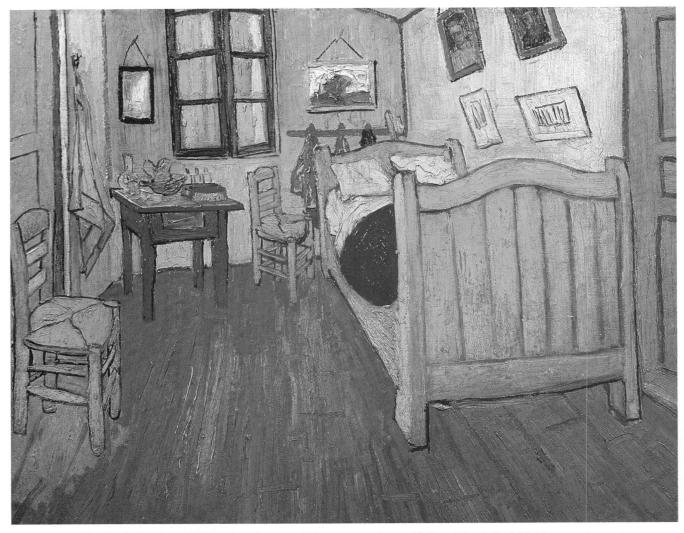

6-32 Vincent Van Gogh. The Artist's Bedroom at Arles, 1889. Oil on canvas, 28" × 36" (72 × 91 cm). Stedelijk Museum, Amsterdam.

Vincent Van Gogh is one of the first artists to understand the potential of color for its own sake. In a letter to his brother Theo, Vincent refers to a painting in which he used mostly complementary colors: "I tried to express the terrible passions of humanity by means of red and green." Van Gogh often used color as a cry of anguish, but he also used it in more peaceful ways. Two paintings of his bedroom are shown here—one in predominantly warm colors (fig. 6–32) and the other in cool colors (fig. 6–33). Almost everything about these pictures is similar except their colors.

Suggestion:

Describe the colors of both Van Gogb paintings in terms of their respective bue, value, and saturation. Also describe your reactions to the colors of each. Which do you prefer, the warm or the cool painting? Why?

Imagine you are an interior decorator. What colors would you use to paint a hospital room? Maybe it would depend on whether you wanted to relax the patients or cheer them up. Would your choice depend on the ages of the patients? Explain.

Imagine you are a stage-set designer. What colors would you use for a lively musical? a mystery play set in England? a comedy? Imagine you are a graphic designer. What colors would you use in a safety poster? an ecology poster? a travel poster?

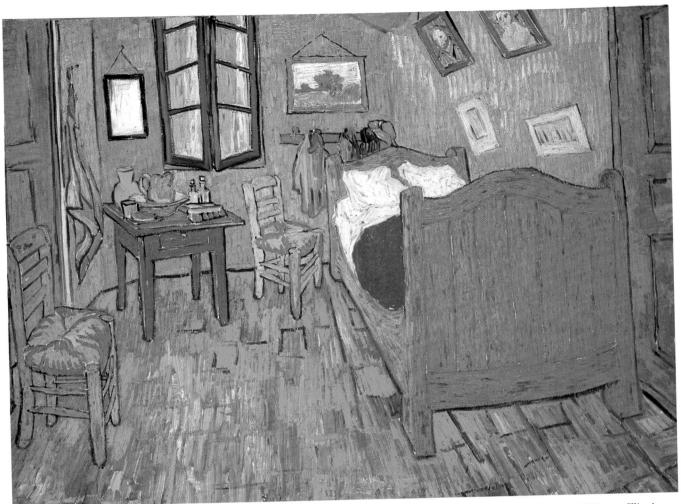

6-33 Vincent Van Gogh. The Bedroom at Arles, 1888–1889. Oil on canvas, 29" × 36" (74 × 91 cm). The Art Institute of Chicago, Illinois (Helen Birch Bartlett Memorial Collection).

Vincent Van Gogh 1853-1890

In 1988, Vincent Van Gogh's colorful painting of irises sold for over fifty million dollars. But did you know that Van Gogh died a penniless man?

Van Gogh spent most of his life without money or possessions, choosing instead to devote his life to art. Throughout his early years as an apprentice and clerk in his uncle's art gallery, Vincent studied drawing methods from manuals and copied the paintings of famous artists.

Vincent was born in a small town in Holland near the border of Belgium. Throughout his life, Vincent maintained a strong relationship with his brother Theo who supported Vincent emotionally and financially throughout his career as

an artist. There were times in Vincent's life when he was extremely depressed and experienced periods of mental illness. During these times, when he was staying at a hospital in St. Rémy, France, and later when he moved to Auvers-sur-Oise, near Paris, Vincent was able to depend on Theo's love and assistance. Theo remained a source of support until the end of his brother's life, when Vincent committed suicide in 1890.

In a letter to his brother, Vincent once asked: "How . . . can I make myself useful, what end can I serve?" The answer to that question is in the bold brushstrokes, the brilliant colors, and the unique images which he portrayed in his paintings. His example of perseverence and determination is an inspiration to us all.

Are you surprised to learn that color—something you have lived with all your life—is so complicated? Actually this discussion barely scratches the surface. Entire books have been written about color theory and the variables of color that artists and designers deal with all the time.

Why learn more about color? Did you know that there are tribal societies in which color is not very important? The people in those cultures have normal vision, but have not bothered to develop the sensitivity needed to recognize many hues. In one example, the culture had words only for light and dark and the color red. In effect, the people could not "see" yellows, oranges, pinks, blues, and so forth.

Think what you would be missing if the only hue you could distinguish were red! Knowing more about color enables you to see more of it. This will help you to enjoy the infinite variety and rich possibilities of color in art, and also in life (fig. 6–34).

Summary

This chapter is about two closely related elements: value and color. The source of both value and color is light. Indeed, light is the source of all vision.

Value refers to the range of light and dark that can be

Challenge 6-6:

Create two pictures of a scene, one in warm colors and one in cool colors with oil crayon on colored paper to demonstrate the expressive potential of color.

a. Student work.

b. Student work.

6-34 How do these colors contribute to the festive mood of the occasion? Balloon Festival. Photograph courtesy Ray Miller.

seen in a work of art, usually under normal lighting conditions. This range can be represented in a value scale with white at one extreme and black at the other. Different surfaces of an object have lighter or darker values depending on the amount of light they reflect. The method for representing the surface light of an object is called shading or chiaroscuro.

Color, one of the most powerful elements in the hands of the artist, is a complicated subject. In the vast majority of cases, artists are involved with the colors of pigments rather than the colors of light. Pigments absorb light rays, reflecting only the colors not absorbed; therefore, intermixing colored pigments is a subtractive process. Combining all pigments results in black, the absorption of all light rays.

Hue is the name of a color as seen in the spectrum or color wheel. Hues can be divided into certain groupings such as primary, secondary, and complementary colors.

Value applies to the lightness or darkness of a color on a scale from white to black.

Saturation describes the brightness or dullness of a color on a scale from bright to gray.

Hue, value, and saturation are affected by color interaction. Certain classic color combinations - color schemes - are utilized frequently by artists and designers.

It is well known that color affects people, a fact that is supported by research. Therefore, color is a powerful tool for expression and for prompting aesthetic responses. To classify hues according to their expressive and aesthetic potentials, artists typically divide them into warm and cool categories.

Suggestion:

Now that you have learned more about color, go back to your description of Renoir's Luncheon of the Boating Party. Can you add anything new about the colors? For example, how would you identify the color of the stripes of the awning in terms of hue, value, and saturation? Would you describe the colors in this picture as being mostly light or mostly dark? mostly bright or mostly dull? mostly warm or mostly cool? Why?

Chapter 7

Visual Elements: Space

7-1 Claude Monet, La Gare St. Lazare, Paris, 1877. Oil on canvas, $32\frac{1}{2}$ " \times 39 \(34 \)" (83 \times 101 cm) Fogg Art Museum, Cambridge, Massachusetts (Maurice Wertheim Collection).

Try the following true–false questions before reading about space.

Space Quiz

1. Space is empty. (T-F)

- 2. Space is always invisible. (T-F)
- 3. Unlike shape or form, space cannot be measured. (T-F)
- 4. The experience of space can be related to the sense of movement. (T-F)
- 5. Spatial is the adjective form of the word space. (T-F)

Space in Our Environment

Space is often thought to be nothing, the emptiness that surrounds objects, or the emptiness inside of hollow shapes such as boxes or buildings. Also, space is thought to be invisible. So, why is it considered one of the *visual* elements? There are at least two answers to that question.

First, space on this earth is not really empty; it is filled with oxygen and other gases we call air. And as you know, air is not always clean and clear. Sometimes it is full of smoke, dust, or little particles that create *pollution* (fig. 7–1) that can be seen. Sometimes it is full of particles of water and dust that we call *clouds* (fig. 7–2) or *fog*, which can also be seen. So, space is not always invisible.

The experience of space is related to the sense of *movement*. While sitting at your desk, you can sense the space under the desk simply by moving your legs and feet. You can sense the *spatial* aspects—the size and volume—of your classroom by walking around in it. (But you can also determine its spatial aspects by staying in one place and looking around the room with your eyes.)

Second, even when space is relatively invisible, we are usually able to determine its size and form. We "see" space by seeing its *boundaries*. Indoors, for example, the ceiling, floor, walls, and partitions of a room (fig. 7–3) determine the extent and form of a space. Interior space like that in a room is often called *volume*. Outdoors, the size and form of a space is determined by buildings, plants, reflecting pools, and other objects (fig. 7–4). We could say that space is "empty form."

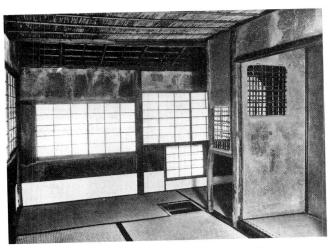

7-3 The Hasso-no-seki tea room, Konchi-in temple, Kyoto.

7-2 Photograph by Barbara Caldwell.

7-4 Foreign Office Building, Brasilia.

How did you do on the quiz? The correct answers are: 1. F, 2. F, 3. F, 4. T, 5. T.

Suggestion:

Discover how well you know the locations of things in your room at home without the help of seeing. Starting from the center of the room, try to locate the middle drawer of your dresser with your eyes closed. Can you sense the correct direction, distance, and height of the drawer (or other object) by relating it to your body and its movements?

7-5 I. M. Pei, Interior view of the *East Building*. National Gallery of Art, Washington, DC.

Space in Three-Dimensional Art

To the architect, space is probably the most important of all the visual elements. The job of an architect is to design pleasing and interesting spaces in which people live, work, or play. I. M. Pei heeded that job description in 1978 when he designed the central court of the East Buildings of the National Gallery of Art (fig. 7–5). The spaces of Pei's interior vary in size, form, and even level, providing an exciting environment for strolling and viewing art. The interior of the National Gallery's Rotunda (fig. 7–6), designed by John Russell Pope and completed in 1941, is very different. A large, circular area defined by huge columns, the rotunda lacks the immense variety of the central court.

7-6 John Russell Pope, Interior view of the West Building of the National Gallery of Art, Washington, DC.

But it is no less dramatic than the newer interior. Pope's design is *formal* (made according to traditional rules of public architecture), whereas Pei's design is modern and *informal*. The courtyard of a library (fig. 7–7) in San Juan Capistrano, California, like the rotunda, is rather formal—even though it is quite new. Designed by Michael Graves in 1983, it features a fountain in a *symmetrical* (identical on both sides) rectangular space. It is less dramatic than either of the interiors at the National Gallery, but it is no less beautiful. And it is very appropriate for the peace and quiet of a library. Which of the three spaces do you prefer? Why?

7-7 San Juan Capistrano Regional Library; SJC, California. Michael Graves, architect. Photograph copyright 1986 by Bruce Iverson.

7-8 Barbara Hepworth, *Pendour*, 1947. Painted wood, $12\frac{1}{8}$ " \times $28\frac{1}{8}$ \times $9\frac{1}{8}$ " ($31 \times 75 \times 24$ cm). Hirshhorn Museum and Sculpture Garden, Smithsonian Institution, Washington, DC (Gift of Joseph H. Hirshhorn, 1966).

Space is also important to the sculptor, especially the modern sculptor who works with open forms. Recall Doris Leeper's *Untitled* (fig. 5–35) in Chapter 5. Unlike Leeper's aluminum piece, Barbara Hepworth's *Pendour* (fig. 7–8) is carved wood. As such, it probably began as a closed form. But the artist intentionally carved openings in it to create a unique relationship between form and space, or positive and negative. A more extreme example of open form is *Linear Construction* (fig. 7–9) by Naum Gabo. Made of a plastic frame and nylon strings, it is more like a harp than a traditional sculpture, and on a much larger scale, is Alexander Calder's huge *mobile* (part of which can be seen in figure 7–5) that hangs in the East Building of the National Gallery.

7-9 Naum Gabo, *Linear Construction*, 1942–43. Plastic with plastic threads, $14'' \times 13\%'' \times 3\frac{1}{2}'' (36 \times 35 \times 9 \text{ cm})$. The Tate Gallery, London.

Red Grooms

Beneath layers of plastic, acrylic and brilliantly colored paint hides a wire armature, or skeleton base, draped with canvas and burlap. These materials, molded into bucking horses, high-riding cowgirls and cowboys, and gymnastic clowns, fill a fifty-foot long space.

Red Grooms decided to create Ruckus Rodeo after visiting a state fair in Fort Worth, Texas. In this sculptured environment, the artist has recreated certain events which you might see at a rodeo, but has exaggerated and distorted the details. A green horse with a yellow mane throws his rider in the air. A sixteen-foot tall yellow bull sports six-foot long horns. Cowboys wrestle steers and ride bareback broncos while fans cheer and hats are enthusiastically waved in the air. The sizes, colors and actions of the people and animals in Ruckus Rodeo are unrealistic and imaginary.

This life-size walk-in sculpture of a western rodeo has been termed a sculpto-pictorama, and its artist, Charles Rogers Grooms, has been nicknamed "Red." Red has created other sculpto-pictoramas including City of Chicago and Ruckus

Manhattan, both of which memorialize significant cities in the United States.

Born in Nashville, Tennessee in 1937, Red Grooms was encouraged by his parents to pursue his early talent and interest in art. Influenced by visits to the Tennessee State Fair and the Ringling Brothers and Barnum and Bailey Circus, Red began to create unique versions of imaginary circuses in his backyard. From performing original skits for his classmates to working at a local art gallery after school, Red was committed to a career as an artist. In fact, by the age of eighteen his paintings had already been exhibited at a gallery in his hometown.

Though he spent a considerable amount of time living and working in Nashville and Provincetown, Massachusetts, Red has spent the majority of his career in New York City. There he has worked collaboratively with other artists since 1957 to create skit-like performances known as "happenings," and sculpto-pictoramas like the dramatic and colorful *Ruckus Rodeo*. With this colorful city as his background and its unique inhabitants as his subjects, Red Grooms has devoted his life to pursuing an art filled with humor and activity, teeming with excitement and life.

Red Grooms, Ruckus Rodeo, 1975–1976. Sculpture, wire, elastic, acrylic, canvas and burlap, $174'' \times 606'' \times 294''$ (442 × 1539 × 747 cm). Collection of the Modern Art Museum of Fort Worth (Commission and Museum Purchase with funds from the National Endowment for the Arts and the Benjamin J. Trillar Memorial Trust).

Space and the Picture Plane

So far in this discussion, the word space has been used to mean a three-dimensional area. Some artists, however, use the term to refer to the two-dimensional surface of a painting or drawing, sometimes called the *picture plane*. Modern artists, especially those who produce abstract paintings or drawings, take a great deal of interest in this two-dimensional space. They make decisions about placing shapes high or low, to the right or to the left, on the picture plane. Piet Mondrian, an artist who was especially skilled at composing two-dimensional space, created works that became very influential in the fields of art and design. The balanced design of his *Composition in White*, *Black and Red* (fig. 7–10) is evidence of his great care in arranging each line, shape, and color.

7-10 Piet Mondrian, Composition in White, Black and Red, 1936. Oil on canvas, 401/4" × 41" (102 × 104 cm). Collection, The Museum of Modern Art, New York (Gift of the Advisory Committee).

Some artists use space to refer to the unfilled areas of the picture plane, to the "background" of a painting or drawing, or to the ground of a figure–ground relationship (Chapter 5). Sometimes, the term *negative space* is used to refer to such areas. In the Mondrian painting, this sort of space would be the white areas. In The wall hanging by Senabu Oloyede (fig. 7–11), it would be the black areas.

7-11 Senabu Oloyede, Oshogbo, Nigeria. Wall hanging, starch resist on cotton. $33 \frac{1}{4}$ " \times 75" (85 \times 191 cm). Gift to Field Museum of Natural History from Robert Plant Armstrong.

Representing Three-Dimensional Space in Two-Dimensional Art

Many pictures, especially those we call "realistic," appear to have three-dimensional space: height, width, and depth. Of course, these pictures do not have actual depth. Perhaps it is better to refer to their space as "pictured depth" or "implied depth."

In Chapter 5, we learned of three methods for representing depth in a picture: shading and foreshortening to make individual objects seem solid, and controlling the size of something to indicate that it is closer or farther away (figures 7–12, 7–13, and 7–14). In this chapter, four additional methods will be presented for indicating depth: overlapping, high and low placement, linear perspective, and aerial perspective. Bouts's The Last Supper (fig. 7–15), in which men and objects appear to occupy different positions in spatial depth, will be used to illustrate the first three methods.

7-15 Dirk Bouts, *The Last Supper* (center panel), 1464–1468. Oil on wood, $6' \times 5'$ (183 \times 153 cm). St. Peter's, Louvain.

7-12 Shading.

7-13 Foreshortening.

7-14 Size.

7-16 Overlapping forms.

Overlapping

One of the simplest ways to suggest depth in a picture is by having things overlap — placing something in front of, and partially covering, something else (fig. 7–16). In the Bouts painting, the two men that overlap the table appear to be closer to us than the table itself, and the table is closer to us than the central figure of Jesus.

7-17 Which of these objects (higher or lower) appears to be closer to us?

High and Low Placement

Usually, something that is lower in a picture appears closer to us than something that is higher (fig. 7–17). This general rule works especially well for pictures showing things resting on a level surface, such as the floor of *The Last Supper*. The two men on "our" side of the table are lower in the picture than Jesus, and are therefore closer to us than Jesus is. Their cups are lower than Jesus' cup and therefore closer.

Suggestion:

Take a blank sheet of paper. Think of the surface of the paper as "space." Somewhere in the middle of this space, place a cutout image of a house or tree. This image becomes a "frame of reference." Now take a cutout of an animal or person and observe how that image looks small when placed below the frame of reference and large when placed above it (fig. 7–18). What accounts for this "magical" effect? (If you do not know the answer, read page 48 on size constancy in Chapter 5 once again.)

7-18 Which of these forms appears larger?

Challenge 7-1:

Arrange images cut out of magazines, catalogs, and newspapers in a collage to suggest depth through overlap, large and small shapes, and low or high placement in the picture.

b. Student work.

Linear Perspective

Of the methods for showing depth, linear perspective is the most complicated. The type of perspective used for The Last Supper is one-point, the same used for the drawing of a basketball court (fig. 7-19). Notice in the drawing that all the lines go in just three directions: vertical (or parallel with the sides of the page), horizontal (or parallel with the top and bottom edges of the page), and toward a point in the distance called a vanishing point. The lines for the posts supporting the backboards are vertical, the sidelines are horizontal, and the center line and end lines go to the vanishing point. The center and end lines may appear to be parallel in the drawing (as they are in real life). But in fact, they are not; they converge (come together). Also, the top and bottom edges of the backboards go toward the vanishing point. (When all these lines are extended by dotted lines they meet at the point.)

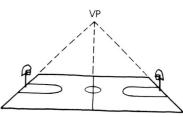

7-19 One-point perspective uses horizontal, vertical, and converging lines.

The diagram (fig. 7–20) of *The Last Supper* should help you to understand how one-point perspective was used in that painting. Many lines are vertical or horizontal. Many more lines converge: the ends of the table, most of the lines in the floor pattern, and most of the beams in the ceiling. Also converging are the dotted lines that connect the heads of the men sitting at the ends of the table and the tops and bottoms of the two windows. The windows, of course, are identical, meaning that they are the same shape and size (even though, in the picture, one is bigger).

The kind of linear perspective used in the second drawing (fig. 7–21) of a basketball court is *two-point*. In this case there are vertical lines and *two* sets of converging lines, but no horizontal lines. One set of converging lines — the center line, end lines, and edges of the backboards — goes to the left vanishing point; and the other set of converging lines — the sidelines — goes to the right point.

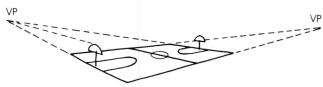

7-21 Two-point perspective uses vertical lines and two sets of converging lines, but no horizontal lines. Therefore, there are two vanishing points.

The kind of linear perspective in the third drawing (fig. 7–22) of a court is one-point, but in this example, the *eye level* is much lower than it is in both previous examples. Eye level refers to the height of the viewer's eyes relative to the ground, or, in this case, the floor of the basketball court. Usually the vanishing point (or points) is on the eye level. Notice that in the third picture the eye level is below the height of the backboards, whereas in the first two pictures eye level is above. In the third picture the viewer seems to be standing on the same level as the floor, whereas in the first two he or she is sitting on about the fifteenth row in the bleachers. Where is the eye level in relationship to the men in *The Last Supper?* Would the viewer be sitting, standing on the floor, or standing on a stepladder?

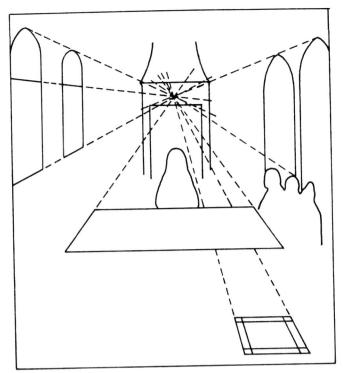

7-20 In artwork using one-point perspective, many lines converge at a single vanishing point that appears to be in the distance.

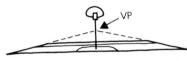

7-22 One-point perspective with the vanishing point located above eye level.

Suggestion:

In a magazine, look for a photograph or any kind of picture of buildings, an interior, or objects. Lay a ruler (or any straightedge) along any of the lines of the picture – perhaps the top edge of a row of windows – and see if you can find the vanishing point(s). (See the example in figure 7–23.) WARNING: One or

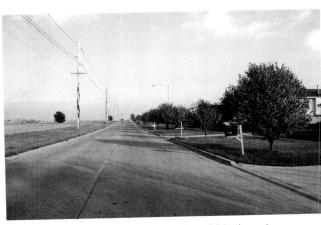

7-23 Can you locate the vanishing point of this picture?

both of the points may be out of the picture. (Glue the clipping to the center of a large piece of paper to help you locate the point(s) outside of the picture.)

Try to find the vanishing point and eye level of the The Country School (fig. 7-30). (TIP: Lay your straightedge along the lines formed by the benches on either side of the room, the top edge of the window on the left, and the top edge of the wall on the right.)

Challenge 7-2:

Draw cubes in one-point perspective that are above, overlapping, and below an eye-level line with three of the cubes centered on the vanishing point, and three off to one side of the vanishing point.

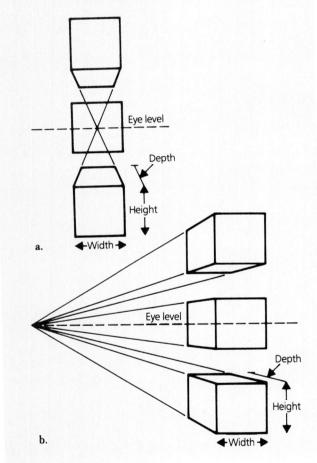

Challenge 7-3:

Create a one-point perspective drawing based on a structure photographed in one-point perspective, identifying converging lines, a vanishing point and eye level.

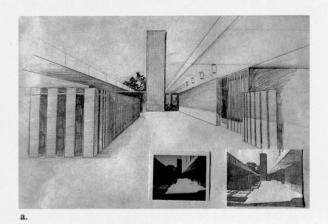

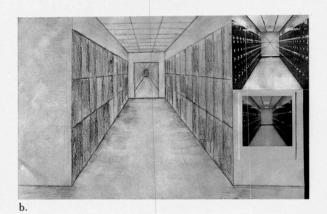

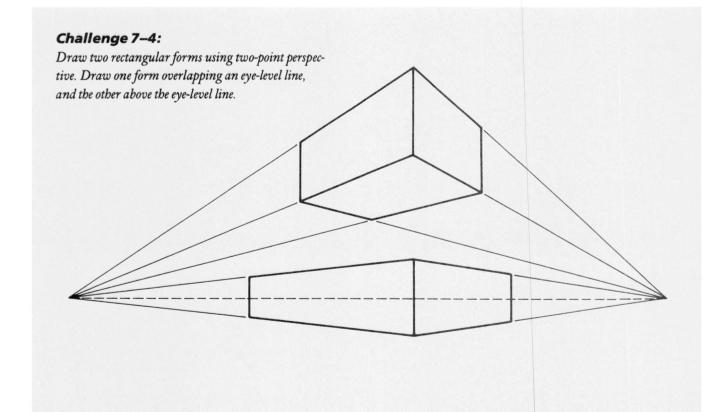

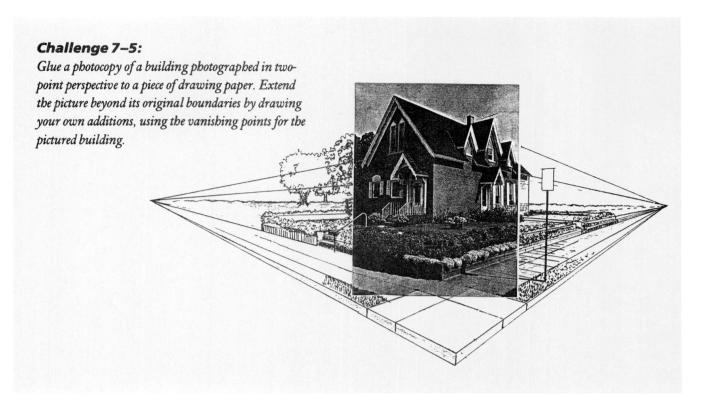

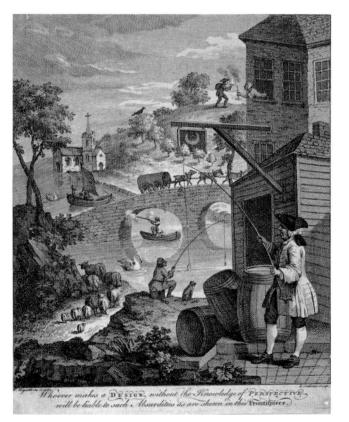

7-24 William Hogarth, Frontispiece to "Kirby's Perspective" (Joshua Kirby's edition of Dr. Brook Taylor's Method of Perspective), 1753. Engraving, $8\frac{1}{4}$ " \times $6\frac{3}{4}$ " (21 \times 17 cm). Reproduced by permission of The Trustees of the British Museum, London.

Suggestion:

Study the picture Frontispiece to "Kirby's Perspective (fig. 7–24) by William Hogarth, which defies the methods of representing depth that we've discussed. How many violations or inconsistencies of size, overlapping, high-low placement, and linear perspective can you see? Make a list of these, and compare your list with a classmate's.

7-25 George Caleb Bingham, Fur Traders Descending the Missouri, Oil on canvas, 1845. 29" × 36½" (74 × 93 cm). The Metropolitan Museum of Art (Morris K. Jesup Fund, 1933).

Aerial Perspective

Aerial perspective applies more to outdoor scenes than to indoor ones. Recall that air often contains tiny particles, a condition we typically call fog, smog, or air pollution. Although this condition makes the space itself more visible, it also makes things in that space less visible, especially in cities filled with smoke and fog like early twentieth-century London. Notice how indistinct the buildings in the distance are in Claude Monet's *La Gare St. Lazare* (fig. 7–1).

But even in the country, and on clear days, air contains enough particles of moisture to affect the appearance of things in the distance, especially with regard to their colors. When an object is far away, its colors become lighter, cooler, duller, and relatively lacking in hue or value contrast, and its outlines and detail become less distinct. In

a picture, this effect is known as aerial perspective. Notice how George Caleb Bingham manipulated the colors in *Fur Traders Descending the Missouri* (fig. 7–25) to achieve the effect of aerial perspective. In essence, the scene consists of four layers, each at a greater distance: the boat, a hazy island behind the boat, a hazier island beyond it, and the still hazier riverbank in the background.

In traditional Chinese ink painting, aerial perspective is used to create glowing mountain scenes. Although the ink technique is monochromatic (Chapter 4), the Chinese artist was able to suggest various degrees of distance through controlling the values and clarity of detail. In *Bare Willows and Distant Mountains* (fig. 7–26), the trees in the lower right are relatively dark and distinct, the trees and houses across the river are hazy and shrouded in mist, and the mountains in the background almost disappear.

7-26 Bare Willows and Distant Mountains, attributed to Ma Yuan, twelfth-thirteenth century, Sung dynasty. Ink and colors on silk. Museum of Fine Arts, Boston (Chinese and Japanese Special Fund).

Challenge 7-6:

Use values of black and white tempera paint to create a simple landscape with an aerial perspective effect. Use lighter values and contrasts to make shapes seem farther away.

Student work.

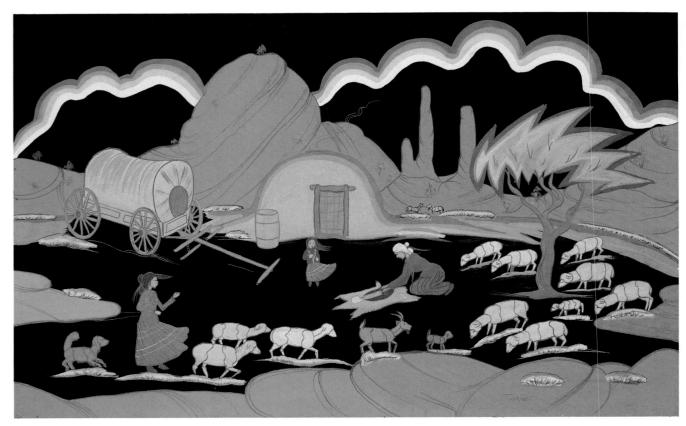

7-27 Andrew Tsinahjinnie, Pastoral Scene, Navajo. Kiva Gallery, Gallup, New Mexico.

7-29 I. Rice Pereira, *Oblique Progression*, 1948. Oil on canvas, $50'' \times 40''$ (127 \times 102 cm). Collection of The Whitney Museum of American Art, New York (Purchase).

Three-Dimensional Space in Abstract Painting

Earlier, this discussion referred to the two-dimensional space of the picture plane as a concern of painters, especially those who produce abstract works. For some abstract painters, the suggestion of three-dimensional space is equally a concern.

Because abstract or semiabstract art is not realistic, people tend to think it lacks spatial depth altogether. But this is not true. Andrew Tsinahjinnie's stylized and semiabstract picture of a Navajo settlement, Pastoral Scene (fig. 7-27), conveys a sense of depth through variations of size, overlapping, high-low placement, and even some foreshortening. Hans Hofmann's abstract Flowering Swamp (fig. 7-28) employs some overlapping. It primarily creates depth, however, through color variation, as warm colors and light values tend to advance while cool colors and dark values tend to recede. Several of the methods of creating depth-foreshortening, overlapping, size variation, and color variation – are employed in Irene Rice Pereira's abstract Oblique Progression (fig. 7-29), in which the sense of movement through and around lines and shapes in space is quite vivid.

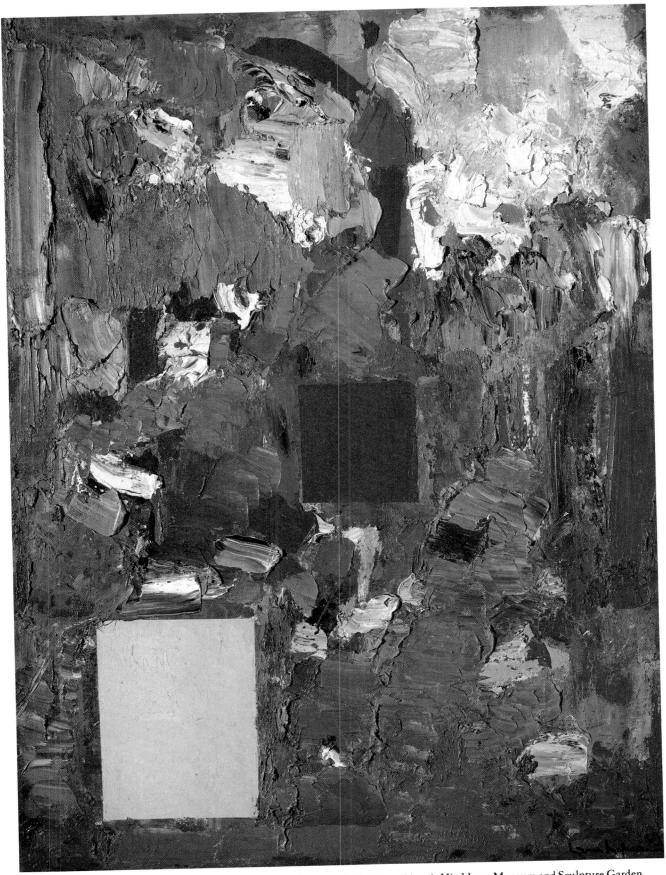

7-28 Hans Hofmann, Flowering Swamp 1957. Oil on wood, $48'' \times 36''$ (122 \times 91 cm). Hirshhorn Museum and Sculpture Garden, Smithsonian Institution, Washington, DC (Gift of the Joseph H. Hirshhorn Foundation, 1966).

Framing

Framing is a method for determining how wide or narrow the borders of a picture are to be. Winslow Homer framed The Country School (fig. 7–30) in such a way that we see almost the entire space and almost all of the activity in a one-room school. Because of the teacher's size and location, she is the most important person in the picture. But she, along with the students, is relatively small in comparison to the size of the painting and, therefore, appears to be relatively far away. By changing the borders of this picture, we can see how framing affects not only the space, but also the point of view and the meaning of a scene.

In the original picture, the single boy sitting to the left of the teacher is one of the farthest-away people. Consider what his position would be if we change the borders around him, that is, reframe him. In the new frame, he is much larger in comparison to the size of the picture and, therefore, he appears to be very close (fig. 7–31). Pictures like this that are framed very close to the central image are sometimes called *closeups*.

7-31 Creating a close-up is one result of changing the frame of a picture.
Winslow Homer, *The Country School* (detail).

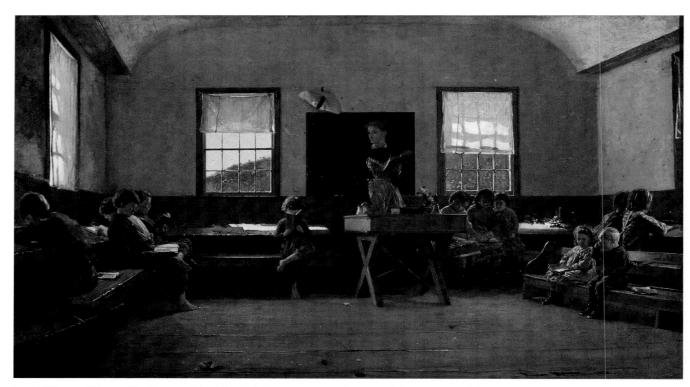

7-30 Winslow Homer, The Country School, 1871. Oil on canvas, 211/8" × 381/8" (54 × 98 cm). The St. Louis Art Museum.

In the new picture, the focus is just on the boy and what he is doing, whereas in the original, he was merely a small part of a large scene. In what ways to you think the story has been changed? Is the new story more interesting or less interesting than the original?

Suggestion:

Cut out two "L" shapes (at least 5 inches for one leg and 3 inches for the other) and use the L's to make an adjustable frame (fig. 7–32). Move the frame across a picture of your own or some other picture. Stop whenever you come to an interesting part. Adjust the dimensions of the frame by sliding the two L's as you see fit and create a new picture out of the original. See how many new pictures with different stories you can make out of just one picture. If a photocopying machine that does enlargements is available, you can enlarge each of your new pictures.

Summary

The size and form of a space can be determined by its boundaries and the objects it touches. The interior spaces of hollow objects and buildings are referred to as volume.

We sense the form and size of a space not only with our eyes but also by our bodily movements.

Space is very important to artists who deal with threedimensional artworks. Architects, especially, have to consider space when they design buildings and interiors. Modern sculptors often include holes in their works to create added space, or make open sculptures out of strong lightweight materials.

Artists who make paintings and drawings often use the word *space* to refer to the two-dimensional area of the picture plane.

Artists who make realistic pictures are involved in representing depth—three-dimensional objects and people surrounded by three-dimensional space—on a two-dimensional surface. In addition to shading, foreshortening, and

making objects large or small (which were explained in Chapter 5), the methods of representing depth are overlapping, high and low placement, linear perspective, and aerial perspective. Semiabstract and abstract artists also employ these methods, as well as color variation.

Framing, locating the borders of a picture, affects not only the space but also the point of view and meaning of a picture.

Suggestion:

Now that you have learned about space, go back to your description of Renoir's Luncheon of the Boating Party. Can you recognize examples of high and low placement or overlapping? Can you locate the vanishing point and eye level? Is the eye level high, low, or average with respect to a standing person?

The framing of Luncheon allows us to see the whole party on the deck. Try changing the space and the scene by reframing the painting.

Chapter 8

Visual Elements: Texture and Movement

8-4 Photographs by Barbara Caldwell.

Texture

Texture refers to the surface quality of something, especially with regard to how it feels to the touch: rough, smooth, hard, soft, gritty, slick, and so forth. Since virtually everything that can be touched has a surface, texture is everywhere (figures 8-1, 8-2, 8-3, 8-4). Terms typically used in art to decribe texture are glossy (slippery, like the surface of a newly waxed floor) and matte (smooth but nonslippery, like the surface of a chalkboard).

Although texture is related to touch (sometimes called the tactile sense), we do not always have to touch something to sense its texture. At times we can feel texture just by looking at it.

Suggestion:

Make a list of some things around the room that are too far away to touch, such as chalkboards, woodwork, hardware, a countertop, or the ceiling.

Describe in a few words the texture of each thing on your list. If you have a chance, touch some of the things you described. Did you discover additional qualities about their textures by touching? If so, change or add to your descriptions. Can you sense the texture of the ceiling by just looking at it and "touching" it in your imagination?

Texture in our daily lives is very important-more important than we often realize. Take eating out, for example. The quality of a restaurant's atmosphere depends a great deal on the quality of its textures. Examples of glossy textures include plates, cups, silverware, glasses, countertops, coffee machines, and mirrors. Matte textures include napkins, place mats, tablecloths, carpeting, and drapes. Rough textures may be found in such things as unvarnished paneling and brick planters.

What about the food (fig. 8-5)? The texture of food as it is felt in the mouth—is as important as its flavor. You would be very disappointed in a hamburger bun that was not "fresh," that is, if it did not have the correct balance between softness and firmness, and between moistness and dryness. The same, of course, is true for everything inside the bun.

8-5

Texture in Art

All art objects have texture. In many works, however, the texture of the object itself is relatively unimportant. The actual texture of the original Migrant Mother (fig. 8-6), a photograph by Dorothea Lange, is smooth and glossy (not much different from the texture of the page on which it is

8-6 Dorothea Lange, Migrant Mother, Nipomo, California, 1936. Photograph: Dorothea Lange Collection, The Oakland Museum.

reproduced in this book). The important textures, however, are the ones we see in the picture: the lined face of the mother, her hair, the hair of her children, and the material of their tattered clothes. Called *simulated* textures, these textures relate to the images in the photograph and not its surface. They cannot be touched by the viewer, but they are nevertheless vivid, and they play an important role in telling a story about the sad conditions of migrant families in the 1930's. Like photographs, realistic paintings typically contain simulated textures. For example, in his painting of a longhorn steer (fig. 8–7), Don Nice captured not only the dappled colors of the animal's hide, but also its texture—right down to the little bristles of hair.

Simulated texture is either nonexistent or unimportant in abstract or semiabstract painting. The texture seen in *The Cow with the Subtile Nose* (fig. 8–8) was not intended to resemble cowhide. The artist, Jean Dubuffet, wanted you to have a heightened awareness of the texture of the paint itself. To accomplish this end he mixed oil and enamel paints, applied them thickly, and manipulated

8-7 Don Nice, Longborn Steer, Western Series, American Predella #6, 1975. Acrylic on canvas and watercolor on paper, 91 " × 120" (231 × 305 cm). Delaware Art Museum, Wilmington.

8-8 Jean Dubuffet, *The Cow with the Subtile Nose*, 1954. From the Cows, Grass, Foliage series. Oil and enamel on canvas, $35'' \times 45\frac{34}{7}$ (89 × 116 cm). Collection, The Museum of Modern Art, New York (Benjamin Scharps and David Scharps Fund).

them to create novel spotted effects. If you saw this work in the Museum of Modern Art, you might be prompted to feel the bumps and ridges - the actual texture - of its paint.

In some paintings, like Edouard Manet's Oysters (fig. 8-9), both kinds of textures play roles. The textures of the oysters in half shells, along with fruit and other objects, are perhaps realistic enough to stimulate your appetite. The texture of the thick strokes of fluid paint used to create the oysters is also visible. This painting gives you the best of both "worlds": simulated and actual textures. It appeals not only to your sense of sight and touch, but also to your imagination of food.

8-9 Edouard Manet, Oysters, 1862. Oil on canvas, 15 $\frac{3}{8}$ " \times 18 $\frac{3}{8}$ " (41 \times 48 cm). National Gallery, Washington, DC (Gift of the Adele R. Levy Fund, Inc.).

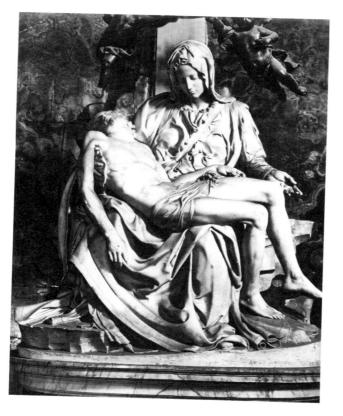

8-11 Marilyn Levine, Trent's Jacket, 1976. Ceramic, wood and metal hooks, 3.5 '' \times 18 '' \times 8 '' (89 \times 46 \times 21 cm). Private Collection. Courtesy of the O.K. Harris Works of Art.

The actual texture of Michelangelo's famous sculpture of the Pietà (Italian for pity) (fig. 8-10) is smooth and hard, the qualities we associate with polished marble. If you were standing by the real statue, that fact would be especially important. But, like Manet's painting, this work also provides the viewer with an experience of simulated textures, in this case, the flesh and clothing of Jesus and Mary. Note especially the ways in which stone has been made to simulate cloth, as the gown clings to Mary's body in places and gathers in heavy folds in other places. Yet you never lose sight of the fact that it is stone.

8-10 Michelangelo, The Pietà, 1498-1500. Marble, 5'9" high. St. Peter's, Rome.

You probably would not be aware of the true substance of Trent's Jacket (fig. 8-11) by Marilyn Levine, even if you saw it in the gallery. An extreme example of simulated texture, the "jacket" is not leather but ceramic (the material of which bricks are made). Levine has gone to such lengths in making a hard material resemble a soft material that she has succeeded in deceiving the viewer. Works like this are sometimes called "fool-the-eye" art. However, do you think Trent's Jacket is capable of fooling your touch?

Since there are no simulated textures in the ceramic vase by Viola M. Wood (fig. 8-12), the only important textures are the actual ones. Much of its interest depends on these textures and the ways in which Wood has controlled and varied them through scratching and stippling the clay, and adding pieces of clay. Note the ways in which rough surfaces are contrasted with the smooth surfaces. Everything about the substance of the piece – its textures, its colors, even its weight-appeals to the senses. Craft objects like this invite viewers to pick them up and hold them.

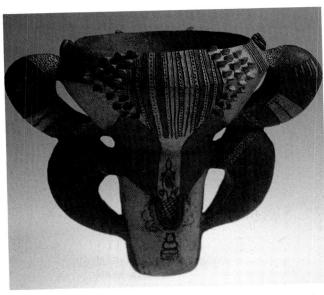

8-12 Viola M. Wood, Festival Form, 1975. Ceramic, 12 " × 8" × $4''(30 \times 20 \times 10 \text{ cm})$. Collection of the artist.

Suggestion:

At home look for some of your favorite personal objects: items of clothing, jewelry, a watch; or old toys, dolls, teddy bears, games, a clock, a radio. Do you like these things because of their textures? Is the texture of a teddy bear actual or simulated, or both?

Find a natural object outdoors that has interesting textures and bring it to class. Also find a made object – a brick, weathered board, or a rusty nail – and bring it to class. Be prepared to describe the texture(s) of each object.

Challenge 8-1:

Create a paper collage of simulated textures taken from magazine pictures and assembled in a new context to create imaginative objects and figures.

b. Student work.

a. Student work

Challenge 8-2:

Produce five different textures on a clay tile using two of three methods: pushing and pinching with fingers, pressing clay on clay, incising and impressing with a tool.

a. Student work.

b. Student work.

Movement

Unlike music and dance, the visual arts are considered the arts of space rather than of time. But space, as you saw in Chapter 7, involves movement. To experience a famous building or sculpture requires you to move in it or around it. Craft objects like Wood's vase (fig. 8–12) are best appreciated by rotating them in your hands. Even two-dimensional art involves movement. When you studied the textures in *Oysters* (fig. 8–9), your eyes probably moved from one object to the next.

Each of these instances could be considered examples of *viewer* movement. The art object was static, but the viewer moved. Viewer movement, even if it involves only the eyes, is a necessary part of experiencing art. This alone would be reason enough to consider movement as one of the visual elements. But there are other relationships between visual art and movement, and these are reviewed in this chapter as *implied movement*, optical movement, actual movement, and sequence.

Implied Movement

An image, whether a picture or a sculpture, preserves a moment in time. By stopping time, it implies a relationship to time, and also to movement. The subject may be as motionless as the oysters in Manet's still life, or as active as the man and the airplane in the scene from the movie North by Northwest (fig. 8–13). The images in both examples are equally static, but the movie photograph implies a great deal of movement. In this case it is implied by the subject matter. Whether you had ever seen the movie or not, you immediately recognize that the man is in danger. You have a basic knowledge of aircraft, and you know that this one—even if it is a slow crop duster—is too close for comfort. Indeed, with some imagination, you can hear its propeller, as well as feel the pounding heart of the man.

8-13 Cary Grant in a scene from North by Northwest, directed by Alfred Hitchcock. Copyright 1959 Loew's Inc. Ren. 1987 Turner Entertainment Co.

8-14 George Bellows, Stag at Sbarkey's, 1907. Oil on canvas, 361/4" × 481/4" (92 × 123 cm). Cleveland Museum of Art (Hinman B. Hurlbut Collection).

In Stag at Sharkey's (fig. 8-14) by George Bellows, movement is implied by both the subject and Bellows's style of painting – specifically, the use of diagonals in the men's bodies, the exaggerated postures, and the artist's lively brushwork. Two boxers are flailing away at each other at close range; the one on the right has his free arm cocked to deliver a punch. Again, the ability to see such movement assumes that the viewer has at least a basic knowledge of the subject, in this case boxing. Although the next moment is not shown, you can easily imagine the punch landing, and the sweat flying from the impact of the blow.

Challenge 8-3:

Create an abstract clay sculpture in which movement is suggested by the shape and placement of forms, and textures are used for surface contrasts.

Student work.

8-15 Umberto Boccioni, *Unique Forms of Continuity in Space*, 1913. Bronze (cast 1931), 43% " \times 34% " \times 15%" (111 \times 88 \times 140 cm). Col lection, The Museum of Modern Art, New York (Acquired through the Lillie P. Bliss Bequest).

The title of Umberto Boccioni's *Unique Forms of Continuity in Space* (fig. 8–15) is itself suggestive of movement, and for good reason. The artist was a member of the *Futurists*, a group in Italy whose aim was to express the speed and motion of modern society. Boccioni's sculpture, though considerably more abstract than the previous example, is recognizable as a figure walking in a rather determined manner. The direction, to the left in this view, is distinct. The forms—specifically, the forward tilt of the

trunk, the bend of the forward leg, and the extension of the rear leg – resemble those of a walker. Even the swollen thighs are suggestive of vigorous striding. But in some places the forms are disrupted and broken up, and in other places they seem to sprout fins – all of which lends the impression that the figure is striding through a wind tunnel. More than just an illustration of a walking person, Boccioni's sculpture is a symbol of dynamic movement.

Claes Oldenburg 1929-

You've seen it a hundred times: someone dumping french fries out of a little paper sack. But Claes Oldenburg has frozen the act in time and space, and Falling Shoestring Potatoes becomes a gravitydefying performance, a large-scale example of implied movement.

Many of Oldenburg's works are large sculptures of commonplace household objects. In some cases - such as Falling Shoestring Potatoes or the artist's 1988 work, Spoon Bridge and Cherry, the bridge-sized spoon that spans a body of water in Minneapolis – the sheer size of the sculpture shows us movement we might not have noticed in the object itself. In all his art, Oldenburg challenges the viewer to look at ordinary thingsa typewriter, a slice of pie-in an extra-ordinary manner.

Claes Thure Oldenburg was born in Stockholm, Sweden in 1929. His father was a member of the Swedish foreign service and the family travelled a great deal between Sweden, Norway and the United States before settling in Chicago in 1936. By the time he was seven years old, Oldenburg had lived in three different countries and experienced many unique environments. Beginning in his childhood and continuing throughout his life, Oldenburg has recorded his daily experiences in these different places in both drawings and notes. These notations have become sourcebooks for ideas for some of his artwork.

Though Oldenburg has expressed his ideas with many different art media, including film, printmaking, drawing and painting, he is best known for his oversized sculptures which monumentalize American life. In each medium explored, Oldenburg has attempted to communicate something about art and about life by examining the everyday, ordinary aspects of our

Claes Oldenburg, Falling Shoestring Potatoes, 1965. Painted canvas, kapok, 108" × 46" × 42" (274 × 117 × 107 cm). Collection, Walker Art Center, Minneapolis, Minnesota (Gift of the T.B. Walker Foundation).

lives in new and exciting ways. "I am for an art that takes its form from the lines of life itself, that twists and extends and accumulates and spits and drips, and is heavy and coarse and blunt and sweet and stupid as life itself."

8-16 Victor Vasarely, *Edetta*, 1984. Acrylic on canvas, $39\frac{3}{4}$ " \times $39\frac{3}{4}$ " (101 \times 101 cm). Courtesy Circle Fine Art Corporation, Chicago, Illinois.

Optical Movement

So far, the examples of movement have consisted of static works that imply movement because of their subject matters, their forms, or a combination of the two. Some static works known as *Op Art* (or Optical Art) seem, almost miraculously, to move in themselves. This movement is an

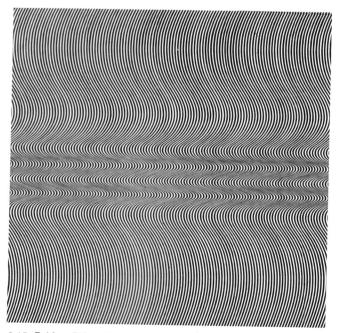

8-17 Bridget Riley, Current, 1964. Synthetic polymer paint on composition board, 58% " \times 58%" (148 \times 149 cm). Collection, The Museum of Modern Art, New York (Philip C. Johnson Fund).

illusion, a response by the eyes to lines, shapes, and colors arranged in certain ways. This movement vaguely resembles the sensastion of dizziness or of vertigo. Stare for a few seconds at Edetta (fig. 8-16) by Victor Vasarely. Does the pattern of shapes shift between being a checkerboard and a network of diagonals? Does it tend to swell and contract almost as if it were inhaling and exhaling? Perhaps you obtained different sensations, or would describe them in different ways. The compact pattern in Current (fig. 8-17) by Bridget Riley is even more interesting, or disturbing, depending on your taste. The monotony of the bending lines seems infinite, offering no places for the eye to stop and focus. Did you experience a vibrating effect along the narrow valleys where the bending of the lines is tightest? Op artists are notably skillful in applying to their work a knowledge of optics, a branch of physics dealing with the science of vision.

8-18 Julio Le Parc, Continual Mobile, Continual Light, 1963. Steel and nylon, 63 " (160 cm) high. The Tate Gallery, London.

Actual Movement

The works of Vasarely and Riley, for all their tortured lines and shapes, are static. Some works, called *kinetic* art, actually move. Some kinetic works are connected by pulleys and chains to electric motors; some, installed outdoors, are set in motion by the wind; still others, called *mobiles*, hang from ceilings and slowly move with the currents of air in a room. Julio Le Parc's *Continual Mobile*, *Continual Light* (fig. 8–18) operates on the principle of the mobile. Unlike Calder's huge mobile in the East Wing of the National

8-19 Eadweard Muybridge, Attitudes of Animals in Motion. Courtesy of Sotheby's Inc., 1987.

Milton Caniff, Terry and the Pirates, 1943. Reprinted by permission of the Chicago Tribune-New York News Syndicate. Copyright (1970-1974). World Rights Reserved.

Gallery (fig. 7-5), however, Le Parc's consists of nothing more than pieces of polished metal hung on nylon threads. Because of their light weight, the metal pieces move rather freely. But the main experience of movement is due to their reflections that dance off walls and ceiling. The motions of Continual Mobile, Continual Light, like those of most other kinetic pieces, are random - that is, without any particular order or sequence. In this respect, kinetic art differs from the arts of music or dance.

Sequence

Some forms of visual art – in particular, the popular arts of comics and movies – involve sequence, the following of one thing after another in logical order. A good example of sequence is the words on this page that are arranged in a certain sequence for you to read.

Using a number of cameras, Eadweard Muybridge produced a series of still pictures to illustrate the sequence of positions used by a horse and rider to leap over a hurdle (fig. 8-19). In fact, the series is "read" like a page in a book, from left to right and from top to bottom. Because of the many repeated scenes, with each scene showing a slightly different position, the suggestion of actual movement is very strong.

Like a series by Muybridge, a comic strip also uses a sequence of pictures called frames. The suggestion of movement in the sequence of Terry and the Pirates (fig. 8-20) by Milton Caniff is probably not as strong as that in the sequence of the leaping horse. But a comic strip is not intended to be a study of movement; it is intended to tell a story. One frame follows another, each showing a scene or slice of action representing a new stage in the story. The

progress of the story is usually aided by conversation, or *dialogue*, that is printed in "balloons" located just above the characters' heads. Because comic strips mix dialogue with pictures while telling stories, they are sometimes referred to as *narrative* art.

The Terry and the Pirates sequence shown here is a very short part, or episode, of a long story about Terry's adventures as a pilot of a fighter plane during World War II. Notice how both the drawing and dialogue—which takes place on the radio between Terry and the pilot of a war-damaged cargo plane—contribute to the story. To make the sequence as dramatic as possible, Caniff used a variety of framing and points of view. The first frame, a close-up of the inside of Terry's cockpit, shows the action from the young hero's point of view; the second shows it from the cargo pilot's; the third is a distant view of both planes flying over the mountains of Burma; and the final frame, a close-up of Terry's plane at an odd angle, concludes the episode.

Suggestion:

Continue the story of Terry and the Pirates. Does the damaged cargo plane make it over the mountains? Does Terry radio for help? Does he return to base? Does either plane encounter enemy Zeros (fighter planes used by the Japanese during World War II)?

A movie, or *film*, like a comic strip, relies on sequence to tell its story. But unlike a comic strip, a film is a picture that actually *moves*. The movement in a film, of course, is in-

dependent of the person looking at it. The same is true of the sequence. The viewer has no control over its direction or speed; he or she cannot look ahead to see what is going to happen nor look back to see what was missed (unless, of course, the viewer is watching it on a VCR).

A sequence in a film is a series of *shots*. A shot is like a frame of a comic strip, except it contains action. If the *Terry and the Pirates* episode were on film, the first shot would be of Terry in his cockpit, the second of his friend in the cargo plane, and so forth, each lasting perhaps five seconds. In the making of a film, a shot takes place from the time a camera starts running to the time it stops. In the viewing of a film, a shot is an unbroken segment of a scene or action. Direct connections between shots are called *cuts*.

Like comic strip frames, film shots can show distant views or close-ups, as well as different points of view and angles. Shots also do many other things—all related to the capabilities of a movie camera. A camera can *tilt* (pivot up and down from a stationary position), *pan* (pivot sideways from a stationary position), *track* (move to follow an action), and *zoom* (make an image appear nearer or farther by means of a zoom lens). Finally, a camera can remain in a fixed position, with movement coming entirely from the action of the scene.

In the opening scenes of *Star Wars*, Princess Leia's starship is captured by a spaceship of the evil Galactic Empire. Following the capture, empire troops blow up the main bulkhead of Leia's ship and attack the defending rebel troops. The battle sequence, which takes less than

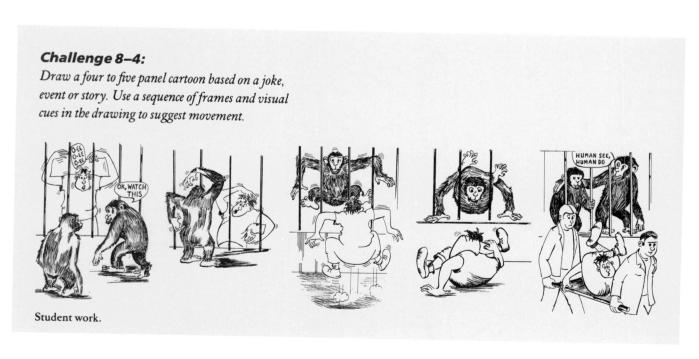

8-21 Artoo-Detoo and See-Threepio helplessly watch rebel troops defend the rebel blockade runner in the film Star Wars.

cut to:

retreat.

fifty-nine seconds of viewing time, requires thirty-two shots (the average length of a shot is less than 1.9 seconds). Eight of those shots are described here. Almost all were filmed with cameras in stationary positions at chest height.

Shot	Length of shot/ Camera position	
Rebel soldiers retreat to corridor where Artoo- Detoo and See-Threepio are hiding.	3 seconds/Fixed camera at chest level	
cut to:		
The robots watch helplessly as rebel troops are fired on (fig. 8–21).	1 second	
cut to:		
Close-up of See-Threepio.	1 second	

Empire troops killing and being killed.	1 second
cut to:	
Close-up of See-Threepio.	1 second
cut to:	
Rebel troops killing and being killed.	1 second/Waist level
cut to:	
Robots move to other side of corridor, followed by explosion.	4-5 seconds/Camera pans to follow robots.
cut to:	
Smoke. Rebel troops in full	1 second

8-22 Artists are often called upon to make storyboards for movies like Star Wars. This illustration represents one shot of a sequence.

The battle sequence ends with Darth Vader entering through the damaged bulkhead and surveying the carnage (camera at waist level to emphasize the evil commander's size). Because of the shortness of the shots and the confusion of a pitched battle, odd angles of view were not used, and a panning camera was employed only once. To do otherwise would have made the sequence too hard to follow.

Often, for movies like *Star Wars* that contain complicated action, artists are hired to make *storyboards*—series of pictures that resemble comic strips. A storyboard corresponds to a sequence; each illustration (fig. 8–22) represents a shot, the difference being that each picture is still. A storyboard helps the director and the camera people to visualize a sequence before the actual shooting begins. The storyboard picture in figure 8–22 corresponds to the first shot in the listed description. Notice that the eye level in the picture is very low (about at the knees), while the position of the camera in the film is chest level.

Sound

In addition to the shot and the sequence, sound is an important element in film, especially in battle sequences where the sounds of explosions and zapping weapons add to the realism. Music is often used to establish mood; in this case, it is used effectively to increase the feeling of tension during the moments before the bulkhead is breached. In *Star Wars*, as in *Terry and the Pirates*, dialogue is very important to clarify the action. In the scenes before the battle, See-Threepio explains to Artoo-Detoo that the pursuing ship knocked out their ship's main reactor. Seconds later, he says, "We're doomed! There'll be no escape for the Princess this time." What would film be like without sound? You have probably seen "silent" movies. You may recall that the action had to be interrupted every so often to show printed dialogues on the screen.

Suggestion:

Add a sequence of your own to Star Wars. Diagram each shot by indicating in the left column the action. In the right column indicate the point of view and whether the camera is stationary, tilting, panning, tracking, or zooming.

Imagine that you are a film producer. Either make up your own story or use a story by someone else for making a movie. Diagram a sequence or two of that movie.

Closely observe movies shown at school. See how an idea or concept is developed by means of a sequence of shots. Take notes on what you see and hear. Perhaps your teacher will be willing to "rerun" some of the sequences.

Take notes on films shown on television, especially commercials. What kinds of shots are used to create favorable impressions of the advertised product?

Next time you see a commercial film, either at a theater or on a VCR at home, take notes on some of the sequences. REMEMBER: When viewing a movie on a VCR, you have the ability to reverse the tape and play a sequence more than once.

Challenge 8-5:

Draw a storyboard that explains the sequence of events in a short video production.

Summary

Texture refers to the surface of something – how it feels to the touch. All artworks, like all objects, have actual textures. Many artworks also have textures that can be seen but not felt. In photographs, realistic paintings, and realistic sculptures, this kind of texture is called simulated texture. In artworks having no simulated textures, such as crafts or abstract paintings and sculptures, the only important textures are the actual ones.

All art involves movement. At the very least, a viewer must move his or her eyes to appreciate an artwork. Beyond that, movement occurs in visual art under differing conditions. Implied movement is the suggestion of movement due to subject matter and qualities of style. Optical movement is the illusion of movement due to patterns of lines and colors typically found in Op Art. Actual movement is found in kinetic art, a type of visual art that is not static.

Sequence is characteristic of comics and movies. In a comic, the sequence of viewing is from left to right (and also from top to bottom in the Sunday comics), but the viewer is free to skip around and move his or her eyes at any speed. In a film, the movement is actual; both the movement and the sequence are determined by the film, not the viewer. A sequence is made up of a series of shots. Each shot consists of an unbroken view of a scene of action.

Suggestion:

Now that you have completed this series of chapters on the elements of art, rewrite your description of Renoir's Luncheon of the Boating Party.

Part III HOMIS It Ordanizaci2

bondoenedanik

A OF CONTROL OF THE OWNER O

distribution in the matter of the contract of

中心是全国和全国的特别的自由的的特别

Chapter 9 Analyzing What You See Chapter 10 Design

noceolacyaddacyalacan

Chapter 9 Analyzing What You See

9-1 Alexander Calder, Spring Blossoms, 1965. The Pennsylvania State University.

Now that you have completed Part II you should be able to identify and describe a lot of things in an artwork that you were not able to do before. The purpose of this chapter, as its title suggests, is to introduce you to the task of analyzing a work of art. Analyzing is somewhat different from describing. But before going further, look at the following four statements. Each is a short analysis of one of the four artworks shown (figures 9-1, 9-2, 9-3, 9-4). See if you can match the right statement to the right picture.

- A. Although they differ in size and color, most of the shapes are similar in being rectilinear. The dominant feature is the post in the center.
- B. Because it consists of a series of identical boxlike shapes separated by equal spaces, this artwork lacks not only variety but dominance.
- C. A series of wavy lines, which are identical in size and shape, provide rhythm but little variety for this artwork. The dominant feature seems to be the center from which the lines radiate.
- D. This work consists of a number of similar shapes of different sizes that form a rhythmic pattern.

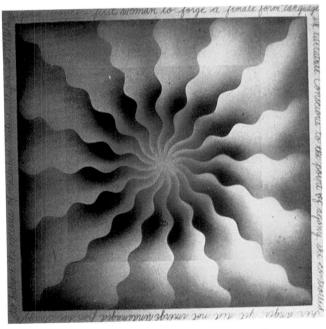

9-2 Judy Chicago, Virginia Woolf, 1973. Sprayed acrylic on canvas, $5' \times 5'$ (153 × 153 cm). Courtesy of the artist.

9-3 Donald Judd, Untitled, 1985. $\frac{1}{2}$ " aluminum and $\frac{1}{8}$ " blue plexiglass over 1/8 " black plexiglass, 6 units each 1/2 × 1 × 1/2 meters, overall 4½ \times 1 \times ½ meters. Courtesy Leo Castelli Gallery, New York.

9-4 Richard Estes, *Drugstore*, 1971. Oil on canvas, 44 $^{\prime\prime}$ \times 60 $^{\prime\prime}$ (113 \times 152 cm). The Art Institute of Chicago.

Perhaps you did not do well in the matching exercise because you were unfamiliar with some of the terms used, such as "rhythm" and "dominance." On the other hand, you may have done very well in spite of this fact, because certain descriptive words, like "wavy lines" and "boxlike shapes," gave you enough clues to match the statement with the correct work. These statements, although very short, show how words, if used well, can both describe and analyze an artwork. Describing has to do with pointing out facts about the lines, shapes, and colors. Analyzing has to do with pointing out the relationships among these things.

Composition

The chapters of Part II dealt with each of the visual elements separately. In this and the following chapter of Part III, we will see how the elements work together to make a complete work of art.

Composition refers to the way that lines, shapes, colors, and such have been put together. The artist, of course, is the person who has to put these things together, which is called composing. The final result of composing a painting or a sculpture is called a composition.

Analyzing the Composition

Even though you, the viewer, do not do the composing, it sometimes helps if you know bow a work of art was composed. In other words, you may have to "decompose" a picture or sculpture in order to see how it was organized, to see what makes it tick. This is called analyzing, or analysis.

As we said earlier, analyzing an artwork consists of finding relationships in the composition. One kind of relationship has to do with two or more things having something in common. There are many ways that two things can have something in common, that is, be related to each other. Consider people, for example.

Usually, when we talk about being related to somebody, we think of families. You are related to your uncle—who may be fat and bald—even though you have nothing in common with him except for the fact that both of you are in the same family. But there are other kinds of relationships besides family relationships. You can be related to other people because you have in common with them the fact that you are in a particular classroom taught by a particular instructor. You can be related to others because you are a fan of the Dallas Cowboys, like to ride horses, have brown eyes, and so on.

When you stop to think about it, everybody is related to everybody in some ways; everybody also is different from everybody in some ways. Often an analysis points out both differences and relationships. For example, Jenny likes indoor activities – art, chess, and cooking – and Susie likes outdoor activities – hiking, swimming, and soccer – yet both are members of 4-H.

Suggestion:

Think of one or two of your friends. List the things that you all have in common with each other (other than the fact that you are each other's friend). Also list the things that are different about the two (or three) of you.

Like people, colors and shapes in an artwork are often related in some ways and different in some ways. Differences and relationships are pointed out in two of the four statements. Statement A, in analyzing the composition of the painting in figure 9-4, says "Although they differ in size and color, most of the shapes are similar in being rectilinear." Statement D, which is about the mobile (fig. 9-1), says "This work consists of a number of similar shapes of different sizes."

Another kind of relationship has to do with one thing being more important than another thing. For example, a leader is more important than a follower. In a group that has a leader, everybody is related to everybody else because they are in the same group. But also each follower is related to the leader in a special way and vice versa. Have you ever been a leader? Have you ever been a follower? Is your relationship to your teacher something like that of a follower to a leader?

This kind of relationship in art is pointed out in the second sentence of statement A: "The dominant feature is the post in the center." The second sentence of C (about the abstract painting in figure 9-2) also speaks of dominance: "The dominant feature seems to be the center from which the lines radiate." You will learn about dominance in the next chapter.

In fact, Chapter 10 will discuss in detail several visual relationships under the topic of design. By being able to recognize these relationships and by learning the vocabulary for them, you will be able to analyze an artwork.

Challenge 9-1:

Analyze American Gothic by Grant Wood using the analysis guidelines provided for this challenge. Procedure. In chapter 3, you described American Gothic, which involved listing things about the painting that can be named and described with certainty - the facts. Analyzing involves identifying the relationship between things in the painting. The question is, bow did the artist organize subject matter and elements including line, shape, texture, colors and space so they interrelate as a composition? Take 15 or 20 minutes to answer the following questions about American Gothic.

Grant Wood, American Gothic. 1930. Oil on beaver board, 30" × $25''(76 \times 63 \text{ cm})$. Friends of

American Art, Institute of

Chicago.

- 1. What similarities can you find among elements such as shape, colors, lines, patterns, size, direction of lines and shapes?
- 2. Are there contrasts of elements such as color, shapes, forms, texture, direction or size?
- 3. Are there elements in the picture that are repeated in some systematic way?
- 4. Are there elements that lead your eye through the composition?
- 5. Is there some element or area in the painting that is dominant or that seems most important?
- 6. What makes the painting seem to be balanced?
- 7. Can you describe a relationship between the subject and the way the artist used the medium (oil paint)?

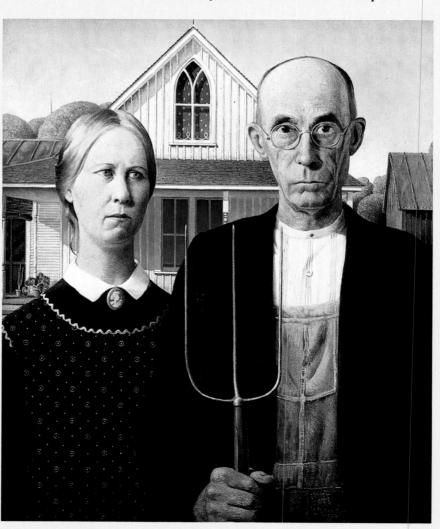

Grant Wood 1891-1942

Few paintings have achieved as powerful a hold on the imagination of an entire country as Grant Wood's American Gothic. A spinsterly woman wearing proper clothing and a serious expression is posed beside a stern man, gripping a pitchfork and staring intently at the viewer. A few strands of hair escape from the woman's tidy bun and fall down her neck emphasizing her otherwise immaculate appearance: the dark jacket suggests that this stoic farmer is dressed to attend church.

The posed figures standing before a white building, with their stiff posture, reserved manner, stony faces and unblinking eyes, have become symbols of the American family. American Gothic has come to symbolize farm life and traditional work values in the midwest United States. In fact, this painting is better known than the man who created it.

Grant Wood was born in 1891 on a small farm in rural Iowa. There he lived a quiet childhood for the first ten years of his life, without telephones, radios, televisions or cars. He was educated in a one-room schoolhouse, and spent his free time drawing on scraps of cardboard from cracker boxes which his mother saved for him. In 1901, Grant's father died unexpectedly; the Wood family sold their farm and moved to the nearby city of Cedar Rapids to be close to relatives. During the next forty-one years of his life, Grant travelled and spent time in Europe, but always

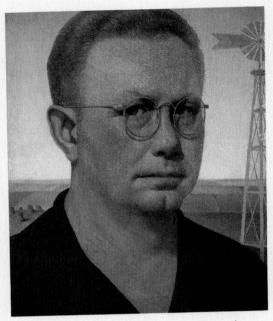

Grant Wood, Self-Portrait, 1932. Oil on masonite 143/4" × 123/8". Davenport Museum of Art.

returned to live and paint in this Iowa city.

Though the time he spent on the family farm was brief, strong memories of his early experiences greatly impressed Grant and later became the subjects of his paintings. From hayrides in the fields to the midday meal, Grant painted the types of people and the landscapes which he recalled from his childhood. During the prime of his career in the 1930s, he painted very little of the life which he observed from the window of his Cedar Rapids home. Grant Wood chose instead to paint a romanticized version of rural Iowa as he remembered it from his youth.

Summary

Composing is what the artist does when he or she puts all the elements together to make a work of art.

Analyzing is what the viewer does when he or she determines how the work was composed. An analysis points out the relationships between and among the elements in a composition.

More about composing an artwork and what kinds of relationships to look for in a composition will be discussed in Chapter 10.

Chapter 10 Design

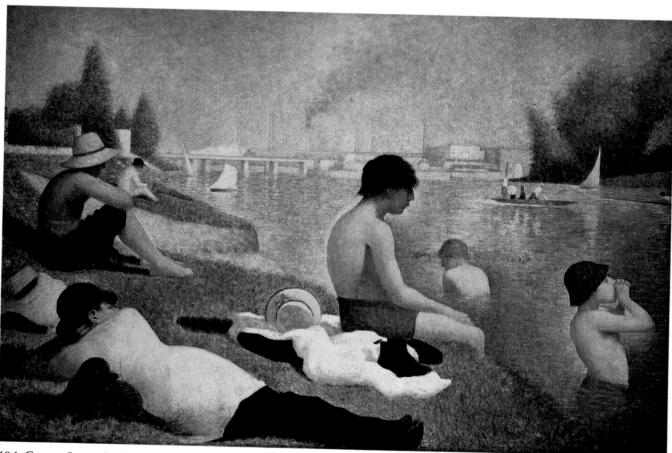

10-1 Georges Seurat, *Bathing at Asnières*, 1883–1884. Oil on canvas, $6'7'' \times 9'11''(201 \times 302 \text{ cm})$. Reproduced by courtesy of the Trustees, The National Gallery, London.

In Chapter 9, you learned that artists compose elements to create a work of art, and that the final result of this process is called a composition. The plan the artist uses to organize the composition is referred to as design. As you can tell from the examples in this book, artists design their compositions with many different approaches. There are no exact rules for achieving good composition in works of art. There are some principles of design, however, that are general enough to allow for differences between one design and another. These principles—unity, variety, dominance, rhythm and movement, and balance—can be helpful in determining how the various elements of a composition are organized so that they work together.

Unity

Unity in art can be compared with teamwork in sports. A basketball team consists of five players, but having five players is no guarantee that the team will win games. If a team is to be successful, the coach must make the five members play as a unit. Likewise, if an artwork is to be successful, the artist must make the elements work together as a unit. If a work of art does not have unity, it will appear to be a collection of individual parts—like a basketball team in which everybody shoots, but nobody assists. You could say that the main purpose of the artist's plan is unity, because if the composition is successful, you are aware of the whole work of art before looking at individual parts.

Several aspects of design that contribute to unity can be demonstrated by examining Georges Seurat's painting, Bathing at Asnières (fig. 10–1).

Proximity

One way to make separate objects look unified is to place them close together, or in proximity. If the proximity of the letters in the words of this sentence were changed, you would have difficulty reading them. In Seurat's painting there are groups of people and objects: the three boys on the right, the items of clothing by the large boy, the man and dog, and the groupings of trees and buildings in the distance. Notice how the individual figures and objects along the riverbank are tied together by their proximity, so that your vision moves from one to another.

Similarity

A second way to achieve unity in an artwork is by making things similar in color, texture, shape, or form. Several objects in the painting, even those that are distant from each other, are connected by their similarity in color. Redorange, for example, appears in the form of the dog, the hat of the boy in the water, his shorts, and in some other items. Can you identify them? What other colors are repeated in Seurat's painting?

Several objects in the painting have similar shapes, for example, the dome shape that occurs in the hats, the heads of the two hatless bathers, and even in some of the trees. Triangle shapes can be found in the back of the reclining man, the shadow behind the large boy's arm, the way the legs of the persons sitting on the bank are bent, the shape caused by the bent arms of the boy holding his hands to his mouth, the boat sails, and so forth. Can you identify some other repeated shapes in the painting?

10-2 Diagram of continuation in Seurat's Bathing.

Continuation

Continuation in an artwork occurs when the viewer's vision is directed by a line, edges of shapes, or an arrangement of objects. The line of the riverbank, which continues from the lower right corner to the upper left side of Seurar's painting, is a good example of an edge that directs the flow of vision. Another is the line of the buildings that extends from the left to the right side of the river. Continuation is often reinforced by direction from one form to another because of the similarity and placement of the forms. For example, your vision tends to move from the large figures in front to the small ones at the far end of the riverbank, then along the buildings across the river, and, because of the boat sail reflected in the water, back down to the boy with cupped hands. The line drawing in figure 10–2 represents the continuation in *Bathing at Asnières*.

Challenge 10-1:

Construct a three-dimensional sculpture from wood scraps selected and organized to create visual movement and unity throughout the form.

a. Student work.

b. Student work.

Faith Ringgold

As a child, Faith Ringgold suffered from asthma. She spent many days at home with her mother, Willi Posey Jones, who was a fashion designer and dressmaker. To keep Faith entertained while she was ill, she would give her fabrics, thread, crayons and watercolors to play with. Without knowing it, Willi was helping her daughter to become an artist.

Faith Ringgold grew up in Harlem, New York, during the Great Depression. This was a difficult time when many people were unemployed and struggling to provide food and clothing for their families. Faith remembers that time as a very important part of her life which influenced her later artwork: "Mostly, I remember people. Faces of people. Everything about people. And . . . early on, I got involved with the souls of people."

Faith studied art education in college and taught in the New York City Public Schools. She found that as a teacher she was also able to learn from her students. Together they explored African heritage and culture through art. From this experience Faith developed a sense of pride in being a black American.

1972 was a year of change for Faith. While teaching African crafts at a New York college, she had a retrospective exhibition of her paintings of the previous ten years. One of her students expressed disappointment in Faith's artwork: "I didn't see any of the techniques you teach us . . . beading, tie-dyeing. Why aren't you using the techniques of African women?" Faith could not answer her student's question. She began to realize that fabric and beads had been part of her life since childhood; perhaps she should use these materials and techniques in her artwork. Faith's childhood experiences, her youth in the Harlem community, and her interest in African culture could be combined to form a new type of art.

Faith began using cloth, beads, rope, thread and ribbon to create unusual sculptures of people. Some of these sculptures were of people she

Faith Ringgold, *Lena*. Courtesy of The Bernice Steinbaum Gallery, New York.

remembered from growing up in Harlem, others were of famous people like Wilt Chamberlain, and Martin Luther King, Jr. Some of her sculptures are small, while others are larger than life. A small sculpture, *Lena*, requires that you look closely to learn about this little person who lives on the street, while *Martin Luther King* is larger than life-size, emphasizing Dr. King's importance to Faith and to all people.

Today Faith continues to work with a variety of traditionally African materials in her art, using them in sculptures of unique individuals, quilts which tell stories of people, and even performances which involve singing and dancing. From images of families in her native Harlem to famous individuals who are noted for their great achievements, Faith Ringgold's artwork portrays both her passion for people and her understanding of the struggles of modern life.

Variety

Unity may be the main aim of an artist's plan, but a composition can be so unified that it is uninteresting. A good example is the unified pattern in a tile floor, where all of the tiles are the same color, in close proximity, and constantly repeated—all very unified, but not very exciting.

Variety refers to differences, and may involve different materials and objects, different forms of the same thing, or contrasts of values, textures, and colors. Seurat's *Bathing* has a lot of variety. There are several people of varied sizes, who are dressed differently and doing different things. In addition to the variety of people, there is a variety of objects: a riverbank, a river, sailboats, buildings, trees, and a dog. There is also a variety of colors, lines, textures, and shapes.

Even with all of this variety, *Bathing* is a peaceful and relaxed scene, in part because Seurat used related colors (yellow-greens and blues). We also associate the positions of the figures with relaxation and inactivity. Variety contributes interest to a picture, or to anything in life. If

10-3 Andy Warhol, 100 Cans, 1962. Oil on canvas, $72'' \times 52''$ (183 \times 157 cm). Albright-Knox Art Gallery, Buffalo, New York (Gift of Seymour H. Knox, 1963).

allowed to get out of control, however, it can be disorderly and confusing. Therefore, variety in *Bathing* has been brought under control by unity.

Once in a while, an artist may use unrelieved repetition on purpose, as in Andy Warhol's painting, 100 Cans (fig. 10–3). The artist repeated the same soup can one hundred times, perhaps as a critical comment on the monotony of repeated commercial images that are forced upon us every day. By comparison, Joseph Cornell's Object (Roses des Vents) demonstrates a great deal of variety through the inclusion of very different objects: maps, charts, rocks, compasses, a spring, seeds, and pictures (fig. 10–4). Cornell has pushed variety to the limit in this sculptural work, perhaps as a comment on our tendency to gather and keep collections of odds and ends.

10-4 Joseph Cornell, Object ("Roses des Vents"), 1942–1953. Wood, plexiglass, compasses, maps of New Guinea and Australia, and small miscellaneous objects, 2 % " \times 21 %" \times 10 %" (7 \times 54 \times 26 cm). Collection, The Museum of Modern Art, New York (Mr. and Mrs. Gerald Murphy Fund).

Dominance

When one element appears to be more important or attracts more attention than anything else in the composition, we say it is dominant. The dominant element or form is usually a focal point in a composition, and we are inclined to look at it first. In Seurat's painting, the large boy sitting on the bank by the pile of clothing dominates

the picture and is a focal point to which our eyes keep returning. Why does he dominate? One reason is his size. He is the second largest figure in the painting. Another reason is his location, which is near the center. The warm colors in his hair, flesh, and shorts contrast with the cool color of the water.

An element may dominate because it is different from everything else, and not because it is large or in the center of the artwork. For example, the Coca Cola sign in the painting by Richard Estes (fig. 10–5) stands out because it is the only major circular shape in a composition filled with mostly rectangular shapes.

A combination of devices work to make the preacher and the young woman the dominant figures in John Steuart Curry's *Baptism in Kansas* (fig. 10–6). The two figures are centrally located at the hub of two circles, one formed by the water trough, and the other by the ring of onlookers. This kind of composition is called *radial design*. Especially important to this radial design, and also for drawing our attention to the central pair of figures, is the fact that most of the people are looking at the dominant pair. (This kind of direction was referred to as *lines of sight* in Chapter 4.) Have you often been compelled to look where other people are looking or pointing?

10-5 Richard Estes, Nedick's, 1969–1970. Oil, $48 \text{ "} \times 66 \text{ "}$ (122 × 168 cm). Private collection.

10-6 John Steuart Curry, *Baptism in Kansas*, 1928. Oil on canvas, 40" × 50" (101 × 127 cm). Collection of The Whitney Museum of American Art (Gift of Gertrude Vanderbilt Whitney).

Challenge 10-2:

Use aluminum foil to make a low-relief sculpture in which textures, shapes and lines are organized around a dominant form. Use a patina to accentuate the relief.

Cardboard shapes glued in place.

Finished work covered with tooled aluminum foil.

a. Student work.

b. Student work.

Rhythm and Movement

When you think of rhythm, you may think of music with a foot-tapping beat. But the term rhythm is also used to talk about the graceful movements of a trained dancer or athlete. When you look at a painting, you may sense a flow of rhythmic movement that results from recurring visual elements like line, alternating light and dark areas, and repeated shapes. This sense of movement resulting from controlled repetition in art is also called rhythm. Al-

though continuation contributes to visual movement in works of art, the artist's rhythmical repetition of figures, shapes, and objects is a more powerful strategy for creating movement throughout a composition.

There are three basic methods of creating rhythm: (1) repetition of the *same* element, such as a shape or figure, with little or no variation; (2) repetition of two or more elements on an *alternating* basis, such as circle–square, circle–square; (3) *progressive* repetition of an element from large to small, dark to light, and so on. Most artworks include more than one kind of rhythm. For example, Andy Warhol's *100 Cans* (fig. 10–3) demonstrates unvarying repetition in the vertical columns of cans. In the horizontal rows, it demonstrates a rhythm based on the alternation of the two colors on the label, red and white.

The Scream by Edvard Munch (fig. 10–7) involves a rhythm of curvilinear shapes and lines that become progressively larger from the upper left to the lower right, directing our vision to the figure in the foreground of the painting. Then the converging lines of the bridge provide a progression of shapes from large to small that directs us back into the left part of the picture. Do you experience a movement in and out of the painting that suggests the echoing of a scream?

10-7 Edvard Munch, *The Scream*, 1893. Oil on canvas, $36'' \times 29''$ (92 × 74 cm). Munch-museet, Oslo.

10-8 Claude Monet, Waterloo Bridge, 1903. Oil on canvas, 25 3/4 " × 36 1/8" (64 × 93 cm). Worcester Art Museum, Massachusetts.

All three types of rhythm can be seen in Claude Monet's painting, Waterloo Bridge (fig. 10–8). The negative forms of the arches alternate with the positive columns of the bridge, creating a rhythmical movement diagonally across the picture. You can see that the arches and columns become progressively smaller from the left to the right end of the bridge. This large-to-small progression reinforces the visual movement across the painting. Monet also created a progression of colors from light and bright in the foreground water, to the dark of the bridge form, to the grayed or dull colors in the background. Repeated white and light green brush strokes on a dark color suggest waves and light reflections in the water.

You can find rhythm in Seurat's *Bathing*, but it is more subtle. The curved line along the head, neck, and back is repeated in all of the seated figures, and in the boy in the

water with cupped hands. The edge of the riverbank provides a continuous flow of line that moves in and out to describe progressively smaller forms projecting into the water. Look closely at the reflections in the water for rhythmic light and dark alternations. A light source coming from the right of the painting results in an alternation of light and dark values on all of the figures and objects. Can you identify more examples of alternation and repetition in the background?

Balance

Look at the two examples of Jacob Lawrence's painting (fig. 10–9a,b) and decide which one you are the most satisfied with. Most people choose example (a) as more satisfactory than (b). Before reading farther, can you explain what was affected by removing the seated figure in the striped pants and the reclining figure from the left front of the picture? Why?

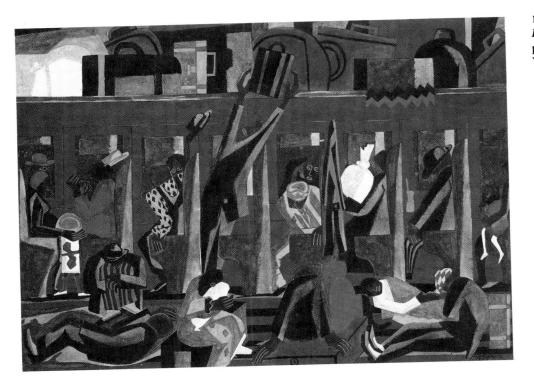

10-9a Jacob Lawrence, Going Home. Collection: IBM Corporation, Armonk, New York.

10-9b This version of Jacob Lawrence's painting has been photographically altered. Which do you think is better balanced?

The balance of the composition is affected by removing the figures. *Balance* in a picture refers to an equal distribution of *visual weight* or eye attraction on either side of the composition's center. The visual weight of images and objects in a painting depends on their relative size, brightness of color, contrasts of value or texture, complexity of shapes, and distance from the center of the composition. The unchanged reproduction of *Going Home* (a) is *asymmetrically* balanced because the artist achieved a feel-

10-11 Robert Indiana, *The* X-5, 1963. Oil on canvas, 108" × 108"(274 × 274 cm). Each of five panels is 36" × 36". Collection of The Whitney Museum of American Art (Purchase).

ing of equally distributed visual weights with figures and objects that are different. Removal of the figures on the left affected this balance, making the right side of the picture seem heavier than the left. The forceful diagonal thrust to the right, caused by the figure putting a bag on the shelf, and the weight of the seated figures in the lower right foreground are balanced by the seated and reclining figures in the lower left foreground of the picture. Lawrence carefully positioned all of the figures and objects in *Going Home* to create a "felt" equalization of visual weights.

Symmetrical balance is simpler to achieve and easier to analyze. The decorative symbols woven into the seventh-century Peruvian mantel (fig. 10–10) are arranged in symmetrical balance, with identical elements equally distributed on either side of a vertical axis in the center of the composition. Robert Indiana's *The X-5* is a contemporary example of pure symmetrical balance in a very precise painting in which one side of the composition is a mirror image of the other (fig. 10–11).

Sometimes the two sides of a composition are similar enough to imply a vertical central axis, and varied just enough to challenge you to identify the differences. This kind of balance is called *approximate symmetry*, and can be seen in the painting called *Mae West* by Salvador Dali (fig. 10–12). At first glance, this appears to be a purely symmetrical painting, but look closely and you will discover a number of differences between the two sides. Do you think the painting looks like a portrait, a room interior, or both?

10-10 Mantle (detail), wool, embroidered with colored wool. Pre-Inca Period, Early Nazca, ca 600. The Metropolitan Museum of Art (Gift of George D. Pratt, 1932).

10-12 Salvador Dali, *Mae West*, ca. 1934. Gouache, 10% " \times 6% " (28 \times 17 cm). The Art Institute of Chicago (Gift of Gilbert W. Chapman).

Radial balance results from the repetitive placement of two or more identical or very similar elements around a central point. The Pomo Indians of northern California wove into their baskets geometric designs that radiate outward from a central point (fig. 10–13). The radial balance affects a spiraling movement over inner and outer surfaces of the basket. A-101 (fig. 10-14) by Tadasky is a radially balanced optical painting designed to create the illusion of movement, which you can sense by staring at the center of the concentric circles until the black lines begin to whirl. John Curry's Baptism in Kansas demonstrates a more subtle use of radial balance (fig. 10-6). The figures of the preacher and young woman are a central point around which there are circles of people and automobiles. Even the placement of the house and barn suggests a larger circle that goes off the page.

10-13 Pomo Storage Basket. California. Nineteenth century. Coiled basketry, $13\frac{1}{2}$ " \times 21" (34 \times 54 cm). Courtesy The Museum of the American Indian, Heye Foundation, New York.

Look again at Seurat's *Bathing at Asnières* (fig. 10–1) to analyze how it is balanced. You will have no trouble recognizing that it is asymmetrical and well balanced. When you begin to analyze the distribution of visual weights, however, you discover that most of the people are on the left, including the man lying down – the largest figure of all. Strong visual movements also are directed to the upper

10-14 Tadasky, A-101, 1964. Synthetic polymer paint on canvas, $52'' \times 52''$ (132 \times 132 cm). Collection, The Museum of Modern Art, New York (Larry Aldrich Foundation Fund).

left by the large man, the placement of the figures, and the diagonal thrust of the riverbank. But on further analysis, you discover that this leftward tilt is counterbalanced by several things: the right-of-center placement of the large boy, the warm-cool color contrasts between the blue water and the orange hair, shorts, and hat of the boys on the right, and the fact that almost everyone is looking to the right.

Not all works of art are as easy to analyze as those by Seurat, who was very concerned about such things as unity and balance. His *Bathing at Asnières* demonstrates all of the design principles. However, some of the other examples included in this chapter do not. Andy Warhol's 100 Cans (fig. 10–3) has unity, but very little variety and no dominance. Cornell's assemblage (fig. 10–4) has variety and

Challenge 10-3:

Make three contour drawings of five or six objects arranged in symmetrical, asymmetrical and radial balance, with one object dominant in each drawing.

some unity (because of a network of horizontal and vertical lines on the upper maps, the compartments in the box, and the rows and columns of compasses), but it lacks dominance and rhythmical movement. Both Robert Indiana's X-5 (fig. 10–11) and Tadasky's A-101 (fig. 10–14) have little variety.

Some works of art seem to defy all of the principles of design. *Black Painting* by Ad Reinhardt (fig. 10–15) appears to be simply a large black square. If you look at it long and hard, you may see the shape of a cross. Even if you do see the shape, however, there is a minimum of variety, no dominance, no focal point, no rhythm, and no visual movement. Since there are no visual weights, other than the painting itself, there is nothing on which to base decisions about balance.

The principles of design are based on the fundamentals of vision—on how we see everything in our environment. (Recall the discussions on perception of color and shape, object size, figure and ground, and space in Chapters 4, 5, 6, and 7.) Although they may not be apparent in all artworks, they are in most, and provide a means of analyzing design. The principles of design also contribute to our understanding of how the parts of an art form work together.

Summary

The artist is always aware that a whole work of art is more important than any single part. Therefore, he or she must have a plan for organizing all of the elements that make up an art form. This plan, or design, can be analyzed in terms of certain principles: unity, variety, dominance, rbytbm and movement, and balance.

Unity is described as a sense of wholeness or oneness that is present when all parts of an art form work together. When you find your vision moving easily over the objects, shapes, and elements in a work of art, and your concern is for the total form rather than individual parts, the composition is unified. Although unity is dependent upon all of the design principles, it is especially enhanced by *proximity, similarity*, and *continuation*.

Too much unity can result in monotony. Therefore, the artist includes some *variety*, such as contrasts of colors, different shapes, and variations of lines or textures to create some degree of interest and excitement. Look for examples of unity with variety in your environment, such as the design of a building, a shopping mall, or a landscaped park.

10-15 Ad Reinhardt, Black Painting, 1960–1966. Oil on canvas, $60'' \times 60''$ (152 × 152 cm). The Pace Gallery, New York.

Sometimes an element or area of an artwork appears to be *dominant*—it attracts your immediate attention. Other parts of the composition may be emphasized in varying degrees, and these contrasts help to direct visual movement from an initial focal point to other parts of the artwork.

Rhythm and movement result from the organized recurrence of an element or elements in a work of art. Three methods of creating rhythm are repetition, alternation, and progression.

Balance is a feeling of equilibrium among all the parts of a composition. Balance in an artwork may be symmetrical, approximately symmetrical, asymmetrical, or radial.

The principles of design are discussed separately in this chapter for purposes of explanation, but they are very interdependent. Artists use them all, and in many different ways, to give their ideas expression through visual art forms. As you learn more about these principles, they will help you to analyze and appreciate a variety of art forms. You may also find them helpful in creating your own works of art.

Challenge 10-4:

Analyze an advertising artwork using the analysis guidelines from chapter 9, challenge 9-1, placing emphasis on the design principles.

Student work.

Part IV What Is It Made Of?

Chapter 11 Introduction To Media

Chapter 12 Two-Dimensional Media

Chapter 13 Three-Dimensional Media

Chapter 14 Careers in Art

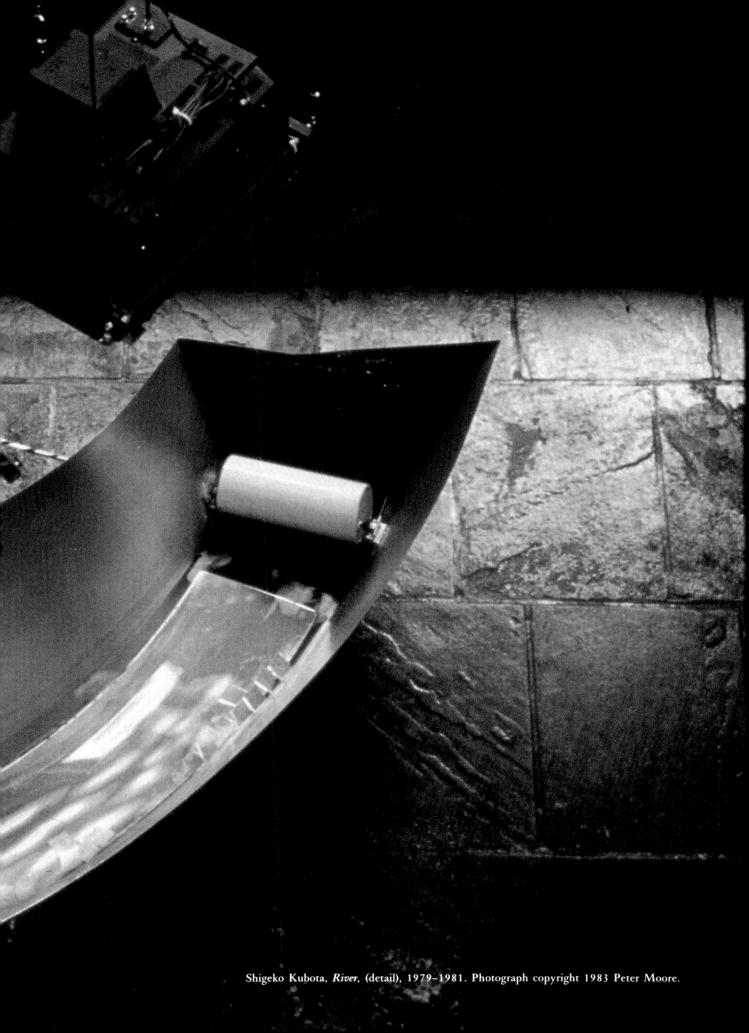

Chapter 11 Introduction To Media

The word *medium* (the singular form of media) has many meanings, two of which apply to art. Medium can refer to the material used for making an artwork, and sometimes to the characteristic way of using that material. It can also refer to the liquid ingredient of a paint, such as water, linseed oil, or egg yolk, in which pigment is suspended. For this discussion, we are interested in the first use of the term.

The following chapters will introduce you to a variety of two- and three-dimensional art forms, and the media associated with each of them. For example, painting is a two-dimensional art for which there are several media: oil, watercolor, acrylic, casein, gouache, and tempera. Media for sculpture, a three-dimensional art, include welded and cast metal, wood, stone, plaster, and plastic. As you will see, the various media are used to make different kinds of art, and for different expressive purposes.

Although the medium is the stuff from which an artwork is made, it is not always a material that does just what the artist wishes. You might think of the artist's work with the medium as a contest. He or she has a purpose that the medium sometimes resists until the artist understands its capacities—what can be done with the material and how far it can be taken in support of the artist's purpose. The procedures used to create a work of art are always affected by the medium. Sometimes it is necessary for the artist to adjust procedures to the medium or to modify the purpose of the artwork. Each medium has special capabilities and limitations, and the more an artist knows about them, the greater his or her mastery of the medium.

The artist's choice of medium and subject matter are interrelated. For example, carved stone would not be a very good medium for expressing the qualities of a landscape. Oil paint, on the other hand, is excellent for representing colors, tones, sky, clouds, hills, and trees—all of the objects and elements associated with landscapes.

Both the sculptor and the painter can do portraits in their particular medium, however. For example, Charles Peale portrayed George Washington in an oil painting as a victorious American Revolutionary War general (fig. 11-1), and Horatio Greenough used marble to produce a largerthan-life sculpture of Washington that looks like a Roman emperor seated on a throne (fig. 11-2).

11-2 Horatio Greenough, George Washington, 1832-1841. Marble, approx. 11'4" (347 cm) high. Courtesy National Collection of Fine Arts, Smithsonian Institution.

11-1 This portrait of George Washington expresses the American feeling of the nationalism and confidence that sustained the country during the Revolutionary War. Charles Wilson Peale, George Washington at the Battle of Princeton, 1780-1781. Oil on canvas. Yale University Art Gallery (Gift of the Associated in Fine Arts and Mrs. Henry B. Loomis, in memory of Henry Bradford Loomis, B.A. 1875).

There are obvious differences between the kinds of information included in the painted and sculpted portraits of Washington. The figure, cannon, and other objects in Peale's painting look three-dimensional, but the depth is an illusion on a flat surface. We derive information from a painting like this primarily through visual perception. An apparently confident General Washington, wearing a Continental Army uniform, leans against a cannon, with the American battle flag and his waiting horse just behind him, the banners of the defeated British troops (Hessian mercenaries) at his feet, while in the background, American soldiers take British prisoners away. The figures and objects, colors and textures are placed in an environmental setting, which contributes to the meaning of the artwork. Do you think the painting expresses the confidence of a general, or the confidence of a young republic capable of winning and defending its freedom?

In contrast to the painting, Greenough's sculpture of Washington has real depth and textures. You can not only see, but also feel the rounded three-dimensional forms and the different textures. Thus, the carved marble provides the viewer with both visual and tactile information. The viewer can move around the sculpture, thereby observing the figure from different angles for more information. Unlike the painting, the sculpture does not describe an environmental setting, but becomes part of the setting in which it is located. Greenough's sculpture was originally created for the Capitol rotunda in Washington, DC, but was removed from there when the American public objected to portraying a former president as a partially nude Roman emperor.

The medium is also the artist's means of expressing ideas. For example, Greenough designed and carved the marble sculpture to express his ideas about George Washington as a great, powerful, and heroic leader of our country. By comparison, the form that Alberto Giacometti gave the sculpture called *Man Pointing* (fig. 11-3) would not be practical for carving in marble, nor would stone be as effective for expressing his ideas about the human condition. Giacometti used bronze casting to produce this spindly, seven-foot-tall figure that does not appear heroic or powerful. Whereas Greenough's massive sculpture of Washington displaces space and suggests great strength, Man Pointing is so slender that the figure seems lost in space – perhaps even threatened by the surrounding emptiness. The bronze casting medium seems well suited to expressing ideas such as man's frailty.

More often than not, the artist has a form or idea in mind prior to selecting a medium. However, the form cannot be forced upon the medium like a mold. The artist learns through trial and error what the material can do, and uses that information to achieve his or her purpose. When analyzing a work of art, we look for good relationships among the medium, subject matter, and expression. Chapters 12 and 13 provide you with examples of artworks in many different media. The more that you learn about media through the study of examples and through your own work with art materials, the easier it will be for you to recognize the interaction between the medium and expression of ideas.

¹¹⁻³ Alberto Giacometti, Man Pointing, 1947. Bronze, 701/2" (179 cm) high, at base 12 " \times 13 1/4" (30 \times 34 cm). Collection, The Museum of Modern Art, New York. (Gift of Mrs. John D. Rockefeller, III).

Chapter 12

Two-Dimensional Media

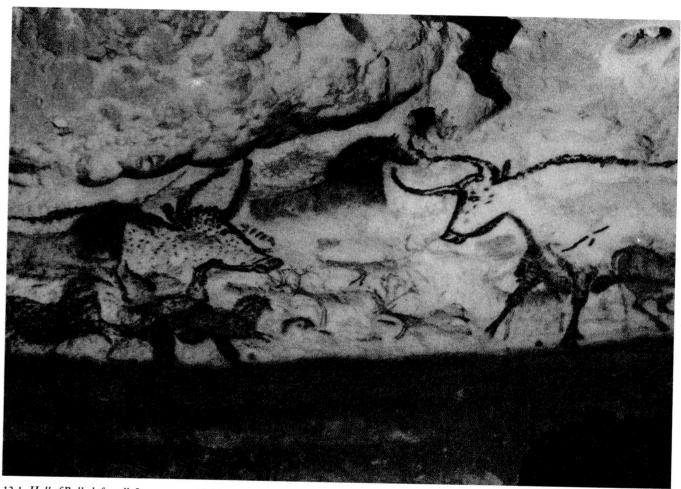

12-1 Hall of Bulls, left wall, Lascaux, ca. 15,000-13,000 B.C. Dordogne, France.

Chapter II suggested that working with a medium is like a contest—similar, say, to a game of tennis. Just as it helps to know something about your opponent when playing tennis, it helps to know the capacities and limitations of your medium when making a picture. Also, in order to appreciate an artwork, it helps to know what the medium is and something about it. This chapter describes various two-dimensional media: drawing, painting, mosaic, printmaking, photography and film, video arts, computer art, and mixed media.

Drawing

Monochromatic Drawing Media

Drawing consists of making marks on paper with a tool such as charcoal, pen and ink, pencil, crayon, or felt marker. You have been using some of these tools since you were a child. Moreover, some of these tools date back thousands of years. During the Ice Age (around 12,000 B.C.), hunter-artists used pieces of charcoal on cave walls

to outline shapes of animals (fig. 12-1); as early as 2500 B.C., Egyptian scribes used ink on sheets of papyrus (made from a plant that still grows along the Nile); in the 1400's, European artists began using pencils. However, just because some of these media can be used by children or have been around since the beginning of human culture, does not mean that drawing is necessarily easy. Sometimes drawing media require more skill than other kinds of media to produce good results. Usually, only two colors that of the tool and that of the paper - are available to the artist.

You learned about values and shading in Chapter 6. Different values can often be obtained in a drawing simply by changing the amount of pressure on the drawing tool. When rubbed hard, a stick of charcoal makes very dark tones; this is because the marks conceal the white of the paper. When the stick is rubbed lightly, it makes lighter tones; the marks allow tiny bits of white paper to show through and mix optically with the black grains of the charcoal. Observe how Käthe Kollwitz varied the pressure on the tool to create an image of herself holding a pencil (fig. 12-2). In some places, like the extended arm, the strokes are broad and dark; in others, like the face and head, they are quite delicate.

Variety like this also can be accomplished with a pencil (which contains a combination of clay and graphite rather than lead). When using a pencil, darkness can be controlled by pressure, but also by the proportion of graphite in the pencil. A hard pencil produces thin, light lines (fig. 12-3), and a soft pencil produces thicker, darker lines (fig. 12-4). (Pencils used in school are usually 2B-

12-3 Hard pencils, such as 2H, produce thin and light lines.

12-4 Soft pencils, such as 3B, produce thick and dark lines.

12-5 Notice how the thicker lines create darker values than the thin lines. Felix Klee, Fritzi, 1919. Pencil, 7 1/8 " × 10 1/8" (19 × 27 cm). Collection, The Museum of Modern Art, New York (Gift of Mrs. Donald B. Straus).

medium soft.) With just a few pencil strokes, Felix Klee, Paul's son, captured the quality of a sleeping kitten (fig. 12-5). Did he press harder in some places than others, use more than one type of pencil, or both?

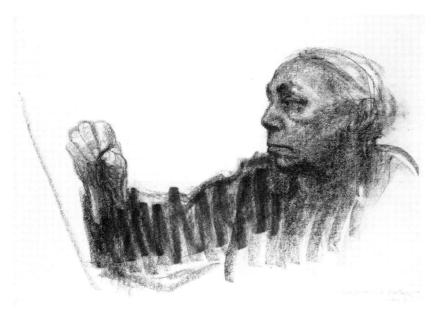

12-2 Käthe Kollwitz, Self-Portrait with a Pencil, 1933. Charcoal, 183/4" × 241/8" (48 × 63 cm). The National Gallery of Art, Washington, DC, Rosenwald Collection.

12-6 The different values apparent in this pen and ink drawing were obtained by various hatching techniques. Bone, *Demolition of St. James Hall*.

Suggestion:

If you have access to pencils with different grades, like 2H (medium hard), 5H (very hard), and 5B (very soft), discover the different kinds of lines they make.

Different values can also be obtained from India ink. Ink taken directly from the bottle is opaque, that is, not transparent. When applied to paper, it completely masks the color of the paper. Using pen and ink, the artist brought out the solidity of the rocks and architectural features in Demolition of St. James Hall (fig. 12-6) through chiaroscuro. In this case, the different values were obtained by hatching (Chapter 4). Notice how bold the strokes are and how they go in different directions. Japanese artist Shin'cihi used ink in a different way to create shaded effects. The forms in Hisamatsu (fig. 12-7) are given depth by means of ink washes – films of water-thinned ink spread with a brush. An ink wash is semitransparent, or translucent. It allows the white of the paper to show through and produce gray. Shin'cihi controlled values by controlling the amount of the water in the mixture, and by overlapping some of the washes. Notice how the thinnest washes were used to represent the lighter parts of the scene (where the sun shines in the morning mist), and how the white of the paper itself represents the lightest part of all.

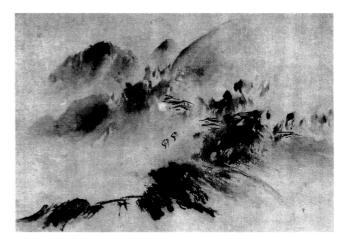

12-7 Shin'cihi, Hisamatsu, 1971.

Colored Chalk or Pastel

Colored chalks lie somewhere between drawing and painting media. Like charcoal sticks or pencils, sticks of colored chalk—made of precipitated chalk, pigment, and powdered gum—can be applied directly to paper. But unlike most drawing media, colored chalks are multicolored. Hunter-artists may have used a rudimentary form of colored chalk—sticks of clay mixed with iron oxide, a pigment that produces brownish reds and yellows—in addition to charcoal. *Pastels*, a high-quality form of chalk with a wide range of hues, were introduced in the 1700's. At that time they were especially popular with portrait painters. Although pastels allow the artist to use a variety of colors without the annoyance of mixing paints or preparing can

Challenge 12-1:

Use black and white and one or two colors of chalk to produce descriptive contrasts of dark and light in a drawing of a jacket.

Student work.

vas, they are quite fragile. Unless sprayed with fixative shellac mixed with alcohol - or framed under glass, the surface of a picture made with chalk or pastel is easily smeared or dusted away.

Painting

Mention the word art, and most people think of painting. Painting comes in many varieties, but all of them have three things in common: colored powders called *pigments*, a liquid called the vehicle, in which the pigments are mixed, and a surface (such as a wall, board, paper, or canvas) called the *support*, to which the mixture is applied.

Watercolor

Watercolors consist of pigments mixed with water, and are applied with a brush to white paper. (Modern pigments are usually bound in gum arabic, a product of acacia trees. Watercolors are sold in tubes, used mostly by professionals, and in little cakes, used mostly by students.) Like ink, watercolors have been around for centuries, although they generally were used only to add a little color to drawings. It was not until the early 1800's, when their potentials were discovered and developed by English watercolorists, that watercolors came into their own. Since then, this medium has been very popular, especially for colorful, lively outdoor scenes.

The methods of working with watercolors are similar to those used for ink washes. In developing a composition, watercolorist Dong Kingman works in stages. He first lays in the lighter washes, then adds and overlaps more light washes. Finally, he applies darker washes, bright colors, and opaque strokes (figures 12-8, 12-9, 12-10). Among other procedures, Kingman also premoistens the paper, stretches it, and blocks out the whites (sometimes with rubber cement, which is later removed). Despite his years of experience, Kingman plans carefully before touching brush to paper. But in the end, Kingman's pictures, like all good watercolors, are fresh and spontaneous looking catching the spirit of the subject with an ease that comes from long practice.

12-8 The first stages of a watercolor painting by Dong Kingman. Chinatown, San Francisco. Watercolor, $18'' \times 22''$ (46×56 cm). Collection of Rocky Aoki.

12-9 Second stage.

12-10 Finished watercolor painting.

Challenge 12-2:

Produce watercolor washes that are flat, graded and mixed, and opaque lines that will cover washes.

a. Flat washes.

b. Graded washes

c. Mixed washes.

d. Opaque lines over washes.

Tempera

The medium of tempera consists of pigments mixed with an emulsion applied to paper, wood, or canvas. (An emulsion is a watery liquid with droplets of oil suspended in it.) Egg yolk, a natural emulsion, has been the traditional emulsion used in tempera, although today many different emulsions – based on such substances as casein (a milk product), gum arabic, and wax – are used. Unlike watercolors, which are thin and relatively transparent, tempera is creamy and opaque. To make an area white, the artist uses white paint, not the paper. To lighten a color, the artist adds white paint, not water. Water is used as a thinner only to make the paint flow better. It is also used as a solvent to clean brushes (or to remove wet paint from clothes).

Tempera was used by the Greeks and Romans, but reached its peak during the late Middle Ages (between 1100 and 1500) as the favorite medium for paintings on wooden panels, like *The Adoration of the Magi* (fig. 12–11) by Gentile da Fabriano. Much of the greeting-card charm of this painting is due to the fact that tempera dries quickly with a soft matte finish and lends itself to fine detail. Because it is opaque, tempera allows the artist to overpaint previously painted areas, and thus to continually improve effects of shading or texture (a method that does not work very well with watercolors). Note the delicate colors in Adoration, in many places embellished with gold foil. Note also the detail of the many figures and animals, especially the decoration of the Magi's crowns and splendid costumes. The advantages of tempera for some kinds of painting, however, are disadvantages for other kinds. Rapid drying prevents the easy blending of colors. The tendency for delicate effects is not always suitable for lively, spontaneous-looking effects. Furthermore, tempera colors tend to change while drying, making it difficult to predict the final results. Tempera gave way to oil in the 1400's and 1500's as the most popular medium, but some artists, notably Andrew Wyeth, use it to this day. When painting subjects like Braids (fig. 12-12), Wyeth finds the characteristics of tempera to be ideal for his purposes.

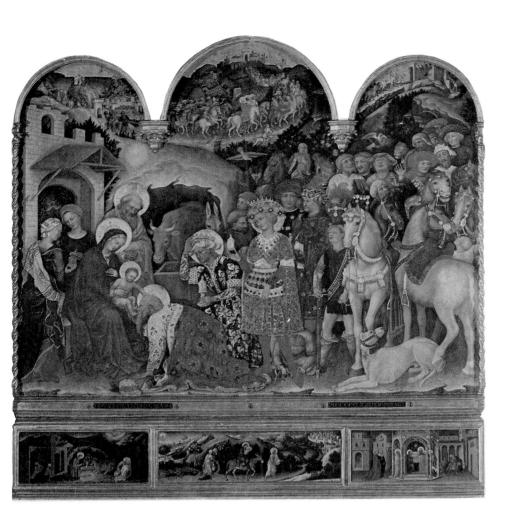

12-11 Gentile da Fabriano, The Adoration of the Magi, 1423. Tempera on wood panel, approx. 9'11" × 9'3" (302 × 282 cm). Galleria degli Uffizi, Florence.

12-12 Andrew Wyeth, *Braids*. Tempera. Copyright 1986 Leonard E.B. Andrews.

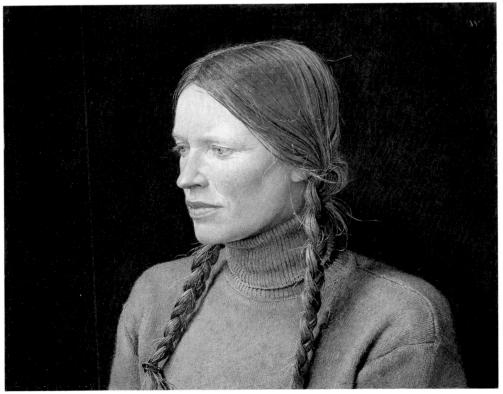

Challenge 12-3:

Create a tempera painting based on a theme from an artwork that interests you.

b. Student work.

12-13 Emilio Cruz, Past Pastures, 1983. Oil on canvas, 72 $^{\prime\prime}$ \times 48 $^{\prime\prime}$ $(183 \times 122 \text{ cm})$. Collection of the artist. Photograph: John Majjiotto.

Oil

Oil is the star attraction - not just of paint, but of all media. It is made up of pigments mixed with linseed oil, and turpentine is the thinner or solvent. The popularity of oil dates back to the 1400's. It was first used for colored glazes - thin films of transparent varnish - brushed over tempera paintings to give them more luster. Somewhat later, at about the time of Leonardo da Vinci, artists did away with the tempera underpainting and began using oil paint from start to finish. Later still, in the middle of the 1500's, canvas replaced wood as the principal type of support. To this day, oil on canvas is perhaps the most popular medium of all.

Oil is much more flexible than tempera. It can be opaque or translucent, as thick as plaster or as thin as watercolor. Most importantly, it dries slowly, thereby allowing an artist more freedom to blend colors and create a great variety of effects. You have seen some of that variety reproduced in the pages of this book. Recall, for example, the differences between the dry brushwork of Hopper's House by the Railroad (fig. 5-33) and the fluid brushwork of Bellows's Stag at Sharkey's (fig. 8-14).

For more examples of oil paint's variety, compare and contrast the styles of Rembrandt (fig. 5-32), the unknown painter of Mademoiselle Charlotte du Val d'Ognes (fig. 6-9), Renoir (fig. 3-1), and Mondrian (fig. 7-10). The works of contemporary painter Emilio Cruz are especially representative of the medium. The word exuberance (full of life and high spirits) is often used to refer to paintings like Emilio Cruz's Past Pastures (fig. 12-13). Exuberance is obviously expressed in the subject matter, especially in the terrifying head. But it is also expressed in the rich creamy paint, the irridescent colors, and the way in which Cruz transforms paint into explosive energy.

Canvas, the most common support for oil paintings, has distinct advantages for the artist. For one thing, it is very light. A $7' \times 6'$ oil painting can be carried by one person. If thoroughly dry, a painting can even be removed from its thin wooden frame (stretchers), rolled, and shipped in a mailing tube. The same size painting on wood would be heavy and very awkward to handle or ship. It may surprise you to know, however, that oil rots fabric, including canvas fabric. To prevent canvases from rotting, artists have had to coat them with a layer or two of a special glue (made from rabbit hides) or gesso (a plasterlike substance) before applying paints. Today synthetic products are available for preparing canvases.

12-14 Helen Frankenthaler, Canal, 1963. Acrylic on canvas, 81" × 57½" (205.7 × 146 cm). Solomon R. Guggenheim Museum, New York (Purchased with the aid of funds from the National Endowment for the Arts in Washington, D.C., a Federal Agency; Matching gift, Evelyn Sharp). Photograph: David Heald.

Acrylic

Acrylic is a synthetic medium that came into use after World War II. It consists of pigments mixed with polymer - a thick, milky, water-soluble liquid that can be applied to any support, including canvas. Acrylic can be made to imitate any of the effects of the paint media discussed, so it is the most versatile medium we've covered so far. When thinned with water, it acts like watercolors. When its colors are extended with liquid polymer, they can be used as glazes. Special materials, "modeling paste" or "gel medium," can be added to acrylic to make it thicker than oils. Normally fast drying, it can be made to dry slowly by the addition of "retarders." Because acrylic is water-soluble, tools and brushes can be cleaned in water rather than turpentine. Most importantly, it can be applied directly to canvas without rotting it. Helen Frankenthaler has taken advantage of this capability by pouring water-thinned acrylics onto raw canvas, a new approach to painting known as stained canvas. The results of colors spreading, mixing, and sinking into the canvas are visible in Canal (fig. 12-14). Sometimes the canvas is warped or tilted in different directions during the process.

12-15 Diego Rivera, Detroit Industry, 1932-1933. Fresco, mural. The Detroit Institute of Arts (Founders Society Purchase, Edsel B. Ford Fund and Gift of Edsel B. Ford).

Fresco

If acrylic is the newest paint medium, fresco is one of the oldest. Varieties of fresco have been employed by various peoples since the Egyptians to make *murals* (pictures on walls). True fresco painting consists of mixing pigments in water, spreading an area of wet plaster onto a wall or ceiling, and applying the colors to the plaster before it dries. (As opposed to true fresco, many cultures used *secco* methods—painting on a wall or ceiling after the plaster had dried.) The first people to use true fresco were probably the Minoans, a seafaring culture that flourished on the island of Crete around 1500 B.C. The most famous examples of fresco were made by Italian artists from the early 1300's to the mid-1500's.

As you know, plaster dries quickly. Therefore the artist must plan ahead, and not spread an area larger than he or she is capable of completing within a few hours. A large mural, such as Diego Rivera's *Detroit Industry* (fig. 12–15), had to be painted in sections. To avoid leaving a water mark, Rivera probably planned each section to end at the

12-16 Diego Rivera, *Detroit Industry* (detail), 1932–1933. Fresco, mural. The Detroit Institute of Arts (Founders Society Purchase, Edsel B. Ford Fund and Gift of Edsel B. Ford).

edge of, rather than in the middle of, a figure or object. This would have meant, perhaps, doing only a few of the laborers or one machine at a time in Detroit Industry (fig. 12-16). Because of the difficulties of working with the fresco method, the artist cannot easily make in-process changes or add fussy details. Perhaps this is why Rivera made the forms in his mural so bold.

Unlike oil or acrylic, fresco is not flexible and versatile. But it has at least two advantages: durability and permanence. Because it is in the plaster (and not a film of paint on the plaster), it can better withstand the effects of air pollution, as well as wear and tear in general. A fresco is part of a wall or ceiling, and will survive as long as the building that contains that wall or ceiling.

Mosaic

A mosaic is a design or picture composed of numerous pieces of stone or glass - called tesserae - set in cement, and typically used to decorate a wall, ceiling, or floor. An artist must piece together thousands of individual bits of tessarae to complete a mosaic. In some ways more like a crossword puzzle than a drawing or painting, a mosaic is unique among two-dimensional media, although it has been called "painting in stone." To the extent that mosaic is colorful, durable, and part of a wall or ceiling, it is similar to fresco.

Mosaics have not been very popular since the 1300's, but they were once more popular than frescos, especially among the Romans and Early Christians. The Romans, who embedded mosaic designs in floors and walls, used tesserae made of stone cubes. The Early Christians, who covered the walls and ceilings of their churches with mosaics, used pieces of glass. Because glass reflects, and because tesserae do not lie on a uniformly flat plane, they reflect in all directions. Imagine the glittering effect of the inside of a church filled with mosaics like Emperor Justinian and Attendants (fig. 12-17). Note the simplicity of both the composition and the individual figures. Even more than fresco, the medium of mosaic forces the artist to think in terms of large bold images. But the severity of the design is tempered by the sparkle of its surface.

Printmaking

Like drawings, prints are produced on paper, but with an important difference. A print can be reproduced several times. Although there are different techniques of printmaking, the major ones involve the use of ink, paper, and a plate - a surface, such as a piece of wood or copper, on which to make the picture or design. To produce a print, a piece of paper is pressed against an inked plate. This process can be repeated many times to make many prints of one image.

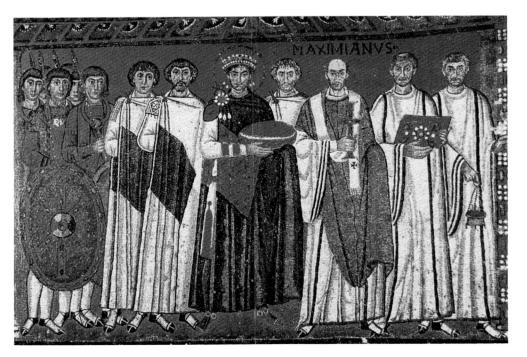

12-17 Emperor Justinian and Attendants, 547 A.D. Apse Mosaic from San Vitale.

Relief Prints

A relief print is so called because the image on the plate is in *relief*, that is, it projects or sticks up from the surface of the plate (fig. 12–18). The *woodcut* was developed in the 1300's as the least expensive way to produce large quantities of religious pictures, and it remains the most common kind of relief printing. (Other materials, such as linoleum, are also used.) The artist draws on a block of wood, then cuts away the areas that are to remain white, leaving the parts that are to print raised from the background. Black ink is rolled across the plate and clings to those parts that are in relief. When paper is pressed against the plate, the black ink is transferred to the paper, making the finished print. To appreciate the skill of Albrecht Dürer, a sixteenth-century German artist, study his *The Riders on the Four Horses from the Apocalypse* (fig. 12–19). Every black

12-18 A cross section of a relief plate.

12-19 Albrecht Dürer, *The Riders on the Four Horses from the Apocalypse*, ca. 1496. Woodcut, 15¹/₄" × 11" (39 × 28 cm). Metropolitan Museum of Art, New York (Gift of Junius S. Morgan, 1919).

12-20 Elizabeth Catlett, *The Survivor*, 1983. Linocut, $11~"\times10~"$ (28 × 26 cm). Courtesy Malcolm Brown Gallery, Cleveland, Ohio.

line—whether describing a shape or detail, or a part of a system of hatching—is exact. Consider that Dürer had to cut *around* each of these lines when carving the wooden block. It is hard to believe that this complex image is in fact a woodcut. Although also skilled in the medium, Elizabeth Catlett approaches it differently. In her *The Survivor* (fig. 12–20), the marks of the cutting tool are much more evident. Like many other twentieth-century artists, Catlett believes that the essential qualities of a medium should be visible, even celebrated, in every work of art.

Suggestion:

Which approach to the medium do you favor: Dürer's or Catlett's? People who like traditional art often appreciate virtuosity, that is, great skill such as that exemplified in Dürer's print. People who like modern art often downplay virtuosity, and appreciate works that bring out the qualities of the medium, even if these qualities make the work appear somewhat primitive. Are you a traditionalist or a modernist? Perhaps you appreciate both approaches, realizing that different standards must be applied to each. In any case, explain your position.

Elizabeth Catlett

African American painter and sculptor Elizabeth Catlett has focused her life and her art on civil rights. "I have always wanted my art to service Black people—to reflect us, to relate to us, to stimulate us, to make us aware of our potential." (Samella S. Lewis, *Art: African American*. New York: Harcourt Brace Jovanovich, 1978, p. 125).

Catlett's first experience with discrimination occurred when she was rejected from an art college which had never before accepted a black student. Bitter but determined, she entered Howard University, a predominantly black school, and pursued her studies with several famous black art professors.

In 1938, following in her father's footsteps, Catlett became an art teacher. Her first job in North Carolina paid only \$59 each month, half the salary paid to white teachers. Recognizing the injustice in this system, Catlett participated in an organized campaign to equalize wages for both black and white teachers.

From this art teaching position, Catlett went on to receive a masters degree in sculpture, to direct the art department at a university in New Orleans, and to teach at two schools in New York. Her dedication to the civil rights movement continued, reflecting itself in her politically active life and her emotionally vibrant artwork. During her first visit to Mexico in 1946 at the age of 27, Catlett decided to stay in this country to work on her lineoleum prints with other printmakers; she remained there to marry, raise three children, and to pursue her career as an artist. She became a naturalized citizen of Mexico in 1962.

Elizabeth Catlett's devotion to black people and to the citizens of Mexico remains an important aspect of her work today. This dedication is apparent in the intensity of the characters in her prints and sculptures—strong-willed, determined and proud, these figures, like the artist who created them, illustrate the powerful impact of a life dedicated to art.

Challenge 12-4:

Produce a three-color print using the linoleum reduction block procedure.

Student work.

Intaglio Prints

Intaglio (Italian for "to cut in"), a printing medium that began to replace the woodcut in Dürer's time, is the opposite of relief printing. Rather than being above the surface, an intaglio image is below it (fig. 12–21). Therefore the artist cuts the lines that are to print rather than leaving them project. An intaglio plate is metal, usually a sheet of copper or zinc (although sheet plastic is sometimes used).

12-21 A cross section of an intaglio plate.

Three kinds of intaglio are *engraving*, *etching*, and *aquatint*. To do engraving, the artist cuts lines into the plate using a special gouge. To do etching, the artist covers the plate with a layer of wax, called a *ground*, and draws into the layer with a needle. When the plate is placed in acid, the exposed lines are eaten by the acid. To do aquatint, the artist bonds particles of resin to the plate, then blocks out those areas that are not to be eaten by the acid with a coat of shellac. When placed in acid, only the very small spaces (interstices) between the resin particles are eaten.

The technique of inking the plate and "pulling" a print are the same for all three intaglio methods. Black ink is rubbed into the etched lines or areas. Images are transferred from these inked areas to a piece of paper under extreme pressure by means of an intaglio press. Engraved lines look hard and brittle; etched lines appear softer; aquatint produces gritty-textured areas of gray. To make Todd (fig. 12-22) Xiaowen Chen used etching and aquatint. Some of the thinner, lighter lines on Todd's desk have been etched once or twice. The darker lines are the result of repeating the process of drawing and "biting" the lines with acid several times. The gray areas on this side of the desk are the result of aquatint. The dark shadows around Todd and especially behind his left shoulder, are the result of a combination of aquatint and densely hatched etched lines. Chen's print demonstrates the medium's rich possibilities for both tonal and textural variety.

Planographic Prints

In planographic printing, the image is neither above nor below, but *on* the surface of the plate (12–23). *Lithography*, one of the most widely used of all printmaking methods, is based on the principle of oil repelling water and vice versa. In traditional lithography, the artist draws on the flat surface of a block of limestone with a grease crayon. Then the surface is dampened with water. Of course, the grease lines

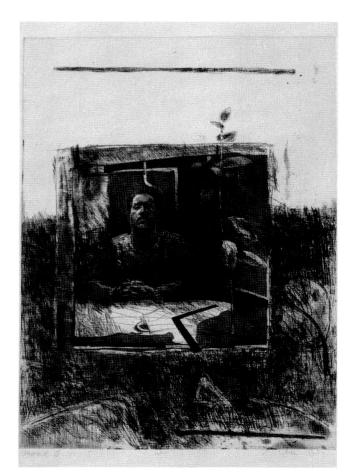

12-22 Xiaowen Chen, Todd. Etching and aquatint.

resist the water. When the artist rolls oily ink onto the plate, the ink is resisted by the water on the limestone, but received by the crayon lines that are eventually transferred to the paper. Because the final print reflects the marks of the crayon, a lithograph tends to resemble a drawing made with crayon or charcoal. The brisk strokes in Kollwitz's *Death Seizing a Woman* (fig. 12–24), a lithograph, seem as spontaneous and direct as those in her self-portrait (fig. 12–2) done in charcoal. In modern lithography, the artist may use liquids instead of crayon, and zinc or aluminum plates instead of stone.

12-23 A cross section of a planographic plate.

Silk screen, the newest of the printmaking media, is essentially a stencil method. The artist may draw a design with tusche (a liquid litho ink) on the screen, a piece of polyester or nylon fabric stretched tightly over a frame (fig. 12-25). The screen is coated with glue that does not adhere to the tusche. Then the tusche is dissolved, leaving that part of the screen open. Instead of painting with tusche, an artist may use crayon or a stencil to block parts of the screen. A stencil may be cut from paper or from a special screen film which is adhered to the screen. When ink is forced through the screen onto paper (fig. 12–26), only the open areas that were cut in the stencil will print. Because silk-screening does not require heavy plates or presses, it is especially popular today.

12-25 Silk screen.

12-26 Pulling a squeegee across the silk screen.

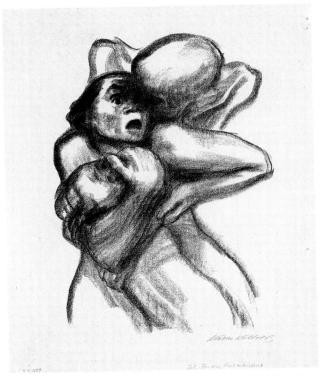

12-24 Käthe Kollwitz, Death Seizing a Woman, 1934, Plate IV from the series Death, 1934–1936. Lithograph, 20 $^{\prime\prime}$ × 14 $^{\prime\prime}$ (51 × 36 cm). Collection, The Museum of Modern Art, New York (Purchase Fund).

Challenge 12-5:

Design a paper stencil for a one-color silk screen that expresses an idea or theme with line and shape.

Student work.

Photography and Film

Photography

Photography, which was invented in the nineteenth century, has become the folk medium (the art of the common people) of modern Americans. Probably you and your friends have all used cameras at some time. Many schoolaged people own cameras, although you and your friends probably know relatively little about the technology of producing good photographs.

Like printmaking, photography is capable of producing identical copies. The finished product is even called a print. But photographers, unlike printmakers, do not make their images entirely by hand. Instead, they select scenes from life, and capture the light reflected from those scenes on light-sensitive film with a camera. A camera is simply a dark box with a lens that lets in light when the photographer trips its shutter (which opens and closes rapidly). To make the image of the scene visible, the film must be developed - a process that involves immersing it in

special chemicals. At this stage the film has become a *negative*, that is, a semitransparent image of the scene wherein the lights and darks are reversed. In a black-and-white film negative, the whites are opaque, light grays are barely translucent, dark grays are semitransparent, and blacks are clear (fig. 12–27). In a sense, the negative is to a photographer what the plate is to a printmaker. To make a print of the image, the photographer passes light through the film negative onto light-sensitized paper, which is then developed. This becomes the print, the final product, a positive image of the original scene (fig. 12–28).

12-27 Black and white film negative.

12-28 The positive image print.

So far, we have touched on the basics. There are additional variables in the process that the photographer can control or manipulate. Some of these involve the subject: lighting, time of day, point of view, and distance. Some involve the equipment: film speed (its relative sensitivity to light), width of lens opening, focus, shutter speed, and flash. (Available light is all important; if, for example, the subject is very dark and flash is unavailable, the photographer would need to use fast film, a wide lens opening, and a slow shutter speed.) Some variables involve darkroom procedures: time and temperature of chemical bath, length of exposure of contact paper, and others.

A most interesting variable is the *focal length* of the lens – the distance between the lens and the plane of the film in the back of the camera. The longer the focal length, the larger the subject appears to be and the more it fills the frame, even though the distance between camera and subject has not changed (fig. 12–29). Lenses with short focal lengths (sometimes called *wide-angle* lenses) are good for indoor scenes or situations where distance is limited (fig. 12–30). Lenses with long focal lengths (*telephoto* lenses) are

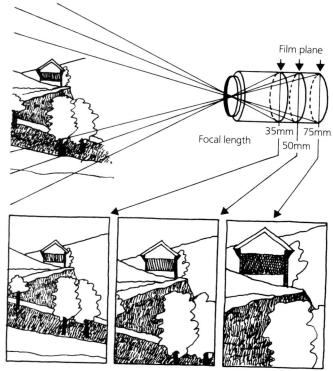

12-29 Focal length.

12-30 Wide-angle lens. Photographs by Barbara Caldwell.

12-31 Telephoto lens.

12-32 Ansel Adams, Half Dome, Merced River, Winter Yosemite Valley, 1971. Silverprint, 15" × 19" (38 × 49 cm). The Detroit Institute of the Arts.

good for enlarging subjects that are too distant to see well (fig. 12-31). Expensive cameras come with interchangeable lenses. Some lenses have fixed focal lengths; some have changeable focal lengths (zoom lenses).

Consider the decisions that Ansel Adams made when he photographed Half Dome, Merced River, Winter Yosemite Valley (fig. 12-32). Did he journey some distance to locate the subject? Did he search for the spot from which to shoot it? Did he try different lenses to compose the scene within the frame? Did he wait long for the light and the cloud formations to appear before shooting? Did he take a number of shots? Could you have achieved the same results with this subject with your camera?

Suggestion:

Look for interesting photographs in magazines like National Geographic, Smithsonian, Life, and Sports Illustrated. Identify those with interesting points of view: low eye level, high eye level, close-up, and so forth. Also identify those that used wide-angle lenses or telephoto lenses. Are you able to tell which is which?

Film

People have always been fascinasted with the illusion of motion. Years ago, viewers were beguiled by the "peep show" (fig. 12–33), a machine that riffled a series of photographs before the viewer's eyes at the turn of a crank. Each photograph showed a slightly different action and, as it passed before the viewer, stopped for a tiny fraction of a second. If the crank were turned rapidly, this stop-and-go movement was relatively invisible, and the illusion of motion was strong. If the crank were turned too slowly, the individual pictures began to separate, and the illusion of motion disappeared. Today's movie projector is based on the same principle of still pictures moving in rapid succession—except, of course, the pictures are printed on a long strip of film and projected on a screen for many to see.

The film camera, like a still-photography camera, is an enclosed box (fig. 12–34). Attached to it are the film *magazines*, large enclosed reels that contain the unexposed and exposed film. By means of sprockets that engage the holes on the side of the film, the film is fed through the camera in a rapid stop-and-go motion that is identical to that of the movie projector. A single frame of film is pulled into position behind the shutter, the film stops, the shutter opens, and a single image is exposed. This is repeated twenty-four times a second—the standard rate of speed for sound film.

Virtually all the variables of still photography apply to film (except shutter speed, which is constant). But in addition to lighting and the placement of people and objects within a frame, the filmmaker must also consider the movement of people and objects, and the movement of the frame itself. Recall the principles of the shot and the sequence in Chapter 8.

Editing, one of the most creative parts of filmmaking, consists of cutting and splicing segments of film to compose the final product. The one-minute battle sequence in *Star Wars* described in Chapter 8 may have been edited from several minutes of film. When first developed, the shots of rebel troops were much longer than one second each, and probably not in the same order as they appeared in the final sequence. To identify segments and rearrange their sequence, the editor uses a *moviola* (fig. 12–35)—a machine that runs the film at various speeds. Imagine the amount of film *not* used in the final product.

Some films, often referred to as *art* films, are shot and edited by a single person. Commercial films like *Star Wars* are the creation of a *director* who supervises an army of people: writers, artists, musicians, carpenters, camera

operators, sound technicians, editors, stunt men and women, not to mention actors and actresses. Think of it. All of these people are involved in the making of an *illusion*.

12-33 The mutoscope.

12-34 The 35 mm Mitchell NC.

12-35 The moviola.

12-36 Shigeko Kubota, River, 1979-1981. Photograph copyright 1983 Peter Moore.

Video Art

Video refers to the picture portion of television. Like photography and film, video transforms light into twodimensional images – but in this case, by electronic means rather than by chemical means. Instead of a black box with a lens and light-sensitive film in the back, a video camera is a tube with a lens and a photosensitive electronic plate in the back. The image on the plate is converted to electric signals by a scanner that reads the image from left to right and line by line from top to bottom in one-thirtieth of a second. The signals are transmitted through the air or carried by cable to a television receiver - basically, a tube with a screen in the front. There, the signals are converted back to the original image by a "gun" that fires them at the screen in parallel lines exactly the same as those read by the scanner. Television signals can also be stored on magnetic tape that can be played back at any time.

Because of recent breakthroughs in technology, many artists who used film are now turning to video. The older video cameras and recording equipment, which had been too large, too awkward, and far too expensive for individuals, have been replaced by camcorders - hand-held units that combine the functions of camera and recorder. Camcorders are not only small, easy to operate, and relatively

inexpensive, they produce high-quality images. Thus for the individual artist, video has distinct advantages over film: tape is cheaper than film, and the artist can play it back immediately on a camcorder instead of waiting for a film to be processed in a laboratory, threaded through a projector, and viewed in a darkened room.

Films will no doubt continue to be made by large companies for people to see in theatres. Video, which promises to become the preferred medium of artists, is usually seen in galleries or on public television. Nam June Paik, one of the pioneers of video art, began making works for galleries and public television as early as the late 1950's, long before camcorders hit the market. He manipulated images electronically to create moving geometric patterns - what some have jokingly referred to as "moving wallpaper." He also incorporated television sets into novel sculptures, a type of mixed media art (discussed later in this chapter). A good example of the latter is *River* (fig. 12–36) by Paik's wife, Shigeko Kubota. River consists of three television sets suspended from the ceiling reflecting their images in a stainless steel trough containing water and a motorized wave machine. Gallery-goers can see the images on the sets, the reflections of the images in the moving water, or the reflections of their reflections bouncing up into space. Critic Brooks Adams compares Kubota's River to "a fountain, an indoor garden, a reflecting pool."

Computer Art

Like video, computer art is electronic. The technology for computer art is developing even more rapidly than that for video art. Presently, two-dimensional images in color can be produced with personal computers - small systems that individual artists can afford. But sophisticated threedimensional images and animated art can be produced only by artists with access to large systems that only government, industries, and universities can afford.

The basic hardware for two-dimensional imagemaking is a computer, a video monitor, a digitizing tablet, and a light pen (see below). The "brain" of the computer, the central processing unit (CPU), basically is a board with electrical circuits and transistors. The smallest unit of information for the CPU is a bit, or binary digit. Binary refers to two numbers: 1 and 0. Think of a bit as an electrical switch: 1 is on, 0 is off. A string of binary numbers that is, a pattern of on-off switches - constitutes a pixel. A

pixel can be translated into a dot in a specific location on the video screen. Of course dots can be extended into lines, and lines can form images.

Most computer operators feed information into a computer by means of a keyboard device like a typewriter or desk calculator. But an artist-operator draws his or her lines with a light pen on a digitizing tablet (fig. 12-37). If the

12-37 Artists working with computers can access thousands of colors in a split second. Courtesy Invision.

12-39 Hiromi Ono, City Faces, 1987. Courtesy SIGGRAPH'88.

12-38 David Hockney, Untitled, from Painting with Light Series. The artist spent eight hours straight on a sophisticated computer to create such images. Courtesy Invision.

computer and video monitor have color capability, the artist can make lines in color. British painter David Hockney was invited to use this technology not long after this system of "electronic painting" had been developed. His Untitled (fig. 12-38) is the delightful result.

State-of-the-art computer imagery is produced by expensive equipment capable of processing enormous amounts of information. To create convincing threedimensional pictures - that is, to create the effects of foreshortening, perspective, aerial perspective, chiaroscuro, texture, cast shadows, and reflections - requires special programs (sets of instructions for a computer to perform). And each of these programs, usually written by engineers or mathematicians, contains long columns of mathematical calculations. For animation - the illusion of objects rotating and moving through space - even more sophisticated programs are required. You have probably seen computer-generated animation, such as threedimensional images of company trademarks rotating and zooming through space, in television commercials. Such

an animation, even if it lasted only ten seconds, would require the efforts of a team of designers and engineers working with a powerful computer. Hiromi Ono is a computer artist, who uses computer graphics programs to create original art. Ono works with digitized video images to product a ghostly interpretation of the urban landscape in City Faces (fig. 12-39).

Suggestion:

Look for examples of computer-generated art on television and take notes on both their three-dimensional and animated effects. Create a design of your own for computer art or a commercial. How would you animate your own initials in space? Create a storyboard to describe the process.

12-40 Many times, artists combine several media to arrive at a single image. Betye Saar, Wizard, 1972. Assemblage box and mixed media, $13\frac{1}{2}$ " × 11" × 1" ($34 \times 28 \times 2.5$ cm). Collection of the artist.

12-41 One specific category of mixed media is collage. Pablo Picasso was one of the first artists to make collage a popular medium in which to work. Pablo Picasso, Still Life with Chair Caning, 1911. Oil and pasted oilcloth simulating chair caning, oval 10 1/8 " x 13 1/4" (27 x 35 cm). Courtesy The Musée Picasso, France. Photograph copyright Réunion des Musées Nationaux.

Mixed Media

So far, we have seen everything from mosaics to computer art in this chapter. Because of the development of new media like acrylics, silk screen, photography, film, video, and computer art, the list of two-dimensional art has grown since the nineteenth century. No doubt it will continue to grow in the twenty-first century. What makes the discussion of media in our day especially complicated is the fact that many artists no longer adopt the pure approach of keeping the media separate. Some do not hesitate to mix two or more together, or to add "foreign" materials. Recall, for example, the stuffed goat attached to a painting in Chapter 1 (fig. 1-11). The artist of that work, Robert Rauschenberg, has made a career out of what he calls "combine paintings," which often are not paintings at all. Not to be outdone by Rauschenberg, Betye Saar combines assorted fabrics, brass hardware, jewelry, knickknacks, and pictorial elements in Wizard (fig. 12-40). Like Rauschenberg's goat, Saar's mixed media work eludes easy interpretation. Because it tends to mix two-dimensional and three-dimensional approaches, Saar's work is also difficult to classify.

Collage

Collage is a specific kind of mixed media combination in the two-dimensional realm. A collage consists of fragments of things - photographs, colored paper, pieces of material, news clippings, and other odds and ends - pasted to a flat surface. In addition, strokes of paint, charcoal smears, or anything, as long as it is basically flat, may be combined with the collage materials. Invented around 1912 by Pablo Picasso and Georges Braque, collages have become very popular in recent years. One of the early collages, Still Life with Chair Caning (fig. 12-41) by Picasso, combines a piece of oilcloth (simulating the woven material of a chair seat) with painting. What was Picasso trying to express? Probably nothing. More likely he simply wanted to experiment, to pioneer a new kind of

12-42 What do the materials used in this collage seem to be suggesting? Yvonne Parks Catchings, The Detroit Riot, 1967. Collage, 28" × 36" $(66 \times 91 \text{ cm})$. Collection of the artist.

medium that others could use for expressive purposes. A half century after Picasso's experiment, Yvonne Parks Catchings expressed the pain of social crisis in a collage titled *The Detroit Riot* (fig. 12-42). The red symbolizes the heat and violence of the riot itself, while the scraps of wood and broken glass symbolize its destruction.

Suggestion:

Recall the earlier discussion about printmaking, and bow Dürer's print reflected a traditional approach to the medium, while Catlett's reflected a modern approach. Examples of concept art, like the one by Baldessari (fig. 12-42), could be said to reflect a post-modern approach. In your judgment, does such an approach offer possibilities for the future? Explain.

Documented Art

During the late 1960's and early 1970's some artists began to expand their media into areas where art was mixed with

Challenge 12-6:

Make a collage of varied papers, fabrics, and printed materials that is unified around an idea, event, or theme.

the life around it. Their works tended to engage the viewer in ways very different from that of traditional media. Recall the wrapped coastline and the performance piece with a coyote in Chapter 1 - both of which relate to the "environment," an art form discussed in the next chapter. Meanwhile, some artists began a trend going in the opposite direction, of reducing their art to just its idea or concept. Some of these artists have argued that it is possible to create art without objects - a category of art that is sometimes referred to as concept art.

One thing that both developments had in common was the use of documentation, that is, evidence of the work's existence in the form of writing, photocopies, photographs, film, audiotape, or videotape. Examples like the wrapped coast and the performance piece were temporary, and therefore had to be documented, in this case with photographs (figures 1-10 and 1-12). Examples of concept art, because they depended so much on ideas, also were temporary. John Baldessari's Cremation Piece is documented in a printed statement (fig. 12-43) that describes not only the idea, but some of Baldessari's actions to carry out his idea back in 1969.

Summary

This chapter has indeed been complex. But it dealt with only one-half of the subject of media. Another, equally complex chapter on three-dimensional media follows.

Two-dimensional media were organized under the topics of drawing, painting, mosaic, printmaking, photography and film, video art, computer art, and mixed media.

Examples of drawing include charcoal, pencil, and

ink – described as monochromatic because they involve only the color of a single tool mixed with that of the paper. Because they are multicolored, colored chalks and pastels resemble painting; however, because of their ease of application and relatively fragile surface, they resemble drawing media.

Painting includes watercolor, tempera, oil, acrylic, and fresco. Most painting media have ancient origins. Oil on canvas was not fully developed until the sixteenth century, however, and acrylic was developed in this century.

Mosaic, because of its bonding to a wall, resembles fresco. Because of its unique materials and working process, however, it differs from fresco and all the painting media.

Printmaking includes relief, intaglio, and planographic processes. Of these, the woodcut, a relief process, is the oldest medium. Engraving and etching, both intaglio methods, date back to around 1500 when they replaced the woodcut. The planographic methods are relatively new: lithography was developed in the 1800's, and silkscreen in this century.

Photography and film, which involve photochemical processes, are products of modern technologies. Video art and computer art, which involve electronic processes, are even more modern.

Mixed media, the last category reviewed, does not so much involve new materials or technologies as new ideas about art. No longer committed to traditional approaches, many twentieth-century artists have experimented with using media, new and old, in novel ways: mixing them, combining them with materials from daily life, combining them with life itself, or by attempting to eliminate the medium altogether.

"One of several proposals to rid my life of accumulated art. With this project I will have all of my accumulated paintings cremated by a mortuary. The container of ashes will be interred inside a wall of the Jewish Museum. For the length of the show, there will be a commemorative plaque on the wall behind which the ashes are located. It is a reductive, recycling piece. I consider all these paintings a body of work in the real sense of the word. Will I save my life by losing it? Will a Phoenix arise from the ashes? Will the paintings having become dust become art materials again? I don't know, but I feel better."

12-43 Conceptual art pieces are usually temporary events. Therefore, many of these events were documented either by filming, photographing or writing in order to keep a record of the actions that took place. John Baldessari, Cremation Piece, 1969. As shown at The Jewish Museum in the exhibition Software, 1970.

Chapter 13

Three-Dimensional Media

13-1 Auguste Rodin, *The Thinker*, 1879 – 1889. Bronze, $28\frac{1}{8}$ " \times 14\%" \times 23\\2" (72 \times 36 \times 60 cm). National Gallery of Art, Washington, DC (Gift of Mrs. John W. Simpson).

Artists use many media in addition to those described for two-dimensional art in Chapter 12. In fact, there are few materials that are not used today in the creation of art. Many of these materials are used to produce works in which the third dimension is real rather than implied as in drawing or painting. If you were asked to list some examples of three-dimensional media, you would probably think of sculpture in wood, stone, and metal, or pottery made from clay. You might also think of media used in school such as papier mâché and plaster, but be surprised to learn that three-dimensional forms can be produced with crocheted fiber (fig. 13-2).

13-2 Norma Minkowitz, Passage to Nowbere. 1985. Fiber, acrylic, pencil, shellac, $7\frac{1}{2}$ " \times 9 $\frac{3}{4}$ " (19 \times 25 cm) diameter.

Sculpture

We will begin this chapter with a discussion of media used in four categories of sculpture: carving, casting, modeling, and construction. Although all sculpture is three-dimensional, different examples vary in their amount of depth. Sculpture that is part of, or attached to, a surface is called relief. In a low relief, the shapes project slightly, as in this section of a carved sandstone wall made in the twelfth century for the Bayon Temple at Angkor Thom, Cambodia (fig. 13-3). High relief figures project a great deal, as in the cast bronze panel by Lorenzo Ghiberti (fig. 13-4). Sculpture that is created to be walked around and seen from all sides, like The Thinker by Auguste Rodin (fig. 13-1), is called sculpture in the round. Both reliefs and sculptures in the round can be cast, carved, or constructed in a variety of materials.

13-3 Processional Scene from the Bayon Temple, Angkor Thom, late 12th century, Cambodia. Sandstone.

13-4 Lorenzo Ghiberti, The Story of Jacob and Esau, detail from The Gates of Paradise, ca. 1435. Gilt bronze, 311/4" (79 cm) square. Formella dell Porta del Paradiso. The Baptistry, Florence.

Suggestion:

Look for relief sculptures in your community. Where are they located and what kind are they? What are they made of? What purposes do the reliefs serve – recording or symbolizing events or beliefs, or decorative?

Carving

We know that humans have carved forms since the Stone Age, using materials such as bones, horn, antlers, wood, and stone. Approximately 15,000 years ago, an Ice Age carver created the little figure known as the Venus of Willendorf (fig. 13-5). Imagine the difficulties the hunterartist must have had in carving this statuette from stone with crude and clumsy tools made of stone. Over 4,500 years ago, Egyptian artists produced life-size figures in both wood and stone, using tools made of bronze (fig. 13-6). The Egyptians placed sculptures like these in the tombs of their rulers, believing they would provide homes for the spirits of the deceased.

13-5 Venus of Willendorf, original ca. 15,000 - 10,000 B.C. Stone, 43/8" (11 cm) high. Naturhistorisches Museum, Vienna. (Cast of original)

held in the hand (like the Venus of Willendorf to works that fill a mountainside like the portraits of four presidents on Mount Rushmore (fig. 13-7) - a gigantic relief carving that required the use of pneumatic hammers and chisels driven by compressed air. The size of carved wood sculpture is limited to the size of wood pieces that can be obtained from the largest trees.

13-7 George Borglum and Son, The Presidents, 1927 - 1941. Carved granite. Mount Rushmore National Monument. Courtesy United States Department of the Interior, National Park Service.

Because sculpting in stone or wood is very demanding, drawings and small clay models are usually made to show what the sculpture will look like from all sides. The first phase of carving a piece of wood or stone usually involves blocking out the general forms of all surfaces with gouges or chisels, giving attention to how these forms interrelate and encourage the eye to move from one part to another. As the carving continues, the forms are refined and decisions are made concerning the locations of positive and negative areas. Positive areas may be solid and/or convex (curving outward); negative areas may be openings and/or concave forms (curving inward). These forms provide contrasts, and they also contribute to eye movement around and across the sculpture. Positive turns to negative as the eye moves smoothly from solid forms to openings in Henry Moore's Reclining Figure (fig. 13-8). Ernst Barlach created contrasting convex and concave areas that direct eye movement around the forms of The

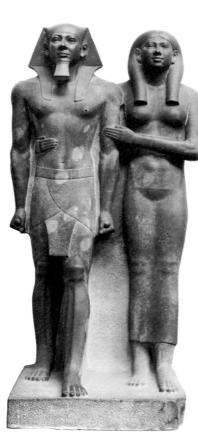

13-6 Mycerinus and His Queen, ca. 2470 B.C., Fourth dynasty. Slate, 56" (142 cm) high. Museum of Fine Arts, Boston.

13-8 Henry Moore, Reclining Figure, 1939. Elmwood, 37" × 6' 7" × 30" (94 × 183 × 76 cm). The Detroit Institute of the Arts (Gift of the Dexter M. Ferry, Jr., Trustee Corporation).

Vision (fig. 13-9). The finished stone or wood sculpture can be highly polished, left textured, or be given a combination of polished and textured surfaces. Moore sanded the surface of Reclining Figure, emphasizing the wood grain, which contributes to the flow of the sculptural forms. Barlach blended the characteristic marks of the gouge and the wood grain in The Vision. Can you identify different meanings, ideas, and feelings that you get from the two sculptures as a result of the ways in which the forms and surfaces have been treated?

Challenge 13-1:

Carve an abstract sculpture from plaster that communicates the sensation of visual movement over a three-dimensional form.

Student work.

13-9 Ernst Barlach, The Vision, 1912. Relief (oak). Collection, Neuve Nationalgalarie, West Berlin.

Casting

Casting to produce a sculpture requires a mold, a hollow area into which a liquid substance such as molten metal, plaster, or plastic is poured and held until it hardens to produce the cast, or the sculpture itself. The simplest casting procedure is a one-piece mold in which a solid cast is made. For example, you can press your hand in wet sand to make a mold, and fill it with plaster to produce a cast. The most complex casting procedure is the lost-wax process.

Lost-Wax Bronze Casting. The first lost-wax castings were of small solid objects like the statuette in figure 13–10. Obviously, solid metal figures could not be made very large because of the weight and expense of the metal. In order to make large figures, ancient cultures developed the method of hollow bronze casting, a procedure that has been continued and developed over the past 6,000 years.

Today, the procedure for casting metal sculpture is referred to as cere-perdue, a French term meaning lost-wax. To create a bronze casting of Abraham Lincoln (fig. 13–11), Keith Knoblock modeled a life-sized figure in plasticene clay (a nonhardening, oil-based material) over an armature, a framework of metal rods and plaster. A mold was made by applying plaster to the clay model in sections. Thin metal shims were placed between mold sections so they could be easily separated later (fig. 13-12). The sections of the mold were removed from the clay model, and a 3/16-inch coating of melted wax was brushed onto each piece, which had been dampened with water to keep the wax from sticking (fig. 13-13). The wax castings were removed from the plaster molds and reassembled into seven sections of the figure, to which wax rods and cup shapes were attached. After the melt-out, these wax rods left channels running through the mold to the cup shapes.

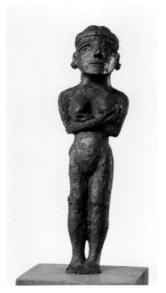

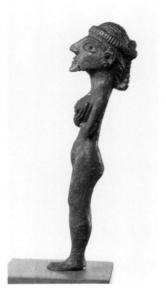

13-10 North Syrian female figure, ca. 4000 B.C. This was found among a cache of six statuettes on the Amug Plain, by far the earliest objects cast in human form discovered to date. Height 51/2". Courtesy The Oriental Institute, Chicago, Illinois.

13-11 Keith Knoblock, Lincoln, 1977. Cast Bronze, 6'43/4" (195 cm). McLean County Law and Justice Center, Bloomington, Illinois.

Long steel nails were pushed through the wax so they protruded inside and outside of the wax. The nails supported the core of the mold after the melt-out (fig. 13–14). Each wax section was suspended in a cylinder made of black asphalt roofing felt with a wire mesh insert (shown raised here) that became part of, and reinforced the mold (fig. 13-15). A liquid mixture of heat-resistant materials called the investment was poured around and inside of the wax casting to form the outer mold and the mold core, leaving the tops of the pouring cups uncovered. When the mold material was hardened, the asphalt cylinders were removed, and the molds were placed in a kiln (an oven capable of very high temperatures) and baked at 1150 $^{\circ}\mathrm{F}$ over a seven-day period until the wax melted and ran out through the channels left by the wax rods. The nails, embedded in both the outer mold and the mold core, held the core in place, preserving the empty space where the

wax had been. Molten bronze was poured through the channels to fill the 3/16-inch voids that were the shape of the sculpture parts (fig. 13-16). When the metal cooled, the molds were chipped and dug away from the cast, and the sections were ground and cleaned with a variety of hand and power tools. The seven casts were welded together and the surface was treated chemically to give it a brownish color. The sculpture was completed by attaching it to a base of concrete in which the skatelike forms on the feet were submerged to help steady the figure.

13-12 Applying plaster to the clay model.

13-13 Coating the sections of the plaster mold with melted wax.

13-14 The wax castings.

13-15 Reinforcing the mold with wire mesh and roofing felt.

13-16 Pouring bronze into the mold.

Plastic and Plaster Casting. If there were no caption under figure 13-17, you might assume it is a picture of a real football player. The life-size figure was cast in a plastic called polyester resin, reinforced with fiber glass. Duane Hanson makes molds for sculptures like this by applying plaster gauze strips directly to the body of a person, whose skin and hair is heavily greased so the plaster will not stick. Molds are made for various parts of the body, then fleshcolored polyester resin is painted into them and laminated with several layers of glass cloth. The hardened casts are assembled to create figures that are sometimes mistaken for real people.

George Segal has also produced molds by forming plaster gauze around living models who are fully clothed. The molds, which are made in sections for various parts of the body, are removed and reassembled to become the sculpture (fig. 13-18). Segal does not smooth away the molded texture of the plaster, so you can see and feel the rough surface of his sculptures.

13-17 Duane Hanson, Football Player, 1981. Polyvinyl, polychromed in oil with accessories, $43\frac{1}{4}$ " \times 30" \times 31½" (110 \times 76 × 80 cm). Lowe Art Museum, University of Miami (Museum purchase with funds from Friends of Art and public subscription).

13-18 George Segal, The Parking Garage, 1968. Plaster, wood, metal, electrical parts and light bulbs, 10' × 12'8" × 4'. Collection of the Newark Museum (Purchase 1968 with funds from the National Council on the Arts and Trustee contributions).

Challenge 13-2:

Create a mask by shaping plaster gauze over a balloon to portray a character or mood.

Student work.

Student work.

Modeling

Modeling is an additive process in which a sculpture is built up using a pliable material like clay, papier mâché, wax, or plaster. In this section, we will consider ceramic sculpture, clay forms that are hardened and finished by firing in a kiln and papier mâché.

Clay is taken through four stages to produce either sculpture or pottery: preparation, shaping, decorating, and firing. Preparation involves mixing water with the clay, aging it for several weeks until it becomes workable, and wedging the clay against a plaster or canvas surface to force out air bubbles. Shaping the clay is done by hand-building methods or on a potter's wheel. Decorating the form can be accomplished with techniques such as those shown in figure 13-19. Firing the clay form is done twice - once to harden it, and a second time to fuse a glaze, a transparent or colored glassy coating, to the work.

Solid Modeling. Perhaps you have made a solid sculpture from a lump of clay. Parts can be shaped from or added to the lump. Any parts of a solid clay sculpture that are thicker than one inch should be hollowed out to prevent the work from exploding when fired. When the clay is dry enough to support itself, but not completely dry, the form can be hollowed out from the bottom with a wire loop tool. Textures and patterns such as those shown in figure 13-19 can be added to the surface.

13-19 Texture in pressed clay.

13-20 David Aronson, Virtuoso. Courtesy Pucker/Safrai Gallery, Boston, MA.

Coiling. The coiling procedure was used by the Chinese over 2,000 years ago to create life-size figures such as the warrior and horse shown in figure 13-21, although slabs of clay formed by pressing them into molds were probably used to make the torso shapes. (Thousands of figures like this were found during excavations at the tomb of the first emperor of Ch'in. It is said that no two of the ceramic warriors have the same face.) Coils are made by rolling ropes of clay to a desired thickness on a canvas-covered surface. The desired form is built by pressing coils together as they are progressively placed one upon the other. Coils are made longer or shorter as the developing work requires. The artist smooths joints on the inside and outside with vertical wiping movements, and finishes the surface by scraping or by beating it with a paddle. Peter Vandenberge modeled clay on the surface of his coil-built sculpture to create three-dimensional features (fig. 13-22). The hat was made from slabs, and colored clay slips were used to decorate the figure.

13-22 Peter VandenBerge, Zwartman, 1986. Clay and slips, handbuilt (coiled), $45" \times 14" \times 17"$ (115 × 36 × 43 cm). Collection of the artist. Photograph courtesy George Erml.

Slab Building. Slabs are sheets of clay that are beaten out with the hand or spread with a rolling pin. Materials such as tubes wrapped in newspapers so they can be removed, newspaper rolled into tubes, crumpled newspaper, foam rubber, vermiculite-filled plastic bags, and dacron are used to support slab-built sculpture until the clay dries enough to stand without supports. Slabs can be used in the construction of smaller sculpture by rolling and folding them, and leaving the forms to dry until they are stiff, but not completely hard. The parts can then be joined together by using clay slip - clay mixed with water to a creamy consistency – and rolls of clay at the joints.

Very large ceramic sculptures built with slabs and coils such as Viola Frey makes are formed and fired in sections. The sections are designed so that they can be stacked upon each other when finished to complete the sculpture for display (fig. 13-23). Frey's Leaning Man III is over eight feet tall. Imagine having a sculpture that large in your home.

13-23 Viola Frey, Leaning Man III, 1985. Clay and glazes, handbuilt, 102½ " \times 35" \times 18" (261 \times 89 \times 46 cm). Rena Bransten Gallery, San Francisco.

Papier Mâché. Papier mâché is an ancient modeling medium said to have been used by Chinese soldiers to make armor prior to the bronze age because of its strength and light weight. It can be mixed by soaking paper in water overnight, mashing the paper in a strainer to remove the water and adding white glue as a binder. The clay-like medium can be modeled into all kinds of shapes, formed in molds and over armatures of wood, rods and wire. The Linares family in Mexico create fantastic papier mâché animal sculptures like that shown in figure 13-24. A more direct method involves soaking strips of newspaper in

13-24 Felipe Linares, Leonardo Linares-Vargas, David Linares-Vargas, Alebrijes, 2989. Papier mâché. Photograph courtesy Musée national d'art moderne, Centre Georges Pompidou, Paris.

wheat paste and laying them over armatures of wadded paper, cardboard, tubes and small cartons to create forms like the one shown in figure 13-25. Even this process requires several days for drying. The plaster gauze used by Duane Hansen and George Segal (figures 13-17 and 18) and suggested for challenge 13-2 has replaced papier mâché because it dries quickly. It does not permit the smoothness and detail of papier mâché, however, which can be carved, bored, sanded and painted when dry.

13-25 Pierre Richard, Move Move Mann, 1987. Papier mâché, 27" × 12" (69 × 30 cm). Collection of Julian Davis Wade.

13-27 Richard Lippold, Number 7: Full Moon, 1964.

Construction

Constructions are sculptures built from parts that may be of the same or different materials. This procedure is a twentieth-century development brought about by the sudden increase in materials and techniques available from modern industry, and by modern attitudes regarding the nature of the art object. Constructions may be made of traditional materials such as wood or metal that are used in new ways. George Sugarman glues together layers of wood that have been cut into shapes with a band saw, and paints the forms to conceal the wood grain and to help direct visual movement over the various surfaces (fig. 13-26). Richard Lippold combines thin metal rods and wires to create constructions that radiate from a center as in Number 7: Full Moon (fig. 13-27). The central cluster of wires reflects light, and the metal rods create open three-dimensional forms. Like an elaborate space platform, Number 7: Full Moon had to be carefully designed before being constructed.

13-26 George Sugarman, Freya, 1964. Laminated, polychromed wood. 303/4" (78 cm) high. Private collection.

13-28 Louise Nevelson, Sky Cathedral, 1958. Painted wood construction, 11'31/2" × 101/4' × 18" (344 × 305 × 46 cm). Collection, Museum of Modern Art, New York (Gift of Mr. and Mrs. Ben Mildoff).

Assemblage. Sculptures constructed from a variety of found objects and materials that, in their original states, were not necessarily meant to be used in art forms, are called assemblages. Even though an assemblage may not be preplanned, it is not necessarily haphazard. Objects are selected for their similarities or contrasts, or for what they may suggest. They may or may not satisfy the principles of

composition, depending on the artist's intent. How an assemblage is constructed depends on the materials used. Discarded wood forms can be nailed, glued, and pegged together with wood dowels as Louise Nevelson did for assemblages made up of dozens of boxes filled with carefully arranged wooden objects (fig. 13-28).

13-29 Marisol, Women and Dog, 1964. Wood, plaster, synthetic polymer and miscellaneous items. $6'5" \times 7'7"$ $(196 \times 124 \text{ cm})$. Collection of The Whitney Museum of American Art (Purchase with funds from the friends of the Museum).

Many artists use the assemblage procedure because of the freedom they experience in combining all kinds of materials to express their ideas. Marisol's creations may include wood, plaster life masks, paint, photographs, fabric, and more in life-size boxlike figures (fig. 13-29). Her constructions are caricatures – descriptions of contemporary personalities, their manners, and characteristics.

Assemblages and constructions include works that may be classified as reliefs, as well as those that are sculpture in the round. Frank Stella cut the parts for Katsura, a construction that projects about two feet from the wall, out of sheet aluminum and painted them with an unrestrained range of colors (fig. 13-30). The composition is given unity by repetition of shapes based on drafting tools.

13-30 Frank Stella, Katsura, 1979. Oil and epoxy on aluminum, wire mesh. $9'7'' \times 7'8'' \times 30''$ (292 × 234 × 76 cm). Collection, The Museum of Modern Art, New York (Mr. and Mrs. Victor Ganz, Mr. and Mrs. Donald H. Peters, and Mr. and Mrs. Charles Zadok Funds).

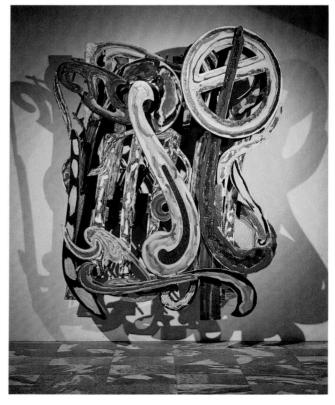

Marisol 1930-

Carved wooden boxes, plaster casts of faces and hands, and bits of fabric are uniquely combined and assembled to form a three-dimensional composition. "Found" objects, or discarded items collected and reused by the artist are embellished with handcrafted materials. Carefully drawn and painted details adorn the sides of figures sculpted from rough pieces of lumber. This arrangement of contrasting elements might be complemented with a background, creating a "tableau," or an arranged scene. The sculpted figures in these unusual works of art, known as assemblages, may wear three or more faces casted from plaster-all the single face of their artist, Marisol.

Born in 1930 in Paris, Marisol Escobar spent the early years of her life travelling from one glittering world capital to another with her wealthy Venezuelan parents. When her mother died when she was eleven years old, Marisol looked to her relationship with her father for support. With his stability and encouragement, Marisol was able to become an adventurous artist and an independent and creative individual.

Her travels brought her from Europe to New York in 1950 where she studied art and developed friendships with other artists in Manhattan. At this time, Marisol explored a variety of different art media, searching for her own artistic style. During this quest for originality and independence, she discarded her last name; since that time she has been known simply as Marisol.

In New York, Marisol discovered a unique means of expression in sculpture, combining unusual materials in new ways. Using carpenters tools-power saws, axes, electrical devices-in combination with traditional art supplies, she began creating the tableaux for which she is now famous.

Challenge 13-3:

Construct a relief of wood shapes that demonstrates compositional organization, and expresses an idea or theme.

Student work.

Knox, 1959).

Metal Construction. The techniques for constructing metal sculpture are too numerous to be fully covered in this discussion. In general, metal can be cut with hand or power saws, hand or power shears, tin snips, and welding torches. Holes can be drilled in metal, and joining procedures include the use of metal screws, nuts and bolts, riveting, crimping edges together, soldering, and welding.

Richard Stankiewicz applied the assemblage technique to industrial scrap and old machine parts, welding them together to create the sculpture shown in figure 13-31. What do you think about the artist's comment on the endless waste of objects and materials that characterizes our twentieth-century society?

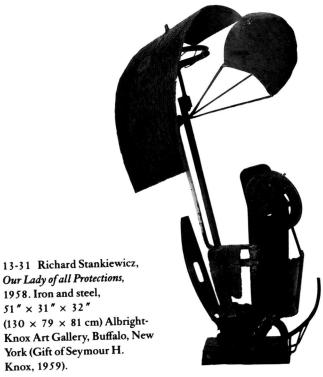

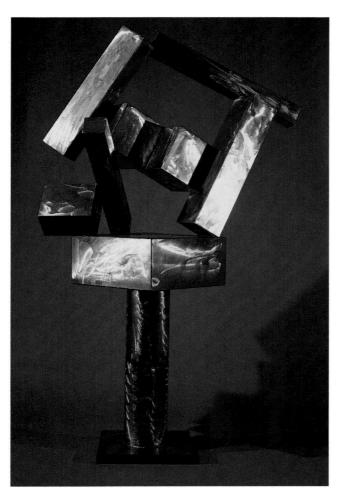

13-32 David Smith, Cubi XVII, 1963. Stainless steel, 107 ½ " \times 64 ½ " (274 \times 164 cm) Dallas Museum of Art (Eugene and Margaret McDermott Fund).

Sheets of stainless steel are welded together by David Smith to create combinations of cubes and cylinders (fig. 13–32). The process of welding and the strength of steel enable him to create constructions of cubes that look like they should fall. Smith's sculptures are often placed outdoors, where the highly polished mirrorlike surfaces reflect everything around them.

Kinetic Sculpture. You were introduced to and shown examples of kinetic sculpture in Chapter 8. These constructions move or have moving parts, and may also incorporate light and sound. Although in previous centuries, machines and robotlike figures had been designed for public or private entertainment, it was not until the twentieth century that movement in sculpture became a definite aim of serious artists. The automated constructions of the past, like today's cuckoo clocks, could only repeat their actions. The movements of modern kinetic sculptures are generally not predetermined, but work at random. The sources of energy for kinetic sculpture in-

clude wind and air currents, falling water, temperature changes, springs, motors of all kinds, air pumps, pull strings, thin rods and wires that vibrate, pendulums, magnets, and electromagnets.

Environmental Art

Environmental art began in the 1960's. As with assemblages and collages (Chapter 12), the media and procedures used to create these forms are mixed, but the basic idea is to involve the spectator in the artwork, or make the work a part of the environment surrounding it. Environmental artists have taken several different directions over the past twenty years, as the following examples demonstrate.

Red Grooms constructs huge enclosed environments that people can walk through. *Ruckus Rodeo* includes fourteen cowboys and cowgirls, a rodeo queen on horseback, a sixteen-foot Brahma bull, and more (fig. 13–33). The floor is covered with painted burlap, and the rodeo audience is painted on canvas that wraps around the walls. Imagine what it would be like to enter the make-believe world of Ruckus Rodeo and walk among Groom's larger-than-life figures frozen in a moment of physical action.

Another kind of environmental sculpture involves making changes in a natural setting. These works are called *land* or *earth art*, and may require construction crews and earth-moving equipment to help the artist complete them, as in the case of *Spiral Jetty* (fig. 13–34). Robert Smithson created a 1,500-foot-long earth and rock spiral that extends into Utah's Great Salt Lake. His choice of the spiral form may have been affected by the legend that the lake was originally connected to the Pacific Ocean by an underground waterway that caused whirlpools to form at the lake's center.

Mary Miss takes another approach in her constructions, which combine wood, steel, and concrete with earth and sometimes water in environmental works like *Field Rotation* (fig. 13–35). Miss enclosed a submerged area with a wall constructed of wood, and mounded earth up against the outsides of the wall. Eight rows of wooden posts extend from the central construction out over a four-and-one-half acre area that makes up the whole artwork. Viewed from the air, this environmental sculpture resembles a giant pinwheel. Many environmental works like those of Smithson and Miss are placed in out-of-the-way locations where you might not have a chance to see them, and of course most are temporary, so that photographs like these are the only records of them.

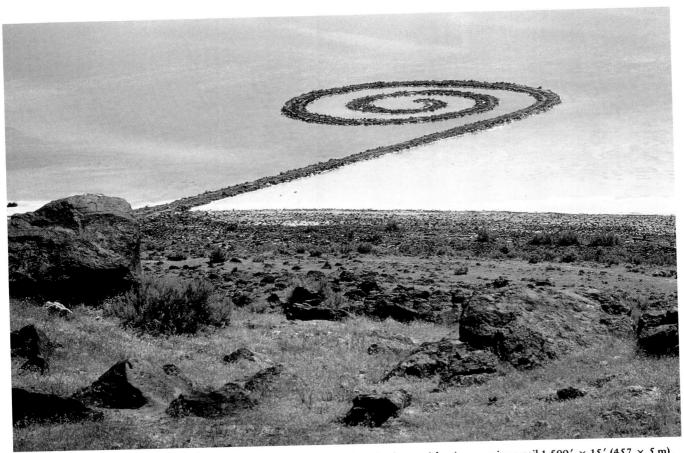

13-34 Robert Smithson, Spiral Jetty, 1970. Black rock, salt crystals, earth and red water (algae) composing a coil 1,500' × 15' (457 × 5 m). Great Salt Lake, Utah. Photograph Gianfranco Gorgoni. Courtesy Contact Press Images, Inc., New York.

13-33 Red Grooms, Ruckus Rodeo, 1975 - 1976. Sculpture wire, elastic, acrylic, canvas and burlap, 174" × 606" × 294" (442 \times 1539 \times 747 cm). Collection of the Modern Art Museum of Fort Worth (Museum Purchase and Commission with funds from the National Endowment for the Arts and the Benjamin J. Tillar Memorial Trust). See page 79.

13-35 Mary Miss, Field Rotation, 1981. Wood, gravel, concrete, steel, earth and water. Structure, $7' \times 56' \times 56'$ (2 × 17 × 17 m), centered in $4\frac{1}{2}$ acre site. Governors State University, Park Forest South, Illinois.

The largest environmental projects have been created by Javacheff Christo, whose *Wrapped Coast* is shown in Chapter 1. In 1983, he finished surrounding eleven islands in Biscayne Bay with 6,500,000 square feet of pink plastic that floated on the water, and extended 200 feet from the shore of each island (fig. 13–36). Can you visualize what the project looked like from an airplane — eleven pink-skirted islands covered with lush vegetation, surrounded by bluegreen water, and basking in a bright sun?

13-36 Christo, Wrapped Islands, 1983.

On a smaller scale, George Segal creates environments based on events from everyday life that include life-size plaster figures and real objects associated with the specific situation. The counter, stools, coffee maker, and other objects in *The Diner* came from a real restaurant (fig. 13–37). You can become a part of this little environment by moving around and viewing it from different angles, and perhaps imagining what the two lonely figures are thinking about.

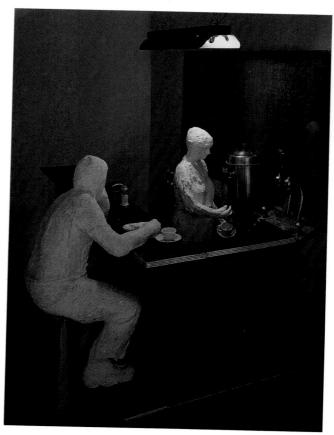

13-37 George Segal, *The Diner*, 1964 – 1966. $8'6'' \times 9' \times 7'3''$ (259 × 275 × 221 cm). Walker Art Center.

And finally, there are the performance works like Joseph Beuys's *I Like America, and America Likes Me* that was presented in Chapter 1 (fig. 1–12). These productions, sometimes called *bappenings*, usually involve the artist in person, some props, and, sometimes, viewers as active participants.

Suggestion:

If there is enough available space, construct an environment in a corner of the classroom that is based on a theme, an experience, an event, or some topic of study that can be shared by entering or looking into the environment.

Ceramic Pottery, Jewelry, Fibers, and Glass

Historically, such daily necessities as dishes, metalware, and clothing had been made on an individual basis by craftspersons in small shops – a method of production known as cottage industry. During the industrial revolution of the 1800's, cottage industries were replaced by large factories. Since then, household objects have been produced in large quantities by mass production methods rather than by the labors of individual craftspersons. Today, artists who work with ceramics, jewelry, fibers, and glass sometimes provide designs for industrial mass production, but mostly they make one-of-a-kind creations that are expressive, personal, and valued for their unique qualities.

Ceramic Pottery

Imagine life without containers to eat and drink from or to store things in. Prehistoric people were confronted with such a problem until the discovery of clay and ways to harden it. They used animal skins, shells, gourds, and woven baskets as containers. The baskets were sometimes coated on the inside with clay to seal them. One theory is that pottery making was discovered by the accidental burning of such a basket, which resulted in hardening the clay lining. The first pots and clay figures were fired in shallow pits lined and covered with twigs and dry wood.

Suggestion:

Every early culture developed pottery forms, techniques for decorating them, and kilns to fire them in. Select an early culture and prepare a report on the characteristics of their pottery forms. How were they made, decorated, and fired? What were they used for?

Hand-Building Procedures. It is easy to make pottery by hand because clay is so responsive. The methods are easily mastered with some practice. Because some procedures for hand building pottery are the same as those described for ceramic sculpture, you should refer back to those pages when necessary. These methods, referred to as pinch, coil, and slab building, may be used separately or in combination to construct pottery forms.

Pinch pots are made by pushing the thumb down in the center of a fist-sized ball of clay, leaving enough clay for the bottom. The walls are formed by squeezing the clay up and out between the thumb on the inside and the fingers on the outside, while rotating the pot in the other hand - a procedure that is repeated until the wall of the pot is as

13-38 Left: Pinch pot with foot. Right: Coil built pot with some coils partially exposed as part of the surface decoration. Earthenware.

thin as desired. A coil may be added to the bottom for stability, and designs can be impressed on the surface (fig. 13-38).

The main advantage of making a *coil pot* is that it lends itself to practically any shape. The procedures for coil pottery are similar to those described for coil-built sculpture. The first coil is attached to a base cut from a slab of clay. The form can be curved outward by offsetting each coil toward the outer edge of the coil underneath it. This process is reversed to curve the form inward. The jar shown in figure 13-39, made by people who lived on the island of Crete over 3,000 years ago, is four feet high. Its thick coils

13-39 Pithos, Knossos, Crete, ca. 1450-1400 B.C. Earthenware storage jar with applied rope decoration, height 4' (122 cm). The British Museum, London.

13-40 Leon Nigrosh, Coil pot. 9" (23 cm) high. Colored whiteware.

were thinned and shaped by beating the outside with a paddle while a rounded form was held inside. Unlike the Cretan pot in which the coils were paddled and scraped smooth, the coils in the vase by Leon Nigrosh (fig. 13-40) were left partially exposed to become part of the design. Coils of clay were modeled to create circular and undulating movements around the pot. Colored slips and a semigloss glaze were used to further enhance the surface.

13-41 Joining edges.

Slab-built sculpture.

Slabs, or sheets, of clay are rolled out with a rolling pin or pounded out with a paddle. Containers may be formed by draping slabs over convex forms like a volley ball, or pressing them into concave forms such as a dish lined with paper toweling to keep the clay from sticking. The edges of slabs can be joined with slip to build geometric containers (fig. 13-41), and the surfaces can be decorated with textures.

Challenge 13-4:

Construct a coil pot using a clay drainage tile as a mold to explore the decorative and expressive potentials of the coiling process.

Student work.

Throwing on the Wheel. Forming clay on the potter's wheel is referred to as throwing. The production of small wheel-thrown pots began about 3000 B.C. The wheel enables a person to make symmetrical rounded forms in much less time than by coiling. In the ancient world, it provided a method of mass production for those who made pottery to sell or trade. Coaxing a ball of clay into the center of a rapidly turning wheel, and raising a cylinder from which a beautiful jar is created requires great technical skill, and a keen sensitivity for good form. Edward Harkness made the vessel shown (fig. 13-42) of porcelain clay, throwing the jar form and the lid separately. He applied some of the white frosting-like clay to the lid, and covered both jar and lid with a yellow-green glaze that resembles jade.

13-42 Edward Harkness, wheel-thrown lidded jar. Porcelain with celedon glaze (jadelike).

Jewelry

Prehistoric people satisfied their need for objects of personal adornment with materials such as bone, wood, seeds, stones, shells, and hair. These items continued to be used, but once metalworking procedures were developed, metal became the most common material for jewelry and ceremonial objects. For over 6,000 years, gold has been the most sought after metal, not only because of its beauty and value, but also because it never tarnishes and is very easy to stretch. One ounce of gold can be hammered into a sheet of one hundred square feet! This ability of gold (or any metal) to be extended or shaped by hammering is called malleability. Because gold is so malleable, ancient metalworkers used it to create paper-thin objects that were decorated by the repoussé process (fig. 13-43). The features of the mask were raised in relief by laying the surface of the metal on a soft layer of warm pitch, and pushing the lines and shapes out from the inside with modeling tools. This thin gold mask, made around 1500 B.C., was attached to the face of a mummified Mycenean prince buried at Mycenae (later part of Greece).

In addition to repoussé, other metalworking procedures developed over 2,500 years ago include casting, annealing (heating metal to make it easier to form), soldering, bending metal over steel stakes or into depressions,

13-43 Funeral mask, about 1500 B.C. Beaten gold, about 12" (30 cm) high. Royal tombs, Mycenae. National Archeological Museum, Athens.

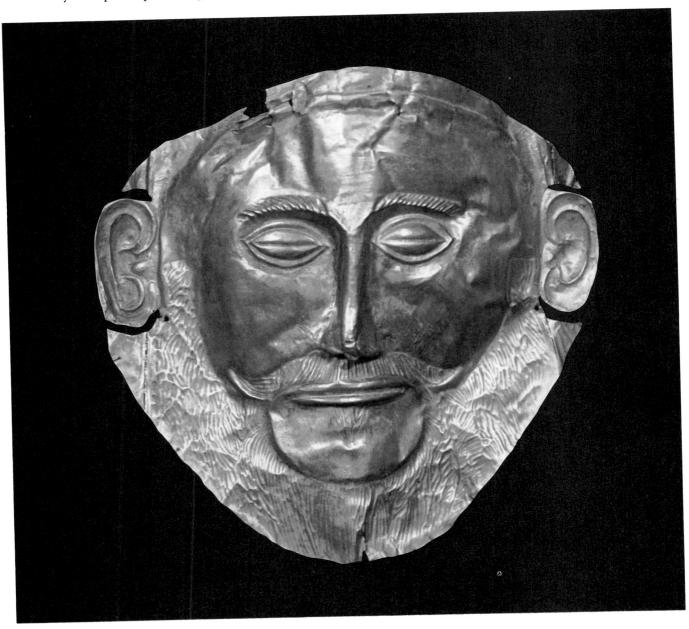

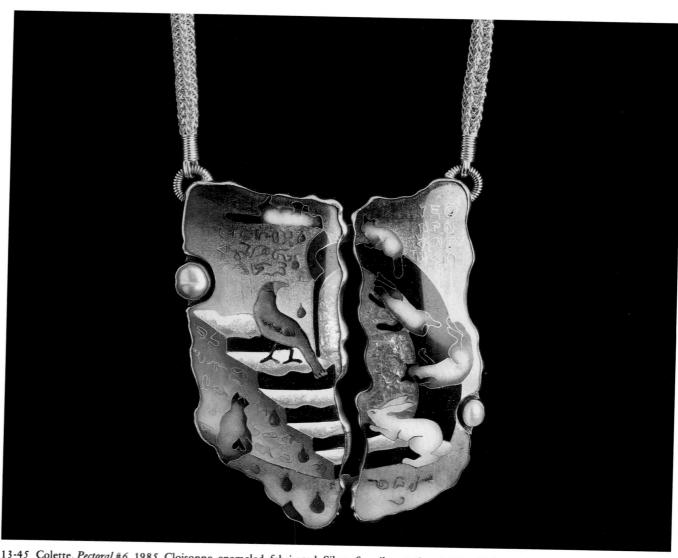

13-45 Colette, *Pectoral* #6, 1985. Cloisonne, enameled, fabricated. Silver, fine silver, 24k and 14k gold, bronze, $9" \times 3" \times \frac{1}{4}"$ (23 × 8 × .5 cm). American Craft Museum, Photograph: George Erml.

13-44 Mary Ann Scherr, Waist Watcher Monitor Belt Buckle. This buckle buzzes if the wearer's posture sags. Silver and gold fill, electronics and leather. Courtesy of the artist.

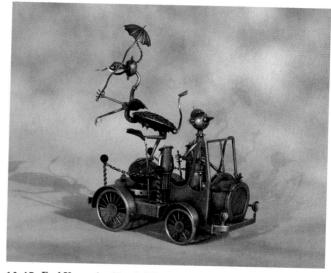

13-47 Earl Krentzin, *Truck.* Silver, 18 k. gold, semiprecious stones. Courtesy of the artist.

13-46 Gerhardt Herbst, Collar and Bracelet, 1985. This aluminum collar and bracelet was colored by anodizing, a process of depositing an oxide film electronically on the metal's surface so it will absorb dye colors. Aluminum, sandblasted, anodized. Collar: 6" diam. × 1". Bracelet: 3" \times 2" \times 34" (8 \times 6 \times 2 cm). American Craft Museum, Photograph: George Erml.

cutting, piercing, and engraving. Look closely at the belt buckle (fig. 13-44); notice how the metal was pierced. Some parts were cut with a saw and soldered on the larger silver form. The metal was bent slightly, and line designs were engraved in the recessed areas.

Enamels consisting of ground glass, to which metal oxides are added for color, may be fused to metal by heating them to about 1,450°F in a kiln. Over the centuries, several different methods have been developed to produce enameled jewelry. One of these is cloisonné, the technique applied to the pendant shown in figure 13-45.

Today, some artists use the materials, tools, and procedures required for making jewelry to produce small sculpture pieces (fig. 13-47). Can you find examples of parts that were sawed, pierced, bent and shaped by hammering and cast-before being soldered together? Whether Krentzin is a jeweler, a sculptor, or both, he produces carefully crafted art forms designed to challenge your imagination and fantasy.

Woven Fiber Forms

The most common method of working with fibers is weaving, which may be done on a complex harness loom or a simple wooden frame (fig. 13-48). In plain weaving, one thread, called the weft, crosses alternately over and under warp threads that are stretched on the loom. Weaving, traditionally a two-dimensional art, is now used in three-dimensional pieces. Some woven forms are made to hang on the wall and project from the surface (fig. 13-49). Several layers of fibers were woven then gathered to make the pocketlike forms which create depth. Portions of some woven works are stuffed with materials such as dacron or foam rubber to give them dimensionality.

13-48 Simple frame.

13-49 Barbara Bohnett, Joy Inside My Tears, 1978. Woven fiber, 42 " \times 22 " (107 \times 56 cm). Permanent collection, Illinois State University Galleries.

Nonwoven Fiber Forms

Three-dimensional forms can be made from fibers with nonweaving procedures like *macramé*, which is done by tying fibers in a series of knots such as the clove hitch and square knot. If heavy fibers are used, small macramé forms can be self-supporting. Sometimes, knots are combined with weaving to give the work more support. The three forms that make up *Implications* (fig. 13–50) by Jane Sauer

have knotted inner cores from which strands of the fiber were pulled to give them a hairy texture.

Fiber sculpture also may be constructed by hooking cords through and around shaped pieces of screening, or wrapping one fiber around a core of other fibers as Claire Zeisler did in *Tri-Color Arch* (fig. 13–51). For pieces as tall as this one (approximately six feet), the artist frequently wraps the fiber around a wire armature.

13-50 Jane Sauer, *Implications*, 1985. Waxed linen, paint, knotted, $14'' \times 6''$ (36×15 cm) diam.; $8\frac{1}{2}'' \times 5''$ (22×13 cm) diam.; $3\frac{1}{2}'' \times 3\frac{1}{2}''$ (9×9 cm) diam. Courtesy of the artist.

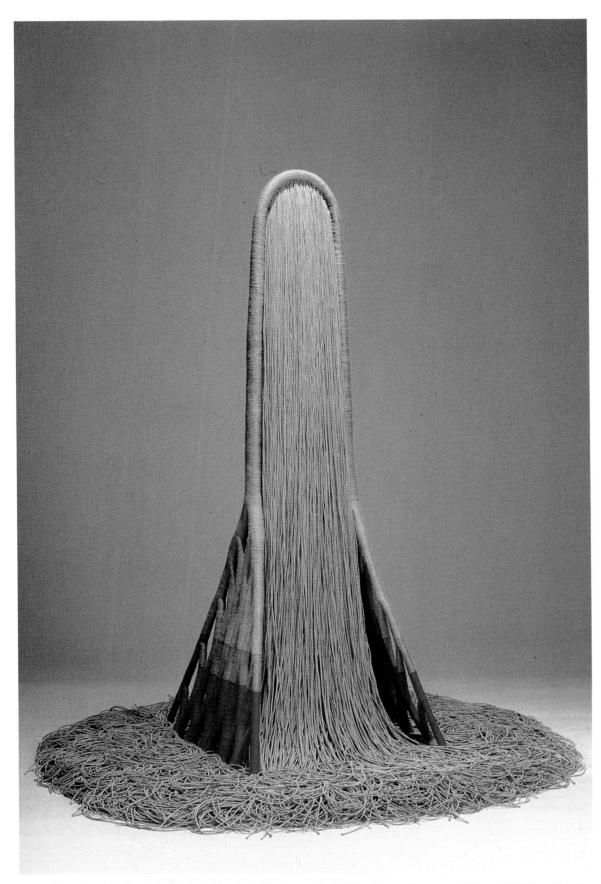

13-51 Claire Zeisler, $Tri-Color\ Arch$, 1983 – 1984. Hemp, synthetic fiber, knotted, wrapped, 74" \times 11" (188 \times 28 cm); spill 66" \times 44" (168 \times 112 cm). Courtesy The Rhona Hoffman Gallery.

Soft Sculpture

Claes Oldenburg was one of the first persons to create soft sculpture out of stuffed fabrics (fig. 13-52). While Oldenburg's works were given attention mainly because he created them to make fun of popular culture and values of the 1960's, they stimulated artists who work with fabrics to explore the use of their materials and methods in the creation of three-dimensional forms. Soft sculpture artists get ideas from everything around them, and from experimentation with combinations of materials. Jo Ellen Trilling combined fabric, wire, fur and paint in Portrait (fig. 13-53). If you look at commercial stuffed animals and figures, you can get some ideas about how soft sculpture is constructed. However, the artist must adapt construction procedures to the individual project and to the materials being used. Almost any fabric-printed or plain, textured, furry, course, or shiny-can be used for soft sculpture.

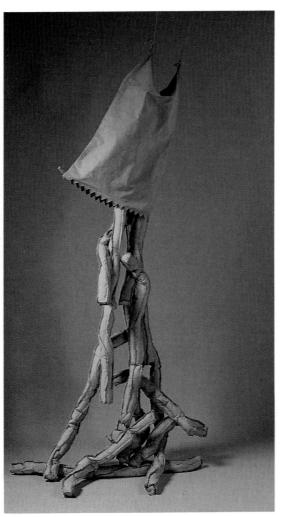

13-52 Claes Oldenburg, Falling Shoestring Potatoes, 1965. Painted canvas, kapok, 108" × 46" × 42" (274 × 117 × 107 cm). Collection, Walker Art Center, Minneapolis, Minnesota (Gift of the T. B. Walker Foundation).

13-53 Jo Ellen Trilling, Portrait. Fabric, wire, fur and paint, $27'' \times 20'' (69 \times 51 \text{ cm}).$

Glass

In addition to fulfilling hundreds of industrial and utilitarian uses, glass is also a beautiful art medium with a very long history. The Egyptians discovered how to make glass about 3000 B.C. The first glass objects were beads and solid shapes. Sometime between 1500 and 1350 B.C., the Egyptians produced glass vessels, such as the fish-shaped bottle in figure 13-54.

13-54 Glass bottle shaped like a fish, ca. 1370 B.C. Egyptian, from el Amarna. Glass, 51/2 " (14 cm). The British Museum, London.

13-55 Rolling the gather on the marver.

13-56 Indenting a groove using jacks.

13-57 Using wet newspaper to form the hot glass.

13-58 Blowing the glass form.

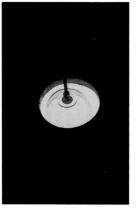

13-59 Reheating the form in the glory hole.

13-60 Shaping the glass attached to a pontil.

13-61 Steve Ramsey, freeblown glass vessels.

The invention of the blowpipe between 200 and 100 B.C. was to glassmaking what the potter's wheel was to ceramics – a mass-production tool that made it possible to produce hollow glass forms rapidly. Glass can be cast flat or into a mold. It can be freeblown (formed on the blowpipe in the open air), or blown into a mold. While hot, glass can be bent, twisted, and pulled into shapes, or welded glass to glass.

When glass is freeblown, the heated tip of a blowpipe is barely dipped in molten glass, then rotated to wind the glass into a gather on the end of the pipe. The artist rolls the gather on a flat metal surface called the marver to chill the outer surface, and to center the gather on the blowpipe (fig. 13-55). The blowpipe is angled down toward the floor, and the first small bubble is blown. Working at the glassblower's bench, the artist rolls the pipe back and forth on the bench arms, and uses jacks (spring steel legs connected at the bend) to indent a shallow groove on the glass just in front of the blowpipe (fig. 13-56), which makes later removal of the vessel from the pipe easier. While constantly rotating the pipe on the bench arms, the artist forms the hot plastic glass with tools such as concave wooden blocks, paddles, the jacks, cutting shears, and

even a wet pad of newspaper (fig. 13-57). Each time it is blown in this forming stage, the vessel increases in size (fig. 13-58). To keep the glass in a workable plastic stage, the artist periodically reheats it by inserting the vessel into the furnace opening, called the glory bole (fig. 13-59). The vessel is transferred from the blowpipe to a pontil, an iron pipe to which the glass is attached for final shaping. The hot glass may be opened up by using a paddle on the inside of the rotating form (fig. 13-60). Eventually, the vessel is removed from the pontil and placed in an annealing oven to cool slowly. The artist may further enhance the glass form by etching, engraving, or sandblasting, cutting, grinding, and polishing. Steve Ramsey used colored transparent glass to create these freeblown vessels that emphasize the effects that glass has upon light passing through it (fig. 13-61). **Stained Glass.** For over 1,000 years artists have been creating windows of stained glass that cause a special excitement when the light in a room is transformed by the colors of the glass. In this window (fig. 13–63), the artist carefully selected colors so that they relate to the theme of the work and balance one another. He also planned the organization of the lead lines that run through the panel so that they not only hold the glass together and provide structural strength, but also create an attractive composition of lines and shapes. When a panel is completely made up of colorless glass (fig. 13–64), the composition of the lead lines is an important factor in your enjoyment of the panel.

Prior to constructing a stained glass form, a full-size drawing of a design for the piece is made on pattern paper. The pattern shapes are cut out and used to guide the cutting of each glass shape. One method of holding individual pieces of glass in place is with channeled lead strips called *came*, which are soldered together at joints where they meet. If the work includes many intricate and curved shapes, or is three-dimensional like a container or lamp, the edges of each piece of glass can be wrapped with copper foil tape, leaving about 1/32 inch overlap on both sides. The pieces of glass are held together by running a bead of solder along the foiled edges. The foil technique was used to construct the Baroque style lamp in figure 13–62. The opalescent glass used in lamps like this contains streaks and swirls that give it movement when lit from behind, softening and diffusing the bulb light.

13-62 Terry Garbe.

13-63 Terry Garbe.

13-64 Terry Garbe.

Challenge 13-5:

Use stained glass remnants to construct a panel of harmonious colors and shapes. Warning: Use extreme caution when working with objects with ragged edges.

Student work.

Summary

Three-dimensional art forms can be created with almost anything. As you have seen, artists are not limited to traditional materials such as wood, stone, or metal for sculpture. If a material is safe to work with, it may be used to create artworks.

Some three-dimensional forms are made to be seen from all sides. These works may be freestanding, located indoors or outside, or suspended from ceilings. Other three-dimensional works, referred to as reliefs, project out from a surface, and are viewed mainly from the front.

Sculpture can be divided into media categories based on the kinds of materials and procedures used to make it. Carving, most commonly done in wood or stone, requires the artist to cut material away to produce a form. Casting may be done in metal, plastic, or plaster and involves making a mold from a model. Modeling is a building-up process, usually done with clay to produce sculpture that is made permanent by firing it in a kiln. Construction, a twentieth-century development, includes several subcategories. Anything that can be glued, nailed, crimped, welded, bolted, wired, melted, soldered, or otherwise joined may be used for constructions.

In the 1960's some artists began creating environmental artworks that capture and transform space, and frequently involve the spectator. There are several categories of environmental art, ranging from an area enclosed with some material such as canvas, and filled with constructed forms, special lighting, and sound effects, to outdoors projects that involve the real environment of land, sky, and water.

Other three-dimensional arts include pottery, jewelry, fibers, and glass, all of which have histories of development extending over several thousand years. Every early culture developed pottery and methods of decorating and firing it. The materials for making jewelry are numerous, and involve procedures developed by ancient cultures as well as some borrowed from modern industrial technology. Even fibers, originally used for weaving and the production of fabrics, are now used to create three-dimensional art. Glass can be blown, cast, molded, and laminated to produce three-dimensional art. Stained glass, once reserved primarily for church windows, is now used to create both two- and three-dimensional artworks such as windows, lamps, containers, and constructions.

In view of the continuing discoveries of modern technology, and the artist's exploratory nature, the list of art media will continue to grow, and the forms that art may take will probably become even more diverse.

Chapter 14 Careers in Art

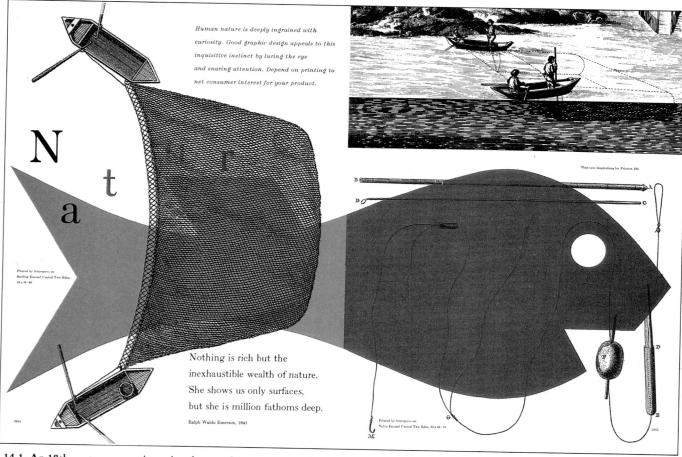

14-1 An 18th century engraving printed over a fish becomes modern graphic design, perhaps influenced by an earlier design. Bradbury Thompson, *Nature*, 1953. Courtesy Westvaco.

Throughout this book, you are invited to look at and read about the work of fine artists, who produce an incredible variety of two- and three-dimensional art. However, their work makes up only a small percentage of the art we experience every day. Do you know that this book was made by artists? A designer selected the type style and decided on the size of the pages and the page layouts. A designer created the cover, and graphic artists provided drawings and charts.

Whenever you open a book, magazine or newspaper, turn on the TV, go to a movie or a play, walk through a shopping center or grocery store, drive down a highway or a city street, or select some item of wearing apparel, you encounter the work of artists. Their designs determine the appearance of things all around us—advertisements, furniture, automobiles, toys, your school building, and walkman to name a few. There are hundreds of art careers, a few of which will be described in this chapter.

Architecture

Architects design and construct buildings for specific functions - from private homes to manufacturing plants and skyscrapers. The architect works to satisfy: a client's needs, estimating costs, local building codes, and providing plans. Architecture is often referred to as the art of space. The architect must use space wisely, and without waste to provide beauty and comfort in functional and flexible environments for the building's occupants. He or she plans for everything that goes into a building, including construction materials, work areas, storage, heating and plumbing, ventilation, stairways, and lighting to name a few. Detailed plans must be drawn up to show how the building will be constructed - from the foundation and supporting structure, to methods for joining and materials to be used. The exterior appearance of a building is also the architect's responsibility. New structures should fit into their surroundings. They should be made with materials and in a style compatible with what is already there.

Architects must be able to draw, build models, (fig. 14–2) have a good background in mathematics, know construction materials and procedures, be knowledgeable of the history of architecture, have a good sense of design and plenty of imagination.

Architectural Renderers. Once the architect has a plan that satisfies a client, an architectural renderer is asked to create drawings and paintings of the proposed building so that everyone involved can understand what it will look like. The drawings may include trees, automobiles, people and surrounding structures to suggest scale, and appearance of the building in the selected environment, (fig. 14–3). The artist must be able to draw the building so that construction materials such as brick, wood, aluminum, stone, and so forth are easily identified. Some architectural renderers are employed by architectural firms, and others work free-lance. Success in this career requires skill and imagination in working with watercolor, gouache and acrylics, pen and ink and pencil.

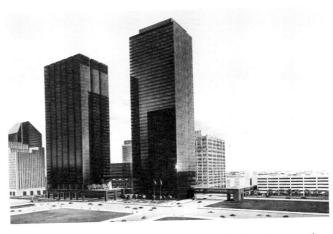

14-2 Model of Selegie Road Commercial Center, Singapore, 1986. Emery, Roth and Sons.

Landscape Architects. Some architects specialize in planning outdoor areas to provide usable and visually pleasing grounds around buildings and residences. They plan for drainage, land contours, planting of trees, flowers and shrubs, and advise architects on how best to relate buildings to the land on which they are located. Landscape architects plan outdoor areas for private homes, commercial sites, school grounds, housing projects, highway beautification and recreational grounds. They are knowledgeable about art, architecture, mechanical drawing, botany and ecology and generally have attended architectural schools that have an emphasis in landscape architecture.

Interior and Display Design

Interior designers plan and design interior space for everything from residential homes to giant industrial plants, from automobiles to airliners, (fig. 14-4). They advise on color schemes, furniture, fabrics, floor coverings, and lighting fixtures. They make drawings, paintings, construct models of interiors, and may plan the interior of one room or an entire department store. Interior designers plan the environments in which people live, work, study and play. Individuals who elect this specialization obtain their training from art schools with programs geared specifically to interior design. They are skilled in architectural drawing, color and design, facility planning, and take a creative approach to problems. They are employed by manufacturers of furniture, automobiles, airplanes, buses, restaurant chains, architectural firms, hotels-any company or corporation that produces something with interior space to be used by people.

14-4 Skylit Solar Court, Albany County Airport, Colonie, N.Y. Norman McGrath, photographer. Photograph: courtesy Einhorn Yaffee Prescott, P.C.

14-5 Milton Glaser, Grand Union Supermarket.

offer some item or service for sale such as department stores, museums, art galleries, manufacturers, and convention centers. They plan and construct exhibits and displays to attract customers for possible sales, or to inform the public about products and services. They design and build display furniture, display cases and lighted boxes, organize props and arrange lighting for the displays. Exhibit and display designers often make sketches and scale models for clients to examine. They need a knowledge of graphic design, type color, display, theatrical lighting, and carpentry as well as skill in drawing and model building.

Department store display designers specialize in interior and window displays for department stores. Large department stores may employ display designers, but frequently they freelance and are employed by several different stores and shops. Individuals who specialize in department store displays provide their clients with a knowledge of design, color, lighting, lettering, illustration and carpentry.

Graphic Design

You encounter the work of graphic designers everyday through advertisements, on TV and in magazines and newspapers, signs and billboards, posters, brochures, record jackets, clothing logos, package design and much more. Graphic designers translate the ideas of clients into visual images that the public will find appealing and difficult to ignore.

Corporate art directors supervise art or design departments charged with the task of creating exciting visual materials that will project a positive and appealing image of the company and the product to the public. They produce visual materials for magazine and newspaper advertisements, promotional packages, audio visual materials, TV ads, brochures, and public relations materials. Corporate art directors are knowledgeable in all areas of graphic design. They must be capable administrators since they work with sales people, production workers, management personnel, and distributors of the product, as well as the personnel in the art department.

Advertising agency art directors also head teams of artists who produce all kinds of advertising materials for clients. Agency art directors consult with clients to determine how to best promote a product. After studying information about the potential market for the product, the agency team develops ideas for advertising and promotional displays, magazine and newspaper ads, and TV commercials. The director prepares sketches and finally a comprehensive layout of the campaign showing type, color, illustrations and photographs for the client's approval. If the client approves the strategy, specialists on the agency team prepare newspaper and magazine advertisements, radio and television commercials, posters and brochures, and so forth. Agency directors must know advertising, have a good design background and be able to visualize and develop ideas for clients.

Graphic designers plan visual presentations for such things as record jackets, advertisements, brochures, package designs, magazine covers, filmstrips, posters and billboards. After researching the problem, graphic designers work out sketches called roughs, which offer clients and art directors alternatives to choose from. Approved roughs are then worked up in detailed drawings called comprehensives (in color if required) including type blocks, the type of lettering, sketches of all artwork and photos arranged to exact size. When the comprehensives are approved the designer, working with other members of the team – computer artists, illustrators, typographers, and photographers – finishes all the parts of the program and turns them over to paste-up artists who prepare the materials for photocopying.

Computer graphic designers. Instead of pens, brushes and rulers, the computer graphics designer uses a digitizing pad or a mouse to draw images in any color desired. The computer graphic designer, equipped with specialized software and laser color printers and imagers, can integrate the process of assembling text, type, images and layout to create full-color or black and white graphics in seconds. Computer technology makes it possible for an individual with a good sense of design and skill in the use of computer graphics to produce full-color graphics that look like they have been airbrushed. Images can also be put on videotapes or slides. Three-dimensional images can be put into the computer and rotated in any direction to see all sides. The computer graphics designer must have a good foundation in graphic design to produce successful work with the computer.

14-6 Courtesy Input-Output Computer Imaging Center, Normal, Illinois

Silk-screen printers use their skills to reproduce images for all kinds of wearing apparel—T-shirts, uniforms, sports clothes, jackets and hats, posters, signs, greeting cards, calendars, illuminated panels on pin-ball machines and mirrors, (fig. 14–7). Screen prints can be produced on almost any surface including paper, fabric, glass, plastic, metal, rubber, wood, leather and fur. The screen printer must have a knowledge of screen construction, stencil making with liquid, solid, and photographic methods, multiple color printing procedures and inks and paints suitable for various surfaces.

14-7 Logo design for t-shirts. Courtesy Select Screen Prints, Bloomington, Illinois.

14-8 Courtesy Nike Inc.

Record Jacket Designers. After becoming familiar with the music and the recording artist or group, the designer sketches several ideas for the album or CD cover. When a sketch is accepted, a comprehensive drawing is made to show color, images and lettering. The designer tries to produce an image that communicates the mood or message of the music, the performance style of the recording artist, or the personalities of the group. Once the comprehensive is accepted, photographers, illustrators, letterers, typographers and printers produce a finished jacket.

Signage. The sign industry provides many career opportunities for the commercial artist/graphic designer. Signage is divided into three categories: a) customer and production illuminated signs; b) commercial, non-illuminated signs (carved and sandblasted signs, truck lettering, wall murals, banners and show cards, etc.); and, c) architectural sign systems/environmental graphics, which includes types "a" and "b" but involves a unified "systems" approach. For example, all of the signs in a hospital, or a corporate office building have a similar design format. Effective signs result from careful attention to design, lettering and color.

Outdoor Advertising. The outdoor advertising industry offers career opportunities that are closely tied to those available to commercial artists involved in package, print, and place-of-purchase design. Designing a poster panel, painted bulletin or an eight-sheet poster for a billboard is often part of a multi-media campaign incorporating TV, radio, and other media. Outdoor advertising media each have a specific set of characteristics that the designer is subject to, such as cost, size, method of reproduction and location. Billboards have become a popular art form offering creative compositions of shapes, colors and sometimes three-dimensional form, moving parts and lighting effects (fig. 14–8). Outdoor advertising designers need skills in photography, painting, illustration, type design and a knowledge of advertising psychology.

Industrial Design

Industrial designers work to improve the appearance and quality of products ranging from something as simple as a soft drink can or as complex as a space shuttle. Designers are responsible for the form and appearance of all the objects that contribute to your daily living from automobiles and calculators to your skateboard and bicycle. Industrial designers must understand production processes, the characteristics of the materials used in those processes and the function of every product they work on.

Product designers are employed by manufacturers that make consumer products or by consulting firms that are hired by manufacturers. They must have artistic talent, a keen sense of design, understand consumer needs, know style trends and be informed about what competing manufacturers are producing. The product must perform well,

be attractive to consumers and economical to manufacturer. When planning a product such as a new vacuum cleaner, the designer works from sketches to develop prototypes (one of a kind models) in paper, clay and wood (fig. 14–9). Once a design is approved, the designer makes detailed drawings and works with engineers to produce a full-scale working, or production model (fig. 14–10). If the working model is approved, detailed working drawings are developed for the engineers to use in tooling up and production of the new product.

Package designers work to design containers that will attract consumers, inform them about the product and instill confidence in the prospective buyer about the product and its manufacturer. Once sketches for a new package are approved, a prototype box is developed using materials such a foam core, colored paper, transfer letters, marker and pencil illustrations, (fig. 14–11).

14-9 Preliminary prototypes of paper, clay, and wood. Courtesy Eureka Vacuum Company.

14-11 (left) Prototype box, and (right) final production box. Courtesy Eureka Vacuum Company.

14-10 Marco Ferrari and Sam Hohulin, Step Saver Vacuum. Courtesy Eureka Vacuum Company.

Furniture designers create all kinds of new furnishings that are constructed from wood, metal, plastic and fabric. They work closely with manufacturing engineers to design furnishings that are durable, attractive, and that can be produced cost-effectively with available technology. Perhaps a furniture manufacturer asks a designer to create a portable plastic table. The designer works up ideas in drawings, and if the manufacturer likes one, the designer builds a model. If the model is approved, the designer makes precise working drawings which are used to produce a production model.

Toy designers are employed by manufacturers of games and toys or are hired by them as consultants. Most toy designers come from industrial design backgrounds and understand how to use materials in relationship to safety, durability, and ease of maintenance. They must like to work in minature and, like other industrial designers, they take the development of a toy or game through the procedures of research, sketching, designing, model building and production. A knowledge of children's interests and development is necessary.

Fashion Design

Fashion designers create wearing apparel for people engaged in every kind of activity, from athletic events to formal occasions. Fashion designers must be creative with colors, textures and fabrics, know how items of apparel are assembled, and be able to sketch their ideas with flair and style in various media. Since their drawings are used for the production of new garmets, and for presentation to consumers, a knowledge of the history of clothing design and contemporary trends is necessary.

Fashion illustrators draw clothing and models for newspapers, magazines, department store catalogs and brochures. They must be able to represent fabrics as they fall on the body in any position, whether the fabric is clinging, hanging straight or in folds. They also have to represent textures, patterns, translucencies, jewelry and hair styles with drawings and painting media. A knowledge of the history of fashion and contemporary fashion is helpful.

14-12 Chris Van Allsburg, The Polar Express.

Illustration

Editorial illustrators are employed by magazines, newspapers, television stations and book publishers. The artist's style is a factor in determining what kinds of illustrations he or she will create. Editoral illustrators need to be able to make drawings and paintings that complement the written text with a variety of media. Some illustrators specialize in certain media such as pen and ink, watercolor or collage and are called on when an art director knows that a job requires that specialty. Illustrators may also specialize in subjects, such as sports activities, automobiles, animals or landscapes.

Medical illustrators create extremely accurate pictures, transparencies and overlays for medical schools, medical supply companies, publishers of medical journals and books and advertising agencies. In addition to drawings for the public and medical profession, they also prepare charts, graphs and diagrams for medical researchers. Their work requires patience, attention to detail, a knowledge of anatomy and excellent drawing skills.

Cartoonists produce drawings for advertisements and stories, gag cartoons, comic strips, cartoon panels, editorial cartoons, adventure comic books, greeting cards and animated cartoons for TV or movies. Gag cartoons and comic strips are meant to entertain while editorial cartoons aim to influence public opinion and advertising cartoons sell products. Most cartoonists do their work with brush, pen and ink, wash and Zip-a-Tone (commercially printed stick down patterns of dots or lines). They may be em-

ployed by newspaper chains, magazines or a syndicate that sells their work to many different newspapers for publication. Some cartoonists work on a free-lance basis and sell their work to publishers. Cartoonists must have rich imaginations and be able to generate ideas continually. The ability to draw well and rapidly in a distinctive style that people recognize is essential for success. Comic strip and gag cartoonists must be able to write stories or one-liners to accompany their work.

Technical illustrators produce drawings for assembly of everything from bicycles to the installation of instrument panels in airplanes and cutaway illustrations of car engines. For a good example of their work, look at an automobile repair manual. Technical illustrators are employed by every kind of industry to provide drawings that aid in the construction and maintenance of complex machinery and industrial products.

14-13 Courtesy Wave, Inc., Worcester, Massachusetts.

Film and Television

Art Directors coordinate the efforts of artists, graphic and costume designers and scene builders involved in making a film or television production. They work with film directors and producers to develop appropriate environments for their production. Art directors are responsible for the authenticity of sets, costumes, props and locations. The director must be able to precisely analyze a script, have mastery of mood development and set construction, know how to obtain materials and equipment and understand the production from beginning to end.

Storyboard illustrators are employed by advertising agencies and the film and television industries to develop storyboards based on a story for a film or the action for a TV commercial. A storyboard may contain fifty or sixty sequenced sketches that illustrate the progress of action, with the dialogue printed under each drawing. The number of storyboards needed depends on the length of the production and may range from three to thirty. The comic-strip-like boards are used by the film director as an outline of the characters' actions in a film or the progress of an animated commercial. Storyboard artists must be able to produce descriptive drawings very rapidly.

Television Graphic Artists are employed by television studios to produce advertising and promotional materials for the studio and newspapers, visuals for newscasts, art-cards for commercials, sets for shows and photographs and logos for the station. They must quickly provide finished products that will be impressive on the screen.

Animation artists also use storyboards to draw and develop the characters for animated films. They study sketches of the background scenery and listen to recordings of the voices for the characters as they develop them in drawings. It takes twenty-four drawings for each second of film. The animation artist must be able to draw well and rapidly, and have the patience to work on a project for a long time. Some feature length films take several years to complete.

Art Education

Elementary and secondary art teachers work with children and adolescents at all grade levels in the schools. Some are assigned to instruct kindergarten and elementary grades one through six, some teach junior high or middle school grades and others teach only high school students. They are certified to teach art and hold degrees from colleges and universities. School art teachers need a background in art history, critical aesthetic analysis and a working knowledge of many different art media in order to help students use these media to express their ideas and feelings. The art experiences provided for children and adolescents can establish the foundation for a lifelong enjoyment of the visual arts. In addition to planning programs that enable all students to acquire basic art skills and knowledge, secondary art teachers must provide experiences for students who wish to specialize in one area of art production and advise talented individuals who might pursue an art career.

College and university art teachers may follow several careers. Some are studio art instructors who majored in a studio area during their college training, and instruct courses in their area of specialization (drawing, painting, printmaking, ceramics, etc.). They generally have a Master of Fine Arts degree. In addition to teaching, most university art teachers produce art for exhibition and sale and some achieve regional and national recognition for their artwork. Participation in selective and competitive exhibitions is expected of studio art instructors.

Art historians are employed by colleges and universities to each art history. They also have completed graduated programs with emphasis in an area of art history, such as Modern Art, Greek and Roman Art or Baroque and Rococo. Art historians conduct research, write papers and books and sometimes give lectures to community groups.

Art educators are employed by colleges and universities that have teacher education programs. They usually have a Master's or Doctoral degree and prior experience as public school art teachers. They plan and instruct courses that help people prepare to teach art in the elementary and secondary schools or become city art supervisors. They may also prepare people to teach art education at the university level, or become involved in art administration.

14-14 John Joiner. Photograph courtesy The Arizona Bank.

Fine Art

Fine artists create two- and three-dimensional works of art to sell. Although the life of a fine artist is attractive to many people, it is a difficult life. A fine artist must have the self-discipline to work several hours a day to produce his or her art. Most fine artists work alone, motivating themselves to start and finish their projects. In order to become known by the art-buying public, fine artists must establish a connection with a gallery. The gallery generally "represents" artists: it agrees to show, advertise and sell their work, and charge each artist a percentage of the final selling price in exchange for its services.

Because it may take years for an artist to establish a reputation, find a suitable gallery and produce enough artwork to sell, many must hold a second job to supplement their income. Most artists need a studio or workshop to work in. And while some are self-taught, many artists have university or art school degrees. In short, being a fine artist may seem simple from the outside—one paints, sculpts, draws or takes photographs, and sells the final work—but it is a life of almost constant challenge.

Crafts

Crafts can be defined as works in wood, clay, fiber, metal, glass and plastic that have some use or are related in form to useful objects. For example, wheel-thrown pottery is a craft, although not all wheel-thrown pots can be used to hold food or liquid.

Like fine artists, craftspeople often find it difficult to make a comfortable living from the sale of their works, so many teach their craft or supplement their income with a second job. Some craft studios specialize in one medium—such as ceramics or stained glass—and employ craftspeople to produce work from the designs of others, rather than original works of their own.

In recent years, the differences between crafted objects and fine art have become less obvious: wooden chairs have taken on the look of fine sculpture, woven clothing is often hung on walls as decoration. The distinctive styles of a few craftspeople have even placed them on a par with fine artists, and created great demand for this work.

Photography

Photojournalists provide the pictures you see in magazines and newspapers. They make pictorial stories with their cameras, rather than notebooks. Photojournalists must be expert in the use of many different cameras and lenses and be able to handle them with speed and accuracy under all kinds of conditions. They also know darkroom and printing procedures. They travel to many different locations to photograph people and events, such as scenes of human tragedy, war, celebrations and affairs of state. Because it takes so many years to develop a reputation as a photojournalist, many of them start out working free-lance. They may take pictures on assignment from editors or shoot them on speculation and try to sell their work to a publisher.

Fashion photographers create pictures for newspapers, department store catalogs and magazines. They work with models in a studio or on location at such places as a beach, a shopping mall or an airport. Fashion photographers must know how models move and pose so they can direct their movements during photo sessions. They are skilled in

creating special lighting effects on location and in the studio. Photographing models in action at fashion shows requires prearrangement of lighting and rapid camera work during the presentation. Fashion photographers create moods in pictures, ranging from natural to dramatic poses and subdued to flamboyant action.

Illustration photographers provide photos for books and magazines, record jackets, travel brochures, corporation annual reports and advertisements. Photographs are frequently used in place of drawings and paintings for commercial publications. Illustration photographers often

14-15 Courtesy The Worcester Telegram and Gazette.

receive ideas from agency and corporation art directors, and try to make those ideas come alive by creating environments populated with models, props, backgrounds and sets. An illustration photographer must be able to produce photos that are vital and stimulating.

Advertising photographers specialize in taking pictures of products for advertisements that are used in magazines, newspapers, on billboards and on TV. The photographer may work with an ad agency art director to fulfill the needs of an ad layout, taking pictures of products ranging from jewelry to refrigerators. The finished photos must attract the public's attention, make the product appealing, and hold the viewer's attention long enough for communication about the product. Because ad photographers take photos of so many different surfaces (foods, fabrics, fur, glass, diamonds, wood, plastic, metal, and so on) they must have expertise in arranging backgrounds and lighting effects.

Portrait photographers make photo studies of their subjects. They generally have a studio, but will go to locations for special events such as graduations, weddings, birthdays and award ceremonies. Portrait photographers are expert at posing subjects and arranging complementary lighting for children, men and women of all ages. They know how to use a variety of cameras, film and developmental processes and can produce photographs that resemble painted portraits.

There are many other art related careers that were not discussed in this chapter. For more art career information you may consult your art teacher or school guidance counselor, or write to college and university art departments and professional art schools.

Challenge 14-1:

Research a career in art that interests you. Consider the training, responsibilities, rewards and other characteristics of the job.

Part V What

Chapter 15 Interpretation: There Is More To It Than Meets

The Eye

Chapter 16 Non-Western Art I

Chapter 17 Non-Western Art II

Chapter 18 Islands of Time I Chapter 19 Islands of time II

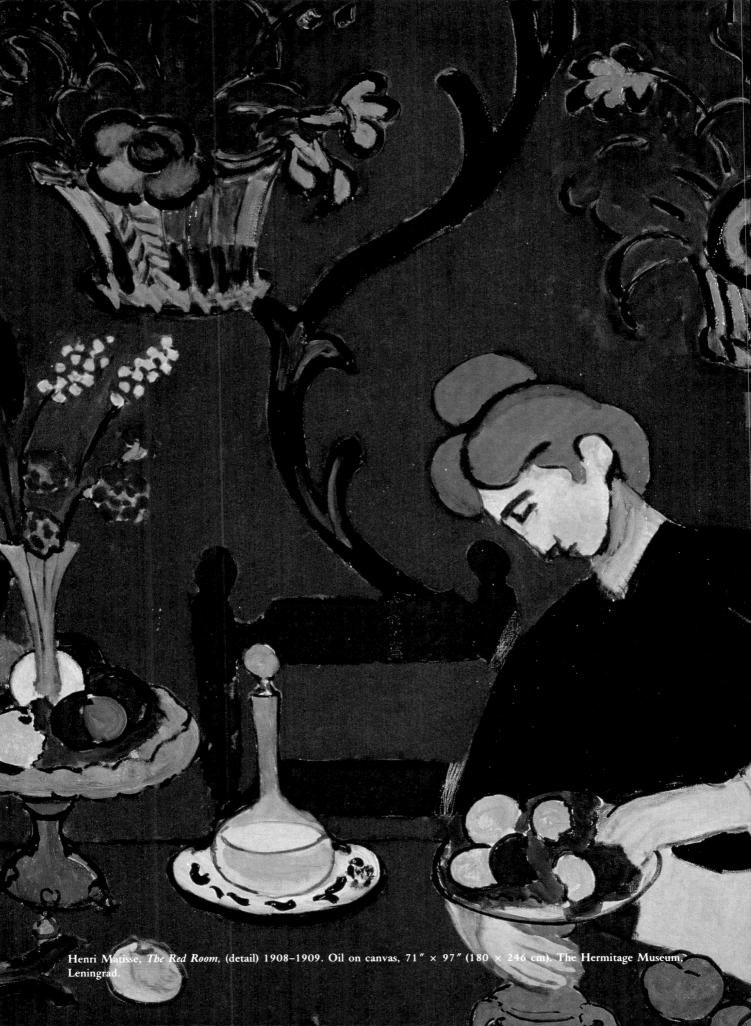

Chapter 15

Interpretation: There Is More To It Than Meets the Eye

15-1 Charles M. Russell, *The Toll Collectors*, 1913. Oil on canvas, $24'' \times 36''$ (61×92 cm). The Mackay Collection, Montana Historical Society.

You have been introduced to the task of describing an artwork (Chapter 5) and the task of analyzing an artwork (Chapter 9). Other chapters discussed the visual elements, principles of design, and the major two-dimensional and three-dimensional media. In those chapters you were provided not only with knowledge about those subjects, but also with a vocabulary of terms to assist you in describing and analyzing art.

Interpretation and Meaning

Now that you are able to describe and analyze, you are ready to *interpret*. To interpret an artwork is to explain the *meaning* of it. What does it express? What is its *content*? You have already experienced some examples of interpretation. You saw how lines could be agitated or relaxed, how

colors could be warm or cool, how shapes could be closed or open, how a composition could be well balanced, and how the positive and negative areas of a carved sculpture could flow into one another. Those qualities expressed certain feelings or ideas that you, the viewer, could interpret. The focus of this chapter is on the interpretation and meaning of artworks.

An Example of Interpretation

Imagine being asked to interpret The Toll Collectors (fig. 15-1) by Charles M. Russell. First of all, you would describe and analyze it.

As you can see, the subject is a landscape containing people and animals. In the foreground are a cowboy and an Indian - both mounted on horses, both carying weapons, both looking serious. In the middle ground are cattle, a cowboy on the left, and more Indians on the right. In the distance are more cattle - seemingly a large herd headed this way. In the far distance are the faint outlines of a mountain range. You might have guessed from the title and the gesture of the Indian that a toll, or payment, is involved. (Indeed, the Indian, who is a Crow warrior, is demanding a toll of \$1.00 a head – indicated by his uplifted finger - before allowing the cattle and the cowboys to cross tribal land.) With just the information provided so far, you may be ready to offer an interpretation.

Because you are aware of the visual elements, the principles of composition, and the oil medium, however, your observations would not stop at just the subject matter and information contained in the title. You would note that Russell's style is basically realistic. Animals, men, and land are quite natural looking; the sense of deep space is especially convincing. The artist skillfully distributed colors and values in such a way as to suggest that the time is early morning (or late afternoon) and that the atmosphere is hazy (note the effective use of aerial perspective). Russell used the oil medium much as Renoir did in Luncheon of the Boating Party (fig. 3-1), that is, with short brush strokes (especially apparent in the distant herd). Lines of continuation uniting the scene horizontally can be seen in the broad sweep of the hill in the foreground as well as the mountains on the horizon. The warm colors of the cowboy and Indian, whose bodies overlap the bluish shapes of the mountains, unite foreground and background. Of course, much more could be said in describing and analyzing Russell's painting, but, for this example, only the main features have been noted. Now you are ready to interpret the work. Like the description and analysis, the interpretation that follows is not intended to be complete.

You might begin by saying that The Toll Collectors is about a meeting between a cowboy and an Indian. However, because of the demand for toll, this meeting portends challenge, even danger. Perhaps the meeting should be called a confrontation. The confrontation itself, however, is not portrayed in an obviously dramatic way. Russell's earthy realism, especially with regard to the ordinary appearance of the men, tends to downplay a sense of drama or heroics. Except for the presence of weapons, there is no indication of violence. Except for the cattle in the background pushing ever closer, there is very little movement. But there is more to consider than the men, their weapons, and the cattle, important as these are. The setting is a vast wilderness – the "Old West." This wilderness not only represents the geography of cattle drives, it imparts to this picture a sense of scale, and enlarges its meaning. The scene becomes a symbol of a much greater confrontation - a territorial struggle between two cultures with extremely different lifestyles and histories.

Sources of Meaning

The meaning stated in the previous paragraph is based on things you see in the picture (and, to some extent, what you read in the title). Meanwhile, the exercises of describing, analyzing, and interpreting helped you to bring out the most from these seen things.

But the meaning of Russell's picture is also based on things you do not see. For example, you do not actually see a "territorial struggle between two cultures." Although this aspect of the interpretation is implied by what is seen, it is also based on what you know. Conflicts between Indians and the white settlers, along with cowboys, cattle drives, sagebrush, and the semi-arid landscape of the western territories, are all a part of your knowledge and mental imagery of the Old West, an American legend. You were exposed to this in school as history. You probably were exposed to much more of this from movies and TV stories about cowboys, Indians, and outlaws. This is not to say that those stories were factual. Most were exaggerated and very misleading about the true conditions of the time in the western territories. But the point is: you are very familiar with the colorful history of the Old West, whether fact, legend, or both. Without this knowledge, Russell's painting would have had little meaning. Indeed, you probably would not even have recognized the two people as being a cowboy and an Indian!

15-2 Charles M. Russell, Wild Meat for Wild Men, 1890. Oil, 201/4" × 361/8" (52 × 92 cm). Amon Carter Museum, Fort Worth, Texas.

15-3 Egyptian tomb, 2450 B.C. Painted limestone.

Russell based The Toll Collectors on memories of his own experiences in the Montana Territory in the 1880's (about the time that Renoir painted Luncheon of the Boating Party in France). One of these experiences included spending a winter with the Blackfoot Indian tribe. Developing an admiration for the Indian that lasted the rest of his life, Russell paid tribute to his "red brothers" by depicting their exploits (fig. 15-2) more than those of cowboys. If you knew more about the artist and had seen many of his paintings, you no doubt would have discovered even deeper meanings in this work.

Unfamiliar Art from Unfamiliar Places

Now, imagine being asked to interpret a painted low-relief mural (fig. 15-3) done on a limestone wall of a 2450 B.C. Egyptian tomb.

You might first of all note that this work consists of two bands (or registers), showing men in a boat and men working (including two carrying bales of some kind of stalks) in the upper register, and men and cattle in the lower. The images of the men are quite simple and flat. Compared to the men, the animals are more varied in both shape and detail. The animals even overlap one another. Other than this overlapping, the mural is almost com-

Sokari Douglas Camp 1958-

Strips of steel are bound together to form the structure of a bed. The metal frame sags with the weight of a body which is not there. There is only the presence of the spirit of a person remaining behind. Surrounding the bed are huddled figures drawn in ribbons of steel. Church Ede is a memorial to the father of Sokari Douglas Camp, the artist who created this unusual sculpture. It reconstructs the Nigerian funerary ceremony which honored her father's death. Turn on the electric motor which operates this moving work of art, and the grieving figures begin to move. As they fan the missing body with fly whisks, the bed begins to shake, symbolizing the continuing vitality of the afterlife. The sound of the whirring motors, the shaking fans held by the mourners, the rattling metal strips which form the bed, and the partially complete figures compel your imagination to complete this scene. At once, the viewer captures a glimpse of the Kalabari culture in which this ceremony originated.

Sokari uses the materials and techniques of contemporary Western art to create sculptures which tell of the Kalabari people among whom she was raised, and her youth in the Niger Valley of southern Nigeria. Though Sokari's early life was spent in Buguma, Nigeria, as a child she moved to England to live with her sister.

Sokari's experiences in Africa and in the

Sokari Douglas Camp, Church Ede (Decorated Bed for Christian Wake), 1984. Steel, cloth, H. 8 ft. Collection of the artist, courtesy the National Museum of African Art, Smithsonian Institution, Washington, D.C. Photograph: Jeffrey Ploskonka, Eliot Elisofon Archives.

Western world have had unique influences on her life and art. Her early exposure to the ceremonies and festivals associated with Kalabari culture were significant to Sokari. Her schooling in England and later in the United States influenced the methods and materials she uses to express these early memories of Nigeria. Sokari Douglas Camp combines Western art with the traditional culture of the Kalabari people to express ideas and communicate stories in an art which is uniquely her own.

pletely lacking in depth. In the upper register, for example, men and boat are all on the same horizontal line.

Although the men are flat, they are shown in a variety of positions. Almost all are doing something different. The variety of their activities provide interest and the repetitions of both men and cattle provide a rhythm and prompt the eye to scan the whole mural. When doing so, you can almost hear the bellowing of the cattle and the grunting of the men carrying bales.

Beyond these impressions - vivid as they are - there is little else that you can get out of this work, leaving you with little to say about it by way of interpretation. Indeed, the more you study the mural, the more questions it raises. Among the many questions you may have are: What is the purpose of the mural? Does it represent some sort of Egyptian cattle drive? Why is it located in a tomb? Who was the artist? Why is the style so simple, so regular, and so lacking in depth?

15-4 Terra cotta grave figure, T 'ang dynasty. Museum of Far Eastern Antiquities, Stockholm.

Unlike your interpretation of *The Toll Collectors*, your interpretation of the Egyptian mural depends almost entirely on what you *see*. What you *know* about ancient Egypt and its art, compared to what you know about the Old West and its legends, is obviously limited.

Now, look at the small statue in figure 15-4. You recognize this as a man on a horse, but also as a captured moment in which the rider is restraining the horse with his reins (now missing). The posture of the horse, which seems to have come to a sudden stop, is in rhythm with the posture of the man, who is leaning back sharply. You may have recognized that it is ceramic. Its rough textures complement the subject matter as well as the forms of the stocky horse and rider. In other words, this sculpture has a meaning based on its visible forms. But without additional knowledge, that meaning is rather limited. It was made in China during the T'ang dynasty (A.D. 600's). This bit of

information helps you to locate it in time and place, and perhaps account for the costume of the man. But think how much richer the meaning would be if you knew something of the history and culture of China, especially during the T'ang dynasty.

As stated earlier, meaning is based on things you see, but also on things you do not see, that is, things you know. Observing the images of a work, along with its colors, shapes, and directions, is not always enough to help you solve its meaning. If the images do not "connect" with your own experiences, background, and education, you may be unable to solve the meaning satisfactorily. This is especially true for a work from an unfamiliar time and place, such as ancient Egypt or T'ang dynasty China. This would even be true for a work like *The Toll Collectors* if a viewer had little knowledge of American legendary history.

Art History

Art history is the study of art, especially with regard to the ways it has existed through time. It provides information about periods of history, periods of art, and changing styles. It also provides information about the social context of art. Knowing the historical and social circumstances of a work will give you a better perspective from which to understand and interpret it.

Like an archeologist, an art historian sifts through the evidence-other artworks, books and writings of the period, and sometimes even court records. Like a story teller, he or she attempts to "re-create" an artwork in the context of its original time and place, and to shed light on

how it was experienced by the people living at that time. As writer Gerald Brommer explains, "Art history adds personality to works of art."

Knowledge of this sort can help you bring an ancient mural and a Chinese sculpture back to life. Of course, you can never experience the mural in exactly the same way the citizens in Saqquara, Egypt did in 2450 B.C., or experience the statue the way people in Hsian, China did in the 600's. But through the help of art history, you can reconstruct those experiences to some extent, and thus better understand the meaning of these works.

The next four chapters, which discuss non-Western and Western art history, will provide an overview of China and Egypt, among other cultures.

Challenge 15-1:

Interpret American Gothic by Grant Wood using information from your earlier description (Challenge 3-1) and your analysis (Challenge 9-1) and relevant knowledge from your own experiences. Use the following guidelines for interpretation.

- 1. Assemble information from your description and analysis to help you identify what the artwork expresses, or what it means. If you did not do a description or analysis, complete them now. The guidelines provided for Challenges 3-1 and 9-1 will be belpful.
- 2. Assemble information from your own knowledge and experiences that is related to the subject matter, the elements such as forms, shapes and colors, and the theme of the artwork to help identify what the work means.
 - a) Are there things the work reminds you of?
 - b) Have you seen, read, or studied about situations or things similar to what you see in the artwork?
- 3. Form a hypothesis about what the work means. A hypothesis is an assumption, or an informed guess based on evidence you have collected.
 - a) Does your evidence based on what you saw in description and analysis support your bypothesis?
 - b) Does your evidence based on what you know from personal experiences, studies, travels, and readings support your bypothesis?

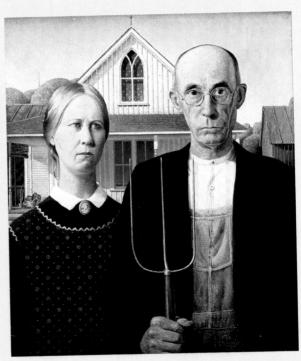

15-6 Grant Wood, American Gotbic, 1930. Oil on beaver board, $30'' \times 25''$ (76 × 63 cm). Friends of American Art, The Art Institute of Chicago.

4. If your evidence does not support your hypothesis, try another one.

Chapter 16

Non-Western Art I

16-0 Ranganathaswanny Temple, Tamilnadi, South India. This is the tallest (236 feet) temple tower in Asia. Photograph courtesy James Ellison Thomas.

Introduction

The great civilizations of India, the Orient, Islam, and Pre-Columbian America, and the tribal societies of Africa and North America are among the many non-Western cultures. Any culture that is not related to Western civilization (the people of North America and western Europe) is referred to as non-Western.

As a collection, non-Western cultures represent an incredible variety of geography, peoples, history, beliefs, and art. Indeed, they have little in common with one another—beyond the fact that they all produce (or did produce) art. But some generalizations about them can be made by contrasting them as a group with Western culture.

Consider the theme of *individualism*, for example. Individualism has been a tradition in Western culture for centuries, and is probably emphasized more today than it was in the past. Among other things, individualism means a doctrine of freedom from the restrictions of government. It is responsible for our concepts of free speech, free thinking, and free enterprise. Individualism has no doubt been a source for the creative energy and inventiveness that have distinguished our culture through time. But individualism has also contributed to people leading lives of egotism and greed, and for placing self-interest above the common good.

By contrast, people of non-Western societies, especially Asians, believe the opposite, that it is better to place the common good above one's own interests. Such an attitude obviously has an effect on the ways people relate to their jobs, families, nation, and even to nature. This attitude, along with other values, beliefs, and themes, also is reflected in a culture's symbols and art.

Another difference between Western and non-Western cultures involves the concept of art itself. Whereas in the twentieth-century West, the purpose of art is primarily for aesthetic enjoyment (Chapter 2), in non-Western societies, art has many purposes, including magic, worship, ritual, sacrifice, propaganda, status, and even politics.

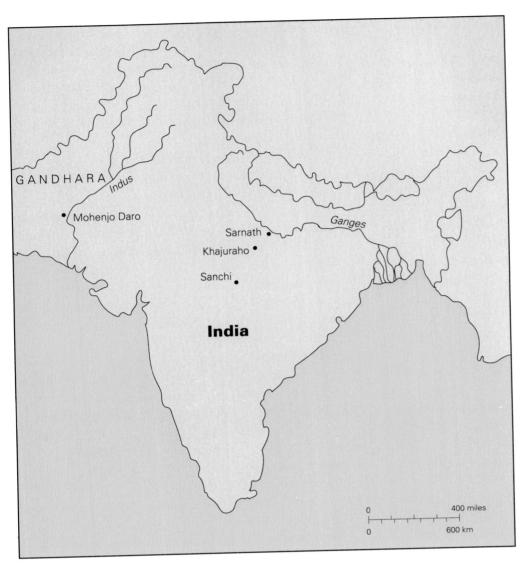

India

India can trace its roots to recently discovered settlements near Mohenjo-Daro on the Indus River in what is now Pakistan (fig. 16-1). Excavations there revealed that these settlements go back in time more than 5,000 years, and that they consisted of cities with hundreds of houses, shops, streets, wells, and drainage systems. There was even evidence that the people of those ancient cities wrote contracts and signed legal documents. Among the smaller finds were seals carved in stone (fig. 16-2) that officials used to stamp (or "sign") documents written on tablets of damp clay. A civilization, as defined by historians, is a culture with cities. (Civilization comes from the Latin word civis, meaning city.) Therefore, the culture of the Mohenjo-Daro settlements would be classified as a civilization. The Mohenjo-Daro civilization appeared in the fertile valley of

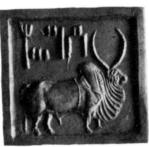

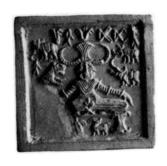

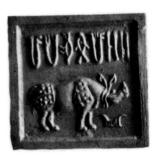

16-2 Seals, Mohenjo-Daro, third millenium B.C. Steatite, National Museum, New Delhi.

the Indus River between 4000 and 3000 B.C. This is an interesting occurrence because other civilizations also emerged in river valleys in different parts of the world at around the same time: the Nile River (Egypt), the Yellow River (China), and between the Tigris and Euphrates Rivers (Sumeria, which is now Iraq).

Thus modern India, which is not quite half as large as the United States, but has more people than North and South America combined, can claim to be one of the oldest continuing civilizations. It is a nation of fourteen languages, many religions (although Hinduism is the main religion), and several ethnic groups. This mixture is a reflection of a geography with extreme contrasts—from snow-covered mountains (among the highest in the world) to steamy jungles, with dry deserts in between. This mixture of cultures is also a reflection of India's rich history.

Around 2000 B.C. a tribal people invaded India from the north. The newcomers not only conquered the native Indians, they introduced their own hymns called the *Vedas* (like the poems of the Jewish Old Testament or the myths of the ancient Greeks). These hymns (which evolved into philosophical creeds called the *Upanishads*) marked the beginnings of *Hinduism*, the world's most ancient religion. Unlike Christianity, Hinduism is *polytheistic*, that is, its worshipers believe in many gods rather than just one god. But perhaps the most unique feature of this religion is its doctrine of *reincarnation* (or *samsara*), the belief that life can be an endless cycle. The stages of birth, life, and death are repeated again and again. Specifically, a person's soul

never dies, but is continually reborn (or reincarnated) in a new body, either human or animal. The type of body that a soul occupies in any given life depends on its *karma*, a kind of reward or punishment based on the soul's behavior in its previous life. If the soul was good, it might be given the body of a prince or princess; if bad, it might be given the body of a rat or snake.

Hindiusm was the dominant religion for about 1,500 years. Then Buddha was born about five hundred years before the birth of Christ. During his youth, Buddha (the "enlightened" one) experienced a vision while sitting under a shade tree in which he saw the endless succession of birth and death in the stream of life. From this experience he determined that all evil and suffering was caused by desire, and that human desire started with birth. After seven years of meditation, he proceeded to the city of Sarnath to preach about his insight and found the new faith of Buddbism. At first considered just a splinter denomination of Hinduism, Buddhism became stronger than Hinduism in India (at least for awhile), and then spread to other countries to become one of the largest religions of the world. The goal of all Buddhists is to achieve nirvana, the final state of eternal bliss. To do so, one must conquer not only desire, but the self, and lead a life of perfect justice, patience, and kindness. Only then can the soul break the endless cycle of birth.

A fitting symbol of the Buddhist faith is the *stupa*, an architectural form that evolved out of a burial mound. The best example of this form is the Great Stupa at Sanchi (fig.

16-3 Stupa I, Sanchee, India, second century B.C.—first century A.D. Solid masonry.

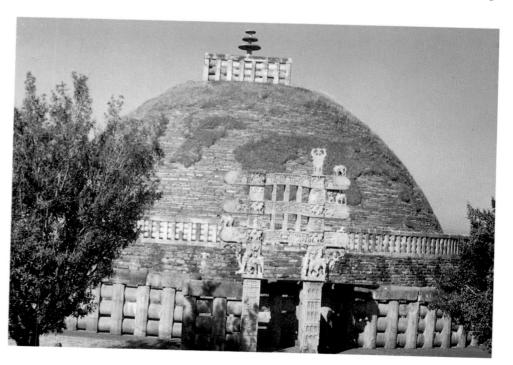

16–3) begun under King Asoka during the second century B.C. Except for a small burial chamber in the center, the Great Stupa is almost solid *masonry* (built of stone, brick, or concrete; in this case, the material is brick). It was intended to represent the dome of heaven or the world mountain. The little balcony on its top was intended to symbolize the domain of thirty-three gods; the ornamental gates, each located at one of the four compass points, were intended to make it a sort of astronomical map. But in addition to the specific symbolism, the circularity of the stupa form is a perfect metaphor for the cycle of life, and the simplicity of the dome itself symbolizes the serenity of nirvana.

There is no image of Buddha himself on the Great Stupa, although he is represented symbolically by his signs, such as his throne, his shade tree, and even his footprints. Human images of Buddha did not appear until about A.D. 100, first in the northwest region of Gandhara (now Afghanistan and Pakistan). Gandhara, which had been occupied by the Greek legions of Alexander the Great four hundred years earlier, was in contact with the civilizations of Greece and Rome. Therefore the style of many of the early images of Buddha (fig. 16-4) resembled Greek or Roman styles. But the content was uniquely Buddhist. Gandhara sculptors were obliged to express the qualities of inward peace and release from desire that Buddha himself preached. Thus he is shown quietly meditating while seated with legs crossed in a yoga position. In addition, he is given elongated ear lobes, a protrusion from the head, a dot between the eyes – all signs of his superhuman perfection.

Later, in areas south of Gandhara, sculptors began to create Buddha statues in a style more akin to that of the carvings on the gates of the Great Stupa. The Buddha from Sarnath (fig. 16–5), wears a thin gown and has a softly curved, feminine body typical of Buddhas made thereafter in India and elsewhere. In addition to the signs included in the Gandhara image, this one shows Buddha with spoked wheels on the soles of his feet and practicing stylized hand gestures called *mudras*.

As time progressed, Buddhism, which had started out as a reform of Hinduism, drifted farther away from the humble teachings of Buddha himself, Partly for this reason, and partly because Hinduism was experiencing a revival, Buddhism was overtaken by its old rival. Ironically, while Hinduism was becoming stronger in India, Buddhism was becoming stronger in the rest of Asia. Perhaps as a tribute to its former rival, Hinduism proclaimed Buddha as one of its many gods. But Hinduism's main gods

16-4 Gautama Budda in Contemplation, Gandhara, 1st to 3rd century A.D. Black schist, $2'4\frac{3}{4}'' \times 22\frac{1}{2}''(73 \times 57 \text{ cm})$. Yale University Art Gallery (Anonymous gift through Alfred R. Bellinger).

16-5 Seated Buddha Preaching the First Sermon, Sarnath, fifth century A.D. Stele, sandstone, 63 " (160 cm) high. Archaeological Museum, Sarnath.

were Brahma the creator, Vishnu the preserver, and Siva the destroyer. To this day, Hindus also worship cows as representatives of the divine, and adhere to a caste system – a rigid division of social classes with "Brahmans" at the top and "untouchables" at the bottom.

Buddhism and Hinduism coexisted for so many years that they often shared the same styles of architecture. Khajuraho is the home of a sacred neighborhood of temples built around the eleventh century. Some temples are Hindu, some are Buddhist, and some are Jainist (another offshoot of Hinduism), yet all are similar. Among the most impressive is a Hindu temple dedicated to Siva as Mahadeva, Lord of Lords (fig. 16-6). Because of its conical domes and richly carved surfaces, the Mahadeva shrine looks like a cluster of beehives. Contrast its abundant decoration with the simplicity of the Great Stupa. Also different is the fact that the Hindu temple is not solid masonry. Within its walls are openings for sanctuaries, aisles, and assembly halls (surrounded by porches). But none of these are large. The principle of construction –

not only of this building, but of most ancient temples - is post and lintel. In a post-and-lintel building, the walls, posts, or columns support a masonry ceiling (fig. 16-7). Because a masonry ceiling is so heavy, the inside of any masonry post-and-lintel building is very small compared to the mass of material used to build it.

Hindu gods tended to be exotic: Brahma had four faces, Siva had three eyes, another god had one thousand, and almost all gods had four arms. Such extraordinary anatomy was a sign of extraordinary knowledge, activity, or power. In the superb example of a Siva bronze, it is the god's extraordinary grace that is signified (fig. 16–8). The god's body, like Buddha's, is supple and feminine, but Siva's posture is anything but sedentary. Performing a dance within a flaming arch, he balances on one foot while executing delicate mudras with each of his four hands. Made for a shrine or to be carried in a procession, this image portrays Siva as Lord of the Dance, one of his many reincarnations.

16-7 Post and lintel.

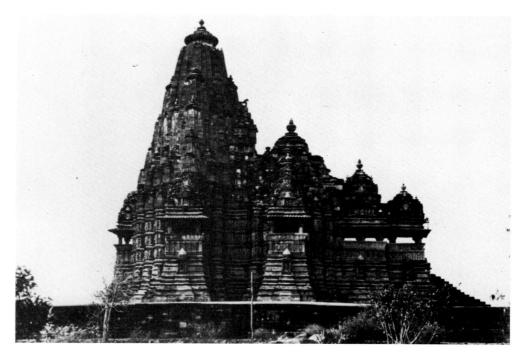

16-6 Kandarya Mahadeva Temple, Khajuraho, India, tenth-eleventh centuries.

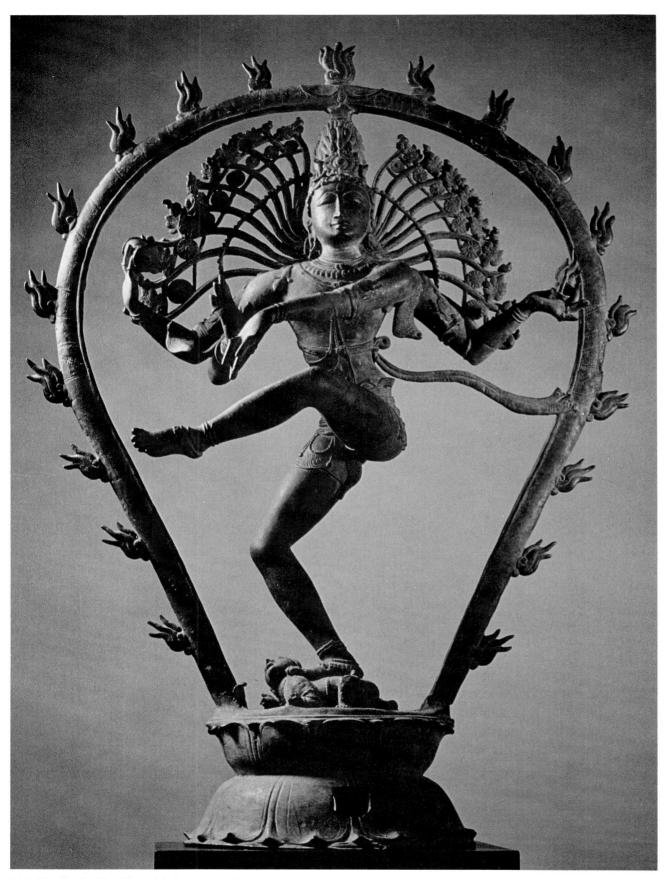

16-8 Tamilnada, Siva, King of the Dancers, Performing the Nataraja, Chola dynasty, India, tenth century, Bronze, $30'' \times 22^{1/2}'' \times 7''$ (76 × 57 × 18 cm). The Los Angeles County Museum of Art (Anonymous gift).

Southeast Asia

Indian culture spread to Burma, Thailand, Kampuchea (Cambodia), Sumatra, and Java (fig. 16-9). It is important to know that Buddhism had divided into two branches Hinayana, the Lesser Vehicle, and Mahayana, the Greater Vehicle. Hinayana supposedly followed the simplicity of Buddha's original teachings, while Mahayana proclaimed Buddha a god and surrounded him with angels, old Vedic gods, and bodhisattvas - special saints who chose continual rebirth rather than nirvana so that they could help others. Mahayana, which prevailed in northern India, spread to Tibet, Mongolia, China, and Japan (see below). Hinayana, which prevailed in southern India, took root in Southeast Asia. However, judging by the rich complexity of styles and symbolism in Southeast Asian art, it is clear that the influences of not only Mahayana Buddhism, but also Hinduism, took root there as well.

Rising on a plain in Java is one of Buddhism's greatest monuments: the stupa at Borobodur (fig. 16–10). The

shrine is actually a rounded hill, terraced and clothed in masonry. Therefore, it effectively embodies the Indian concept of the sky as a bowl covering the world mountain. It consists of nine levels. Of these, the base (which is mostly underground) and first four levels are rectangular, the next three are circular, and the top level consists of a single stupa. The relief sculptures on the base depict people caught in the grip of desire, and the endless hell of birth, death, and rebirth that Buddha warned about. The next four levels illustrate a variety of Buddha's teachings, or sutras (threads). The circular levels contain no relief carvings, but seventy-two miniature bell-shaped stupas, each harboring a seated Buddha. Thus the stages of enlightenment are unfolded as one progresses from the bottom level to the large stupa at the top, the climax of the shrine. The symbolism is Buddhist, but the tropical profusion of architecture and carving is more like Hindu art. Imagine the experience of intrepid pilgrims as they climb the stairs, walk through the corridors, and view this virtual encyclopedia of Buddhist culture.

16-9 Southeast Asia.

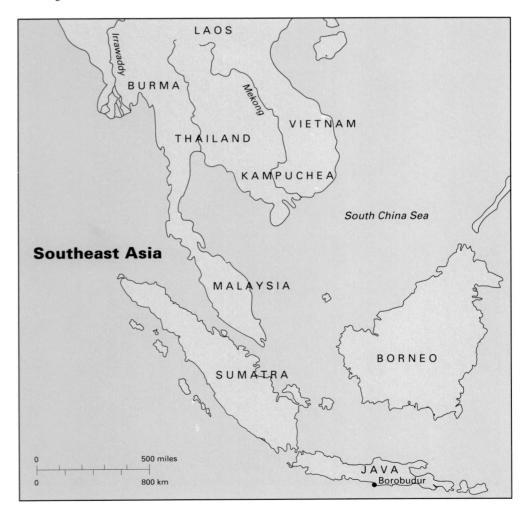

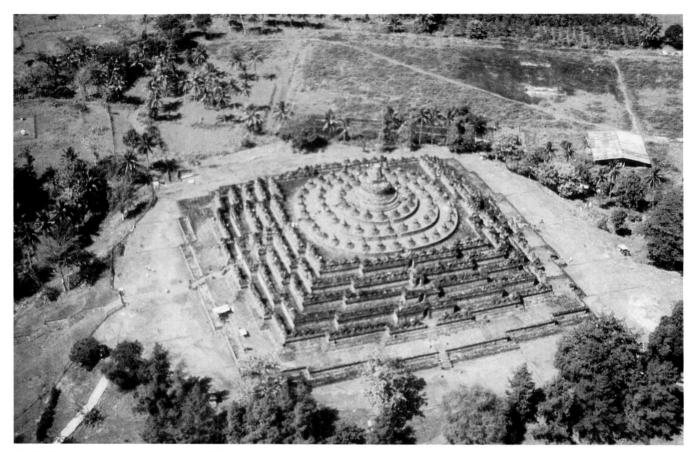

16-10 Stupa, Borobudur, Java, ca. A.D. 800.

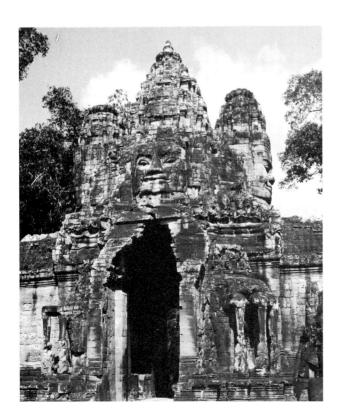

16-10A Rulers in ancient Cambodia were seen as gods. To make their divinity visible, they constructed huge temples influenced by the Hindu religion. This temple, Angkor Thom, shows the sculptured faces of Jayavarmin VII. It was built about 1190 A.D.

16-11 China.

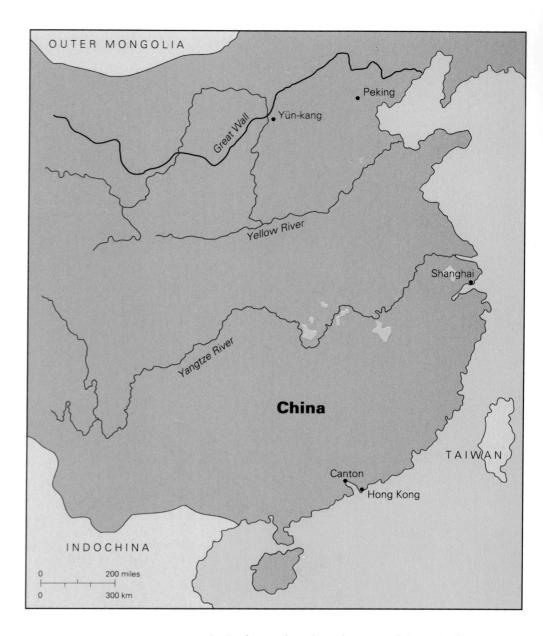

China

Modern China (fig. 16–11) is a country endowed with great rivers, fertile valleys, windswept plains, majestic mountains, and natural harbors. It is remarkably similar to the United States in size and geography, but its population is four times as large. In history, China is twenty times older.

Any country this large is bound to have regional diversity among its people. Nine-tenths of the population is crowded into the eastern sixth of the nation. The spoken language is so varied as to be unrecognizable in different areas. Overshadowing this variety, however, is a common racial heritage, a cultural lineage as old as India's, and a written language that is understood by everyone. China—hemmed in by the Pacific Ocean on the east, high moun-

tains in the south and southwest, and desert in the west and north—was splendidly isolated through much of its history. Thus it was able to develop its cultural traditions in relative security.

The earliest art of historic China that we know about is from the Shang dynasty that thrived from the eighteenth to twelfth centuries B.c. in the northern part of the country. (Dynasty refers to a succession of rulers who are members of the same family.) To appease the spirits of their dead kings, the Shang were known to sacrifice and bury human captives or servants with the deceased. Also included in the graves were remarkable bronze objects cast by means of piece molds rather than the lost-wax process (Chapter 13). When these bronzes were discovered in 1928, scholars were so impressed by their craftsmanship that

they believed the Shang must have practiced this technique for centuries. Most of the objects are ritual vessels for holding wine or food used in sacrificial rites (fig. 16–12). Their forms, unlike those of most vessels, tend to be rather angular. The low-relief decorations, consisting of animal symbols along with spirals, ovals, and zig-zags, are compact and vigorous. In many ways these vessels resemble suits of armor, perhaps a reflection – consciously or not – of a militaristic and barbaric society.

The cruel custom of human sacrifice continued for a while during the Zhou dynasty but soon was ended and became a relic of a barbarous past. Indeed, the Zhou period saw the flowering of Chinese philosophy and writing. The sixth century B.c., the century Buddha was born, was the golden age of Chinese philosophers. (Half a world away in Greece, another age of philosophy was dawning at about the same time.)

Lao-tzu, one of the sages, recommended withdrawal from the hurly-burly of society to become one with

16-13 Portrait of Confucius based on Ancient Traditions. Relief from the Stele in the Pei Lin of Sigan-Fou. The Bettman Archive, New York

16-12 An example of a vessel used in sacrificial rites. Libation tripod (Chia), 12th century B.C., Shang dynasty, middle An-yany. Bronze, $20'' \times 12'' (53 \times 30.5 \text{ cm})$, courtesy of the Freer Gallery of Art, Smithsonian Institution, Washington, D.C.

nature. A quiet person who distrusted intellectuals, Laotzu taught mostly by example and by the precepts of a philosophy called Taoism. According to Taoism, the secret of wisdom and lasting happiness was to follow a life of simplicity, modesty, patience, and obedience to the laws of nature. To this day, the principle of submitting to nature is deeply ingrained in the minds of the Chinese. By contrast, Westerners tend to believe that nature should submit to the will of people (an attitude fostered by the Old Testament teachings of Genesis 1:26 and Psalm 8:6). China's greatest thinker was Confucius (fig. 16-13). Like Lao-tzu, Confucius advocated humility, patience, and respect for nature. But unlike Lao-tzu, he recommended taking an active role in society rather than withdrawing from it. He came up with the familiar maxim, Do not do unto others as you would not wish done unto yourself, five hundred years before Christ. Like Christ, he taught by word of mouth rather than by writing. Fortunately his words were

16-14 Bodhisattva from the Yun K'ang temple grotto. Northern Wei Period, Late fifth century, Sandstone, 57½" × 29" (146 × 74 cm). The Metropolitan Museum of Art (Rogers Fund, 1922).

recorded by his disciples, and kept alive by scholars down through the ages. His teachings and sayings, like the Gospels of the New Testament, influenced a whole culture, which in this case, spread to Korea, Japan, and parts of Southeast Asia.

The Han dynasty, which took control of China in 206 B.C., was contemporary with the Roman Empire in the West. Just as Rome extended its boundaries all over Europe and northern Africa, China, under the Han emperors, extended its boundaries to Korea in the north, Vietnam in the south, and Afghanistan in the west. Silk

production increased dramatically, and trade routes penetrated as far as Rome. Confucianism was the official policy of the state. Also like Rome, the Han empire was to experience chaos and barbaric invasions during its final years. During this time Buddhism was introduced into China. The new religion seemed to answer the needs of the Chinese people during their times of trouble.

The new religion also provided some ready-made subject matter and styles for art. A fifth-century bodhisattva (fig. 16–14) – part of a collection of sculptures carved into the side of a sandstone cliff – reflects many of the qualities

of the Indian statues of Buddha. Its gown is similar to the gown of the Gandhara Buddha (fig. 16-4), while its soft features and gentle mudras are similar to those of the Buddha from Sarnath (fig. 16-5). The bodhisattva's passive face and body capture the spirit of serenity preached by Buddha himself, despite the fact that it was made during the period of unrest after the Han dynasty.

Buddhism continued strong into the T'ang dynasty (A.D. 618-907), one of China's greatest periods. An enlightened emperor, Tang Tai Zong, brought order to the northern borders, led his armies to the ends of the deserts in the west, reestablished the old trade routes, established libraries and universities, and encouraged the arts and the development of printing. Students flocked to China's capital from Tibet, central Asia, Korea, and Japan. Although excellent Buddhist art was made at this time, non-Buddhist art is perhaps more reflective of T'ang vigor. The ceramic sculpture of the man on a horse discussed in Chapter 15 is a case in point (fig. 16–15). Mounted warriors were important for keeping order within the empire and protecting trade routes on the empire's borders. The taut posture and stocky proportions of horse and rider reveal the stoic determination needed for this kind of mission. One can easily imagine the two escorting a caravan of silk merchants across the Gobi desert, a place not unlike Russell's desert in the American West (fig. 15-1).

16-15 Terra cotta grave figure, T'ang dynasty. Museum of Far Eastern Antiquities, Stockholm.

16-16 Bare Willows and Distant Mountains, attributed to Ma Yuan, Sung dynasty, twelfth-thirteenth century. Boston Museum of Fine Arts.

The T'ang dynasty, after three centuries of successful rule, ended in a series of civil wars. During this troublesome period, the Chinese turned to a source of hope, just as their ancestors had turned to Buddhism at the end of the Han dynasty. Only this time, the source was nature, and the image of this source was a landscape instead of a statue of Buddha or a bodhisattva.

Landscape painting may have been taken up by Chinese artists even before the T'ang dynasty, but the finest examples of this art came into being during the Sung dynasty (960–1279). Popular among Sung artists was a cult of nature based on all three elements of China's spiritual heritage: Taoism, Confucianism, and Buddhism. Thus, a reverence for nature, Confucian philosophy, and the serenity of Buddha were combined. Ma Yuan's Bare Willows and Distant Mountains (fig. 16-16) exemplifies this combination. The same work was discussed in Chapter 7 as an example of aerial perspective (fig. 7-26). Ma Yuan accomplished the effects of mist and endless space with the technique of ink wash on silk - a medium that requires the respect of the artist, just as nature requires the respect of all people. A wash cannot be forced; the artist must literally "go with the flow" as the watery ink glides across the surface and sinks into the pores of the fabric. In addition to washes, Ma Yuan used darker lines for detail and to provide focus. Because of his skill and sensitivity, he was able to produce a convincing vision of airy landscape and also a sense of mystical infinity. Unlike Western paintings, which

16-17 Underglaze porcelain jar, Chiangning, Kiangsu.

were meant to be hung on walls, Chinese paintings, which were often stored in scrolls, were meant to be viewed in private-like reading a book of poems. The Sung landscape, as much as any Chinese art, is exemplary of Chinese civilization and expressive of its deepest spiritual values.

Fine landscapes, such as the one shown in figure 4-12, continued to be produced during later dynasties, even during the Yüan dynasty when China had been overrun by the Mongol hordes of Kublai Khan. But no review of Chinese art would be complete without discussing ceramic art. The genesis of this art goes back to prehistoric China. Discoveries of excellent pottery at sites in Honan have been dated to 3,000 B.C. or earlier. As we saw in Chapter 13, the Chinese of the Ch'in dynasty (just prior to the Han dynasty) made life-size ceramic sculptures using slab and coil methods (fig. 13-21). Under the T'ang emperors, the popularity of tea provided the stimulus for designing dinnerware. The Chinese began to produce bowls, plates, jars, vases, bottles, flasks, pitchers, and ewers that were both functional and graceful. Porcelain, a white ceramic that is hard, nonporous, and translucent, may have been invented during the T'ang dynasty. (To a Westerner, the test of porcelain was translucency; to the Chinese, it was the musical note a vessel made when struck.) At any rate, porcelain was produced in quantity by Sung potters, eight centuries before it was produced in such places as Meissen, Germany, and Sèvres, France. Europeans were unable to discover the true ingredients of a porcelain clay body until the eighteenth century. To the Chinese, Sung artisans produced the most "classical" examples of ceramic wares - porcelain or otherwise. But to Westerners, Ming pottery (1358–1644), which tends to be more lavishly decorated, is the most popular. The stately porcelain jar in figure 16-17 is a good example of the kind of ceramic vessel that European potters tried to imitate – mostly without success - in the sixteenth and seventeenth centuries.

Challenge 16-1:

Create a watercolor landscape painting in the style of the Chinese Sung dynasty painters, using value gradations to show foreground, middle ground and background.

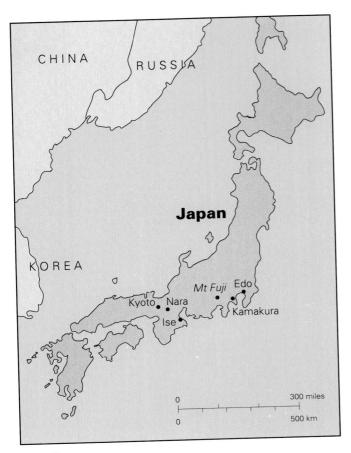

16-18 Japan.

Japan

In many ways Japanese culture is an extension of Chinese culture. Following the introduction of Buddhism to Japan in the mid-sixth century, much of its art and architecture was to be molded by the influence of its huge Asiatic neighbor. But Japan's culture predates Buddhism, and its post-Buddhist culture bears the marks of Japanese conditions and native styles. Over the centuries, the island nation (fig. 16-18) has alternated between isolation and interchange with foreign governments, and between independent creativity and imitating the creativity of others. The religions of Japan are basically two: Shintoism, the native religion, and Buddhism. Although Christianity entered the country in the sixteenth century and made many converts at first, its long-range influence was insignificant.

The facts of early Japanese history are clouded in myth. We do know that the islands were occupied by a loose collection of tribes and clans (families claiming descent from a common ancestor). When not fighting among themselves, they fought the Ainus - aboriginal

white people who had migrated from the Amur River (separating modern Mongolia and Russia). Out of a primitive form of ancestor worship came Shintoism, the oldest and still largest religion of Japan. Shinto (the way of the gods) emphasizes reverence for family, race, and, above all, the ruling family as a direct descendent of the gods. It is also responsible for an early form of Japanese architecture: the Shinto shrine. The main building of the Ise Shrine (fig. 16–19), originally constructed in the third century, was supposedly destroyed and rebuilt every twenty years. If so, the structure we see today is a faithful copy of the methods and styles of third-century Japan. Although of wood, the principle is post and lintel, in this case, thick wooden columns (hewed from the trunks of cypress trees) to support a thatched roof. The cylindrical weights running the length of the ridgepole and providing a distinct rhythmical accent, help to stabilize the whole.

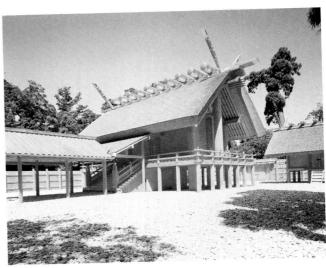

16-19 Shoden, main building of the Ise Shrine. Rebuilt in 1973, reproducing third-century type. Copyright Grand Shrine of Ise.

Sometime in the 500's, Buddhism was introduced to Japan by a Korean king. After some opposition, the new religion became firmly established, and Chinese influence, mostly through Korea, rose dramatically. In 710 the Japanese established a capital at Nara for the imperial family, and began to model their political, economic, and social life on that of T'ang dynasty China. The extent of this influence can be seen in the Horyu-ji temple complex at Asuka (fig. 16-20). Some of the temples, among the oldest wooden structures in the world, adhere so closely to T'ang models that they provide a glimpse of seventh-century Chinese architecture (most of which has disappeared in China). Consisting of massive, slightly curved, tiled roofs supported by wooden columns, these structures are

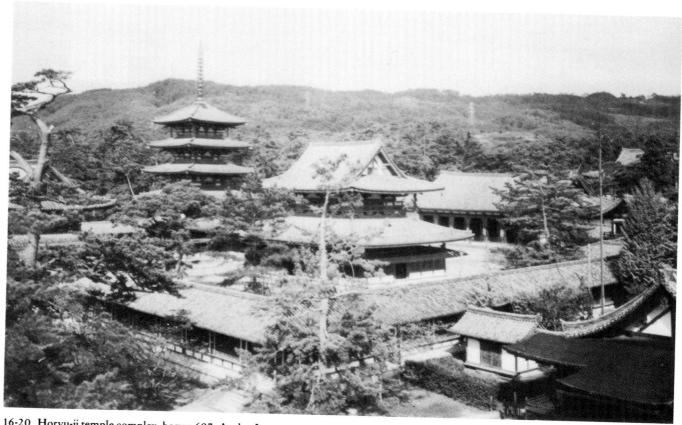

16-20 Horyu-ji temple complex, begun 607. Asuka, Japan.

basically post and lintel. Yet their openness and complicated system of bracing foreshadow modern frame construction (Chapter 19).

In 784 the capital was moved to Heian (modern Kyoto), and Japanese culture entered what some refer to as its golden age. Although the emperor continued to be the nominal leader of Japan, real power was held by certain powerful clans attached to the court. The Fujiwara family, the dominant clan, strove to surround themselves and the court with art. Their artists, now relatively independent of Chinese styles, produced lacquered wooden carvings and

painted scrolls of the finest quality. Paintings consisted of two types: richly colored and gilded scrolls of Buddhist subjects, and inked scrolls of humorous subjects. An example of the second type shows Buddha in the form of a frog being honored by a whimsical collection of monkeys, a cat, a rabbit, and a fox (fig. 16-21). Japanese use of satire, animal caricature, and cartoon styles anticipated American comic strips by about six centuries. Note that the lines of the frog's bench, the altar, and the scroll table go back in space but do not converge. Sometimes this is referred to as "isometric perspective."

The leadership of the Fujiwaras was ended by a clique of warriors who created a shogunate (military dictatorship) and moved the center of power to Kamakura, the city that gave its name to the period from 1185 to 1392. Among other things, the new leaders smashed an invading armada mounted by Kublai Khan in 1274 and 1281. As a reaction against the refined art of the Kyoto court, Kamakura art leaned toward realism. Sculptors endowed their figures with life-like anatomy and color, and enlivened their eyes with glass. The temple guardian in figure 16-22 was made to ward off demons and evil spirits, but because of his vivid realism, he could frighten almost anyone—real or imagined.

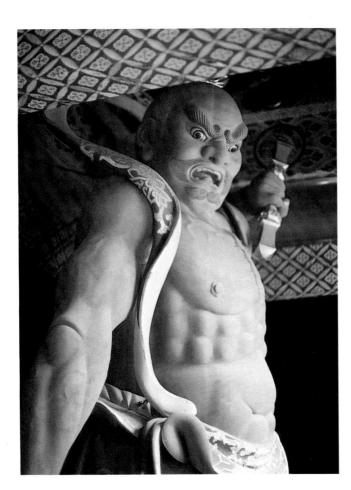

16-22 Temple Guardian, Kamakura period, ca, 1300. Wood, fully painted. Toshogu Shrine, Kyoto.

16-21 Animal caricatures, detail of a horizontal scroll attributed to Toba Sojo, later Heian period, ca. late twelfth century. Ink on paper, approx., 12 " (30.5 cm) high. Kozan-ji.

16-23 Sesshu, *Landscape*, Ashikaga period, 1495. Detail of a hanging scroll, ink on paper. Tokyo National Museum (photograph courtesy of the International Society for Educational Information, Inc.)

The Ashikaga shoguns of Kyoto took control in 1392, but were unable to maintain a permanent peace; therefore, their reign of nearly 200 years is referred to as a "dark age." But the arts thrived during this time. Once again, China was the source. Chan Buddhism, the sect that inspired Sung artists, known as Zen Buddhism in Japan, became an important cultural force. The cult of Zen appealed especially to the aristocracy and a Japanese warrior class called samurai. Japanese painters imitated the landscapes of the Sung and Ming masters, but with a personal flourish. Sesshu, the most celebrated of the Zen painters, could establish a plausible scene (fig. 16-23) with just a few bold strokes – applied with the finesse of a samurai wielding a sword. Do you recall the principle of closure (Chapter 4)? To complete the details and contours of a Sesshu scene requires the cooperation of a sophisticated eye and mind.

The cult of Zen gave rise to the tea ceremony, a major social institution of the aristocracy that featured calculated grace. Supplying tea ceremony needs dominated the art of potters who produced bowls, water jars, and tea-powder jars. This ware, like Sesshu's art, attempted to strike a delicate balance between refinement and informality.

The Ashikaga shogunate was a political failure – its sophisticated art notwithstanding. The Tokugawa, an upstart family of shoguns, moved the seat of government to Edo (modern Tokyo) in 1617. To impose order, the new shogunate undertook drastic measures. Christianity, introduced by St. Francis Xavier in 1549, was banned, less for religious reasons than for political reasons. Tokugawa leaders sought to close Japane to all outside influence. Except for a handful of Chinese and Korean traders, no foreigners were allowed on Japanese soil. The shogunate also sought to freeze Japanese society. The lines between the social classes – samurai, farmers, artisans, and merchants (in that order) – were not to be broken; employees were bound to their employers for life. Because of this stratification, each social class developed its own culture. Zen landscapes, such as the one by Tohaku in Chapter 5 (fig. 5-34), continued to cater to the tastes of the aristocracy. But a new kind of picture, known as ukiyo-e ("the art of the floating world") drew its subject matter from popular entertainment, popular fiction, and sight-seeing, and catered to the tastes of the merchant class. Because of its whimsy, some of ukiyo-e art can be considered a descendent of the humorous Heian scrolls (fig. 16-21). The favorite medium was the woodcut, invented by the Chinese during the T'ang dynasty and introduced to Japan during the eighth century. With this method, ukiyo-e artists could make dozens of inexpensive replications. Scenes such as Hiroshige's *Obashi*, *Sudden Shower at Atake* (fig. 16–24) provide vivid glimpses of Japanese life during the Ashikaga period. But they came to be valued in the West during the late 1800's for their aesthetic virtues. European artists of that era, as you will learn in Chapter 19, were influenced by the Japanese aptitude for flat pattern and bold composition.

16-24 Ichiryusai Hiroshige, *Obashi, Sudden Shower at Atake* (Storm on the Great Bridge) Japanese, Tokusawa period, date of print: $1857.\ 13\times8^{11}/_{16}$ " The Toledo Museum of Art Toledo, Ohio (Carrie L. Brown Bequest Fund).

Chapter 17 Non-Western Art II

This second chapter on non-Western art, looks at the art of Islam, tribal Africa, pre-Columbian America, and North America.

Islam

Islam refers to the religion of the Moslems, and to all the nations – which occupy a sandy stretch of land from Gibraltar to India – where that religion predominated (fig. 17–1). Islam is one of the five major living religions (the others are Hinduism, Buddhism, Judaism, and Christianity). It is also the newest.

Mohammed (the Prophet) was born in Mecca (on the west coast of Arabia) 570 years after Christ, and over 1,100 years after Buddha. Like Buddha, Mohammed had a vision; he was told by the angel Gabriel that he was the messenger of Allah (God). The people of Mecca did not believe him, and even threatened his life. In 622 he was forced to flee from Mecca to Medina. The year of Mohammed's flight (Hejira) is the first year of the Moslem calendar.

Eight years later Mohammed returned to his hometown of Mecca in triumph, and most of Arabia was converted. Not long after his death, his followers converted the peoples of the Middle East, North Africa, and Spain

17-1 Islam.

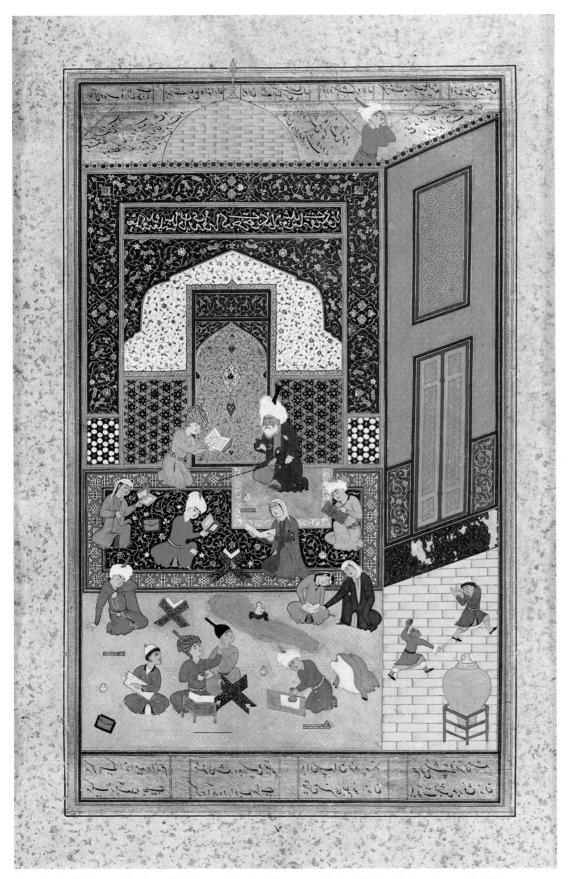

17-0 Artist Unknown, Layla and Majnun at School, 16th century, Safavid Period. Ink, colors, and gold on paper, $4\frac{3}{4}$ " \times $7\frac{1}{2}$ ". (12 \times 19 cm). Khamseh (Quintet) of Nizami, style of Shaykh Kadeh. The Metropolitan Museum of Art (Gift of Alexander Smith Cochran, 1913).

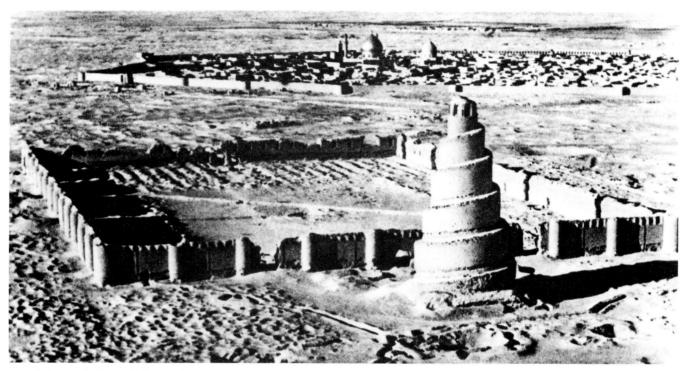

17-2 Mosque of Mutawakkil (view from the north), 848 - 852 A.D., Samarra, Iraq.

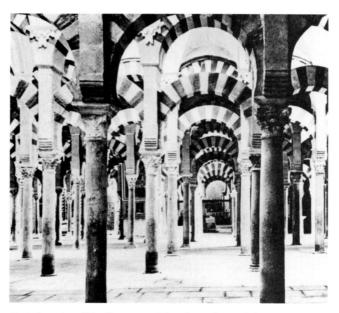

17-3 Interior of the Sanctuary (view from the east), Mosque, Cordova.

17-4 Arch.

in a lightning series of conquests. The new faith was, and still is, centered around the *Koran*, the Moslem's sacred book. Like the sayings of Confucius, it is a collection of one man's wisdom as recorded by his disciples and followers. The content of the Koran is closely related to the Christian Bible. It professes *monotheism* (belief in one god), and it recognizes the Jewish prophets. Jesus, however, is identified as one of the prophets rather than the Son of God, and Mohammed is the last of the prophets. Worshippers are required to pray in the direction of Mecca five times a day. There is no priesthood, and no mysterious rites. The only public worship is on Friday noon.

The Moslem place of worship, called a *mosque*, reflects the simplicity and directness of the faith. Typical of early mosques, the one at Samarra, Iraq (fig. 17–2) was simply a walled rectangle—large enough (ten acres) to contain all the worshipers of Samarra. It faces south, the direction of Mecca. The *qibla*, or wall on the Mecca side, is identified by a small niche in the center (*mibrab*). Opposite the qibla is the *minaret*, or prayer tower, from which the *muezzin* (crier) called the faithful to prayer. Later minarets were slender (resembling a medium-range ballistic missile). This

one resembles the legendary Tower of Babel (which may have still been standing at that time in the old city of Babylon, about 120 miles to the south). Today, nothing remains of the roof or of the 464 pillars that supported it, and enclosed an open court.

Fortunately, the mosque at Cordova, Spain, is still intact (fig. 17-3), so we can get an idea of its interior. Notice how the multiple aisles draw the eye to the qibla wall. The double-tiered arches add complexity, as well as drama, to this effect. An arch (fig. 17-4) is a masonry type of construction that uses a number of small stones in a curve rather than a single horizontal lintel. The wedge-shaped

blocks-which are very visible in the Cordova archespress against one another rather than falling. Long before Islam, the Romans (Chapter 18) had used arches to support masonry ceilings. The relatively thin Cordova arches were designed to support a wooden ceiling.

Like the mosque at Cordova, the Court of Lions of The Alhambra, a palace in Granada, Spain (fig. 17-5), is an outstanding example of Islamic arch construction. But unlike a Cordova arch, which flaunts stones of boldly contrasting colors, an Alhambra arch is liberally decorated with stucco and tile reliefs. Yet unlike the busy carvings at Khajuraho (fig. 16-6) and Borobodur (fig. 16-10), these

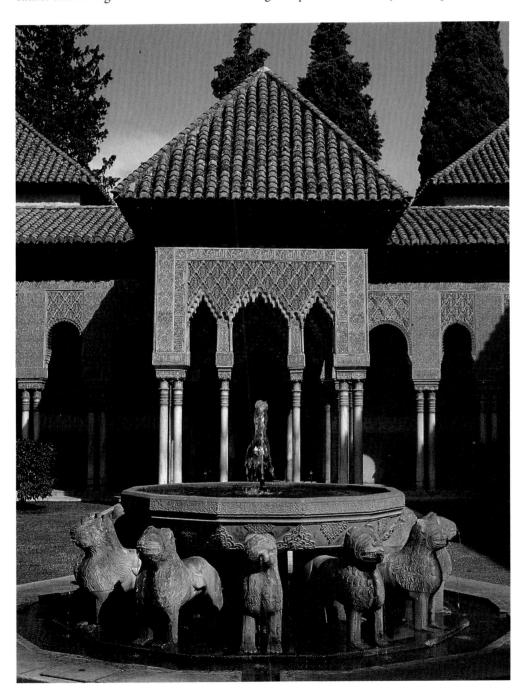

17-5 Court of the Lions, The Alhambra, 1354 - 1391, Granada. Copyright Joe Viesti.

reliefs are delicate, lending an effect that is both rich and airy. The arches themselves seem almost to hang from, rather than support, the ceiling. Granada was the last Islamic city on the European continent to fall to the Christians. In 1492 it surrendered to the armies of Spain's Ferdinand and Isabella. But the splendor of its Islamic heritage, especially its architecture, left a lasting impression on the European imagination.

Mohammed was vehemently opposed to *idolatry*, the worship of idols. He smashed all of Mecca's sculptures of gods and goddesses. Indeed, his opposition to idolatry was so strong that he forbade the use of religious images of any kind. To this day, the walls of mosques, unlike those of Buddhist temples or Christian cathedrals, are devoid of statues or pictures. There was no prohibition against abstract decorations, however. Moslem artists lavished the insides of Islamic buildings with such inventive designs that the term *arabesque* was coined to mean a complex pattern of intertwined lines and shapes.

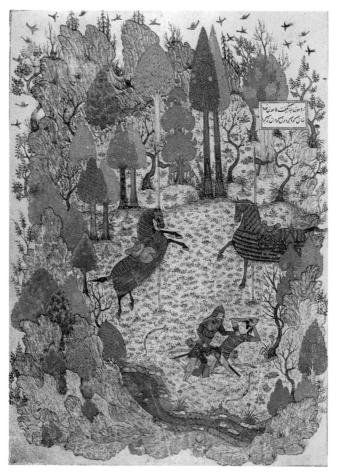

17-7 Two Warriors Fighting in a Landscape, from a Persian manuscript, 1396. The British Museum, London.

The kind of lacework arabesques seen in the Alhambra are also found in Islamic crafts. Objects of ceramic, bronze, silver, and glass — all richly endowed with arabesque decoration — were used to furnish mosques and palaces. But the most highly valued of Islamic crafts was textiles, especially the weaving of carpets. The Ardabil Carpet (fig. 17–6), which may have as many as three hundred knots to the square inch, was probably made by a group of weavers. Intended to cover a floor or hang on a wall of a Mosque, it sports a medallion design in the center surrounded by stylized and interlaced leaves and flowers. To study such an intricate design must have been in itself a religious experience.

The fact that there are no human or animal figures in the carpet is due in part to the Islamic aversion to idolatry, mentioned earlier. Another reason is that Arabian culture was originally nomadic (specifically, Bedouin shepherds moving their flocks and their families from pastureland to pastureland). Such a culture tends to specialize in portable craft objects rather than sculptures or paintings. Even after the conversion of Bedouin Arabs to Islam, and even in those Islamic provinces that were not Arab to begin with, the skills of pictorial art never developed to any extent.

Book illustration was an exception to this general Moslem rule, however, especially in Persia (modern Iran). Islamic scholars translated and copied Greek texts, some of which were illustrated. A degree of picture-making skill may have entered Islam from that source. Persia, a highly developed culture long before the advent of Islam, was also a crossroads for traders and invaders from east and west. The country was overrun by Mongol horsemen led by the notorious Genghis Khan (grandfather of Kublai Khan) in the 1200's. Two Warriors Fighting in a Landscape (fig. 17–7), a Persian illustration, reflects a Mongol-Chinese influence in both subject matter and style. Experience with Mongol warriors was probably fresh in the mind of the artist. The choice of a landscape setting was due to his or her knowledge of Sung painting. The gentle shading of some of the objects, especially in the rocks and mountains, reflects Chinese style. But the delicate details and two-dimensional design are definitely Islamic.

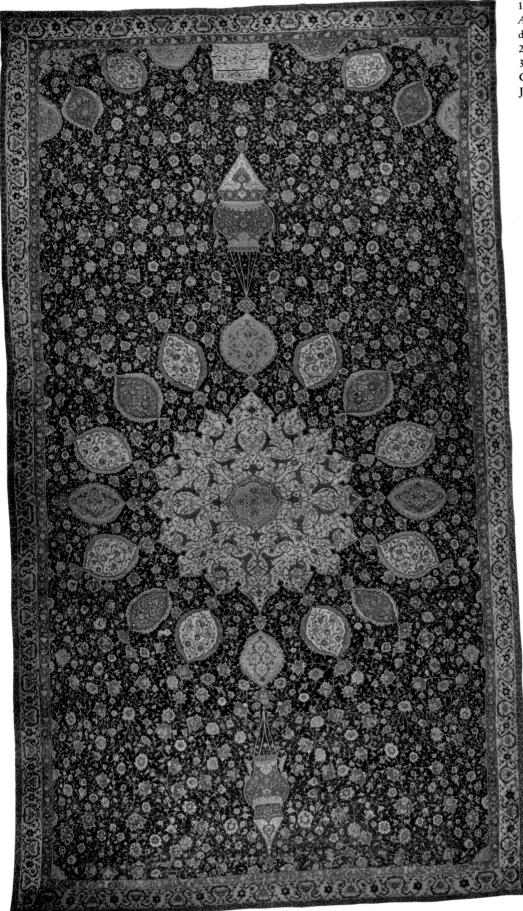

17-6 Maqsud of Kashan, The Ardabil Carpet, 1540, Safavid dynasty, Persia. Silk and wool, 23'11" × 13'5" (716 × 396 cm). The Los Angeles County Museum of Art (Gift of J. Paul Getty).

For centuries Islam led Christian Europe in all the civilized arts: government, philosophy, literature, science, mathematics, and medicine, in addition to architecture and crafts. Many of these accomplishments were transmitted to European culture during the Crusades (Chapter 18). The extent of this legacy is indicated by the Arabic words in our vocabulary: alcohol, bazaar, cable, caravan, check, chemistry, magazine, nadir, satin, tariff, and zenith, among others. Arabic numerals (1, 2, 3, 4, etc.), together with the concept of zero and algebra, replaced Roman numerals (imagine trying to divide XLV by IX). European builders enriched their cathedrals by borrowing the pointed arch, stained glass, and arabesque designs from the Moslems. And European craftspersons enriched European life by mastering the secrets of porcelain and silk-which came from China through the Moslems.

Africa

Unlike Islam, Africa is a checkerboard of religions and belief systems. Like the African continent, which is divided among deserts, highlands, grassy savannas, and river forests, the African population is divided among nomadic tribes, farming villages, and great kingdoms—each with its own language.

By the same token, there is no such thing as a single style of African art. Depending on the culture, the purpose, or, sometimes, even the individual artist, African art can vary from realistic to abstract, or from highly struc-

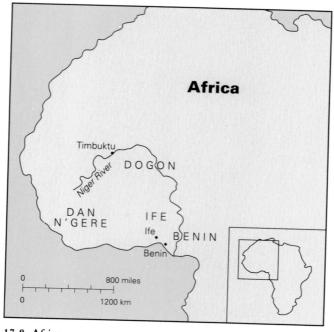

17-8 Africa.

tured to relatively formless. African art is not easily classified into sculpture or craft; a footstool can resemble a human figure, a jar handle can be shaped like a crocodile, and a hat can look like a pair of antlers. Africans did not (and still do not) make sharp distinctions between art and life, as Westerners do. Some of their art, like Western art, was intended to be permanent, but much of it was made to be used for a special occasion and then thrown away. Its functions are as varied as Africa's different beliefs and cultural agendas: to appease spirits, to honor ancestors, to ensure fertility, to symbolize authority, to frighten enemies, or simply to celebrate. (Recall the memorial sculpture of Sokari Douglas Camp - Chapter 15.) For these reasons, African art is difficult to analyze. Yet this art, as a class of objects, has succeeded in capturing the imagination of modern artists and collectors. With this in mind, we will look at a sampling from those regions of Africa (fig. 17-8) that are especially noted for their art.

The Dogon, a peasant-village people in Mali, are well known for their wood sculptures. With endless imagination, Dogon carvers whittled bowls, jars, stools, masks, granary doors, and figurines in any form-human, animal, or combinations thereof. Although Dogon styles vary, their human figures exhibit a sensitive blend of organic and geometric. The forms of the ancestral couple in figure 17-9 consist of tall cylinders surmounted by egg-shaped heads, while their surfaces are engraved with complex geometrical designs. This particular sculpture manages to express a tender, almost wistful, relationship between a man and woman, whether because of or in spite of the abstractness of its style. It was these abstract tendencies of Dogon carving, together with their keen craftsmanship, that appealed to early twentieth-century artists and collectors. We must remember, however, that Dogon images were made for ritual purposes and not to be admired as art objects.

The Dogon are also known for their architecture, which has attracted the attention of twentieth-century sociologists and city planners. The houses and granaries of the Dogon village in figure 17–10 are organically related to the natural contours of the hillside, providing an interesting variety of levels and spaces. The buildings themselves, which are handbuilt, have the qualities of sculptures. But of main interest to urban sociologists are the ways in which the plan of a house and the relationship between the houses in a village foster a sense of community. Each house is intended to symbolize a human body, with the kitchen area being the head. On a larger scale, the arrangement of houses and granaries in a village is also intended to represent a human body. This symbolic inter-

17-10 Dogon village, Mali, West Africa. Photograph: courtesy Woodfin Camp and Associates, New York.

17-9 Seated Man and Woman, Dogon origin, Mali. Wood, 30" (76 cm) high. Photograph Copyright 1989 by The Barnes Foundation, Merion Station, Pennsylvania.

locking of houses and village reflects the interlocking in Dogon social structure in which families are linked by both marriage and collective ownership. In this way, each Dogon citizen is connected socially and symbolically to the village.

Unlike the village culture of the Dogon, the Ife society (centered around Ife, Nigeria) that flourished between the 1100's and 1300's was aristocratic. Its art, as indicated by the bronze portrait in figure 17-11 is lifelike rather than abstract. The young king's facial features seem anatomically correct; the details of his royal headgear seem faithfully recorded; even the pattern of his tattooing, which follows the contours of his face, seems accurate. Yet for all its naturalism, this portrait is very restrained as aloof as a proud king. Because Ife bronzes were made

17-11 Oni (King) of Ife, twelfth-fourteenth centuries. Bronze, 141/2 " (37 cm) high (life-size). The British Museum, London.

17-12 Flute player, fifteenth-sixteenth centuries. Benin culture, Nigeria. Engraved bronze, 241/2" (62 cm) high. The British Museum, London.

by the lost-wax method of casting (Chapter 13), some experts speculated that Ife artists had inherited this technology from Egyptian sculptors. And, because of the Ife king's classical air, some have speculated about a Greek source for its style. Today, however, most experts feel that Ife art was created independent of outside influence. Still, the superb craftsmanship and aesthetic qualities of this art compels one to compare it with the art of other cultures, particularly ancient Egypt, classical Greece, and Renaissance Italy (Chapter 18).

A little to the south of Ife was the Benin kingdom that flourished between the 1400's and 1700's. There is evidence that the Ife and Benin kingdoms had historical ties, but the connections between the two are not clear. At any rate, Benin sculptors shared with their Ife neighbors the method of lost-wax, and created bronze castings of a high technical level. The body of the little flute player in figure 17-12 neatly combines the virtues of naturalism and caricature. His proportions (the relationship of a part to a whole) are obviously exaggerated, although not nearly to the degree that those of the Dogon couple are. His overall height is about three times the height of his head, whereas an average man's height is about seven times. The proportions in his face, compared to those in the Ife bronze, are also exaggerated. Nevertheless, there is something very lifelike about his large almond-shaped eyes, the folds of his kilt, his stubby legs, and, especially, the way his little arms support the flute. And his body and clothes, like the Ife king's, are liberally decorated with engraved designs.

The fact that masks are found in tribal societies all over the world suggests that wearing one satisfies a universal urge: to change identity, be anonymous, or assume the power and/or authority of another person or animal. This may explain the thrill of wearing masks on Halloween. In tribal societies, masks were usually used with costumes and body painting in the context of rituals, typically the dance. The purpose of such a ritual could vary from a sacrificial offering to entertainment. Masks were used differently among the Dan-Ngere people of the Ivory Coast. Masks were emblems of authority, much like a police uniform. A person wearing the mask of a judge was not pretending, but being a real judge who could try and convict people. (Imagine, for example, being issued a parking ticket by a meter maid wearing a mask.) Each Dan mask was required to express the personality of a partic-

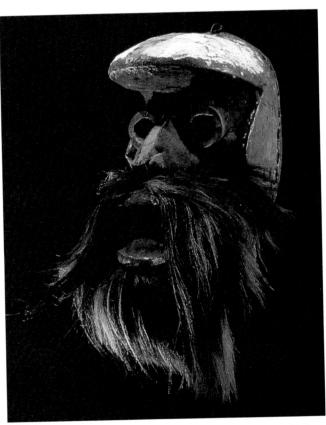

17-13 Mask, Dan-Ngere people, Ivory Coast. Wood, animal hair, copper and pigment, 11 \times \times 6½" \times 8" (28 \times 16.5 \times 20 cm). Collection, The University Museum, Illinois State University, Normal, Illinois.

ular role. Roles could vary from teachers to executioners. Thus mask carvers were challenged to come up with a whole repertory of forms and styles. Some masks were smooth, highly polished, and with delicate features – perhaps intended to express pleasant roles. Some, like the one in figure 17-13, were coarse with enlarged features. Sporting a large nose, staring eyes, gaping mouth, and embellished with fur, this is a striking mask. Was it intended to represent a shaman, a witch doctor, a philosopher, a hermit, a cranky old man, or all of the above?

In Africa, art is not separated from life, as it often is in the West. It is an intrinsic part of the social and spiritual ecology of the tribe - in which daily living, the natural, and the supernatural are all mingled.

Pre-Columbian

Around 4000 B.C., people of Asian stock began migrating to the New World across a land bridge (now a chain of islands called the Aleutians) connecting Asia and Alaska, and began to settle in both North and South America. Pre-Columbian, as the name implies, refers to the history of those people up to the time of Columbus. However, the term is most often used to mean the Indian civilizations that flourished in Mexico, Central America, and South America (fig. 17-14) before the arrival of the Spanish conquistadors in the 1500's.

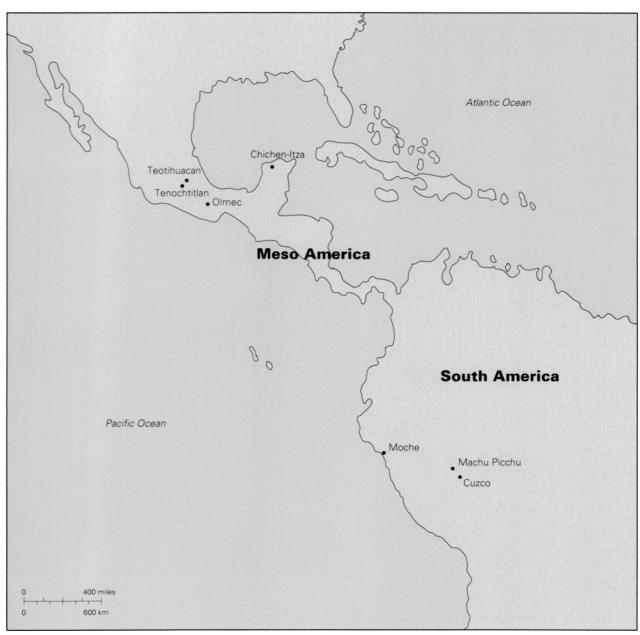

17-14 Meso-America and South America.

South America

The civilizations of South America developed mostly in the central Andes Mountains. The earliest civilization was fully developed by 700 B.C. – around the time of China's Chou dynasty – and was known for its irrigation canals. The Moche culture arrived on the scene somewhat later. Thriving from A.D. 1 to 800, the Moche people were known for their metallurgy and sun-dried brick pyramids, but also for their remarkable ceramics. The potter's wheel was unknown – not only to the Moche but to all pre-Columbian peoples – so all pottery was handbuilt or cast from molds (Chapter 13). Glaze also was unknown, so their pots were decorated only with slip (Chapter 13). However, Moche potters were so skilled that their round vessels appear wheel-thrown, and the surfaces of their pots resemble those of glazed ware. The portrait jar in figure 17-15, although obviously not wheel-thrown, is an example of their superb craftsmanship. The dual function of portrait and storage vessel is in itself a tour de force. As a portrait, it is as solemn and dignified as the Ife bronze; as a vessel, it is both functional and lightweight. Note especially the slenderness of the stirrup spout, one of the unique features of Moche pottery. Around 800, the Moche kingdom, along with other groups in the highlands and along the coast of modern Peru and Bolivia, came to an end. They may have been conquered by a people known as the Tia-

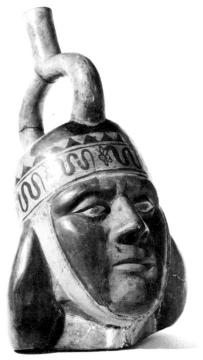

17-15 Portrait jar, Moche, Peru, fifth-sixth centuries. Ceramic, 111/2 " (29 cm) high. American Museum of Natural History, New York, #121197. Photograph: T.L. Bierwerx.

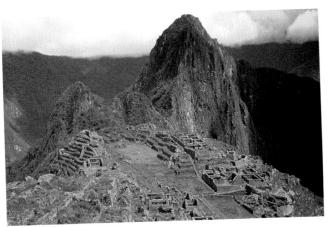

17-16 Temple of the Sun, an Inca ruin at Machu Picchu, Peru.

huanacons, but this is not certain. It is certain, however, that around 1400, another ambitious group started from Cuzco (Peru), and rapidly overran all the Peruvian kingdoms. Named for the title of their leader, Inca, these people proceeded to establish an empire that stretched over 2,000 miles from northern Ecuador to Chile.

To connect Cuzco to the main regions of their empire-scattered as it was along the most rugged mountains in the world—the Incas strung hanging bridges across rivers, and built solid roads. To eke food from the highland soil, they learned to terrace and irrigate; they also domesticated the llama and the alpaca. To record their business transactions, they used a unique system of knotted cords for numerals. They worshiped gods of thunder, earth, sea, mountains, and rivers. Of these, the most important was the sun god, who they believed was their ancestor. Sun temples were built all over the empire, including one at Machu Picchu (fig. 17-16).

Located on top of a high mountain, Machu Picchu is an extraordinary place to locate a temple, let alone a whole settlement. To supply such a site, not to mention construct some two hundred buildings there, must have been a severe challenge to Incan builders. Incan masonry, in which stones are fitted so closely that a knife blade cannot be run between them, is remarkable - especially considering that the stones were not cut to uniform sizes. Today Machu Picchu is sometimes called the City in the Sky or the Lost City. Since it was rediscovered in 1911, it has raised more questions than answers. Was it primarily a religious sanctuary? Was it also a fortress? Why was it built there? And why was it suddenly abandoned? The answers died with the Inca civilization itself when Atahalpa, the last great Inca ruler, was executed by conquistador Pizarro.

Meso-America

Meso-America refers to the area of the Western Hemisphere comprising modern Mexico and the northern countries of Central America. The pre-Columbian civilizations that arose there were different enough from the Incas and the others of South America to consider them separately. They developed mainly in the central highlands of Mexico, the lowlands along the Gulf of Mexico, and the lowands of the Yucatan Peninsula.

The oldest civilization, centered at Olmec, dates to around 600 B.C. - roughly contemporary with the oldest culture in South America. Later civilizations in Meso-America were in many ways heirs of Olmec's culture. While the Olmecs were prospering in the swampy lowlands along the coast (in the Mexican states of Tabasco and vera Cruz), another group was just beginning to get organized in the central highlands north of modern Mexico City.

That group, called Teotihuacán, dominated the region from 300 B.C. to A.D. 800 (roughly the same time as the Han and T'ang dynasties combined). Like the Incas, they worshiped nature, in this case centered around Tlaloc, god of rain, and Quetzalcoatl, a culture hero who was later deified as a feathered serpent. To feed their gods and produce unity between the gods and the people, the Teotihuacáns practiced human sacrifice. These rituals occurred frequently at their capital, Teotihuacán ("place of gods") – perhaps the largest city in pre-Columbian America. Estimates of its peak population range from one hundred thousand to almost one million. Consisting of numerous temples and palaces, the ritual center of the city

17-18 Feathered Serpent on the Pyramid of Quetzalcoatl, ca. A.D. 500.

was planned around a broad avenue (fig. 17-17). The largest temple, dedicated to the sun, was a five-tiered pyramid with a broad stairway. A smaller temple, dedicated to Quetzalcoatl, was decorated with repeated sculptures of the feathered serpent's head, together with Tlaloc's. His image (fig. 17-18) unites the characteristics implied in his name: quetzal, a brilliantly plumed bird, and coatl, a snake. Judging by his fierceness, there is little doubt that Quetzalcoatl commanded the respect of the faithful.

The downfall of the Teotihuacáns, around 800, coincided with the rise of the Toltecs who took over many aspects of Teotihuacán culture, though their language (Nahuatl) may have been different. Around 1300, the Aztecs, another Nahuatl-speaking group, came to power

> 17-17 View of Teotihuácan, Mexico, ca. A.D. 510-660.

17-20 Corbeled arch.

and established Tenochtitlán (modern Mexico City) as their capital. A very warlike people, the Aztecs expanded their empire to include all of Mexico. However, despite their skills as warriors and empire builders, they fell to the Spaniards in 1520 when Cortez conquered Tenochtitlán.

While the Teotihuacáns were building their civilization in the highlands, the Mayas were building theirs in the lowlands of Guatemala and Honduras. Although they spoke a different language (Mayan), the Mayas were in contact with the highland groups. Of all the pre-Columbian cultures, that of the Mayas was perhaps the finest. Between A.D. 300 and 900 - their classic period - they developed writing, a form of arithmetic, a calendar, and the corbeled arch. Mayan numerals - a dot (equal to the number 1), a bar (equal to five dots), and a crescent (equal to four bars) - have been compared to Arabic numerals for simplicity and effectiveness. The Mayan year was divided into eighteen twenty-day months, with five extra days for special religious observations, an arrangement that resembles a modern calendar in principle. The relief carving in figure 17-19 illustrates not only the Aztec version of the Mayan calendar, but also an example of Aztec carving. To the Mayas, the calendar and the related science of astronomy were so important that many of their priests were astronomers.

The corbeled arch (fig. 17-20) enabled Mayan builders to penetrate their masonry structures with openings for rooms and hallways. Like a round (true) arch, the corbeled

17-19 The Aztec Calendar Stone. Relief. Courtesy The American Museum of Natural History, #334432.

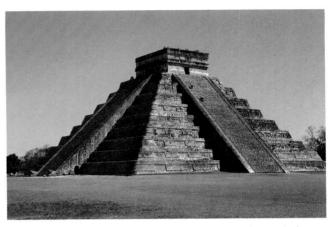

17-21 El Castillo, Mayan pyramid temple of the Toltec period, at Chichén Itzá, Yucatán, dedicated to the Feathered Serpent, patron deity of Chichén Itzá.

arch uses short stones. Unlike a round arch, however, it spans an opening by means of succeeding rows of stones projecting inward until they meet at the top. This kind of arch cannot span a wide area, and it requires a lot of masonry material for support; therefore, the rooms in a Mayan temple were narrow (no more than fifteen feet wide) and dark.

Around 900, the Maya abandoned their sites in Guatemala and Honduras and moved to the Yucatan Peninsula. The reasons for this move are still a matter of speculation: drought, crop failure, foreign intervention, or a combination thereof? While in Yucatan, the Mayas were invaded by peoples of Toltec affiliation. But this did not prevent them from building some of the finest architecture in pre-Columbian Mexico. Mayan temples were usually built on tiered pyramids, similar to those at Teotihuacán, and faced with cut stone, richly decorated with relief carvings, and covered with stucco. The major temple at Chichén Itzá (fig. 17-21), rising grandly from the Yucatan plain, stands not only as an example of handsome Mayan architecture, but also as a reminder of a once proud culture.

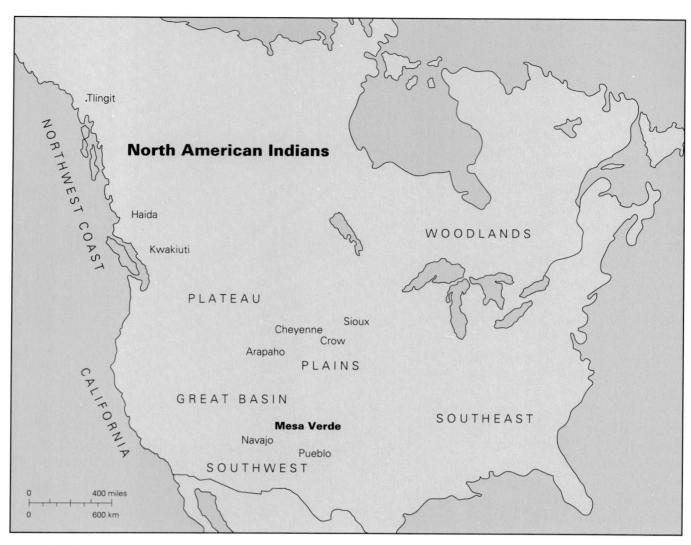

17-22 North America.

North America

The previous review of South America and Meso-American cultures focused on developments prior to contact with Europeans. The review in this section on North American Indians focuses mostly on *postcontact* developments. Little is known about the histories of North American Indians prior to the 1500's. Unlike the Mayas, they left behind no writing, and few monuments of architecture and sculpture. What we do know of their precontact days comes mostly from graves and burial mounds.

We do know a great deal about their histories since the 1500's, however. Unlike the Incas, Toltecs, Aztecs, and Mayas, their cultures were not immediately destroyed or absorbed by conquerors. Despite displacement and massacres by the white settlers, most of them managed to maintain their cultural identities through the 1800's (and some through the 1900's). Since the late 1800's, native North Americans have been the object of intense study by historians and anthropologists.

The diversity among North American tribal groups (fig. 17–22), in terms of customs and beliefs, was great. One expert tallied fifty-six different languages. But all groups, except perhaps the Plains Indians, lived near rivers and lakes, and raised corn (maize), beans, and squash. Although they had different religions, all practiced a form of nature worship, giving homage to such gods as the sun, morning star, south wind, water spirit, and rabbit.

Southwest

One early culture, the Anasazi, did leave a substantial record of their existence. Located in the plateau country of what is now New Mexico, northern Arizona, and southwestern Colorado, the Anasazi made pottery and weavings, and built masonry-walled structures as early as the first century A.D. One type of structure consisted of partially underground chambers called kivas used as chapels. Another consisted of concentrated living settlements like the one nestled in a cliff at Mesa Verde (fig. 17-23). Similar to the Dogon village, the Mesa Verde settlement is multileveled and interconnected. But unlike the Dogon structures, the Anasazi buildings were made of solid materials, including stone, timber, and some adobe (sun-dried bricks). Containing over two hundred rooms, twenty-three sacred kivas, and, at one time, housing at least twenty-three clans, the cliff dwelling was like a modern condominium – in this case, with an excellent view of Mesa Verde National Park.

The Pueblo Indians, a farming culture consisting of the Zuni and Hopi tribes, were the Anasazi's heirs. Although Pueblo people, housed in traditional adobe dwellings, still exist in New Mexico and Arizona, many of their old skills have been lost. Thanks to some native American artisans, however, some of their pottery skills are being revived in the traditional style of the hand-built Acoma vase in figure 17-24. The vase is symmetrical,

17-24 Acoma Pueblo Water Jar, circa 1900, 13 3/4 " (34.9 cm) diameter. Each Pueblo potter develops characteristic shapes and designs. Courtesy of Sotheby's, Inc.

smooth, and thin-walled. The slip ornamentation is divided into three fields, with stylized parrots enclosed by leaves, arches, and geometric designs. The preference for abstract figures and repetition is typical not only of Pueblo art but that of nearly all tribal cultures.

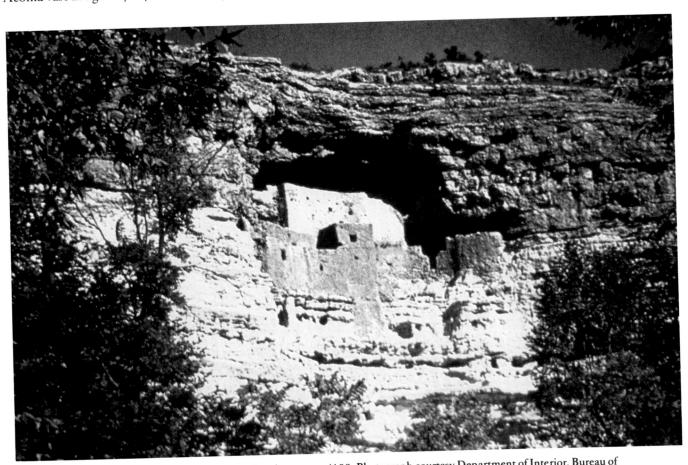

17-23 Cliff Palace, Mesa Verde National Park, Colorado, ca. A.D. 1100. Photograph courtesy Department of Interior, Bureau of Reclamation.

Maria Martinez ca. 1900-1980

Some of the most refined pottery ever produced in the United States has been made without the use of high technology, machinery or even the potters' wheel. A unique technique for creating "black-on-black" pottery was developed by Maria Montoya Martinez, a Native American artist.

This remarkable pottery is made by handpinching thick coils of clay together to create delicate forms. Simple tools made from vegetable gourds are used to smooth and shape the wet clay before the pots are placed in the sun to dry. The dried pots are then covered with a thin layer of liquified clay called "slip" and special riversmoothed stones are used to polish or "burnish" the surface to create a glossy shine. Good polishing stones are highly valued and are often passed on from one generation of potters to another. In the final step, the pots are fired in a fire fueled by wood and manure. To achieve their characteristic rich black coloring, the fire is smothered with manure and covered with wood ashes to prevent air from escaping. The smoke which is produced carbonizes the clay pots, darkening the vessels and leaving a silvery-black sheen.

Maria Martinez was born at San Ildefonso Pueblo in New Mexico. She lived and worked in this small Native American community for over eighty years. There, Maria ritually collected sacred clay from special sources in the surround-

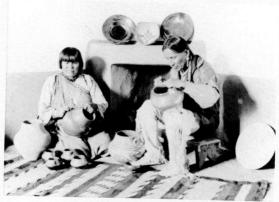

Maria and Julian Martinez, ca. 1920. Photograph: Pedro de Lemos.

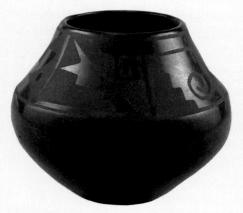

Maria bowl. Collection of Gilbert and Jean Davis.

ing mountains. Mixing these clays with proportions of water and volcanic ash, she produced a workable material appropriate for potting.

During her lifetime, Maria worked very closely with her husband, Julian, and her son, Popovi Da, to create these unique vessels. Both were responsible for decorating Maria's pots with carefully painted designs of a matte or dull finish, created before the pot was smoke-fired. Brushes made from pieces of yucca plant are dipped in the slip and used to paint this type of unique pattern on the polished surface of the pot. Once the vessel is heated and the smoke-firing process complete, the polished surface shines, while the painted surface remains matte.

Today, Maria is known worldwide for the highly skilled method of pottery production which established San Ildefonso as a leading pottery producing community. She received two honorary doctoral degrees from universities, and was invited to visit the White House as a guest of the president. Appearing at world's fairs beginning in 1904, Maria toured the United States, demonstrating her art for thousands of admirers.

By developing a method for creating blackon-black pots, Maria Martinez was able to revive the art of pottery making in the Pueblo community of the Southwest. Her knowledge and expertise has been passed on to other generations of potters in her community, enlivening the economy and culture of the Pueblo people.

Although the Navajo were originally a hunting tribe from a different language group, they became associated with the Pueblo in the 1600's. Many of their customs were learned from the Pueblo, including the art of weaving. Navajo blankets and rugs are among the finest in the world. Compare the design of the Navajo rug in figure 17-25 with that of the Persian rug (fig. 17-6). Both are radially symmetrical, but there the similarity ends. The Persian design – although mostly abstract – contains stylized images of leaves and flowers as well as geometric shapes. And, because of its arabesque interlacing of figures, shapes, and lines, it is much more complicated than the Indian example. On the other hand, the Navajo design is starkly abstract, containing precisely outlined, flat shapes – the colors of which are subtly related and keenly balanced between positive and negative.

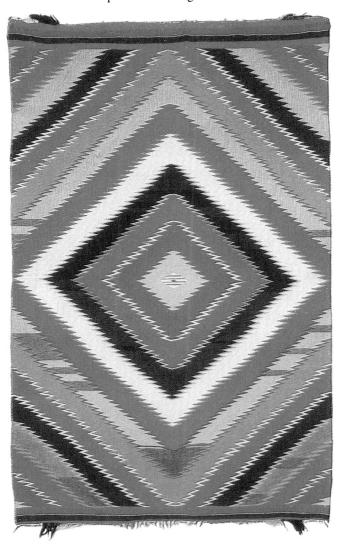

17-25 Navajo rug, 1850 - 1880. Wool. The Indian Art Center of California, Studio City.

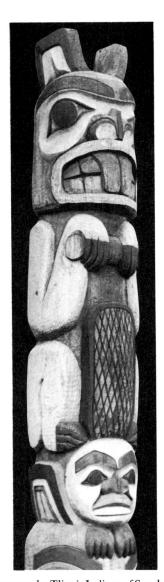

17-26 Haida totem pole. Tlingit Indians of Southeast Alaska.

Northwest Coast

The Northwest Coast comprises the Indian cultures – such tribes as the Tlingit, Haida, and Kwakiutl-who lived along the Pacific coast from Alaska to California. They depended mainly on food from the ocean, but they also farmed and hunted and gathered on the land. Unlike the Pueblo, who built boxy houses of adobe brick, the Northwest Indians built gable-roofed houses of cedar planks. Wood was their most important raw material. In addition to houses, wood was used to make sea-going canoes, totem poles, and wooden boxes - all without the help of metal

A *totem* is an animal believed to be related by blood to a family or clan; a totem animal also symbolizes a family or clan. A totem pole (fig. 17-26) is simply a tall post carved

17-27 Haida Art. Chest for clothes and jewelry, nineteenth century. Wood inlaid with shells and animal tusks. The British Museum, London.

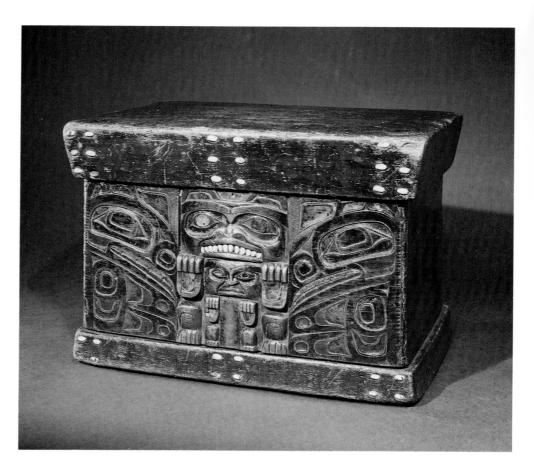

with the clan's symbols. Totem poles stood in front of houses as signs of prestige and to showcase the family's totems. Other objects were often adorned with totems. Haida artists, for example, carved reliefs of clan symbols on the outside of the wooden chest in figure 17–27. The two central figures are shown frontally; the largest may be a bear, and the smaller seems to be a human. These are flanked by what appears to be the heads of other animals – perhaps birds or fish – shown in profile. Although their heads are profile, their eyes are frontal. The design is perfectly symmetrical - one side is a mirror image of the other. In addition to totem poles and chests, Northwest carvers decorated their canoes and houses, and made masks, rattles, charms, and wooden dishes. Like the chest and the totem pole, all of these were invested with exuberant designs of stylized animals and humans.

Plains

Such tribes as the Crow, Sioux, Comanche, Cheyenne, and Arapahoe roamed the great plains, that vast middle section of the continent stretching from the Mississippi to the Rockies. Of all the North American peoples, the Plains Indians are the most legendary. It was they who hunted buffalo, fought the white man, defeated General

Custer, and stimulated the imaginations of generations of people. Paradoxically, there was no plains culture before the arrival of the Europeans, who brought with them the horse and rifle. Without these, Indians were unable to hunt buffalo efficiently. Once horses and rifles became available, the buffalo became the mainstay of Plains Indian life – the source of food, clothing, and shelter. They ate its flesh, and they fashioned shirts, leggings, robes, shields, thongs, and cone-shaped tents called tepees from its hide.

Buffalo hides were even the source of Plains art. Buffalo-skin robes, tepees, and tepee linings were painted with geometric designs. Leather shirts were decorated with feathers, beads, thongs, and hair. The shirt worn by a Plains Indian chief discussed in Chapter 1 (fig. 1-3) is a case in point (though it was made from deer hide rather than buffalo hide). In addition to embellishing their shirts, Plains Indians assembled headgear out of pelts and feathers, necklaces out of beads, bones, claws, or horn, and vests out of fur and leather thongs. Add face painting to all of this, and the resulting costume is truly a mixedmedia work of art. The pictures by George Catlin, who visited some forty-eight tribes and persuaded warriors and chiefs to sit for portraits (fig. 17-28), provide us with a priceless record of this now extinct Plains art.

Conclusion

As stated at the beginning of Chapter 16, the overviews in Chapters 16 and 17 have shown that non-Western cultures represent an incredible variety of geography, peoples, history, beliefs, and art. Why is it important to study non-Western art?

One reason is that it has influenced our own art and daily life. Chinese porcelain, Japanese woodcuts, Islamic arabesques, and African sculpture are only a few examples of a legacy that has enriched our lives as well as theirs. Non-Western art can continue to be a source of inspiration. Studying the works of others helps us to see our own culture from a different perspective. Finally, and perhaps

most importantly, understanding the cultural products of other people helps us to understand the people themselves. By seeing the world through their eyes, we foster tolerance and acceptance of other people and other points of view. All of which emphasizes that we belong to one race – the human race - riding through time on a single spaceship called earth.

Challenge 17-1:

Select, research and then write a summary of the art of one of the non-Western cultures introduced in this chapter.

17-28 Although George Catlin who painted this portrait, was not himself a Native American, his painting allows us to see for ourselves the decorated clothing and striking face paint of the Plains Indians. George Catlin, The White Cloud, Head Chief of the Iowas, ca. 1845. Canvas, 273/4" × 223/4" (70.2 × 58 cm). National Gallery of Art, Washington, DC, (Paul Mellon Collection).

Chapter 18 Islands of Time I

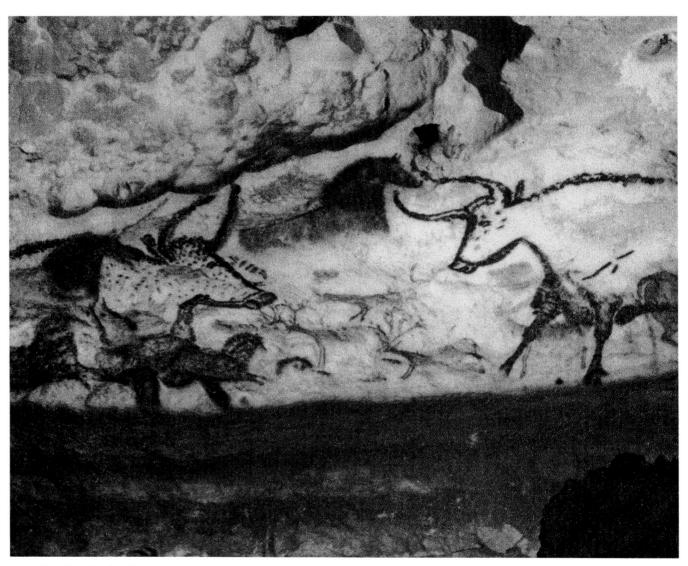

18-1 Hall of Bulls, left wall, Lascaux, ca. 15,000 - 13,000 B.C. Dordogne, France.

The history of Western art begins with the earliest of cultures, and ends with the present. This is such a big subject that only a few periods, or *islands of time*, will be reviewed. This chapter will review islands of time from the prehistoric era (12,000 B.C.) to the High Renaissance (A.D. 1500's). Chapter 19 will survey the history of art from the 1600's to the present.

The discovery of the world's oldest known painting, marking our first island of time, is a history in itself. In 1897 in northern Spain, Marcelino de Sautuola, an amateur archeologist, took his five-year-old daughter with him to explore a cave near their home. Sautuola, who had already found odd-looking tools in the area, thought the two of them could find more in the cave. Because the cave was so

full of rubbish accumulated over thousands of years, the ceiling was low, and the father had to stoop. His daughter, who did not have to stoop, was delightfully surprised to see pictures of animals on the ceiling. Sautuola was also surprised, for he believed they were, in fact, a very ancient art. But when he announced this amazing find to scientists, he was met with disbelief. Later, other cave paintings (some partially covered by calcium deposits that scientists knew were thousands-of-years old) were discovered in northern Spain and southern France. Eventually everyone realized that these paintings were the world's oldest known art, and that they probably had been made by people who lived at the end of the last glacial age.

The Ice Age

What kind of place was Europe during the Ice Age (fig. 18-2)? England was still covered with ice; the rest of the continent was as cold as Siberia, forest-covered, and

populated with big animals: bison, wild horses, reindeer, elk, and wild goats, in addition to extinct beasts like wooly rhinos and wooly elephants. Europe was also populated with a race of people who hunted the animals, killing them with spears made of shafts of wood tipped with animal bone, and then butchering them with knives made of chips of flint. Animals were a source not only of meat, but of hides for clothes and shelter, of bones, horns, and tusks for tools, and perhaps even of tails for paintbrushes.

Although these Ice Age people sculpted in clay, wood, bone, ivory, and stone (recall the little stone Venus of Willendorf, fig. 13-5), they are best known for their animal paintings on the walls of limestone caves (fig. 18–1). They probably obtained pigments, such as gypsum (white) and iron oxide (brownish reds and yellows), from the ground and charcoal (black) from campsites, then mixed these with animal fat or blood serum, and applied the mixture to the walls with animal tails or sticks frayed at one end.

18-2 Europe during the Ice Age.

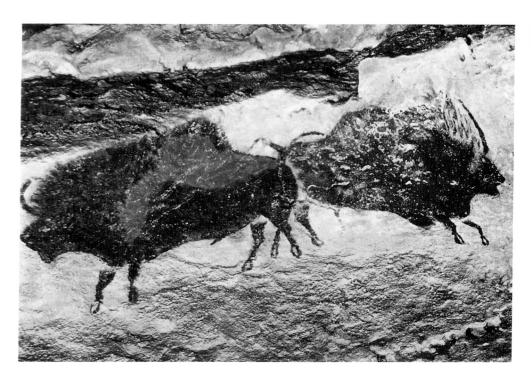

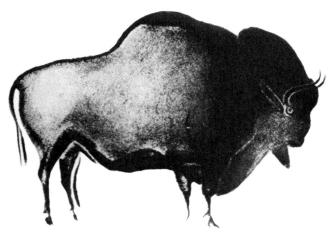

18-4 Standing Buffalo, ca. 20,000 B.C. Cave painting. Font-du-Gaume, France.

Given their crude technology, along with the poor working conditions of a cave, it is a wonder that these hunter-artists were able to produce any art, let alone such vivid images. Ice Age animal pictures capture not only the forms of real beasts, but also their colorations, their details, and even their movements (fig. 18–3). In some caves, chiaroscuro was used to suggest an animal's roundness (fig. 18–4). Thus, in many respects Ice Age images reveal a level of artistry to rival that of even modern cultures. However, Ice Age skills seem to have been limited to depicting only the side views of single animals. Little, if any,

foreshortening was used to suggest an angle view of an animal or even of its parts. Rarely are two or more animals shown together in any purposeful way. Most of the combinations are due to chance, that is, an animal was painted on a wall regardless of the locations of other images on that same way. Some animals are overlapped without any apparent reason. Apparently hunter-artists were not interested in organizing these images into a unified composition. Furthermore, they did not seem interested in depicting other subjects: trees, plants, ponds, rocks, even people.

What was the purpose of these paintings, many of which are located in cramped, inaccessible places? Scientists speculate that the purpose was magical. Painting an animal was equated with gaining power over that animal. The caves may have been temple-sanctuaries, where hunter-artists gathered to paint animals, and magically ensure their success in the hunt. But no one knows for sure.

2500 B.C. Egypt

Much more is known about the art and beliefs of the ancient Egyptians. Many of their monuments are still standing (fig. 18–5). Their written language, a form of picture writing called *bieroglyphic* (fig. 18–6), was decoded by members of Napoleon's army in 1799.

Object Depicted	Egyptian vulture	Flowering reed	Flowering reeds	Forearm	Stool	Quail or chick	Foot	Horned viper	Owl	Water	Mouth	Reed sheltering field
Sign	1	4	44	L		•	L	~ ×		~~~~	0	
Translation	Α	Ī	Υ	Α	Р	W	В	F	М	N	R	Н
Sound	A as in FAT	Y	Y as in Hebrew YODH	AH as in FATHER (guttural)	Р	W	В	F	М	N	R	H as in ENGLISH
Object Depicted	Wick of twisted flax	Placenta	Animal's belly with teats	Bolt folded cloth	Pool	Hillslope	Basket with handle	Stand for jar	Loaf	Tethering rope	Hand	Snake
Sign	8		€	 -		4	~			₽	-	٢
Translation	Н	CH	CH	S	SH	Q	K	G	T	CH	D	J
Sound	Emphatic H	CH as in Scottish LOCH	CH as in German ICH	S	SH	Q as in QUEEN	K	Hard G	T	CH as in CHEST	D	Emphatic S

18-6 Hieroglyphic writing with ink on papyrus, ca. 1025

18-5 Ramses II, about 1257 B.C. 19th dynasty. Sculpted from cliff each about 21 m high. Abu Simbel.

By 2500 B.C., Egypt had been a civilization for nearly 1,000 years. Just as India's civilization began along the banks of the Indus (Chapter 16), Egypt's developed along the banks of the Nile (fig. 18–7). Nile farms had become so successful that Egyptians were able to produce a surplus of food, thus allowing people to do other things besides farming or hunting. As they gathered in Egypt's cities, their new jobs included such things as mayor, priest, judge, engineer, teacher, laborer, and, of course, artist. Egypt's civilization was very organized with high levels of mathematics, engineering, and construction skills—as can be seen in the scale of its surviving architecture and sculptures (fig. 18–5, fig. 18–8).

The Egyptian religion was polytheistic. Egyptians also believed in *immortality*, or life after death — especially for such people as the pharaoh (king), priests, noblemen, and others who were high on the social ladder. In order to ensure that the soul of an important man would live forever, great efforts were taken to embalm and mummify his body, and also to bury him in a solid tomb with his earthly belongings and statues (recall the regal portrait of Mycerinus and his queen, fig. 13–6). Also included were

painted images of not only the deceased, but of his wife, servants, maids, laborers, and even animals. It was believed that these images participated magically in his eternal happiness. The most impressive tombs—not only in

18-7 Ancient Egypt.

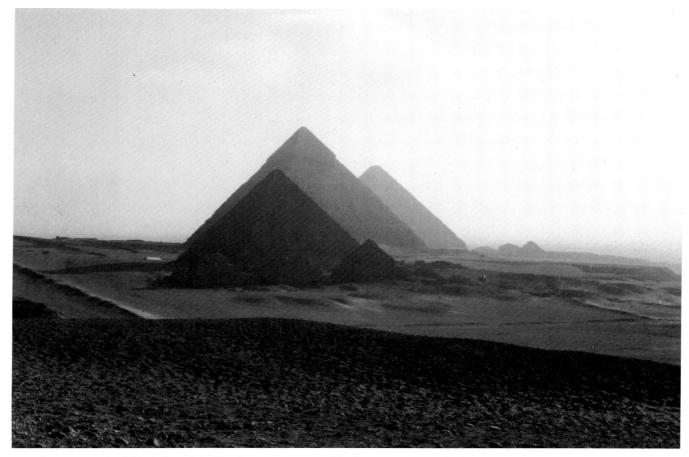

18-8 Great Pyramids of Gizeh. From left: Mendure, ca. 2460 B.C.; Khafre, ca. 2500 B.C.; Khufu, ca. 2530 B.C.

Egypt, but anywhere—are the pyramids for the pharaohs Khufu, Khafre, and Menkaure at Gizeh (fig. 18–8). But most of Egypt's surviving art is to be found in *mastabas* (fig. 18–9)—relatively modest tombs for people below the rank of pharaoh.

In the mastaba of a nobleman who supervised the building of Khafre's pyramid, is a series of painted murals. One mural that was discussed briefly in Chapter 15 consists of two registers (fig. 18-10) depicting the slaves of the nobleman at work on his estate. In the upper register on the left, one laborer can be seen uprooting a tall stalk of papyrus. Grown on the banks of the Nile, papyrus was used to make writing material (paper was invented much later by the Chinese: Chapter 16). To the right of center are two slaves carrying bales of papyrus - perhaps to the boat on the left. The men in the boat may be preparing to load it with a cargo of papyrus for shipment. In the lower register, laborers are tending the nobleman's cattle. In the center, one man is feeding a steer. Just above it is another steer resting on its stomach. On the right, another man seems to be leading a herd. As noted in Chapter 15, however, it is a type of composition that lacks almost any suggestion of three-dimensional depth. Overlapping is minimal; figures, such as the men in the boats, were drawn larger or smaller because of their importance, not to show near and far. In the upper register, all the men and the boat share the same ground line. Likewise, the men and the cattle in the lower register stand or walk on the same ground line. The animal resting on its stomach is on a separate ("floating") ground line. In one respect – the depictions of animals – this art can be compared to Ice Age art. Like those painted by the hunters. Egyptian animals are relatively realistic in shape and detail, and are shown only from the side. However, because Egyptian artists did not use chiaroscuro, the beasts of the tombs seem to have less depth than those of the caves.

Why is Egyptian art so flat and repetitious, especially with regard to depictions of people? One reason had to do with their belief in immortality and the magical role of art in that belief. The figure of a human, for example, follows a strict formula: his head, legs, and feet are shown from the side while one eye and his shoulders are shown frontally. This style was intended to convey the main features of the human body as clearly as possible. Over time, it became the "correct" way to show people, especially important people like Ti (fig. 18–10). To depart from this formula would have been an error, like a spelling mistake. Such a mistake might do magical harm to the soul of the deceased. The figures of the servants also reflect this formula,

- 1. Chapel
- 2. False door
- 3. Shaft into burial chamber
- 4. Serdab (chamber for statue of deceased)
- 5. Burial chamber

18-10 Egyptian tomb, ca. 2450 B.C. Painted limestone, tomb of Saqqara. Stone relief, approximately 48 " (122 cm) high.

18-11 *Peplos Kore*, Acropolis, Athens, ca. 530 B.C. Marble, approx, 48" (122 cm) high. Acropolis Museum, Athens.

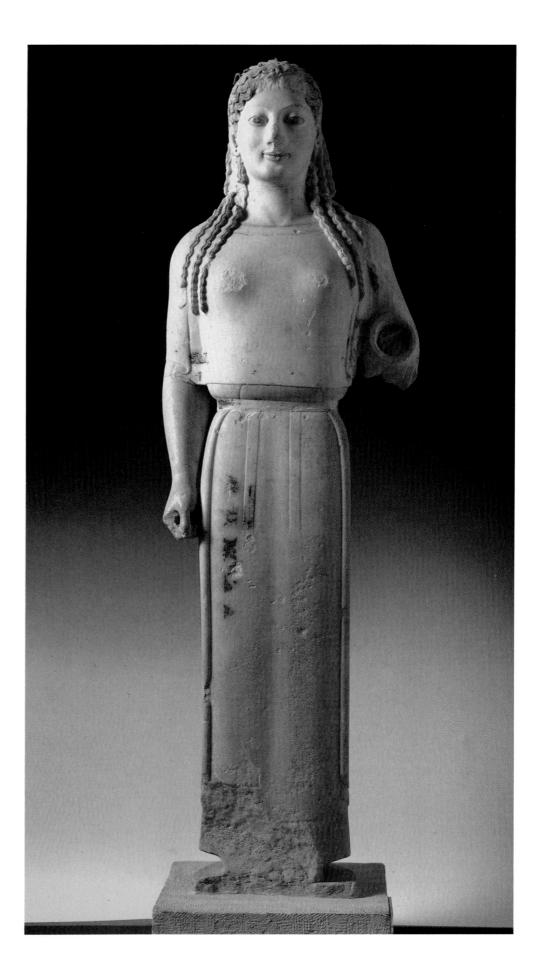

but they show somewhat more variety. Why? Because a servant is less important than a master. Another reason for this artistic rigidity had to do with the basic conservatism of Egyptian society. All of its cultural forms, including art, changed little over thousands of years. Egyptian art was almost as eternal in fact as it was in intent.

Classical Greece

Greek civilization, unlike the Egyptian, evolved and changed its forms. Witness the difference between two statues separated by less than one hundred years. The simplicity and stiffness of the young maiden sculpted in 530 B.C. (fig. 18-11) contrasts vividly with the naturalness of the goddess Athena, a Roman copy of a statue sculpted by Phidias in 450 B.C. (fig. 18-12).

The great era of Greek culture, known as the Classical Period, lasted from about 480 B.C. to 323 B.C. Around 450 B.C. (the year of the Athena statue), the citizens of Athens began rebuilding a fortified hill called the Acropolis (fig. 18–15) and the temple of Athena called the *Parthenon* (fig. 18–16); both had been destroyed by the Persians. This was not only the time of Phidias, but also of philosophers Protagoras and Socrates; Sophocles and Euripides, the writers of famous Greek tragedies; and Pericles, the leader of Athens who established that city as the center of art and culture in the Greek world.

Phidias's statue, like all Greek sculpture of this time, expresses two principles: humanism and idealism. Humanism is defined as a view of life based on the nature, dignity, and interests of people. While other societies in the ancient world, like Egypt and pre-Islamic Persia, continued to be dominated by superstition, the Greeks were beginning to investigate the workings of the world, and to question old ways of thinking. They believed the investigation should begin with humans. As Protagoras stated, "Man is the measure of all things." The realism of Phidias's statue reflects this humanistic tendency. In contrast to the puppetlike maiden of 530 B.C., the Athena has the form and posture of a real woman. Her gown, which gathers at the waist and hangs in natural-looking folds, suggests the presence of a real body underneath. She places her weight on one foot more than the other, in this case her right. This causes a subtle movement throughout the body: the right hip is higher than the left; the upper body is bent so that the left shoulder is higher than the right (fig. 18-13). This movement, sometimes called "weight shift," amounted to a real breakthrough in the art of representing the human figure.

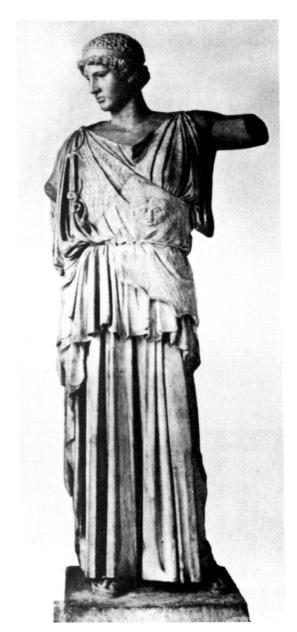

18-12 Phidias, Athena Lemnia, Roman copy after original of ca. 450 B.C.. Marble, approximately 6'6" (198 cm) high. Body, Albertinum, Dresden; head, Civic Museum, Bologna.

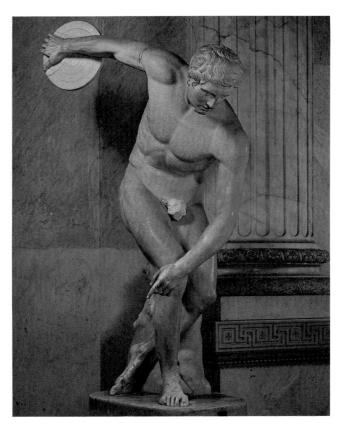

18-14 Myron, *Discobolus*, Imperial Roman Copy. Marble, 60" (152.4 cm) high. Museo Nazionale Romano, Rome.

An idealistic tendency is also reflected in the statue by Phidias. Idealism has to do with a concept of perfection. *Athena* is obviously young, athletic, and beautifully proportioned. Greek philosophers reasoned that there was a perfect form for everything: a perfect woman, perfect man, perfect horse, perfect tree, and so forth. This statue is Phidias's attempt to portray ideal womanhood as well as the goddess Athena.

Ideal manhood received equal attention from the Greeks. The *Discobolus* (fig. 18–14), a Roman copy of a bronze sculpture by Myron, shows a young athlete poised to hurl a discus. The suggestion of movement—especially daring for the 400's—must have seemed incredibly lifelike to the Greek public. Still, as with *Athena*, realism is tempered by idealism—as seen in the *Discobolus*'s proportions, its balanced posture, and its passive face.

Greek architecture of the time also expresses humanism and idealism. The Parthenon (figures 18–15 and 18–16), unlike an Egyptian pyramid or an American skyscraper, is built on a human scale. Although it is grand, it is not overwhelming. The method of its construction, as you can see, is post and lintel. The idealism of the Parthenon can be seen in the proportional relationships between the columns and the rest of the temple: their width relative to

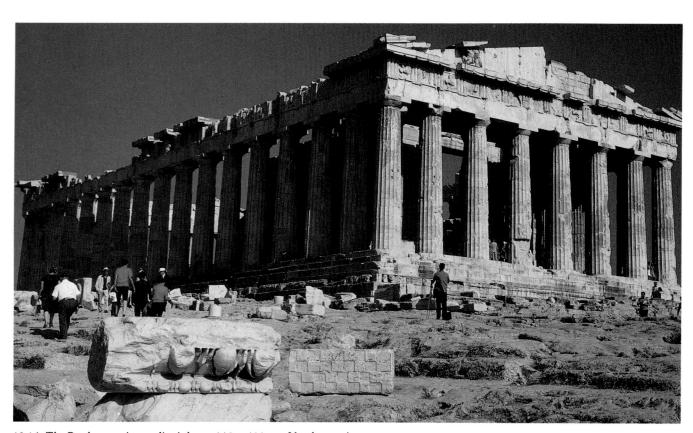

18-16 The Parthenon, Acropolis, Athens, 448 - 432 B.C. Northwest view.

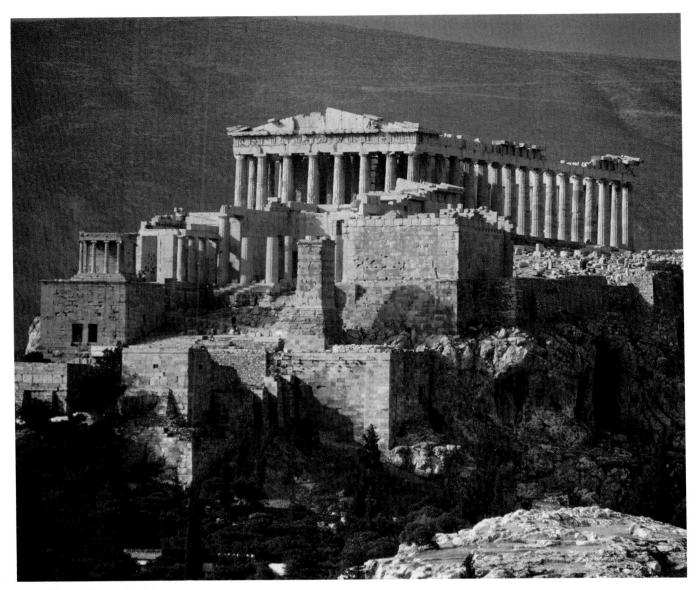

18-15 View of Acropolis, Athens.

their height, their width relative to the spaces between the columns, and their height relative to the height of the temple. These proportions represent a refinement of the Doric style of temple that took place over hundreds of years. The steps in this process (reading from left to right) are illustrated in figure 18-17.

The entire ancient world was in awe of Greek achievements, not only accomplishments in sculpture and architecture, but in literature, philosophy, and human rights. Later generations of Europeans shared this awe, and, as we shall see in this chapter, much of European art bears the influence of Greek artistic styles.

18-17 Changes in Doric order proportions.

18-18 Wall painting transferred to panel, from a villa near Pompeii. 79 A.D.

First and Second Century Rome

The Romans were the principal heirs of Greek culture. They copied Greek statues by the thousands. (Phidias's Athena and Myron's Discobolus are known to us only through Roman copies.) Original Roman sculptures resemble Greek sculptures. Roman paintings - known to us only through a few surviving murals in Roman homes were largely based on Greek paintings. As you can see, the pleasant urban scene in figure 18-18 employs all the devices that we associate with pictorial depth – foreshortening, chiaroscuro, placement, variations of scale, aerial perspective - except one: a consistent application of linear perspective (note that the eye levels of the various walls, temples, and monuments are inconsistent). Neither the Greeks nor the Romans had developed a system of one- or two-point perspective. Finally, Roman temples - also made with post and lintel methods - resemble Greek temples (fig. 18-19), although most Roman temples are in the Corintbian style rather than the Doric.

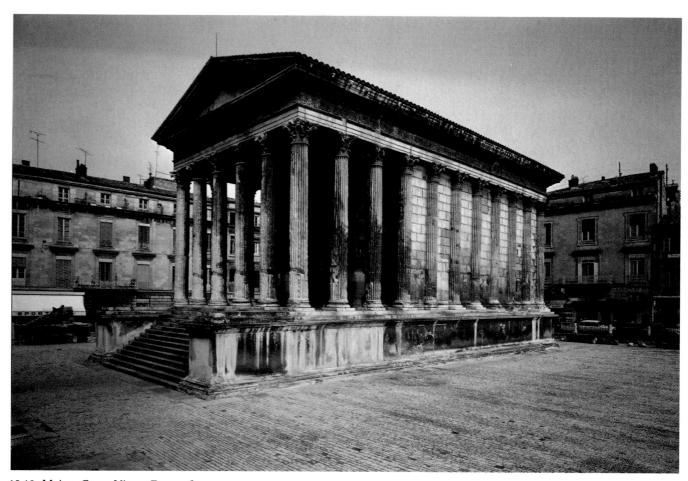

18-19 Maison Caree, Nimes, France, first century B.C.

18-20 The Forum of Pompeii.

There was one art form, however, in which the Romans were original and unsurpassed in the ancient world: architecture, especially for secular (nonreligious) structures. In the center of every major city was a forum, a combination of commercial district and civic center that contained law courts, money exchanges, record offices, and assemblies. Today these forums are in ruins (fig. 18-20). Romans built harbors, bridges, sewers, and gigantic water conduits called aqueducts (fig. 18-21) that still line the landscape of Europe. They also built imposing structures for recreation: gymnasiums, public baths, race tracks, and stadiums like the Roman Colosseum (fig. 18-27). Most of these structures employ one or both of two Roman technologies: the arch principle of construction, and concrete. These construction techniques were far more efficient than the post-and-lintel methods.

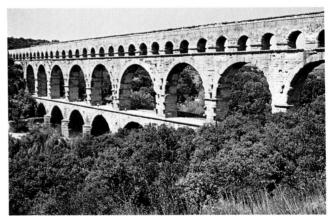

18-21 Pont du Gard. Roman arch, near Nimes, France, first century B.C.

18-27 Colosseum, Rome ca. A.D. 70 – 82.

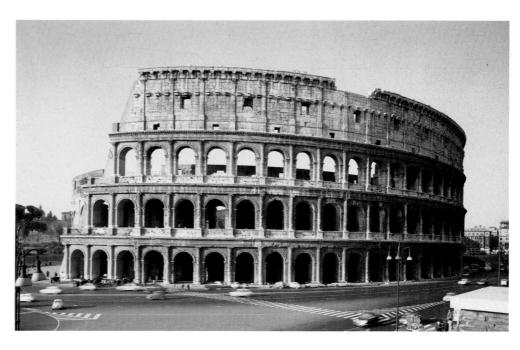

The material used in just about all of the surviving architecture of the Egyptians, Greeks, and Romans is masonry. A masonry lintel, however, lacks *tensile* strength, the ability to withstand stress (fig. 18–22). A masonry lintel longer than twenty feet is apt to crack of its own weight; a temple with a masonry ceiling has to be supported by a forest of columns. A wooden lintel, which is lightweight and has tensile strength, needs less support. But wood is not a good material for public buildings because it rots and burns.

A round arch (fig. 18–23), as opposed to either a post and lintel structure or a corbeled arch (see Chapter 17), solves the problem of masonry's tensile weakness. During construction, the stones of an arch are supported by a temporary wooden framework until the last stone (the keystone) is in place. Once it is finished, an arch is extremely strong—capable of spanning more than one hundred feet. A barrel vault (fig. 18–24) is an arch extended in depth. Like a ceiling, it can be used to cover a rectangular area. A cross vault (fig. 18–25), formed by two intersecting barrel vaults, can cover a rectangular area while remaining open on all four sides. A dome (fig. 18–26) is simply a radial form of the

arch, and can be used to cover a circular area. The Romans, who had developed concrete as early as the second century B.C., used this material as well as stones for making barrel vaults, cross vaults, and domes. Resembling a thick sludge before it hardens, concrete can be poured into forms of almost any shape. Like stone, concrete is much stronger as an arch than as a horizontal lintel.

The legendary Colosseum (fig. 18–27) – begun under the emperor Vespasian and dedicated by his son Titus in A.D. 80 – employs every variation of the arch system except the dome. Three levels of *arcades* (repeated arches) ring the outside; barrel-vaulted ramps lead to the arena, and cross-vaulted corridors circle the entire stadium on all levels. In addition to covering the ramps and corridors, these vaults supported the stadium seats, which at one time held 50,000 spectators. Beneath the arena were cells for wild animals and locker rooms for the gladiators. At the dedication, more than 5,000 animals were killed. At one performance, the arena was flooded to stage a mock naval battle involving thousands of actors. Over 620 feet (189 meters) long, 513 feet (156 meters) wide, and 157 feet (47 meters) high, the Colosseum is ten times the size of the Parthenon.

18-22 Post and lintel.

18-23 Arch.

18-24 Barrel vault.

18-25 Cross vault.

18-26 Dome

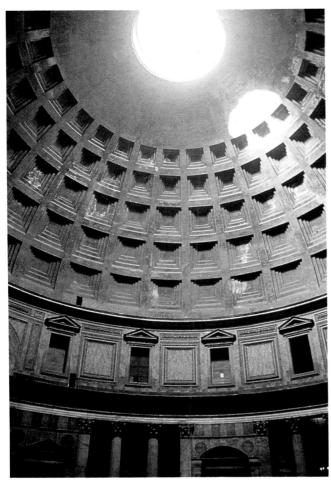

18-29 Pantheon, interior, dome. Photograph: Jan Lukas.

For thirteen centuries the solid concrete dome covering the Pantheon (fig. 18-28) held the record for being the largest in the world. (The view of the dome is obscured by the massive columned porch in the front.) Finished in A.D. 125 during the reign of Hadrian, the Pantheon was dedicated to the seven planetary gods – a legacy of the Greek religion. In the 600's it was converted to a Christian church. Because of this, the Pantheon was spared the dismantling that marred or ruined almost all other Roman buildings. Today it is a shrine for tourists. On clear days the sun, streaming through a round hole at the top, forms a bright disk that moves across the surface of the floor and walls with the speed of the rotation of the earth (fig. 18-29).

The architecture of Rome was a symbol of the power as well as the splendor of the ancient world until Rome's decline in the 300's and 400's. Christianity replaced the religious system of Greece and Rome, and almost all of the culture of the Roman Empire was rejected as pagan, if not immoral.

18-28 Pantheon, Rome, ca. A.D. 118 - 128. Photograph: Nimatallah.

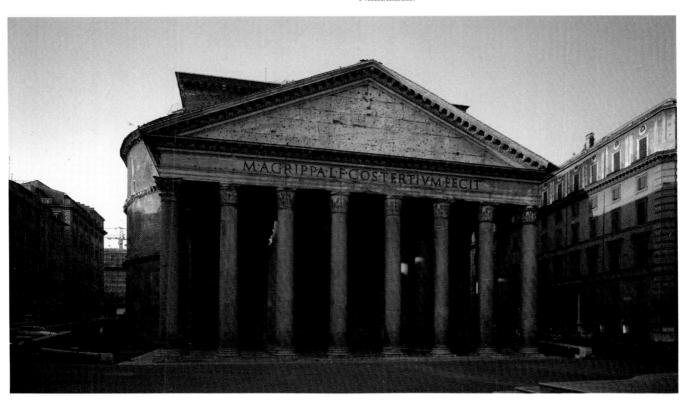

18-30 Sutton-hoo Helmet, seventh century, Saxon. The British Museum, London.

18-31 Frankish ornaments, (right) sixth century. Silver and paste, $1\frac{1}{8}$ " (10 cm) each. Photograph by Bobby Hansson. (Gift of J. Pierpont Morgan, 1917) (left) Langebardic ornament, seventh century. Silver-gilt and niello, $6\frac{5}{16}$ " × $3\frac{3}{4}$ " (16 × 10 cm). (Purchase, 1955, Joseph Pulitzer Bequest.) The Metropolitan Museum of Art, New York.

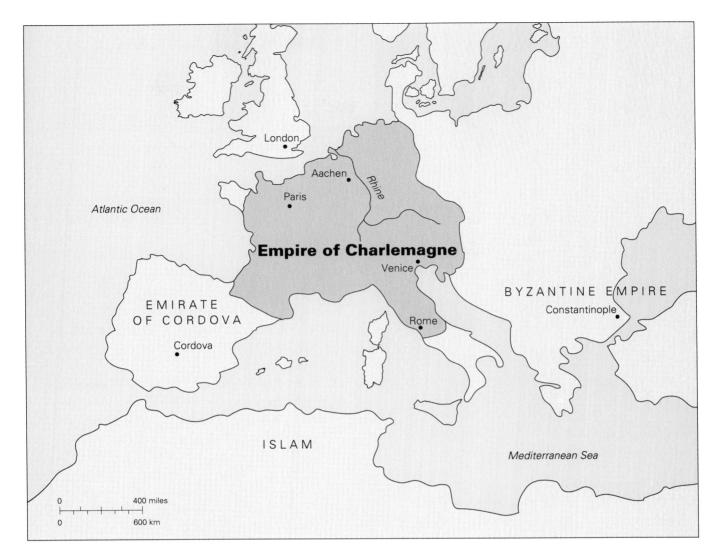

18-32 Empire of Charlemagne.

Through the Dark Ages to Charlemagne

During the 400's, western Europe entered the medieval era-literally, the Middle Ages. This term applies to the long period of time between the Fall of Rome and the Renaissance (to be discussed). During the early part of this period, civilized life had all but disappeared. The people of Europe were illiterate and largely nomadic. They produced little painting, no large buildings, and no in-theround sculptures. However, they did make such things as military helmets (fig. 18-30) and attractive ornaments for their weapons, their horses, and themselves. You may recognize the technique of cloisonné (Chapter 13) in the fancy pins (fig. 18–31) used to fasten their garments.

In the 800's, a Frankish king named Charlemagne united most of the continent into a Holy Roman Empire (fig. 18–32). A patron of the arts as well as a great military

18-33 Interior of the Palatine Chapel of Charlemagne.

leader and statesman, Charlemagne attempted to bring Europeans out of the Dark Ages by stimulating a rebirth of culture. He imported scholars, architects, and craftspersons from all over, but primarily from Constantinople, headquarters of the Byzantine Empire. The forerunner of Eastern Christendom (modern Russia, Armenia, Greece, Yugoslavia, and parts of eastern Europe), the Byzantine Empire was much more civilized than western Europe. Charlemagne's private chapel (fig. 18–33)—which may have been modeled after a chapel in Constantinople—represents the beginning of medieval masonry architecture.

The hope of a united Europe and accelerated cultural growth was dashed with Charlemagne's death. But two political units grew out of his empire and continued to survive, though somewhat shakily: the Holy Roman Empire (a cluster of German kingdoms) in the east and a French kingdom in the west. These, together with the states owned by the Catholic church in Italy and the Anglo-Saxon kingdoms across the English Channel, formed the power blocks of medieval Europe. Together they transformed the continent from a wasteland of peasant villages to a civilization of art and architecture. France was in the forefront of this transformation.

Medieval Crusades and Pilgrimages

By the 1000's and 1100's, large churches with vaulted ceilings were beginning to spring up all over Europe, particularly in France. This was the time of the Crusades, when knights and peasants traveled to Palestine to recapture Jerusalem from the Moslem Saracens. In 1189, Richard the Lion-Hearted, king of England, met the king of France in the church at Vézelay to begin the Third Crusade. They probably led their troops through Vézelay's doors under a relief carving of Christ and the apostles (fig. 18-34). Christ is shown in the center giving the apostles (seen holding their gospel books) their spiritual assignments. The scenes in the eight side compartments show the apostles healing the sick. The scenes on the lintel below show them preaching the gospel to all nations. The knights who passed through the door and glanced up at this relief believed that they, like the apostles, had received a spiritual assignment.

Compare the style of this relief to the classical examples reviewed earlier. Unlike the bodies of the Greek sculptures, these are stylized, unnaturally slender, and seem to be floating rather than standing firmly on the ground. The folds of their gowns are more decorative than natural, though they do reveal their bodies to some extent. Unlike Roman murals, the scenes of this relief are completely lacking in three-dimensional space. Some of these characteristics are due to the limitations of relief carving, but most are due to a dramatic difference in point of view. The Greeks and Romans focused on humans and the natural world; the medieval Christians focused on God and the divine world.

18-34 Central portal of La Madeleine, Vézelay, 1120 - 1132.

18-35 The nave of St. Sernin.

The 1100's were also a time when pilgrims traveled to major shrines on the European continent to see and be in the presence of a *relic*—a remnant of a saint's clothing, hair, or even bones. It was believed that a relic had the power to cure disease, forgive sins, and perform miracles. One of the churches on the pilgrimage route was St. Sernin in Toulouse (fig. 18–35). Imagine how pilgrims must have felt as they marched in a procession beneath the barrel vault of St. Sernin's main aisle, while listening to choirs of monks intoning chants. Notice that the vault is reinforced with ribs that form their own rhythmic procession as they lead the eye to the rear of the church. Notice also the heaviness of the supports and the relative darkness of the interior.

Gothic France

Although the Crusades were military failures, Europeans gained a great deal from their Moslem adversaries (Chapter 17). Among other things, they learned about building arches and making stained glass. These important lessons were applied to the next style of church architecture, which eventually evolved into the Gothic style, a variation of arch construction noted for its efficiency. Gothic builders added three important features to architecture: the pointed arch (fig. 18-36), ribbed vaulting (fig. 18-37), and the flying buttress (fig. 18-38). Because vaulted ceilings are heavy, the walls or piers holding them must be very thick to avoid bowing outward. Ceilings based on the pointed arch direct the thrust of gravity downward more than round vaults do, and are therefore more stable. Reinforcing the vaults with ribs along the lines of thrust makes them even more stable. Flying buttresses, which are constructed outside the building, provide support at those critical points where the ceiling joins the wall. Flying buttresses surround Chartres Cathedral (fig. 18-39), the first major church to employ Gothic construction throughout.

18-36 Pointed arch.

18-38 Flying buttresses.

18-37 Ribbed vaulting.

18-39 Chartres Cathedral, France, twelfth-sixteenth centuries.

18-40 Nave of Amiens Cathedral.

Two views of the inside of Amiens Cathedral (figures 18–40 and 18–41) demonstrate the amount of space available in a church of this type. Notice in figure 18–40 the pointed arches of the arcade on the left and in the windows at the rear of the cathedral. Notice in figure 18–41 the soaring vaults overhead based on the pointed arch. Notice in both figures the ribs outlining the contours of the vaults. In what ways do you think a Gothic cathedral expresses the Age of Faith?

Producing more space per pound of material than any other kind of masonry construction, the Gothic system allowed for large windows that could flood the interior with light. However, the brightness of this light was tempered by the used of stained glass. (Recall the methods of making stained glass windows in Chapter 13.) A window from Reims Cathedral (fig. 18-42) illustrates not only the splendor of this glass but the characteristics of Gothic pictorial art in general. Notice that the bodies of Christ and the saints, like those in the Vézelay relief, are stylized, and that the space around them is abstracted into symbols and patterns of color. Although some of this is due to the peculiar demands of the stained glass medium, it is also due to the spirituality of medieval life. An abstract and symbolic art is often more appropriate than a realistic art to express the world of faith.

The Gothic style of architecture, which spread to other parts of Europe, flourished in the 1200's and 1300's. After that, it began to be challenged by architects working in Florence, Italy.

18-41 Choir vault of Amiens Cathedral.

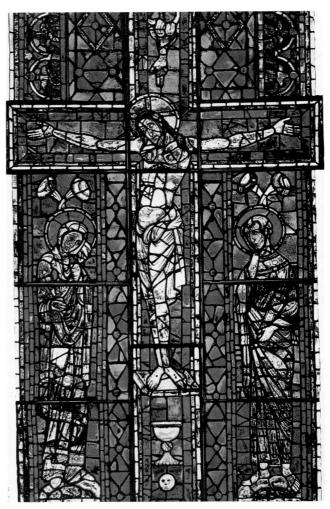

18-42 Crucifixion, detail of a window from St. Remi, Reims, ca. 1190. Stained glass, approximately 12' (366 cm) high.

The Renaissance in the 1400's

Renaissance, which literally means *rebirth*, refers to a period of time when attitudes changed dramatically, particularly in Florence, Italy. The spirit of humanism, which had ignited the achievements of the Greeks some 1900 years earlier, was being revived. Like the Greeks, Florentine thinkers focused on people and earthly life more than earlier generations had. This focus is reflected in Renaissance art, as we shall soon see, and also in an increased level of questioning. Whereas Greek questions led to advances in philosophy and logic, Renaissance questions had more to do with science. At the end of the 1400's, Leonardo da Vinci (see below) began exploring the fields of optics, mechanics, and human anatomy, and Christopher Columbus began exploring the world. In the next century, Nicolaus Copernicus, Polish astronomer, theorized that the

earth revolved around the sun, and not the other way around as people had believed for centuries. These, and later researchers, helped to create the scientific explosion that has affected all of our lives - intellectually, materially, and spiritually.

In addition to stimulating a more scientific attitude, Renaissance scholars also revived an interest in the classical civilizations. In medieval times, the writings of people like Sophocles, Plato, and Virgil (Roman poet) gathered dust or were interpreted solely in light of Christian doctrine. Now the writings of these people were avidly collected and read for whatever universal truths they might contain. Earlier, Greek statues, Roman statues, and Roman copies of Greek statues were ignored or destroyed; now they were preserved and admired by artists. Earlier, Roman buildings had been robbed of their stones for constructing churches; now they were studied by architects.

Florentine architect Filippo Brunelleschi admired the Pantheon (fig. 18-29), one of the few intact buildings. Brunelleschi's interest in Roman architecture is reflected in the small domed chapel (fig. 18-43) he designed for the wealthy Pazzi family. Notice that its spatial relationships,

18-43 Filippo Brunelleschi, interior of Pazzi Chapel, South Croce.

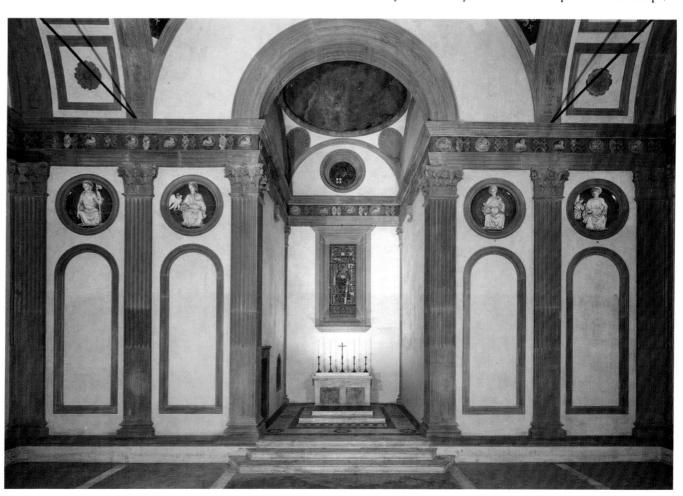

18-44 Filippo Brunelleschi, dome of Florence Cathedral, 1420 – 1436.

18-45 Donatello, *St. Mark*, 1411 – 1413. Marble, approximately 7′9″(236 cm) high. Or San Michele, Florence.

in contrast to those of a Gothic cathedral, are relatively simple. The use of a dome, in addition to plain walls and color accents inspired by classical decorations, is a clear sign of change in architectural taste, away from Gothic. Brunelleschi's most ambitious project, the dome of the Cathedral of Florence (fig. 18–44), is very Renaissance in its boldness. Spanning a diameter of 140 feet (43 meters), it is 300 feet (93 meters) high (351 feet high including the decorative "lantern"). No dome this wide had been built since the Pantheon, no dome this high had even been built in the world. Despite its size and originality, though, this dome is Gothic in its construction. Unlike the dome on the Pantheon, Brunelleschi's is pointed and ribbed.

The change away from medieval styles is clearly reflected in Renaissance sculpture. Donatello (Donato di Niccolo Bardi), who often accompanied Brunelleschi on his trips to Rome, shared the architect's interest in classicism. Donatello's *St. Mark* (fig. 18–45) shows many Greek sculptural tendencies: human proportions, weight-shift posture, and a natural relationship between clothing and the body underneath. Indeed, St. Mark's gown looks as though the apostle had slept in it. The principal difference between Phidias's *Athena* and the *St. Mark* – aside from their gender – is in their faces. Athena's expresses classical calm; St. Mark's expresses the passion and seriousness of a Christian evangelist.

The men in *The Tribute Money* (fig. 18–46), a fresco by Masaccio (Tommaso Guidi), also look serious. They are as weighty and solid as sculptures, and their intense facial expressions recall that of St. Mark. They could be members of the Florentine council assembled for an emergency meeting. Actually, they are Jesus and his disciples confronting a tax collector in Capernaum (from St. Matthew 17:24-7). (Jesus is in the center telling St. Peter to obtain a coin from the mouth of a fish. Peter is shown in three places: with the disciples; obtaining the coin on the left; and paying the collector on the right.) The men's bodies, shaded with bold strokes of chiaroscuro and illuminated from the right, appear quite three-dimensional. Depth also exists in the space they inhabit. The building on the right may be the first in art history to have been rendered in one-point perspective; the hills in the background are shrouded in aerial perspective. The Tribute Money, one of a series of murals on the subject of St. Peter, served as a textbook of pictorial techniques for later Renaissance artists like da Vinci and Michelangelo.

The High Renaissance

At the end of the 1400's, art entered a phase called *High Renaissance*, which lasted about twenty years. This phase brought to perfection the experiments and discoveries of artists like Donatello and Masaccio. A good example of High-Renaissance art is Raphael's *School of Athens* (fig. 18–47).

The subject—an assemblage of famous philosophers from the ancient world (including Socrates, Plato, and Aristotle)—is obviously classical. More importantly, the men have idealized bodies and graceful gestures, and a beautiful, spacious environment to move about in.

Raphael's mural, finished in 1511, was not the first successful High Renaissance work. Sixteen years earlier, in 1495, Leonardo began *The Last Supper* (fig. 18–48) on the wall of a Milan monastery. Most people recognize this mural and know that it was made by Leonardo da Vinci, but few realize that painting was only one of Leonardo's

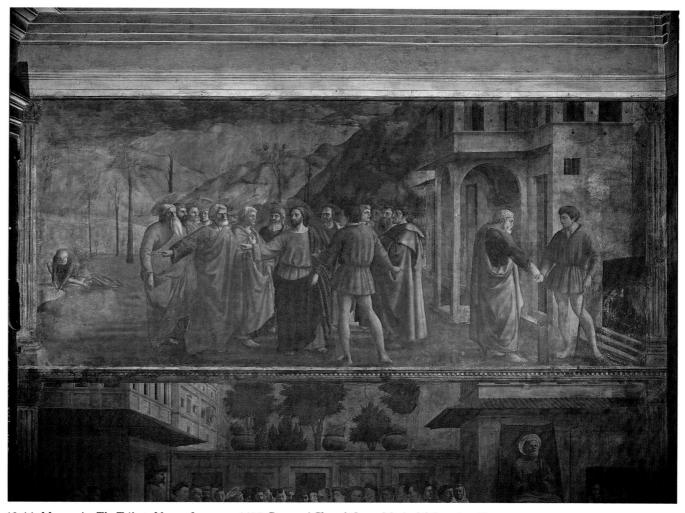

18-46 Massaccio, The Tribute Money, fresco, ca. 1427. Branacci Chapel, Santa Maria del Carmine, Florence.

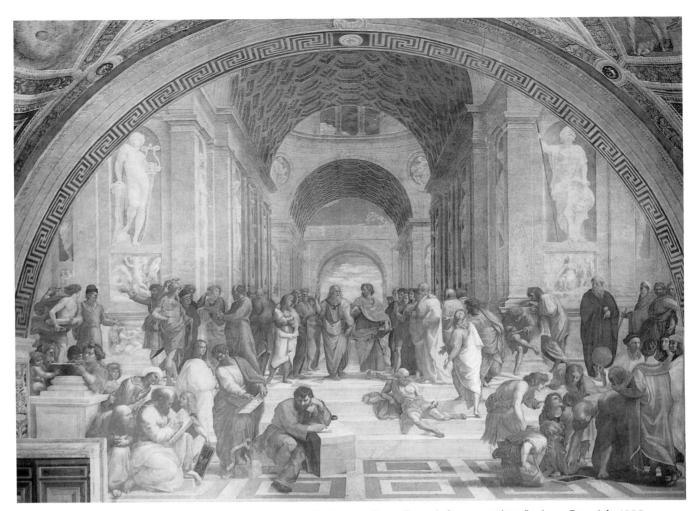

18-47 Raphael, *The School of Athens*, Stanza della Segnatura, The Vatican, Rome Fresco in lunette: 25′3¼″ at base. Copyright 1985, Scala/Firenze.

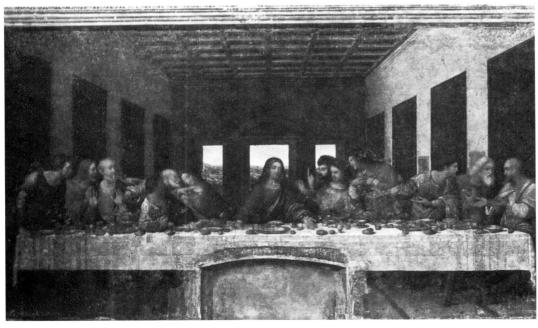

18-48 Leonardo da Vinci, *The Last Supper*, ca. 1494. Oil and tempera on plaster. 14 $^{\prime}$ 5 $^{\prime\prime}$ \times 28 $^{\prime}$ $^{\prime\prime}$ (4.39 \times 8.54 cm). Santa Maria delle Grazie, Milan.

skills. The great artist was also a sculptor, an architect, an engineer, and an inventor who filled notebooks with descriptions of everything from band brakes to parachutes. In addition, he was a scientist whose thinking was ahead of his time in the fields of astronomy, hydrology, sound, optics, and especially anatomy (fig. 18-49). He is said to have dissected as many as fifty cadavers in his search for knowledge. More than any man in history, Leonardo exemplified the definition of Renaissance Person – an individual skilled and well versed in many fields.

Before Leonardo started painting, artists were unable to show people moving about in a picture without sacrificing stability. In Masaccio's The Tribute Money, for exam-

ple, the composition is stable, but the men are relatively static. In other paintings, the opposite was true; people moved about freely, and the composition was chaotic. The Last Supper is the first major painting to successfully reconcile movement and stability. One reason is that the composition is deceptively simple: a horizontal picture containing a long table that is symmetrical and parallel with the plane of the picture. Jesus is not only located at the middle of the table, his head is at the center of the picture and at the vanishing point. On both sides of him, the twelve disciples respond in various degrees of movement to the statement, "One of you will betray me." Despite their agitation, all have idealized bodies and graceful gestures.

18-49 Leonardo da Vinci, Embryo in the Womb, ca. 1510. Pen and ink. Royal Collection, Windsor Castle. Copyright reserved. Reproduced by Gracious Permission of Her Majesty the Queen.

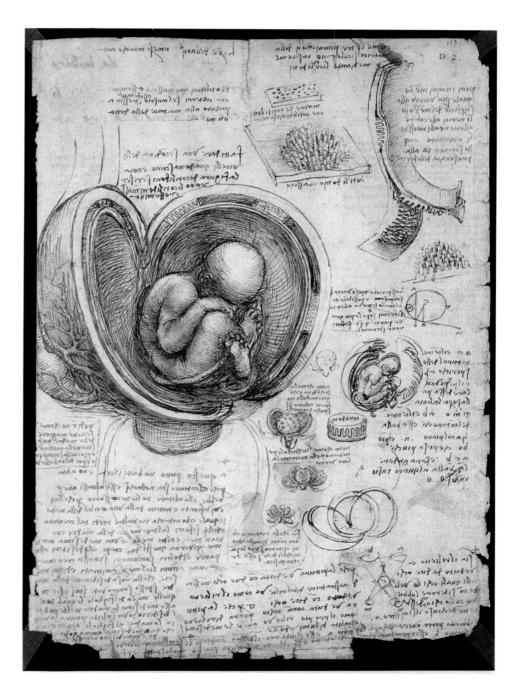

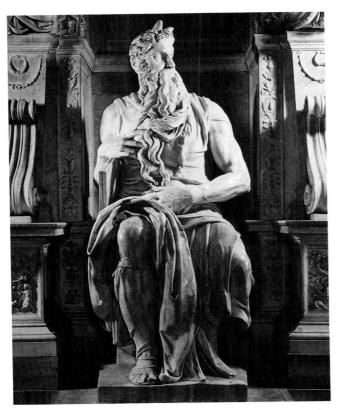

18-50 Michelangelo, *Moses*, 1513 – 1515. Marble, approximately 8'4" (254 cm) high. San Pietro in Vincoli, Rome.

The one on the left who is leaning back with his face in shadow is Judas. All fit comfortably in the rectangular space that Leonardo defined by means of one-point perspective. The first painting to successfully integrate active figures in a realistic spatial world, *The Last Supper* has been popular from the time it was completed in 1498.

The works of Leonardo's younger contemporary, Michelangelo Buonarroti, have also continued to be popular through time. There are other parallels between the two: both artists began their careers in Florence, and both were active during the High Renaissance. Like Leonardo, Michelangelo was broadly skilled in the arts—sculpture, painting, architecture, even poetry—though he was not involved in scientific pursuits. Both artists branched out to other cities: Leonardo to Milan, Michelangelo to Rome.

In the early 1400's, Rome was a collection of old ruins, dirt roads, and cow pastures. When Michelangelo came of age as an artist and first began to produce art for the Vatican (a special area in Rome for the headquarters of the Catholic church), Rome was beginning to rival Florence in development and culture. By the time Michelangelo died, Rome had surpassed Florence and went on to become the thriving city and center of culture that it is today.

The Pietà (fig. 8-10), which was discussed briefly in Chapter 8, was Michelangelo's first work for the Vatican; it is also an excellent example of High Renaissance sculpture, as the figures of Jesus and Mary are extremely beautiful and harmoniously related. The Moses (fig. 18-50), begun some fifteen years later, falls within the High Renaissance period, and is definitely grand and monumental. But in this case, beauty has given way to righteous anger. The Moses is too awesome to be included in the same category with School of Athens, The Last Supper, and Pietà. Michelangelo, a man of strong passions, revered Moses and other heroes of the Old Testament, and these passions are often revealed in his work. However, his aim was not to express his personal feelings – as some artists today strive to do – but to glorify the people of the Bible, often by endowing them with superhuman proportions. Nevertheless, Michelangelo's feelings (which were often disturbed) frequently found their way into his later works. More than anything, it is the psychological power of these works that has fascinated the public for centuries. The Moses was originally intended to be part of a grandiose tomb for Pope Julius II – a project that was never completed because Julius himself lost interest in it.

One project that Julius did not lose interest in was the ceiling of the Vatican's Sistine Chapel (fig. 18–51). He

18-51 Interior of the Sistine Chapel, The Vatican, Rome.

18-52 Michelangelo, ceiling of the Sistine Chapel, 1508-1512. The Vatican, Rome. Only five of the nine panels from Genesis are shown.

wanted Michelangelo to cover its vast surface with a mural. Protesting that he was a sculptor, not a painter, Michelangelo began in 1508 to do a fresco on the subject of God's creation. Covering 5,800 square feet (537 square meters), 70 feet (21 meters) above the floor, Michelangelo's creation itself was almost godlike. It took him four years, but in the end, the weary artist had transformed the surface of a vaulted ceiling into a complex pictorial drama (fig. 18-52). The triangular spaces (called *lunettes*) around the perimeter of the mural are filled with figures representing the ancestors of Jesus, the Jewish people of the Old Testament. Between the lunettes are niches containing the largest figures, who were supposed to have predicted the birth of Jesus: Old Testament prophets alternating with female oracles (fortune tellers) from Greek myth. The nine panels running the length of the ceiling in the center contain episodes from the Old Testament book of Genesis: the

Creation, the Fall, and the Flood. (Recall the scene of God separating light and dark in fig. 6–1).

God, who is in each of the Creation episodes, is represented by two figures in the *Creation of the Sun and Moon* (fig. 18–53). Clothed in loose-fitting, billowing gowns, these figures have massive, muscular bodies like that of *Moses* (which Michelangelo sculpted soon after the completion of the Sistine ceiling). Although they resemble Greek gods, the face of the figure on the right is fierce, like *Jebovah*, God of the Old Testament. Throughout the fresco, Michelangelo borrowed from Greek sources as well as Jewish and Christian sources for his ideas. The use of oracles and heroically proportioned bodies is Greek, the Old Testament themes are Jewish, and the predictions of the coming of Jesus, which are symbolized throughout the mural, are Christian.

Just as the imagery and subject matter of the Sistine

ceiling successfully reconcile ideas from different sources, the composition successfully reconciles movement and stability. Containing more than 300 energetically moving figures, the mural could have become a teeming confusion of humanity. Not only that, scenes take place on different planes and in different directions, and are drawn to different scales. And too many events—worlds being created, prophecy, sin, worlds being destroyed – coexist in the same mural. Michelangelo prevented chaos, however, by dividing each scene into its own rectangular or triangular space. The final effect is both energetic and composed. The Sistine ceiling is considered by some to be the greatest masterwork of the Western world.

The third of Michelangelo's artistic talents lay in architecture. Like his sculpture and painting, his architecture came to represent both the High Renaissance and the Catholic church. The west end of St. Peter's basilica (fig. 18-54) – the principal church of the Vatican – was designed by Michelangelo and completed after his death. (Although based on Michelangelo's design, the dome itself was mod-

18-54 Michelangelo, St. Peter's, 1546 - 1564 (view from the west). Dome completed by Giacomo della Porta, 1590.

18-53 Michelangelo, Creation of the Sun and the Moon, detail from the Sistine Chapel ceiling. 1508-1512. Fresco, approximately $9'2'' \times 18'8'' (3 \times 5.5 \text{ m})$. The Vatican, Rome.

ified by Giacomo della Porta.) The use of a pointed dome surmounted by a lantern is clearly indebted to Brunelleschi and the Cathedral of Florence. But the sense of mass, and the unity of windows, columns, and ribs, is Michelangelo's (and High Renaissance). Like the statue of Moses, St. Peter's is truly monumental – a fitting symbol for the headquarters of the Catholic church, as well as being the ancestor of all of the famous domes in the world, including the Capitol dome in Washington, D.C.

The High Renaissance represents a peak development in European art. Although the movement itself ended in the mid-1500's, its basic ideals continued as touchstones of Western art until the latter part of the 1800's, when the modern movement repudiated most of those ideals. But that is a story for Chapter 19.

Challenge 18-1:

Select an artist of the Italian Renaissance and use library resources to write a profile.

Challenge 18-2:

Use two complementary colors to paint a landscape or an interior scene with gradations of color and one-point perspective to produce an illusion of depth.

Chapter 19 Islands of Time II

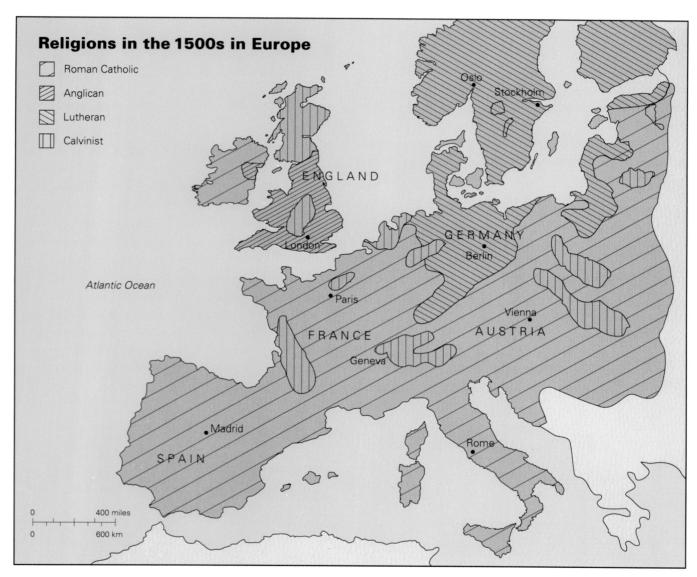

19-1 Religious divisions in sixteenth century Europe.

Chapter 18 ended with a discussion of High Renaissance art in the early 1500's. The 1500's was also the century in which the split in Christianity between Protestant and Catholic began. This development, known as the Reformation, was significant not only for religion but for European culture in general. In 1517, just five years after Michelangelo completed the Sistine ceiling, Martin Luther (fig. 19-2), a German monk, prepared a long list of criticisms of the Catholic church. He reputedly nailed the list to the door of a church in Wittenberg. More importantly, the list was printed and circulated throughout Germany (as the printing press had just been developed) - an act that eventually led to a revolt against the pope and the Catholic church. New denominations-Lutheran, Anabaptist, Mennonite, Calvanist, and Anglican - sprang up in Germany, Scandinavia, Switzerland, the Netherlands, and England.

19-2 Martin Luther.

19-3 St. Ignatius Loyola, engraving.

Meanwhile, Catholics responded with a *Counter-Reformation* led by Ignatius Loyola (fig. 19–3) and his order of monks called the Jesuits. Although Loyola and the Jesuits helped to rid the Catholic church of many of its practices, they also helped to harden its doctrines against the Protestants. By the 1600's, the split in Christianity, which had become quite bitter, divided Europe into Catholic and Protestant factions (fig. 19–1). This split is reflected in the art of the 1600's.

The 1600's and the Baroque Style

Italy, as we learned in the previous chapter, was the center of developments in Renaissance art. By 1600 the ideas of this art had spread to other parts of Europe. Gothic styles were abandoned completely, and architects, painters, and sculptors in northern Europe, as well as those in Italy, developed a style called *Baroque*. This new style, a legacy of High Renaissance art, emphasized complexity, drama, and grandeur—particularly as it was practiced in Catholic countries. To this day, the term baroque is often used to disparage anything that is excessive or pompous. With this

in mind, King Louis XIV's palace at Versailles, France (figures 19–4 and 19–5), is probably the most baroque project ever undertaken. Built by an army of architects, landscape designers, sculptors, stonecutters, and decorators (during the peak of construction, they numbered 36,000 men plus 6,000 horses), the palace and its gardens, stand as a colossal monument to France's most famous king.

The most popular Catholic painter of the early 1600's was not an Italian, but Peter Paul Rubens from Flanders (now Belgium) – a small country on the North Sea. In great demand, Rubens painted for rulers and aristocrats (a privileged class with inherited wealth) all over Europe. His subjects included portraits of famous people, classical myths, heroic battles, and scenes from the Bible, like the Massacre of the Innocents (fig. 19-6). Based on the Gospel of Matthew (2:16), this lively canvas illustrates the killing of all children under the age of two by King Herod's soldiers, after the infant Jesus had been taken to safety in Egypt by Mary and Joseph. It is a vigorously painted commotion of figures charging, fleeing, struggling, and falling. Although true to its subject and full of horror and anguish, Massacre of the Innocents is also full of high drama and grandeur like an opera. It is set on the steps of a Greek temple, with classical ruins just visible in the distant haze. All of the actors - soldiers, men, women, and children - have been endowed with handsome, robust bodies. Even their costumes, torn or otherwise, are splendid. One can imagine the sounds of a tragic aria being sung by the beautifully dressed "soprano" in the center.

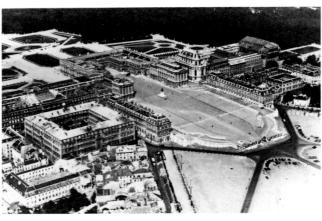

19-4 Versailles Palace (aerial view), 1661–1688. Palace 1,935′ (589 m) wide.

Compare Rubens's painting to Rembrandt's Adoration of the Shepherds (fig. 19–7). Both are based on the Christmas story, but different episodes of that story. They are also very different in other ways, especially in their respective styles. The Rembrandt is not at all theatrical. Instead of handsome athletic bodies, all of the people have ordinary bodies; all, including Joseph and Mary, are dressed in peasants' clothes; the setting—as dark, rustic, and dirty as any stable at night—is anything but grand. The newborn child and the intimate group around him are set aglow by the lantern held by Joseph, while the shepherds in the outer circle—their faces reflecting the radiance of the child—are visible in the shadows. Because Adoration is not theatrical, it more successfully captures the mystery of this sacred moment in the Christmas story.

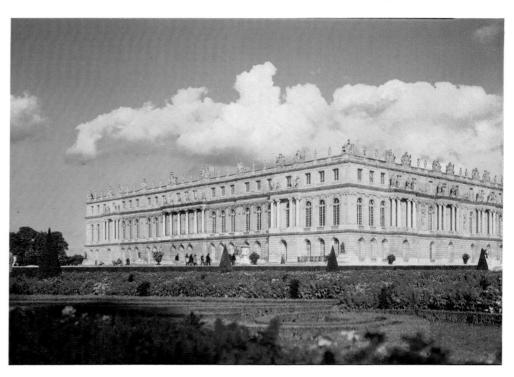

19-6 Peter Paul Rubens, Massacre of the Innocents, ca. 1621. Oil on panel, 6 $^{\prime}$ 6 $^{\prime}\!\!\!/4$ $^{\prime\prime}$ \times 9 $^{\prime}$ 11 $^{\prime\prime}$ (199 \times 302 cm). Alte Pinakothek, Munich.

19-7 Rembrandt van Rijn, Adoration of the Shepherds, ca. 1646. Oil on canvas rounded at the top, $38\frac{1}{4}$ " \times 24 $\frac{1}{4}$ " (97 \times 62 cm). Alte Pinakothek, Munich.

Rembrandt, a Dutchman, made over eight hundred paintings, drawings, and etchings of religious subjects. In this respect, he differed from his fellow Dutch artists. A small country on the North Sea just north of Flanders, the Dutch Republic had recently separated from Flanders because it was predominately Protestant. Unlike Catholics, Protestants tended to look upon religious art as idol worship—akin to magic or superstition. Because of this attitude, and because the Dutch Reformed church did not commission artists to make murals or sculptures, Dutch artists turned to other subjects, particularly *genre* subjects, that is, scenes of everyday life like *Mother and Child* (fig.

19–8) by Pieter De Hooch, and still lifes like *Vanitas* (fig. 19–9) by Maria van Oosterwyck. The clients of artists in Catholic countries were primarily the Catholic church and the aristocracy; the clients of Dutch artists were the wealthy middle classes—merchants, bankers, burgomasters, lawyers, doctors—who found comfort in the images of genre painting and created a demand for it.

Rembrandt painted religious and nonreligious works (recall *The Mill*, his somber landscape discussed in Chapter 5, fig. 5–32). His clients bought both kinds, although his art was not appreciated then as much as it is now. Rembrandt was unique in his time. Unlike most Dutch painters, he

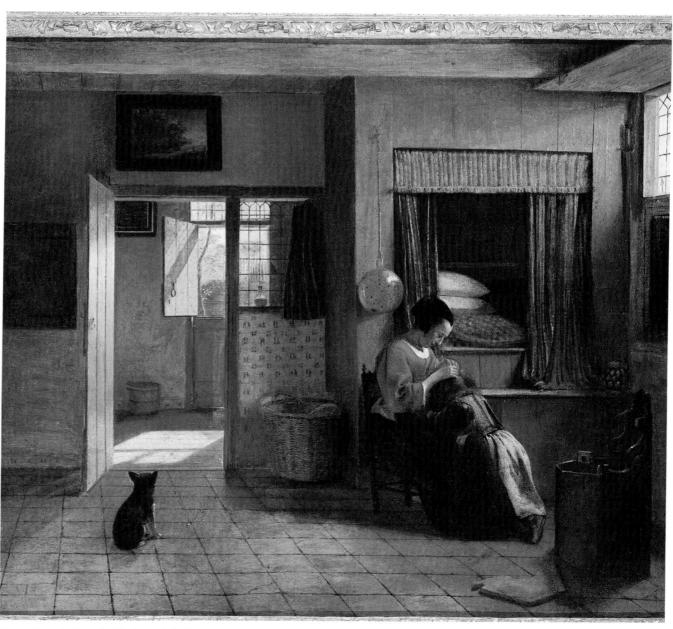

19-8 Pieter de Hooch, *Mother and Child*, ca. 1660. Oil on canvas, 4'8" × 6'2¼" (142 × 189 cm). Collection: State Museum Kröller-Müller, Oherlo, The Netherlands.

19-9 Maria van Oosterwyck, Vanitas, 1668. Oil on canvas, 28½ " \times 34½ " (73 \times 89 cm). Kunsthistorisches Museum, Vienna.

continued to make religious art; unlike most Baroque painters in Catholic Europe, he filled his pictures with ordinary people in ordinary settings. In other words, Rembrandt illustrated the stories of the Bible in the context of everyday life. He is perhaps the only artist, certainly the greatest, to express Christian content from a Protestant perspective.

Meanwhile, in the century of Rubens and Rembrandt, the field of science was gaining momentum. No longer limited to isolated casual experiments (as those of Leonardo were, Chapter 18), research in the 1600's was more systematic and organized. Francis Bacon, English philosopher, outlined a method of science based on observation. Galileo Galilei, a Florentine astronomer, constructed a telescope that was able to verify Copernicus's theory that the earth revolves around the sun (Chapter 18). Johannes Kepler, a German mathematician, improved on Copernicus's idea by determining that the planets traveled in elliptical orbits. Isaac Newton, English mathematician and inventor of calculus, brought together the research and thinking of the century and devised the law of gravity, a principle that explains the movements not only of the planets, but of the whole universe.

The Enlightenment, Rococo, and Neoclassicism

The scientific boom of the 1600's led to the Enlightenment, a philosophy of life that flourished in the 1700's. Conservative Catholics and Protestants objected to the new science because they felt it challenged the beliefs and doctrines of the Bible. Enlightenment philosophers, however, believed that science not only revealed the secrets of nature, but improved people's lives. Placing their faith in reason and science more than in orthodox religion, these philosophers (fig. 19–10) conceived of the universe as an intricate machine, like a huge clock. According to them, God started the clock, but then got out of the way. This concept of the universe was known as *Deism* — a religious view that influenced America's founding fathers, including Benjamin Franklin and Thomas Jefferson.

Meanwhile, the major art style of the 1700's seemed to be going in a direction all its own. Called *Rococo*, this style did not reflect the views of Catholics, Protestants, or the Enlightenment, but the views and lifestyles of the pleasure-seeking aristocracy. *The Swing* by Jean-Honore Frag-

19-10 Voltaire.

19-11 Jean-Honore Fragonard, The Swing, 1766. Approximately $32'' \times 35''$ (81 × 89 cm). Reproduced by permission of the Trustees of the Wallace Collection, London.

onard (fig. 19-11), a scene of aristocrats at play in a makebelieve world, is typical of the style. Although *The Swing* shares with Baroque art fluid brushwork and lively movement, its pastel hues, satiny textures, and delicate figures are much lighter in spirit. Its content is also lighter, if not "light-headed."

Later in the century, a reaction set in against Rococo. The middle classes, a segment of society that grew dramatically in size and power during the 1700's, felt that Rococo art did not represent their values. Johann Joachim Winckelmann, a German art historian, said that Europe needed an art of "noble simplicity and calm grandeur" to replace Rococo. The hopes of the public and Winckelmann were fulfilled in 1784 when Jacques Louis David unveiled his *The Oath of the Horatii* (fig. 19–12). Painted only eighteen years after The Swing, David's picture could not be more different. Rather than fun-loving aristocrats, The Oath features Roman warriors swearing an oath to fight a duel to the death; off to the right their women are slumped in despair. Rather than a beautiful garden, it is set in a severely simple Roman court. It is also very different in style. Its darks and lights are strong, its colors are mostly primary, and all of its forms, including the people, are starkly defined - as if sculpted in stone. The Oath of the Horatii was the first painting of a new style that, like Renaissance art (Chapter 18), found inspiration in the themes and principles of classical art. Indeed, this new art

19-12 Jacques Louis David, Oath of the Horatii, 1784. Approximately 14 × 11 ' (4.2 m × 3.3 m). Louvre, Paris.

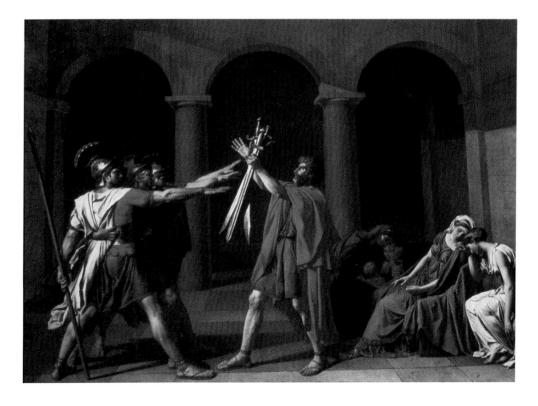

19-14 Thomas Jefferson, State Capitol, Richmond, Virginia, designed 1785 - 1789.

became known as Neoclassical. It was approved by intellectuals as an embodiment of seriousness and reason, and by the French middle classes as an allegory of honor and patriotism. It also became a symbol of the French Revolution. David, who was personally active in the French Revolution, eventually became Napoleon's court painter.

Meanwhile, another revolutionary-Thomas Jefferson - became caught up in the fervor of Neoclassicism when he was ambassador to France (1785-89). An architect as well as a statesman, Jefferson admired the Neoclassical buildings that were being erected in Paris (fig. 19-13) as part of Napoleon's grandiose plans to redesign the city. But Jefferson especially admired the Roman temple in Nimes (fig. 18-20) which he used as a model for the Virginia State Capitol (fig. 19–14). Later, he used classical models for the campus of the University of Virginia. Thus Neoclassicism, the art of "noble simplicity and calm grandeur," was brought to the shores of America where it became very popular. Architecturally, Washington, D.C., is the most Neoclassical city in the world (recall the design of the rotunda of the National Gallery, fig. 7-6).

19-13 Pierre-Alexandre Vignon. Façade, La Madeleine, Paris, 1762 - 1829. 350' (107 m) long, 147' (45 m) wide, podium 23' (7 m) high.

19-15 Eugene Delacroix, Arabs Skirmishing in the Mountains, 1863. Canvas $36\frac{3}{8}$ " \times 29 \%" (92.5 \times 74.6 cm). The National Gallery of Art, Washington, DC (Chester Dale Fund).

Romanticism, Realism, Impressionism, and **Post Impressionism**

As we have seen, cultural styles occur in cycles. The closer we get to the present, the shorter the cycles seem to become. Not long after Neoclassicism had become established, Romanticism took over. A broad cultural movement that peaked in the first half of the 1800's, Romanticism was a revolt against the artistic and philosophical principles that had become associated with Neoclassicism. The optimism of the Enlightenment was dashed by the realities of life in the early 1800's. The atrocities of the French Revolution and the failures of the Napoleonic wars were largely responsible. Faith in reason was replaced by renewed faith in God, and especially, by faith in emotion. It could be said that Romantic writers and artists trusted their hearts rather than their heads.

Eugene Delacroix, a colorful man with strong emotions, was the idol of Romantic painters and poets. He loved the outdoors and wild animals. He preferred the simple life of rural peasants, especially the Moslem Arabs of North Africa. This was ironic because Delacroix himself was considered a "man-about-town" in Paris, the capital of French culture, and anything but rural. But to Delacroix, Arabs were not only close to nature, but fierce and courageous warriors. Many of his attitudes are expressed in Arabs Skirmishing in the Mountains (fig. 19-15), a portrayal of a fierce battle in the wilderness at the foot of a mountain crowned with an ancient fortress. The colors shades of red and orange set against a bright sky - are vivid, and Delacroix's brush strokes, unlike David's, are as lively as the battle.

Marie Rosalie (Rosa) Bonheur's Gathering for the Hunt (fig. 19-16) demonstrates that Romanticism and the love of the outdoors can be expressed in more subdued ways. Her picture contains no Arabs, guns, or falling horses, but a group of French farmers, horses, and dogs on a hazy autumn morning. The brushwork is calm, the colors are balanced between warm and cool. The composition is horizontal, stressing, nature's breadth and continuity. Although Gathering for the Hunt is much less dramatic than Arabs Skirmishing in the Mountains, it is no less a tribute to nature. It also shows tendencies of another movement of the 1800's: Realism.

19-16 Marie Rosalie Bonheur, Gathering for the Hunt, 1856. Oil on canvas, $30\frac{1}{2}$ " \times 58½" (78 \times 149 cm). Haggin Collection, The Haggin Museum, Stockton, California.

At mid-century, Gustave Courbet emerged as the leader of the Realist movement, which, as opposed to either the Neoclassical or Romantic movement, portrayed life as it is—without nobility, drama, or condescension. His *Burial at Ornans* (fig. 19–17), a homely scene of townspeople gathered around a grave, is typical of Realism. The public at the time thought that such a subject, especially

when painted without a trace of beauty or sentiment, was too commonplace to be considered art. Despite his dedication to the unvarnished truth, however, Courbet ignored a major aspect of 1800's life: the city and its people. It was left to Edouard Manet, another Realist, to focus on the modern city and its people, especially the well-to-do middle class. Like the woman in *Gare [Railroad Station] Saint-*

19-17 Gustave Courbet, Burial at Ornans, 1849. Approximately 10" × 22" (76 × 56 cm). Courtesy The Louvre, Paris and Réunion des Musées Nationaux.

19-18 Edouard Manet, *Gare Saint-Lazare*, 1873. Oil on canvas, 36¾ " × 45½ " (93 × 115 cm). National Gallery of Art, Washington, DC (Gift of Horace Havemeyer in memory of his mother, Louisine W. Havemeyer).

19-19 Claude Monet, La Grenouillère, 1869. Oil on canvas, 29 1/8 " × 39 1/4" (75 × 100 cm). The Metropolitan Museum of Art, H.O. Havemeyer Collection (Bequest of Mrs. H. O. Havemeyer, 1929).

Lazare (fig. 19–18), Manet's people often have the offhand look of someone caught in a moment of casual activity. The woman will go back to reading her book, and the small girl gazing through the iron bars will lose interest as soon as the cloud of steam fades. Manet not only captured the spirit of everyday city life, he pioneered a fresh approach to painting. The figures, unlike those of David, Bonheur, and even Courbet, appear rather flat - or, as an American critic said, as if they had been clipped out of a sheet of tin. Their sense of flatness is due not only to a lack of chiaroscuro, but also to the brightness of the colors and to the bold pattern of the bars directly behind the figures.

Manet's subject matter and style were influential to still another art movement of the 1800's: Impressionism. You have already seen examples of Impressionism in this book: Luncheon of the Boating Party by Auguste Renoir (fig. 3-1), The Bath by Marie Cassatt (fig. 5-25), and Waterloo

Bridge by Claude Monet (fig. 7-1). Monet's La Grenouillère (fig. 19-19), even more than those, exemplifies the characteristics of the style. Like Manet's scene at the railroad station, La Grenouillère shows an offhand moment in the lives of some city dwellers, in this case, at a riverside marina. But Monet went beyond Manet in his treatment of the subject by constructing the entire picture out of nothing more than bright daubs of paint, a method known as broken color. When viewed at close range, the daubs tend to be more apparent than the forms. But when viewed at a proper distance, the daubs merge into recognizable trees, people, restaurant, and boats. This kind of painting is often more fresh and vibrant than traditional paintings in which the forms are carefully drawn and the colors are carefully blended. The sensation of rippling water is especially effective.

In many ways Monet's real subject matter was light and color, or as he explained, "to reveal no more of reality than the shifting flux of appearances." Monet's circle of artists included some who broke away to become known as Post Impressionists. Although they learned about color from the Impressionists, these artists did not accept the idea of art being a "shifting flux of appearances." Paul Cezanne, in particular, desired a more structured art, "something solid and durable, like the art of the museums." The fruit and objects in his Still Life with Apples and Peaches (fig. 19-20) seem indeed to be solid and durable. Furthermore, Cezanne took pains to balance the visual weights and directions so that the composition would be as solid and durable as the fruit. Georges Seurat, another Post Impressionist, admired the Impressionists broken color, but strove to use it more systematically while composing his pictures with utmost care (recall his Bathing at Asnières fig.

10-1). Still another Post Impressionist, Van Gogh, admired the brightness of Impressionists' colors. Unlike Monet, however, Van Gogh used color to express emotions rather than just the vagaries of reflected light (recall his paintings, figures 6-32 and 6-33). Edvard Munch, like Van Gogh, often used acrid color and rhythmical lines to express despair, as in his work *The Scream* (fig. 10-7). The works of Paul Gauguin, the last of the Post Impressionists to be reviewed here, display the flatness of form found in the works of both Manet and Monet. But in Gauguin's paintings, such as his The Vision After the Sermon (fig. 19-21), this flatness is much more decorative. Like the pictures by Cassatt (fig. 5-25) and Van Gogh (figures 6-32 and 6-33), Gauguin's shows the influence of Japanese woodcuts (fig. 19-22) particularly with regard to the use of crisp outlines, flat pattern, and bold design. (These woodcuts were of the ukiyo-e variety discussed in Chapter 16.) Japanese prints,

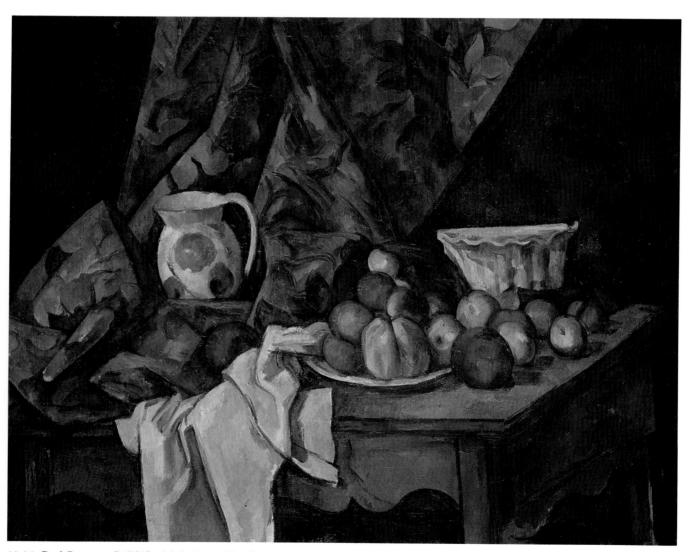

19-20 Paul Cezanne, Still Life with Apples and Peaches, ca. 1905. Oil on canvas, $32'' \times 39\%''$ (81 × 101 cm). National Gallery of Art, Washington, DC (Gift of Eugene and Agnes Meyer).

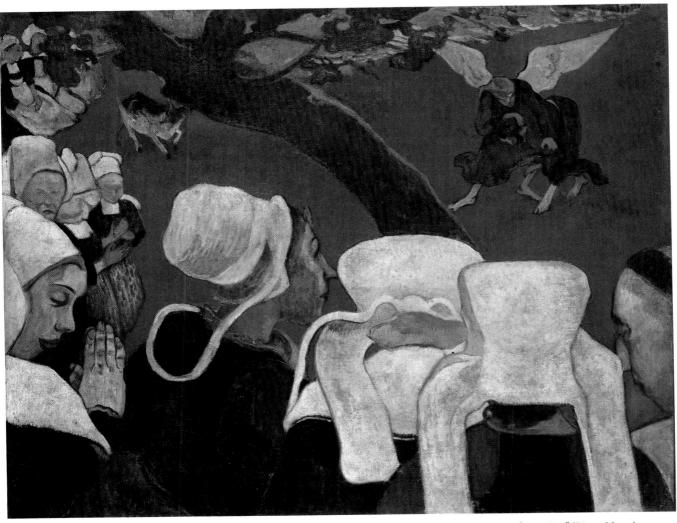

19-21 Paul Gauguin, The Vision after the Sermon (Jacob Wrestling with the Angel), 1888. Oil on canvas, 28¾ " × 36¼ " (73 × 92 cm). National Gallery of Scotland, Edinburgh.

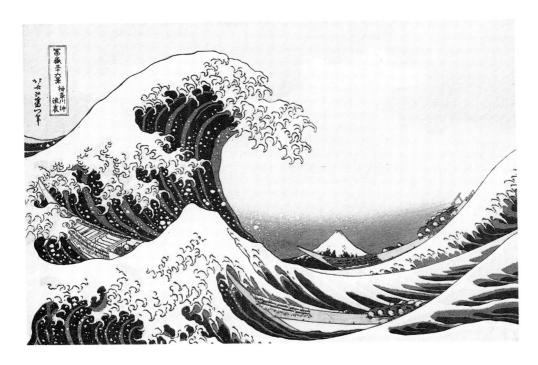

19-22 Hokusai, The Great Wave from Thirty-six Views of Mt. Fuji, Todugawa period. Woodcut, 10" × 14¾" $(26 \times 38 \text{ cm})$. Museum of Fine Arts, Boston.

which had been used by the Japanese to wrap their exports, were avidly collected by both Impressionists and Post Impressionists.

Thus by the end of the 1800's, art had reached a turning point. Specifically, it was turning away from the principles of pictorial realism that had been introduced by Donatello and Masaccio (Chapter 18) and that had come to dominate European art ever since. Instead of realism, the values of compositional structure, of expressing emotion, and of pattern and color were beginning to take priority. These values were to be asserted with even greater force in the twentieth century.

The Industrial Revolution

In addition to art movements, the 1800's also witnessed the *industrial revolution*—the rapid changeover from cottage industry to smokestack industry and mass production (Chapter 13). The side effects of this development are reflected in the clothes and leisure activities of Manet's and Monet's people, who had more material benefits and more mobility than ever before. They are also reflected in the detached look of the woman at the railroad station and the

impersonality of the people at the marina, as they, like many people in a post-industrial urban society, seem to experience boredom and a sense of rootlessness. The impact of the industrial revolution, however, was felt more directly in the art of crafts (discussed in Chapter 13) and in architecture.

19-23 Frame construction.

19-24 Joseph Paxton, interior view of the Crystal Palace, Hyde Park, 1851. From a print by R. Cuff after W. G. Brounger.

Architecture: Frame Construction

Up to the 1800's, major public buildings were mainly cathedrals, palaces, theatres, and town halls - all built according to post-and-lintel and arch methods of construction, or variations thereof (Chapter 18). The new industries of the 1800's required new kinds of buildings: factories, massive warehouses, railroad stations, department stores, and office buildings. Masonry architecture was too costly and inefficient for such buildings. Meanwhile, the new industry itself, which produced such things as standardized nails, rivets, boards, metal beams, and glass panes in huge quantities, made possible a new method of construction: wood frame and metal frame.

Masonry methods of construction are load-carrying, that is, walls, columns, buttresses, and so forth, are used to support floors and ceilings. By contrast, frame construction is non-load-carrying, that is, many thin, relatively lightweight beams are joined to form a rigid framework like a cage (fig. 19-23). Walls are added to the framework as needed; since they are non-load-bearing, these walls may be of any material, even glass. The earliest examples of frame construction were probably wood-frame houses (called "balloon-frame") that sprang up in the boom towns of the American Midwest in the early 1800's. But the most significant early example was the Crystal Palace (fig. 19–24), a vast network of wood and iron beams and panes of glass to house the first world's fair. Erected in 1851 in less than six months (compared to six centuries for some Gothic cathedrals), this enormous glass-enclosed shed covered 800,000 square feet (74,000 square meters). The name Crystal Palace was invented by the fairgoers themselves, who had never seen anything so large or so radiant.

The next stage in the development of frame construction took place not in London or Paris, but in Chicago. During the 1880's, when Post Impressionists were pioneering new styles of painting, Chicago builders were pioneering new kinds of commercial construction. Because of the fire of 1871, there was a need for new buildings in Chicago's Loop (downtown), but real estate prices in the Loop were extremely high. So, using the technology of metal-frame construction and the newly invented passenger elevator, Chicago architects developed a building that took advantage of the inexpensive vertical space of the sky instead of the costly horizontal space of the ground - the skyscraper. Significantly, the style of this architecture, called the Chicago School, was relatively lacking in columns, arches, arcades, pediments, towers, and domes that people had

19-25 Louis Sullivan, Wainwright Building, St. Louis, Missouri, 1890 - 1891. Photograph: George Barford.

grown to expect in public buildings. Louis Sullivan, the leader of the Chicago School, coined the motto Form Follows Function to express the ideal of a new architecture that would reflect its function and method of construction. His design for the Wainwright Building in St. Louis (fig. 19-25), a simple cube with a two-story base, middle section, and ornate top, became a classic for downtown office buildings, and a symbol of the new industrial economy. Sullivan never intended his motto to mean the complete elimination of ornament, however, as he endowed all of his buildings with decorative accents which he personally created. (In the Wainwright, these are visible not only on the ornate top but also beneath each of the windows and around the main entrance.)

Art of the First Half of the Twentieth Century

The twentieth century, the century of two world wars, mass genocide, inflations, depressions, and "future shock," has also been a tumultuous one for art, especially during the years before World War I (1914–18). More changes occurred during that period than had occurred collectively in the previous four hundred years.

In 1905 a show in Paris contained such provocative paintings that a critic referred to them as *fauves* (French for wild beasts). Featuring brilliant colors and simple shapes, like those in Henri Matisse's *The Red Room* (fig. 19–26), the paintings in that exhibit were truly "modern"—in the twentieth-century sense of the word. In our day, they would not be out of place at all. But they seemed very wild to the 1905 public, as the critic's label suggests. Today, Fauvism—no longer a derogatory term in art—refers to an

important breakthrough in the modern movement; and colors, like those in *The Red Room*, are considered beautiful. Matisse took red—the most stimulating hue of all—and tempered it with the cool colors in the window, the color of the woman's blouse, and the blue of the many decorative lines. He thus brought the powerful forces of brilliant color under control. Matisse was a master at making balanced paintings with daring color combinations.

At about the time the Fauvists were shocking Paris, artists in Germany were beginning to rebel against traditional art and traditional ways of thinking about art. Some even organized into groups—one in Dresden called *Die Brucke* (The Bridge) and another in Munich called *Der Blaue Reiter* (The Blue Rider). These people and others active in the modern movement prior to the Nazi takeover (1933) are known collectively as *German Expressionists*. Unlike the Fauvists, who tended to use bright color and flat pattern for their own sake, German Expressionists

19-26 Henri Matisse, The Red Room, 1908 - 1909. Oil on canvas, 71 " × 97" (180 × 246 cm). The Hermitage Museum, Leningrad.

19-28 Emile Nolde, Masks, 1911. Oil on canvas, 29 " × 30 " $(73 \times 77 \text{ cm})$. The Nelson-Atkins Museum of Art, Kansas City, Missouri (Gift of the Friends of Art).

tended to use these things to express personal feelings about life. Sometimes these feelings were sad or disturbing. As its title suggests, Old Peasant Woman Praying (fig. 19-27) by Paula Modersohn-Becker, expresses melancholy as well as sympathy for peasant life. Its sincerity of expression is reminiscent of the work of Van Gogh - one of the German Expressionists' heroes. If she had not died at age 31, Modersohn-Becker would probably have become a dominant figure in the Expressionist movement. Masks (fig. 19-28) by Emil Nolde, a member of Die Brucke, represents the German interest in primitive art and the grotesque. Serious themes couched in harsh styles, as we have seen in previous examples, are typical of twentiethcentury German art, for example, Käthe Kollwitz's Death Seizing a Woman (fig. 12-24) and Ernst Barlach's The Vision (fig. 13-9).

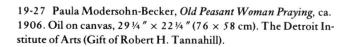

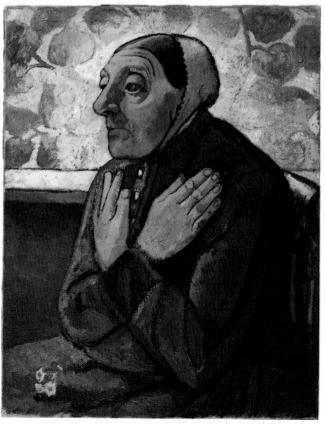

Islands of Time II 291

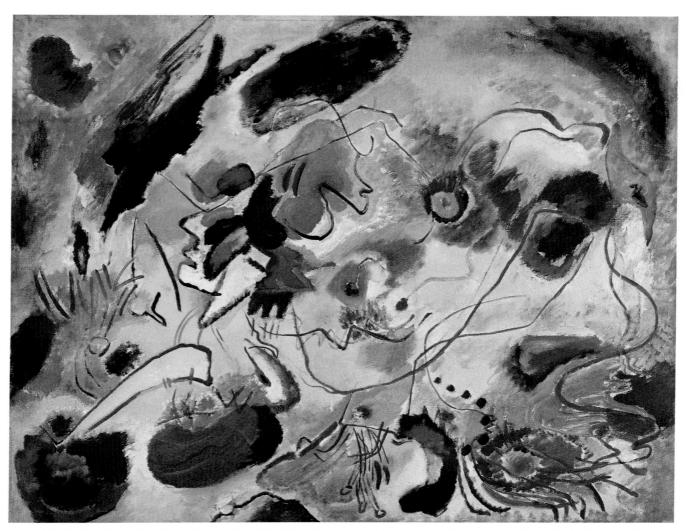

19-29 Wassily Kandinsky, Sketch 1 for "Composition VII", 1913. Oil on canvas 301/4" × 391/8" (78 × 99.5 cm). Stadtische Galerie im Lenbachhaus, Munich.

Although Wassily Kandinsky was Russian-born, he was the leader of Der Blaue Reiter and a highly respected member of the German Expressionist movement. Most significantly, Kandinsky was the first artist to pursue total abstraction. As early as 1910, he made a watercolor that was completely devoid of subject matter and recognizable imagery. The suggestion of turbulent emotion in his Sketch I for "Composition VII" (fig. 19-29) is typical of the freeform, coloristic abstractions that Kandinsky had developed out of the tradition of German Expressionism.

In 1905, the year of the Fauvists' show in Paris, Pablo Picasso was a struggling young painter in that city. His The Old Guitarist (reviewed in Chapter 6, fig. 6-30) is typical of his early work. Inspired by the success of Fauvism, Picasso embarked on a groundbreaking project of his own in 1906. The result of these efforts, Les Demoiselles d'Avignon (fig. 19-30), in which the human form is savagely distorted, was unveiled in 1907. Imagine how radical this painting must

have seemed to the 1907 public; even Matisse was shocked, calling it a mockery of the modern movement. Today, after nearly a century of modern art, it still looks disturbing. But Les Demoiselles is not without purpose. The figures and the background are consistently distorted to create a system of shallow peaks and valleys - as if the whole canvas had been wadded and then spread flat. Les Demoiselles was to become the prototype of a significant early twentiethcentury style: Cubism.

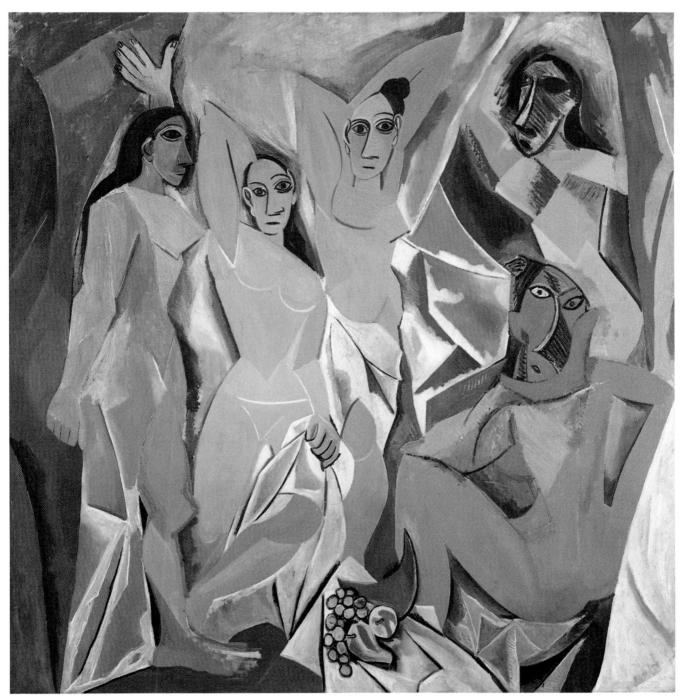

19-30 Pablo Picasso, Les Demoiselles d'Avignon, 1907. Oil on canvas, 96 " \times 92 " (2.24 \times 2.34 m). Collection, The Museum of Modern Art, New York (Acquired through the Lillie P. Bliss Bequest).

19-31 Georges Braque, Violin and Palette, 1909 – 1910. Oil on canvas, $36\frac{1}{4}$ " \times $16\frac{7}{8}$ " (92 \times 42 cm). Guggenheim Museum, New York, Photograph: David Heald.

19-32 Marc Chagall, *I and the Village*, 1911. Oil on canvas, $6'3'' \times 59''$ (192 \times 151.5 cm). Collection, The Museum of Modern Art, New York (Mrs. Simon Guggenheim Fund).

The first variety of Cubism, called analytical or facet Cubism, was developed by Picasso in collaboration with French artist Georges Braque between 1909 and 1912. A good example is Braque's Violin and Palette (fig. 19-31), a painting in which still life objects are broken up and recombined to fashion a network of semitransparent, tilted planes or facets – like the surface of a gem. Almost from the time it was introduced, facet Cubism influenced other artists. In I and the Village (fig. 19-32), Marc Chagall interspersed memory images of rural Russia among the transparent planes of facet Cubism. In Brooklyn Bridge (fig. 19-33), Joseph Stella employed interlocking facets to express a kaleidoscopic impression of urban America. In addition to these, we have seen examples in earlier chapters. Piet Mondrian's Composition in White, Black, and Red (fig. 7-10) is an outgrowth of facet Cubism. Even sculpture was affected by Cubism. Recall Umberto Boccioni's Unique Forms of Continuity in Space (fig. 8-15) and David Smith's famous Cubi series (fig. 13-32).

Despite their success with facet Cubism, Picasso and Braque continued to experiment. In 1913, the two artists created the first collage (Picasso's Still Life with Chair Caning, fig. 12–42). Out of the collage medium, Picasso and Braque developed the second variety of Cubism, called synthetic Cubism. Unlike facet Cubism, synthetic Cubism features a variety of colors and textures in the con-

19-33 Joseph Stella, *Brooklyn Bridge*, 1917 – 1918. Oil on canvas, 84" × 76" (213 × 193 cm). Yale University Art Gallery (Gift of Collection Societe Anonyme).

19-34 Georges Braque, *The Table*, 1928. Oil on canvas, $70\frac{3}{4}$ " \times 28 $\frac{3}{4}$ " (180 \times 73 cm). Collection, The Museum of Modern Art, New York (Acquired through the Lillie P. Bliss Bequest).

text of predominately flat shapes—as in Braque's *The Table* (fig. 19–34). (Picasso's whimsical *Three Musicians*, fig. 5–10, is another good example of the style.) About the only things the two varieties of Cubism share are sharp angles and interlocking design. Although Picasso often returned to Cubism—using a combination of facet and synthetic methods—he also experimented with a variety of styles, including a kind of realism (*A Woman in White*, fig. 6–8). Meanwhile, Braque spent the rest of his career making still lifes like *The Table*.

In 1913, while Picasso and Braque were experimenting with new approaches to style and media, Giorgio de Chirico experimented with a new approach to subject matter. The style of *The Mystery and Melancholy of a Street* (fig. 19–35) is not particularly new, especially for 1913. But the subject matter, specifically with regard to the peculiar mix of figures and objects — a deserted square containing a child with a hoop, a gypsy wagon, and a long shadow—is novel. It is also strange, like a bad dream. Notice the exaggerated perspective making the square appear longer, and, therefore, emptier. The paintings of de Chirico, along with the writings of Sigmund Freud, the father of modern psychology, influenced *Surrealism*, an art movement

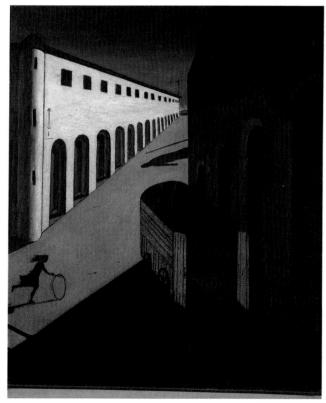

19-35 Giorgio de Chirico, *The Mystery and Melancholy of a Street*, 1914. Oil on canvas, 34¼ " × 28½ " (87 × 72 cm). Private Collection. Photograph courtesy Aquavella Galleries, Inc. New York.

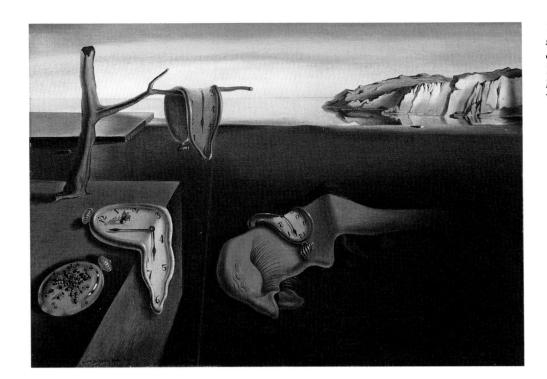

19-36 Salvador Dali, *The Persistence of Memory*, 1931. Oil on canvas, $9\frac{1}{2}" \times 13"$ (24 × 33 cm). Collection, The Museum of Modern Art, New York (Given anonymously).

specializing in unconscious experiences. *The Persistence of Memory* (fig. 19–36), a haunting painting by Salvador Dali, is a good example of an art that often used extremely realistic methods to portray the mysterious and sometimes foreboding world of dreams. Dali's *Mae West* (fig. 10–12) is mysterious, but not necessarily foreboding.

Dada, the final early twentieth-century movement to be reviewed, was the most paradoxical of all. Born in 1916, when the First World War was raging, Dada consisted initially of a small collection of artists, poets, and refugees who gathered in a cafe in neutral Zurich, Switzerland. Relatively sane at first, their activities soon became preposterous: writing poetry by cutting words out of seed catalogs, reciting two or three poems simultaneously, wearing silly costumes, dancing to the sounds of a barking dog, making collages out of random arrangements of garbage. The name Dada (French for bobbyborse) was supposedly discovered by sticking a knife into a French-German dictionary and selecting the first word that appeared. Dadaists tended to thumb their noses at everything.

Dada spread to other cities: Paris, Cologne, Barcelona, and New York. Although the movement died in 1922 and left few lasting works of art, it did inject into the art world a taste for the absurd and ironic. (Some would say that Dadaists were simply reflecting the absurdity of modern life, especially the existence of war.) One artwork has become a symbol of the Dada spirit: *Fountain*, a urinal laid on its back and signed "R. Mutt" by Marcel Duchamp

(fig. 19–37). Duchamp, a Frenchman who was working in New York at the time, tried to enter *Fountain* in a show, only to have it rejected. Today, however, Duchamp's artwork resides in a distinguished art collection.

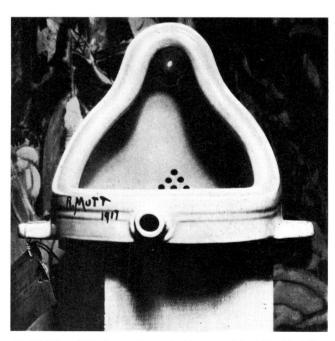

19-37 Marcel Duchamp, *Fountain* (photograph by Alfred Steiglitz, reproduced in *The Blind Man*, *No.2*, May 1917. Porcelain, 24% " (63 cm) high. The Philadelphia Museum of Art (Louise and Walter Arenberg Collection).

Architecture of the First Half of the Twentieth Century

The Chicago School style of commercial building continued into the first decade of the 1900's. However, the most innovative architecture of this period came from a man who specialized in designing homes: Frank Lloyd Wright. His remarkable Robie House (fig. 19–38) with its dramatic overhangs and horizontal lines—was designed to blend with the prairie landscape of northern Illinois. An apprentice of Louis Sullivan, Wright was the first architect, European or American, to create a distinctive style out of frame construction. The Robie House, like Matisse's *The Red Room* or Kandinsky's *Sketch I for "Composition VII"*, looks modern even today.

By 1910, the Chicago style of architecture was "out of style." The imagination of the American public had been captured by New York architects who were designing skyscrapers in various *eclectic* styles. Eclectic means borrowing from various sources, usually historical. Despite the fact that their buildings were modern metal-frame structures, New York designers decorated them with styles borrowed from Greek, Gothic, or Renaissance sources. The prime example of eclectic architecture is the Chicago Tribune Tower (fig. 19–39), a skyscraper made to look like a Gothic tower, even including flying buttresses! Ironically, this Chicago landmark, designed by a New York architectural firm, was completed in 1924, the year of Sullivan's death. That year also marked the end of Sullivan's principle, Form Follows Function (at least for the time being).

While architects in America were rejecting Sullivan's principle, those in Europe were discovering it—though without knowledge of Sullivan's work. In 1919, the

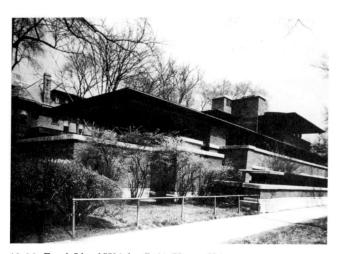

19-38 Frank Lloyd Wright, Robie House, Chicago, 1909.

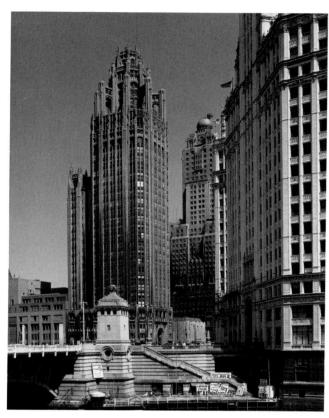

19-39 Tribune Tower, 1925. North Michigan Avenue at the River (north bank). Architects: Hood and Howells.

Bauhaus (German for house of building), a special German design school was established. Its main building, The Shop Block (fig. 19–40) designed by Walter Gropius, was the world's first multistoried permanent building to be faced with continuous walls of glass. Gropius was also the school's first director. Some of Europe's most famous modern painters, including Kandinsky and Mondrian, lectured there. Mondrian's style (Chapter 7), which lent itself

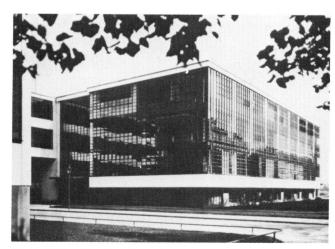

19-40 Walter Gropius, Shop Block, The Bauhaus, Dessau, Germany, 1925 – 1926.

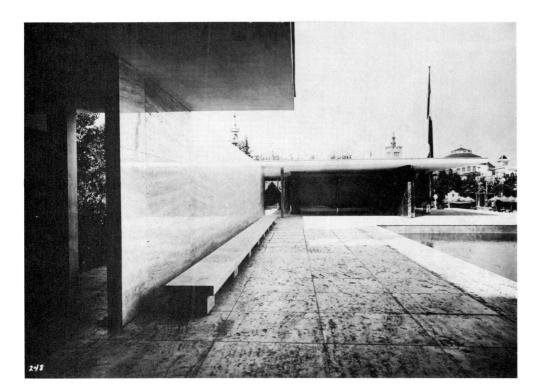

19-41 Ludwig Mies van der Rohe, German Pavilion at the International Exhibition, Barcelona, Spain, 1929. Demolished. Photograph courtesy Mies van der Rohe Archive, The Museum of Modern Art, New York.

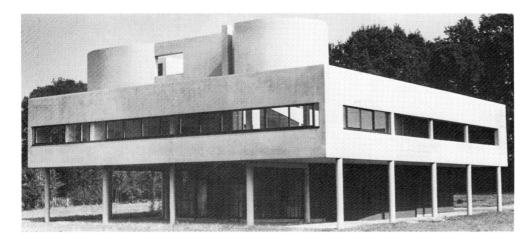

19-42 Le Corbusier, Villa Savoye, Poissy-sur-Seine, France, 1929 - 1930.

to the design of modern architecture, was especially influential. The simple geometry of his art is reflected in the sleek lines of the German Pavilion (fig. 19-41), a very modern looking building for 1929 by Ludwig Mies van der Rohe, a friend of Mondrian who became Bauhaus director after Gropius.

Also in 1929, construction began on Villa Savoye (fig. 19-42), a multilevel house consisting of little more than a box on stilts by Le Corbusier (born Charles Eduoard Jeanneret). The forms of both the German Pavillion and Villa Savoye are simple, unadorned, and modern. Thus the legacy of modernism and design honesty, originally championed by the Chicago School, Sullivan, and Wright, had been assumed by European architects.

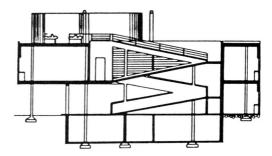

Art of the Second Half of the Twentieth Century

The end of the Second World War (1939–45) marked a turning point in twentieth century history. The war ushered in the nuclear age. America and Russia—the so-called superpowers—took over the world stage. Since then many things have happened: the cold war, baby boom, arms race, space race, Korean and Vietnam wars, détente, budget deficit, and others that we read and hear about daily.

The end of the Second World War also marked a turning point in the modern movement when artistic leadership passed from Europe to America. Up to this time, American involvement in modern art was weak and tentative. No American had pioneered a new movement, invented a new medium, or even shocked the world with

daring color. Only in the field of architecture had Americans demonstrated unusual creativity, but as we saw, this creativity was superceded by eclecticism. The most popular American art before the war was *Regionalism*, a conservative style that specialized in local themes — particularly the simple lifestyles of rural Americans. A good example is John S. Curry's *Baptism in Kansas* (fig. 10–6). Such a style, however, was inappropriate in the 1940's when Americans had been thrust into world leadership.

In the mid-1940's, young American artists like Arshile Gorky began experimenting with abstract styles. Although his *The Liver Is the Cock's Comb* (fig. 19–43) was probably influenced by Cubism and German Expressionism, it represents the origins of a new American abstract art. However, the real breakthrough came in 1947 when Jackson Pollock began his famous "drip" paintings. Pollock would lay a canvas on the floor and walk across its surface spilling, pouring, and flinging paint as he went along (fig.

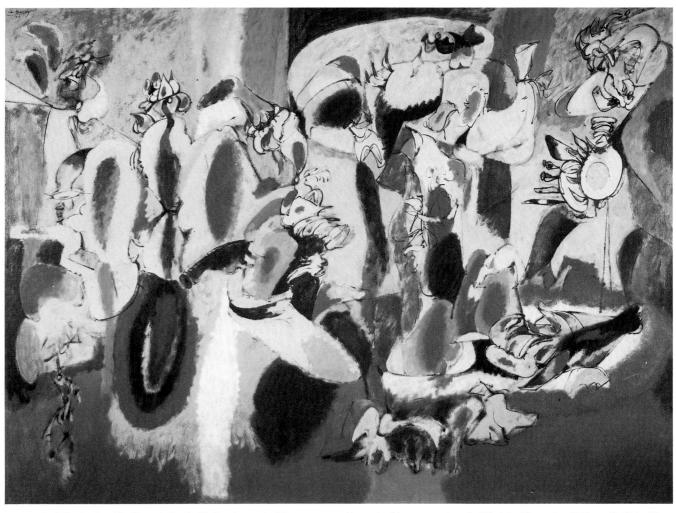

19-43 Arshile Gorky, *The Liver is the Cock's Comb*, 1944. Oil on canvas, 6′ × 8′2″(1.83 × 2.49 m). Albright-Knox Art Gallery, Buffalo, New York (Gift of Seymour H. Knox, 1956).

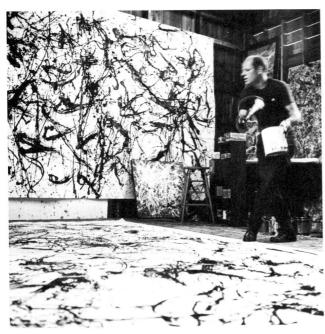

19-44 Jackson Pollock painting, 1950. Photograph copyright 1990 Hans Namuth.

19-44). The dancing lines and rhythms in Cathedral (fig. 19-45) reflect the rhythms of Pollock's bodily movements as he produced the work. No artist, European or American, had ever made a painting this way on such a scale and with such energy. Other American painters also began making bold abstract canvases - though not necessarily employing Pollock's methods – in a style that came to be called Abstract Expressionism or Action Painting. Another example is Hans Hofmann's Flowering Swamp (fig. 7-28). Abstract Expressionism was a new style on the world scene, an outbreak of American creativity that impressed even European critics. Since that time American art has continued to rival, if not dominate, European art in international culture.

The spirit of American creativity did not end with Abstract Expressionism. Even as that style flourished, artists continued to experiment, generating a seemingly endless supply of ideas. By the end of the 1960's, this creativity had produced a situation of pluralism – the existence of many different styles and kinds of art. You may recall the discussion of today's artistic variety in chapters I and 2. Because you have already encountered many examples of postwar art in previous chapters, we will simply summarize that art under a few headings and refer back to some of those examples.

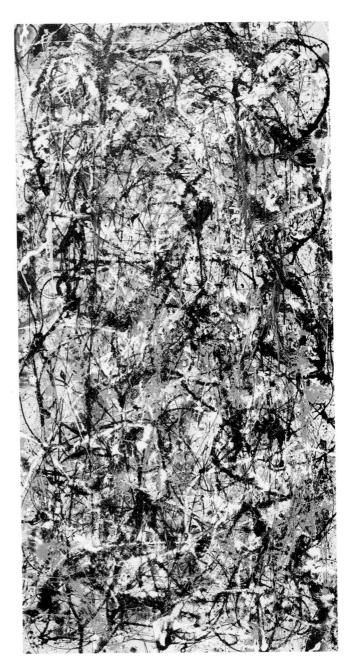

19-45 Jackson Pollock, Cathedral, 1947. Oil, 75" × 35" (191 × 89 cm). Dallas Museum of Art (Gift of Mr. and Mrs. Bernard J. Reis).

Abstraction

Not all postwar abstract painting contains free forms made with bold gestures. In contrast to Abstract Expressionism, much Abstraction reflects an interest in color effects, principles of design, even optical effects, and is geometric. See, for example, Josef Albers's Homage to the Square: Glow (fig. 1-6), Irene Rice Pereira's Oblique Progression (fig. 7-29),

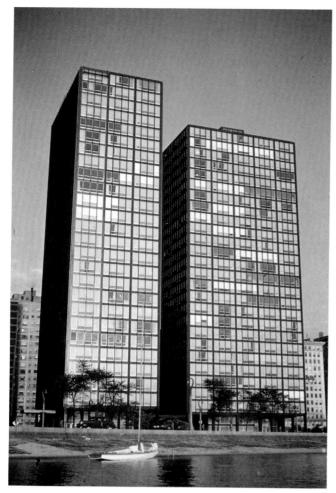

19-46 Ludwig Mies van der Rohe, Lake Shore Drive Apartment Houses, Chicago, 1950–1952. Photograph: George Barford.

Bridget Riley's *Current* (fig. 8–17), and Tadasky's *A-100* (fig. 10–14). Abstraction was also expressed in a variety of postwar sculptures: Alexander Calder's mobile (fig. 9–1), Donald Judd's *Untitled* (fig. 9–2), Richard Lippold's *Full Moon* (fig. 13–25), and Frank Stella's *Katsura* (fig. 13–28).

Assemblage

The art of assemblage, invented by Picasso and Braque around the time of the First World War, experienced a revival after the Second World War. See Robert Rauschenberg's *Monogram* (fig. 1–11), Louise Nevelson's *Sky Cathedral* (fig. 13–26), and Joseph Cornell's *Object (Roses des Vents)* (fig. 10–4).

Pop Art

The outrageousness of Rauschenberg's assemblages were partly responsible for the emergence of *Pop Art*, a movement in the 1960's that satirized popular culture by borrowing themes from comics, advertising, and ordinary life,

for example, Roy Lichtenstein's Whaam! (fig. 1–7), Andy Warhol's Soup Cans (fig. 10–3), Claes Oldenburg's Falling Shoestring Potatoes (fig. 13–50), and Marisol's Women and Dog (fig. 13–27). Related to Pop Art are Red Grooms's Ruckus Rodeo and George Segal's The Diner—environments reviewed in Chapter 13 (figures 13–31 and 13–35, respectively). Because of their humor and nose-thumbing stance, Pop Art and related styles are sometimes identified as neo-Dada (new-Dada), suggesting that they have revived the spirit of the Dada movement.

Performance, Environment, and Concept

Some untraditional forms of art can also be seen as legacies of Dada: Joseph Beuys's *I Like America and America Likes Me* (Chapter 1), Christo's *Wrapped Coast* (Chapter 1), Mary Miss's *Field Rotation* (Chapter 13), and John Baldessari's *Cremation Piece* (Chapter 12).

Realism

Perhaps most paradoxical of all, there has been a significant revival of realistic art (though not the same as the Realistic movement of the 1800's). Examples of this can be seen in Don Nice's *Longborn Steer*, *Western Series*, *American Predella #6* (Chapter 8), Richard Estes's *Nedick's* (Chapter 10), and even in the sculptures of Marilyn Levine (Chapters 1 and 8) and Duane Hansen (Chapter 13).

19-47 Le Corbusier, Unité d'Habitation, Marseilles, France, 1952.

Challenge 19-1:

Select an art style from Chapter 19 and use library resources to complete a style review including: dates, context, purposes, characteristics and artists.

19-48 Le Corbusier, Notre-Dame-du-Haut Chapel, Ronchamp, France, 1955.

Architecture of the Second Half of the Twentieth Century

Because major buildings require large investments of time, materials, and capital, architects are less free to experiment than artists. For this reason perhaps, postwar architecture has been much less pluralistic. Indeed, until very recently, postwar architecture has been dominated by two men-Mies van der Rohe and Le Corbusier – the European architects who were so inventive in the 1920's (see earlier discussion).

Fleeing the German Nazis, Mies moved to Chicago in the 1930's, where he taught architecture and received commissions for buildings. Living by his own motto, Less Is More, he designed starkly simple, glass-enclosed towers, like the Lake Shore Drive Apartment Houses (fig. 19-46). Some praised him for returning the principle Form Follows Function to the city of its birth; others criticized him for carrying it to extremes. Today, the Chicago skyline is dominated by buildings designed by either Mies, his students, or his imitators - including the architects of the Sears Tower (fig. 4–17). Indeed, skylines around the world have been affected by Mies's philosophy of less is more. In downtown Chicago that philosophy has been applied with taste and imagination, but in many other cities, it has resulted in glass-coated monotony and architectural boredom.

Contrast Mies's apartment towers with Le Corbusier's Marseille Apartments (fig. 19-47). Instead of narrow steel columns, the Le Corbusier building is supported on massive concrete buttresses; rather than being on the same plane as the wall, its windows are deeply recessed; rather than a smooth envelope of metal and glass, the wall itself is unadorned concrete. Le Corbusier pioneered the use of ferroconcrete (concrete reinforced with metal rods), Like metal-frame, ferroconcrete has tensile strength; but like sculpture, it can be cast into a variety of forms. Notre-Dame-du-Haut Chapel (fig. 19-48), one of Le Corbusier's more dramatic projects, demonstrates the sculptural possibilities of ferroconcrete. Le Corbusier's style provided a postwar alternative to Mies's glass box.

19-49 Alternate view of Notre-Dame-du-Haut Chapel.

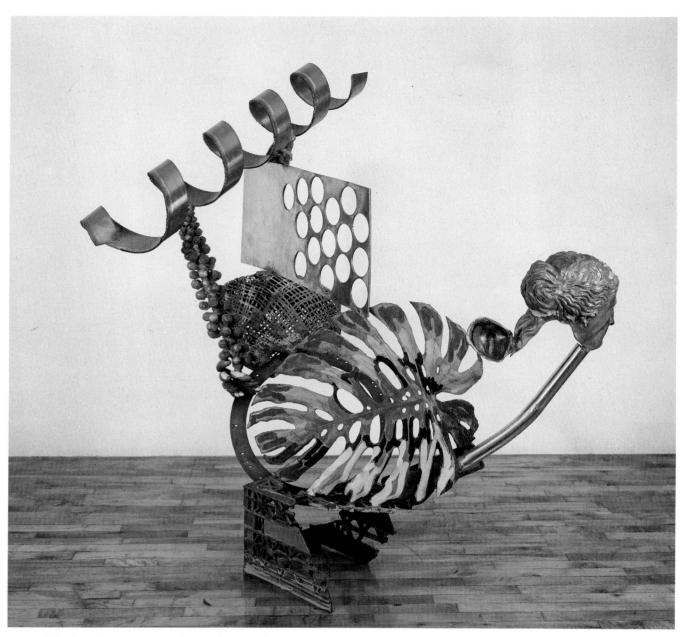

19-50 Eclecticism in art means combining elements of several different styles within one work of art. What is recognizable in this sculpture? How many different kinds of artistic techniques and materials has the artist used? Nancy Graves, *Akroterion*, 1989. Iron, stainless steel, carbon steel, aluminum, bronze, 60½ " × 56" × 47" (154 × 142 × 119 cm). Courtesy M. Knoedler and Co., New York.

Postscript: The Post-Modern Era

This chapter, starting where Chapter 18 ended, has reviewed the history of art from the 1600's to about 1980. You learned that the period known as Modernism started in the late 1800s. What about the present, though? Many people who study culture, not just those in the arts, are saying that Modernism is over, that we live in a *post*-modern period. They believe that modern art, for exam-

ple, has run out of steam, that it has not produced any significantly new ideas for two decades. There are many signs of this: pluralism (discussed earlier), the apparent lack of rules, and a general lack of confidence in Modernism. The only rules left now are those that Modernism created, and even those are being broken; witness the satire of Pop Art and other neo-Dada examples, and witness also the indications of a revival of Realism. In architecture, many young designers are rejecting the modern styles of both Mies van der Rohe and Le Corbusier. Indeed, some ar-

19-51 Charles Moore, Piazza D'Italia. Perez Architects, New Orleans, Louisiana.

chitects are even reviving eclecticism – one of Modernism's taboos. Charles Moore's Piazza d'Italia (fig. 19-51), a public square in New Orleans, is a fantastic collection of columns and arches reminiscent of Classical, Renaissance, and Neoclassical architecture.

Still another sign of the stagnancy of modern art is the fact that we are at the end of a century. Maybe this is not the time for new ideas; culture is being put on "hold." Unconsciously, perhaps, people are waiting for the beginning

of the twenty-first century, when, like the beginning of the twentieth century, the mood will be right for cultural rebirth. Think how exciting it was for people like Henri Matisse, Paula Modersohn-Becker, and Pablo Picasso! Weren't they fortunate to be the right age for the beginning of this century? Have you ever stopped to consider that you are the right age for the beginning of the next century? Some people in your generation will be the famous artists of the 2000's. Maybe one of them will be you.

Part VI In the Final Analysis

Chapter 20 Criticism and Critics Chapter 21 A Critical Method

Chapter 20

Criticism and Critics

20-1 One is a famous sculpture of a biblical hero by Michelangelo; the other is a popular comic by Charles Schulz. Although vastly different in form and content, both have a lot to offer if we take time to examine them critically. (left) Detail of Michelangelo's *The David*, 1501 – 1504. Marble. Gallery of the Academy, Florence. (right) *Charlie Brown*, 1973. United Features Syndicate. Charles M. Schulz.

We tend to think that criticism means disapproval. For example, if we don't like something, we "criticize" it. And, of course, if we are the ones *being* "criticized," whether by a parent, teacher, or a friend, we may be upset.

This use of the term is very limited, however. Have you ever thought that criticizing something can involve saying *positive* things about it? For example, when criticizing one of your drawings (fig. 20–2), your teacher may point out just its good qualities. Indeed, a person does not necessarily have to say either bad things or good things when criticizing. In one sense, criticism is simply a discussion of the characteristics of something – particularly if that something is a work of art. In this book, for example, there are many discussions of artworks. Few of those discussions in previous chapters have been criticisms of art in the full sense of the word, however.

For our purposes, we will say that art criticism is a systematic discussion of an artwork, usually involving four stages: (1) description, (2) analysis, (3) interpretation, and (4) evaluation. Sometimes a criticism involves only the first three stages. Chapters 3, 10, and 15 reviewed, respectively, each of the first three (recall describing Renoir's Luncheon of the Boating Party in Chapter 3, analyzing Seurat's Bathing at Asnieres in Chapter 10, and interpreting Russell's The Toll Collectors in Chapter 15). The next chapter will review the fourth stage—evaluation—which is something like judgment. That chapter will also explain how to put the stages together to do a criticism.

In this chapter, we will examine several kinds of *professional* criticism, as well as the *critics* who write it. Professional criticism can be found in newspapers and magazines and on radio and television. The people who write it or

broadcast it are paid for doing so. We will also discuss the reasons why we, who are not professional critics, should get involved in criticism.

Professional Criticism

Most of the movies you see were recommended to you by something or somebody. For example, you may have seen an advertisement for a film that led you to think it was exciting; or you may have heard your friends say good things about it. Usually, when you see the film, you are satisfied, but sometimes you are not. You soon learn that advertisements can be misleading. You also learn that just because other people like a film, does not mean that you will.

Yet, to avoid wasting your time and money on every film that comes to town, you need to have some kind of information. One source of information that you may take advantage of is film criticism. Unlike an advertisement, film criticism does not always try to make you think a movie is exciting. Film critics are not obligated to sell movies, and they say negative things about them as well as positive things. Unlike the opinions of your friends, which are often very limited, professional criticism usually explains a great deal about a particular film. If you read a criticism (sometimes called a review), you will have a better basis on which to make up your mind.

Most newspapers, even those with relatively small circulation, have film critics on their staffs who criticize the films currently on view in the local theatres. Many television stations feature on-camera critics who not only discuss the current films, but show "clips" of those films. The best known critics, of course, are those on national television. Each of the major networks has a film critic who reviews films, usually on the morning show. Even the cable networks and the public networks have such critics; no doubt you have seen some of them. The interesting thing about all these critics is that they often disagree.

Disagreement is especially apparent with two critics—Gene Siskel and Roger Ebert—who appear on camera together (fig. 20–2). Perhaps the most famous of all the national critics, Siskel and Ebert have their own half-hour show in which they criticize (or review) about five or six films. In addition, they write film criticism for two different newspapers. Siskel's column is in the *Chicago Tribune* and Ebert's is in the *Chicago Sun-Times*.

Newspapers like the *Tribune* and *Sun-Times* also contain reviews of art shows, books, musical programs, plays, and even architecture. In fact, every major city newspaper,

and many smaller newspapers, review these kinds of things fairly regularly. If your hometown newspaper does not carry such reviews, you can find them in weekly newsmagazines like *Time* and *Newsweek*, each of which has separate "departments" for art, music, theater, movies (cinema), and books.

Suggestion:

Look for criticisms of art, music, and theater events in newspapers or magazines.

Also look for criticisms of current films. You may discover films that you will want to see. Bring the criticisms to class. It would be interesting to compare two criticisms of the same film by different critics. Do they say similar things? Do they agree in their judgments?

Look through some old magazines for criticisms of movies you have already seen. Did the judgment of the critic agree with your own judgment of the film?

20-2 Roger Ebert (left) and Gene Siskel (right). Scenic design: Michael Loewenstein. Courtesy Public Broadcasting System.

Besides newspapers and regular magazines, there are a number of publications that specialize in just one of the arts. For those interested in the visual arts (painting, sculpture, photography, etc.), there are many magazines to choose from: Arts, Artforum, Art in America, Art News, and others (fig. 20–3). Those who want advice about recent books can read the Saturday Review of Literature and the New York Review of Books. Downbeat and Rolling Stone are intended for those who like to follow the latest in jazz and rock music. TV Guide provides information and critical reviews for those who are particularly interested in what television has to offer. There are even publications for criticizing things that are not art, literature, music, film, or television. Motor Trend magazine, for example, offers critical reviews of the latest cars.

What is the purpose of all this criticism? We have already suggested a reason for reading a film criticism. By providing information and an evaluation, a film criticism helps us decide whether or not we want to spend our own time and money on a film. Roger Ebert once said that he sees about two hundred films a year. Of course, he is paid

to do this. Would you like to be paid to see movies? But Mr. Ebert's job does not stop there. He also writes about many of the films he sees. If we read one of his criticisms, we benefit from the time he has taken to see and criticize a particular film. In a sense, a criticism is a preview that helps us make a more intelligent decision.

But there are other reasons for criticism besides saving us time and money. Good criticism also educates. It can point out things to look for in an artwork that we might overlook. It can encourage us to see artworks that are unusual or unfamiliar. In the long run, it can influence our taste. If the influence is good, we may grow to like more difficult things and to dislike childish things.

In summary, professional criticism:

- informs the public of ongoing artistic events movies, art shows, musical programs, plays, books, and so forth;
- 2. provides information and evaluations of particular events so that people have a basis for making selections;
- 3. points out things in an artwork that might be ignored,

- thereby helping people to see more and enjoy more about a work:
- 4. introduces unfamiliar artworks, thereby encouraging people to see and enjoy things that they would ordinarily miss;
- 5. influences taste so that people may grow in their likes and dislikes.

Nonprofessional Criticism

As long as there are people who are paid to criticize artworks, why should other people – such as you and I – do it also? The rest of this chapter will be devoted to answering that question.

First, criticizing art is good training. Have you ever heard the saying: To learn physics, be a physicist? In this case, it would be: To learn about criticism, be a critic, or To learn about the field of art, be an art critic.

Second, the reasons for professional criticism that were mentioned earlier are also appropriate for doing your own criticism. In this case, however, you would be making selections, discovering new things in familiar works of art, exploring unfamiliar works of art, and developing your taste without the help of professionals. Also, the more skilled you become, the more you can evaluate the performance of professional critics. You might become a critic of critics!

Third, criticism enables you not only to discover new things about artworks, but also to organize this knowledge in such a way that you can share it with others. Have you ever analyzed an interesting piece of popular music, and then wrote about it or talked about it with a friend?

Fourth, artworks, like good films, often deal with attitudes or ideas about life. Have you and your friends ever analyzed a good film? If so, you probably came up with a lot of interesting things to discuss. Analyzing an artwork can also generate ideas for sharing and discussion.

Finally, the more you learn about art and the ideas it expresses, the more you learn about yourself and your own ideas and feelings.

20-4 When you talk about your favorite rock bands, do you ever think that you might be engaged in a form of criticism?

Summary

Art criticism, as defined here, is a systematic description, analysis, interpretation, and evaluation of an artwork. Sometimes criticism includes just the first three stages. A specific method of criticm will be explained in the next chapter.

Professional criticism of the arts can be found in newspapers, magazines, radio, and television. Basically, professional critics inform and educate the public through studying and writing about works of art.

People who are not professional critics can benefit from criticizing art in many ways: learning more about art and criticism, developing their own taste, and sharing experiences with others.

Chapter 21 A Critical Method

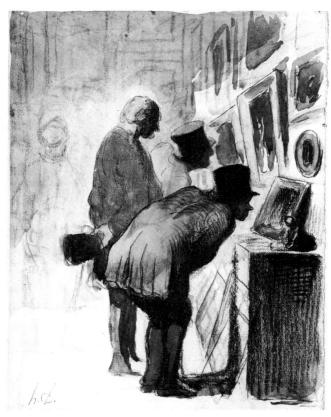

21-1 Honore Daumier, *Connoisseurs*, 1862–1864. Watercolor, pen and charcoal. The Cleveland Museum of Art (Dudley P. Allen Fund).

Chapter 20 explained the purposes of art criticism. Developing your own critical skills will contribute to your enjoyment and understanding of art, and also help you evaluate the analyses of professional critics. Every work of art includes some describable elements, some kind of organization, and some expressive content. In addition, every artwork can be judged as to its quality.

Preceding chapters introduced you to three stages in the critical analysis of artworks: *description* (Chapter 3), *analysis* (Chapters 9 and 10), and *interpretation* (Chapter 15). Criticism may include a fourth stage, *evaluation*. This process is explained at the end of this chapter. The four stages of criticism are outlined here to provide a plan that can help you to think and talk about art.

I. DESCRIPTION: Identify things about the work that you can see, name, and describe with certainty. Be sure your statements are not evaluative, opinionated, or interpretive – just record what is there.

A. Label Information

- 1. Title of work and artist's name.
- 2. When and where the work was created.
- 3. The medium (or media) used.

B. Subject Matter

- Recognizable images such as people, buildings, trees, and other things.
- If the work consists of geometric shapes or free forms, indicate that and then go on to Art Elements.

C. Art Elements (Chapters 4-8)

- 1. Line
 - a) Straight, curved, dotted, broken, wavy, swirling, jagged, textured, horizontal, vertical, diagonal, etc.
 - b) Contour lines or outlines.
 - c) Due to abrupt color, value, or texture changes.
- 2. Color and Value
 - a) Colors are warm, cold, bright, dull, dark, light, opaque, transparent.
 - Values result from combinations of black and white, or shades and tints of color.
- Shapes (two-dimensional) and Forms (three-dimensional)
 - a) Representational, abstract, organic, geometrical, open, closed.

4. Texture

- a) Rough, smooth, coarse, soft, bumpy, hairy, sandy, and so on.
- b) Simulated (you can see, but not feel it) or real (an actual part of the work you can feel).
- c) Don't confuse texture with *pattern* the repetition of some motif in a recognizable order, such as polka dots or a checkerboard. Identify patterns.

5. Space

- Two-dimensional art (illusionary a) depth): shallow or deep? Due to chiaroscuro, foreshortening, linear perspective, aerial perspective, overlap, high-low placement?
- b) Three-dimensional art (real depth). Due to voids, concaves, convexes, volumes?
- II. ANALYSIS: How have the things listed under Subject Matter and Art Elements been organized or interrelated to work together?

A. Similarities

- 1. Are there things similar in shape, color, texture, form, or size?
- 2. Are there lines similar in direction or kind?

B. Contrasts

- 1. Are there contrasts in color such as dull-bright, cool-warm, dark-light?
- 2. Are there contrasts of shape, form, texture, movement, size, complexitysimplicity?

C. Continuities

- 1. Are there elements in the composition that are repeated in some systematic way?
- 2. Are there elements that cause directional flow through the composition?

D. Dominance

1. Is there some area, elements, or arrangement that seems most important?

E. Balance

- I. What contributes to balance in the composition?
- 2. Is balance symmetrical, asymmetrical or radial?

F. Relationships

- I. What are the relationships between the theme of the artwork and the art elements?
- 2. What are the relationships between the theme of the artwork and the medium or procedure used to produce it?
- III. INTERPRETATION: Use the information from your description and analysis to help you identify the content of the work (what the artwork expresses about human experience).
 - A. Hypothesis (an assumption or informed guess, about the meaning of the work)

B. Defense

- 1. Defend your hypothesis with evidence from description and analysis information.
- 2. Defend your hypothesis with evidence from other sources such as art history, past experiences the work reminds you of, or presumed purposes: to praise, criticize, predict, record an event, make a political or social statement, ridicule, and so on.
- IV. EVALUATION: Based on your analysis in the first three stages, what is your judgment of the quality or success of the work? Judgment may be affected by the following criteria.
 - A. Craftsmanship—the degree of skill in use of media and procedures relevant to the subject matter and purpose of the artwork.
 - B. Design Quality-the degree of visual organization of the materials and elements that make up the work. Consider unity, variety, proximity, balance, dominance, and rhythm.
 - C. Expressiveness rate the expressiveness of the work relative to the subject, idea, or theme it is based on.
 - D. Personal Response the extent to which the artwork provokes a personal response, one that could be shared with others.
 - E. Originality—the degree of uniqueness, imagination, and freshness demonstrated by the artwork.
 - F. Comparison the art critic or connoisseur would consider how the work compares with other artworks of similar kind.

Using the First Three Stages of the Critical Analysis Model

The following examples will provide you with some guided practice in art criticism. Once you are familiar with the strategy of gathering facts about a work of art before drawing conclusions, you will feel more confident in your ability to discuss and enjoy artworks. An adequate analysis can be based on completion of the first three stages of the model. Because the last stage, evaluation, is difficult even for art professionals, it will be discussed separately.

Hemlock in November

Description. You will find it easy to describe this work by Charles Burchfield, a well-known Regionalist painter. It is a watercolor of a wooded grove, including an evergreen tree identified as a hemlock in the title (fig. 21–2). The hemlock is surrounded by trees that are losing their leaves. The tree and stump forms in the foreground, which are emphasized by warm, dark colors and strong textures, appear three-dimensional.

The clearing in the background that contains some different varieties of evergreens is flooded with white light that filters down through the trees. The painting includes a mixture of warm and cold, transparent and opaque colors that have been tinted and shaded. The space in this painting appears deep because of overlapping, the diminishing sizes of the trees, and aerial perspective.

Analysis. The first thing you see in this painting is the hemlock, which contrasts with the surrounding trees because of its size, textures, green needles, and dark colors, all of which are silhouetted against a cool, silvery light. The rhythm of the branches and needles causes a lively upward movement. Due to these factors and its slightly offcenter placement, the hemlock is the dominant form in the composition.

Light is everywhere, filtering down through the branches and giving the tree trunks a silvery glow. Clusters of the evergreen's needles reflect the light that becomes a background haze into which distant trees disappear. The brown, gold, yellow, and white foreground colors are repeated in the fallen leaves, the leaves on the trees at each side of the picture, and in the top branches of the hemlock, resulting in a framing effect around the painting.

The bases of the trees on each side of the hemlock are progressively higher on the picture plane as they go back in the distance, causing a directional flow from the foreground to the background. The triangular shape of the leaf-covered foreground reinforces this flow, and leads to a small evergreen shimmering with light.

Relationships can be seen in the artist's use of predominantly cool colors and the transparent gray washes to suggest a cold fall day. Heavy lines, warm colors, and rhythmical brush strokes applied to the hemlock relate to a theme of growth and life.

Interpretation. Our description and analysis suggest several meanings for *Hemlock in November*:

- It is about the effects of seasonal change upon the natural environment.
- 2. It is about the mood of a cold fall day in a wooded grove.
- 3. It is about the hemlock's defiance of approaching winter.

We will defend the first hypothesis for our example of interpretation. The picture is filled with a cool, hazy kind of light that we associate with cold fall days and the feeling that winter is in the air. The trees have lost or are losing their leaves, which have been transformed from green to the colors of fall. Even the trunks of the bare trees, and some of the hemlock's needles have been transformed to a silver-white color by the light. However, the green of the hemlock is a promise of continuing life. These are all effects that we associate with seasonal change.

What description and analysis information would you use to support either of the other hypotheses?

21-2 Charles Burchfield, Hemlock in November, 1946–1966. Watercolor, 42 " \times 32 ½ " (107 \times 83 cm). Private collection. Photograph courtesy of the Burchfield Art Center, Buffalo, New York.

21-3 Robert Stefl, Illinois Landscape #14, Photograph.

Whereas Burchfield's painting expresses the experience of fall, and the effects of a seasonal change upon the environment, *Illinois Landscape #14* (fig. 21–3) by Robert Stefl, a contemporary photographer, refers to the effects of winter on the land. Like a painting, a photograph can express ideas and feelings that may be teased out in the process of critical analysis.

Illinois Landscape #14

Description. This photograph by Robert Stefl depicts a gently rolling field, lined with rows of corn stubble that pokes through and casts shadows on wind-packed snow. On the horizon are three leafless black trees and several clumps of grass. Warm browns appear in the rows of stubble that extend in rough lines across the field, and in the clumps of grass on the horizon. The distant trees support angular branches that end in a maze of feathery lines. The sky and the snow-covered field are filled with light values of gray-blue and white, and there is an illusion of deep space.

Analysis. When you first look at *Illinois Landscape #14*, your attention is directed by the converging lines of corn stubble to the tree on the right. The branches of the lone tree seem to point toward the two trees on the left. The spaces between the rows of stubble become progressively

wider from the left to right, causing a wavelike flow across the foreground to the rows on the right, which direct your eyes back to the lone tree.

The warm browns of the corn stubble and grass contrast with, but are dominated by, the cold colors in the field and sky. The compelling linear movement of the rows and one-point perspective direct our attention to the trees and the empty space between them. The silhouetted trunks of the trees and the fragile lines of their branches contrast with the cold gray-blue of the sky. The texture of the snow in the furrows looks crisp and crunchy to the step.

Interpretation. We will hypothesize that *Illinois Landscape #14* expresses the wonder of the trees' survival under very threatening conditions.

The point of view of this photograph results in a composition that directs our attention to the trees. The most obvious hardship they must endure is the cold grip of winter, which is evident in the bleakness of the land, and the isolation of the trees. A second threat comes from man, who continually clears the land for farming. The rows and furrows extend up to and beyond the trees which stand like the last sentinels of a grove that existed before the field was cleared and they too may feel the axe.

Before you read the title of figure 21-4, can you guess

what the subject matter is? Abstract works of art may be based on objects, but the form of the object is changed to emphasize qualities that you normally might not see. Even though a work is not representational, you can respond to the visual forms in it. The critical analysis process can help you explain the organization of abstract works and propose meanings for them, as in the following illustration.

Flowering Apple Tree

Description. This oil painting by Mondrian, a major figure in the Modern movement, consists of lines and primarily geometric shapes, rather than recognizable objects. The lines vary in thickness and intensity and are predominantly curved or arched, with some horizontal and vertical lines. The colors are dull grays, blue-greens, and brownish hues with black line. The outlined shapes are flat, and some are leaflike. There is a minimal sense of spatial depth and no perspective depth such as that you can see in Hemlock, and in Illinois Landscape #14.

Analysis. You can identify the similarities and contrasts in this work. The orderly, repeated lines in the composition create rhythmical movements up, down, left, and right on the surface of the painting. The vertical lines in the lower central area direct your attention to the enclosed leaflike shapes. An area in the center, with lines radiating from it, tends to be a focal point, effecting a feeling of formal balance. Two-dimensional shapes and the use of colors that are all at about the same value level cause the composition to appear relatively flat. Since one-half of the painting is approximately the same as the other the work is basically symmetrical.

Interpretation. Flowering Apple Tree is about the rhythm, movement, and balance that can be found in the structure of a tree. The title indicates the painting is based on a tree. Knowing that, we can relate the central vertical and upward curving lines to a tree trunk and branches, and the outlined shapes to leaves. Since there is no definite tree form in the work, we can concentrate on the rhythmical movements caused by the lines and shapes.

21-4 Piet Mondrian, Flowering Apple Tree, 1912. 30¾ " × 41¾ " (78 × 106 cm). Haags Gemeentemuseum, The Hague.

Evaluation

So far, our critical analyses have dealt with the first three stages of the critical analysis outline, which are often adequate to deal with your needs and questions concerning a work of art. However, evaluation (refer to part IV of the outline) may be undertaken when there is a concern for estimating the quality or lasting importance of an artwork. We will use *Hemlock in November* to illustrate the process of evaluation.

Craftsmanship. Craftsmanship is demonstrated by the artist's skillful control of washes to effectively suggest the variable light conditions in a heavy growth of trees. To suggest deep space, Burchfield used contrasts of opaque and transparent colors and aerial perspective. The forms are crisp and the colors are fresh – a favorable characteristic of watercolor.

Design quality. Our analysis of *Hemlock* earlier in this chapter indicated that all of the parts are effectively organized around the dominant evergreen tree. The stronger the design of an artwork is, the less aware we are of individual parts, and the more we can attend to the meaning of the work.

Expressiveness. This area of evaluation involves a judgment about the strength of human feelings aroused by the work of art. Sometimes our reactions to an artwork are based on what it reminds us of, and our feelings are related more to that experience or event than to the art form. A successful work should arouse feelings that are associated with the work itself. The artist organizes symbols and forms to express what he or she knows about human feelings concerning some experience. For example, assume that *Hemlock in November* is about the effects of seasonal change upon the natural environment. How successful do you feel the painting is not only in arousing your feelings about seasonal change, but in providing you with fresh insights about this theme?

Originality. Originality is closely associated with expressiveness, involving a judgment about the uniqueness or freshness of an artwork. Is the hemlock tree in Burchfield's painting an unusual interpretation, or is it what you would expect to see, say, in a calendar or greeting card picture of the same subject? Have you seen similar approaches to lighting, color, and form in other pictures representing late fall, or are there unique qualities here?

Comparison. Comparing an artwork with historical examples is more a task for art professionals such as museum directors and art critics than it is for nonprofessionals. Historical examples, particularly of well-known works that have stood the test of time, provide touchstones for judging the quality of other works with similar subjects in similar styles.

Pine Trees with Setting Sun (fig. 21-5) by Vincent Van Gogh is a work that has many similarities to Hemlock in November. Although the paintings were done with different media (the Van Gogh is oil, the Burchfield is watercolor), they are similar in subject and style. Both are landscapes with trees as a principal subject; both emphasize the vertical; both emphasize the effects of light, and both employ lively brushwork and exaggeration - seen particularly in the trees - to make the picture vivid. Art professionals familiar with works like these would probably prefer the Van Gogh for a number of reasons. The brushwork is more animated – it seems to come from within the forms and to enliven the whole picture. The painting also contains more variety. Notice the asymmetrical composition and the different directions of the branches, especially the way in which the diagonal and horizontal branches of the near tree provide a counterpoint to the vertical emphasis. Despite its variety, the Van Gogh is at least as well organized as the Burchfield.

Still, on the grounds of craftsmanship, design quality, and expressiveness, you might prefer the Burchfield – and this is your right. However, imagine you are a museum director with a large budget to spend on art, and can afford the best. You no doubt would select the Van Gogh over the Burchfield for a number of reasons *not* seen in the works themselves. Some things that professionals consider before purchasing an artwork are:

- 1. how well-known the artist is;
- 2. the importance of the artist's achievements;
- 3. the importance of the artwork in the history of art;
- 4. the recognizability of the artist's style;
- 5. the demand for the artist's work;
- 6. the probable lasting value of the work;
- 7. the opinions of other curators, art dealers, collectors, and investors; and
- 8. the freshness of treatment of an idea, a medium, a style, or a technique.

21-5 Vincent Van Gogh, Pine Trees with Setting Sun. Collection: State Museum Kröller-Müller, Otterlo, The Netherlands.

Given these reasons, the Van Gogh wins handily. Consider reason 8, for example. Van Gogh pioneered an expressionistic style in the late 1880's when such a style was not popular. For all of his efforts, he received almost no recognition during his lifetime because his style was too fresh for the times. But in the early part of this century, his work and expressionistic styles in general became not only acceptable, but celebrated. Van Gogh paved the way for artists like Burchfield, who like many others in this century, was influenced by Van Gogh. Reasons 1, 2, and 3 also weigh heavily in the choice of the Van Gogh over the Burchfield.

Suggestion:

Continue your role as a museum director. How would you choose between the Burchfield and the Stefl? Between the Burchfield and the Mondrian? You may have to do a little research.

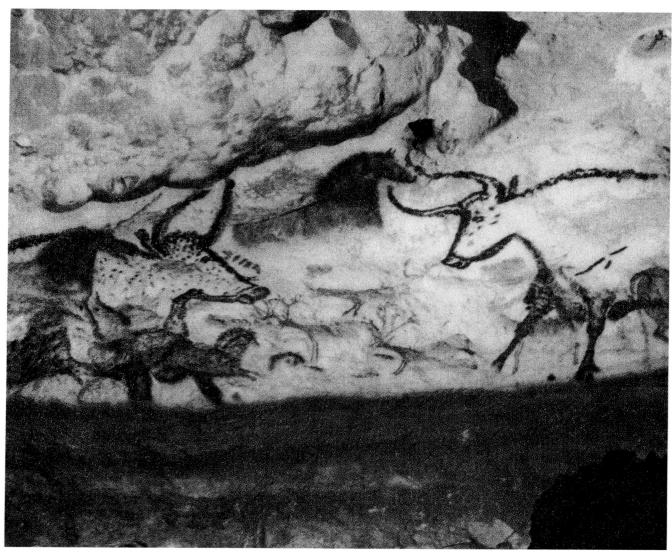

21-6 Hall of Bulls, left wall, Lascaux, ca. 15,000-13,000 B.C. Dordogne, France.

Conclusion

We have reached the end of our text, but we have not concluded the story of art. That story begins with the images made on cave walls by prehistoric people, and continues through the cultures of the world, past, present and future. We began with questions about what art is, how and why it is created. In the process of answering these questions, you learned about the elements and principles of design and how the artist uses these elements to create art. You have learned about the wide variety of art forms, and art media, and seen how different artists use them in their work. As an art student, you have learned how to use the elements and principles and some art media in your own artwork. You have been introduced to the art

history of both Western and non-Western cultures to help you learn about works of art: where, when and why they were created, the style of art, and cultural influences upon artists. Throughout the text, you have used information obtained from all of these experiences to practice art criticism. As you've learned, art criticism is concerned with questions such as: What should I look for in the work? How is it organized? What does it mean? How successful is the work? Most importantly, you have discovered how to learn from the nonverbal language of art that provides all civilizations of the world with a means of communication.

Now that you have completed the book, we are certain that you not only know more about art, but also are better prepared to continue learning from it. No one can

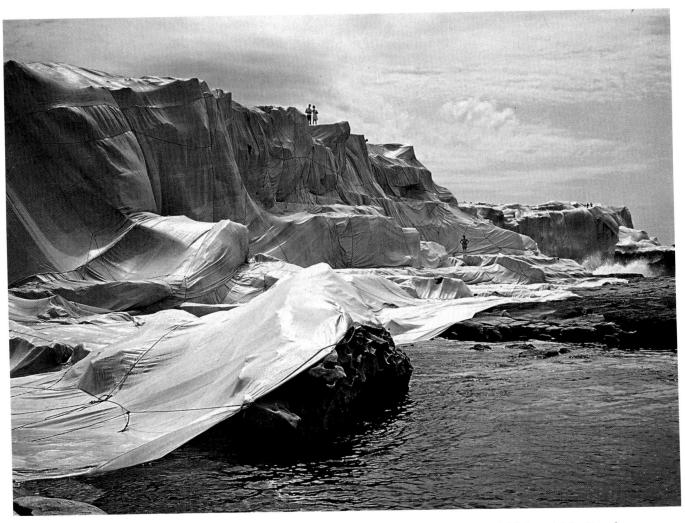

21-7 Christo, Wrapped Coast, One Million Square Feet, Little Bay Australia, 1969. Erosion control fabric and 35 miles of rope. Photograph: Harry Shunk. Copyright Christo, 1969.

predict just what forms art will take in the future, or what social functions it will serve. However, the importance of art in human affairs over the past 3,000 years and the diversity of forms it has taken suggest that the art of your future will be both exciting and important. We hope that you'll continue to look for ways art can help you learn about and enjoy the world around you.

Challenge 21-1:

Write a critical analysis of an artwork that has not been discussed in class, using the four-stage model provided in your text.

Pronunciation Guide

Adams, Ansel ad-ums, an-sul Aguilar, José Roberto ab-gwee-lar, hoe-zay roe-bair-toe Amiens ah-mee-en Angkor Thom ang-core tahm Asuka ah-soo-kah Auvers-sur-Oise oh-vair soor wahs

Baldessari, John bal-dah-sar-ree, jahn
Barlach, Ernst babr-lock, airnst
Benin beh-neen
Beuys, Joseph boys, jo-sef
Boccioni, Umberto bought-she-ob-nee, oom-bair-toe
Bonheur, Rosa (Maria Rosalie) bon-err, rob-zah
(mair-ee-ah, rob-zah-lee)
Borglum, George bore-glum, george
Borobodura bor-oh-boh-dubr-rah

Bouts, Dirk bow-ts, dear-k Braque, Georges brahk, zhor-zh Brunelleschi, Filippo brew-nell-*less*-key, fee-*leep*-po

Cassandre, A.M. cah-sahn-drey, A.M. Cassatt, Mary cass-satt, mair-ee

Castillo, El cas-tee-yuh, el

Catchings, Yvonne Parks catch-chings, e-von parks

Cézanne, Paul say-zahnn, pawl

Chagall, Marc sha-gabl, mark

Chartres shart

Chichén Itzá chee-chen eet-zah

Chirico, Giorgio de key-ree-coe, jor-jyoh day

Christo (Javacheff Christo) kriss-toe (yah-vab-cheff)

Colette co-let

Corbusier, Le (Charles Édouard Jeanneret) core-boo-zeeay, Luh (sharrl aye-do-are zhann-ah-ray)

Cordova cohr-dob-vah

Courbet, Gustave core-bay, goo-stahv

Cruz, Emilio cruszh, ay-meal-lee-o

Dali, Salvador dab-lee, sal-vah-door

Daumier, Honoré dough-mee-ay, oh-no-ray

David, Jacques Louis dah-veed, zhahk loo-ee

Delacroix, Eugène du-la-krawh, 00-zhen

Donatello (Donato di Niccolo Bardi) doh-nah-tell-oh

(doh-nay-toe dee nick-oh-low bar-dee)

Dubuffett, Jean *due*-boo-fay, zjahn Duchamp, Marcel doo-*shahn*, mar-*sell* Dürer, Albrecht *dur*-er, *ahl*-brecht

Edo ay-doe
Escher, M.C. (Maurits Cornelis) esb-er, M.C.
(ma-oo-ritts cor-nay-liss)
Espada, Ibsen ess-pab-da, ib-sen
Estes, Richard ess-tuss. ri-chard

Fragonard, Jean Honoré fra-go-*nabr*, zjahn oh-no-*ray* Frankenthaler, Helen *frank*-en-thall-er, *bell*-en Frey, Viola fry, vi-oh-la

Gabo, Naum gab-boh, naum
Gare Saint Lazare gahr sen lah-zahr
Gauguin, Paul go-gen, pawl
Gentile da Fabriano djen-tee-lay da fa-bree-ab-no
Ghiberti, Lorenzo gee-bair-tee, low-wren-tso
Giacometti, Alberto zjah-coe-met-ee, al-bair-toe
Gizeh gee-zah
Gogh, Vincent Van gah, vinn-cent van
Gorky, Arshile gore-key, are-sheel
Gropius, Walter grow-pea-us, vbalt-ter

Hardouin-Mansart, Jules are-doo-ehn mahn-sar, zjool Heian bey-on Herbst, Gerhardt bair-bts, gair-bardt Hiroshige, Ichiryusai hee-roh-shee-gee, ee-kee-ree-oo-sigh Hofmann, Hans bof-mahn, hahns Hokusai hoe-ku-sigh Hooch, Pieter de hoak, pea-tear duh

Ife ee-fay
Ingres, Jean Auguste-Dominique engr, zjahn oh-goost

Ingres, Jean Auguste-Dominique engr, zjahn oh-*goost* doh-min-*eek*

Kamakura kah-mah-koo-rah
Kandinsky, Wassily can-din-skee, vahs-sea-lee
Klee, Felix clay, feel-licks
Knoblock, Keith nob-block, keeth
Knossos knob-sohs
Kollwitz, Käthe kahl-vitss, kay-teh
Kubota, Shigeko coo-bow-tah, she-gay-koh

Lascaux lass-coe Le Parc, Julio luh park, who-lee-oh Leonardo da Vinci lay-oh-nar-dough da vinn-tshee Lichtenstein, Roy lick-ten-stine, roy Linares, Felipe lin-nar-rays, fee-leap Linares-Vargas, David lin-nar-rays var-gus, dah-veed Linares-Vargas, Leonardo lin-nar-rays var-gus, lay-oh-nar-dough

Ma Yuan ma yu-an Manet, Edouard ma-ney, eh-do-are Marisol (Marisol Escobar) mare-eh-soul (ess-coe-bar) Martinez, Julian mar-tee-nesz, zhoul-lee-an Martinez, Maria Montoya mar-tee-nesz, mare-ee-ah mon-toy-yah Martinez, Popovi Di mar-tee-nesz, pop-poe-vee de

Masaccio (Tomasso di Guovanni Guidi) ma-zatsh-she-oh (tom-ma-zo dee djoh-van-nee goo-ee-dee)

Matisse, Henri mah-tea-ss, ahn-ree

Meissen my-sen

Michelangelo (Buonarroti) me-kel-an-djay-low (boo-oh-nair-row-tee)

Mies van der Rohe, Ludwig mees van der roe-ay, lood-vhig Mili, Gjon mee-lee, jahn Modersohn-Becker, Paula mo-dair-sohn beck-r, pawl-la

Mohenjo-Daro moh-ben-joe dab-roh

Mokuan mow-coo-an

Mondrian, Piet mown-dree-ahn, peat Monet, Claude mo-nay, clohd Munch, Edvard mounk, ed-vard

Mycenae my-see-nee

Nara nah-rah Noguchi, Isamu noh-goo-chee, is-sah-moo Nolde, Emil nobl-day, aye-meal

Ognes og-neh Oldenburg, Claes Thure old-en-berg, klahss thure Oloyede, Senabu oh-low-yeah-dee, sea-nah-boo Ono, Hiromi oh-no, he-roe-me

Pei, I.M. pay, I.M. Pereira, Irene Rice pay-rare-ah, eye-reen rice Phidias fid-ee-us Picasso, Pablo pea-cabs-so, pab-blow Pollack, Jackson pab-lock, jack-sun Pompeii pahm-paay

Raphael rab-fay-ell Rauschenberg, Robert rau-shen-berg, rab-bert Reims reemz

Reinhardt, Ad rhine-hardt, ad Rembrandt van Rijn rem-brandt van rhine Renoir, Pierre Auguste ren-wahr, pea-air oh-goost Rivera, Diego ree-vay-rah, dee-ay-goh Rodin, Auguste roh-dan, oh-goost Rubens, Peter Paul (Petrus Paulus) rue-bens, pea-ter pawl (pay-truss pab-oo-luss)

Saar, Betye sahr, bet-tee San Juan Capistrano san hoe-ahn cap-is-tron-no Sauer, Jane soy-er, jane Scherr, Mary Ann shear, mair-ee ann Sesshu sess-shu Seurat, Georges suh-rab, zhorzh Shin'cihi shin-chee-hee Sisley, Alfred sizzle-aye, al-fred Sojo, Toba so-jo, toe-bah Sri Yantra sree yan-tra Subleyras, Pierre suh-blay-rah, pea-err

Tadasky tah-das-key Tanahashi, Kazuaki tah-nah-hash-she, kay-zoo-auk-key Tohaku, Hasegawa toe-hah-coo, hah-seh-gow-wah Tsinahjinnie, Andrew sin-ah-jin-nee, ann-drew

Van Oosterwyck, Maria van oo-ster-wick, mah-ree-ah Vasarely, Victor va-sah-rell-ee, vic-tor Vau, Louis Le voh, loo-ee luh Versailles vehr-sigh Vézelay vay-zeh-lay Vignon, Pierre-Alexandre vee-nyon, pea-air al-ex-sahn-der

Warhol, Andy war-hole, an-dee Willendorf vill-en-dorfh Wright, Frank Lloyd right, frank loyd Wu Chen woo-chen Wyeth, Andrew why-eth, an-drew

Xiaowhen Chen chee-oh-when chen

Yu Chien you che-en

Zeister, Claire zie-stir, klare

Glossary

abstract art Art stressing the form of its subject rather than its actual appearance. The subject is broken down into elements: line, shape, etc., not necessarily resembling the subject itself.

Abstract Expressionism A twentieth century style in which feelings and emotions are emphasized. Accident and chance are stressed rather than accurate representation of subject matter.

acrylic paint A synthetic painting medium in which pigments are mixed with acrylic, a plastic emulsion that acts as a vehicle and a binder.

aesthetic The theory of perceiving and enjoying something for its beauty and pleasurable qualities. This theory tries to explain and categorize our responses to art forms.

aerial perspective The diminishing of color intensity to lighter and duller hues to give the illusion of distance.

analogous colors Colors that are next to each other on the color wheel and are closely related, such as yellow, yellow-orange, yellow-green and green.

approximate symmetry The use of forms which are similar yet different, on either side of a vertical axis.

aquatint A form of intaglio printmaking in which resin is melted on the metal plate to resist the biting action of acid so that tonal areas can be produced when the plate is printed. May be combined with engraving and etching on the same plate.

arabesque A flowing, intricate pattern of stylized organic motifs arranged in symmetrical designs.

arcade A series of arches on pillars used as a screen and roof support for a walkway.

architecture The art and science of designing and constructing buildings.

armature A framework used to support material being modeled in sculpture.

assemblage An artwork composed of objects, parts of objects or materials originally intended for purposes other than art.

asymmetrical balance A feeling of balance attained when the visual units on either side of a vertical axis are actually different but are placed in the composition to create a "felt" balance of the total artwork.

balance A principle of design referring to the arrangement of visual elements to create stability in an artwork. There are three kinds of balance: symmetrical, asymmetrical and radial.

Baroque A period and style in seventeenth century European art in which painters, sculptors and architects used dramatic movement, light, soaring spatial illusions and ornate detail to encourage emotional involvement.

barrel vault A half-round stone ceiling made by placing a series of arches, one behind the other, resulting in a ceiling that looks like a tunnel.

bas relief See low relief.

batik A method of dyeing cloth using removable wax to repel the dye on parts of the design where dye is not wanted.

Blaue Reiter, Der (The Blue Rider) A group of Munich artists including Käthe Kollwitz, Oskar Kokoschka and expatriates such as the Russian Wassily Kandinsky, and the Swiss born Paul Klee. Concerns were with presentation of subjective feelings toward reality, and imagination. This group greatly influenced the development of Modern art.

Brücke, Die (The Bridge) A small group of German artists led by Ernst L. Kirchner who emphasized violent color and distortion of features in their paintings and woodcuts in protest of the economic and social conditions in Germany prior to World War I. Other members included Emil Nolde and Wassily Kandinsky.

Buddha Any Buddhist sage who has achieved enlightenment in accordance with the teachings of Gautama Siddhartha, founder of Buddhism.

Buddhism A religious belief based on the teachings of Gautama Siddhartha, who held that suffering is a part of life but that mental and moral self-purification can bring about a state of illumination carrying the believer beyond suffering and material existence.

calligraphy Handwriting or letters formed by hand. Elegant penmanship usually featuring a flowery, precise line.

came Channeled lead strips, either H or U shaped, used in stained glass windows to join the pieces of glass together. The U shape is used on outer edges of the design and the H for all other purposes.

caricature A likeness of a person, distorted by exaggerated features or mannerisms.

cartoon A comic strip or caricature showing some action, situation or person. May be single or multiple frame. In painting, a full-size preliminary drawing from which a painting is made.

carving The process of producing a sculpture by cutting, chipping or hewing wood or stone.

casein A type of paint made from milk or cheese protein used to achieve a transparent or opaque effect.

casting The process of making forms by pouring a fluid substance such as molten metal, liquid plaster or plastic into a mold.

ceramics Objects made of clay and fired in a kiln to a permanent form. Ceramics are often decorated with glazes and fired again to fuse the glazes to the clay body.

chiaroscuro From the Italian meaning "light-dark." The use of value contrasts to represent the effects of light and shadow.

cire perdue see lost-wax process

Classical Originally, the art of ancient Greece produced in the fifth and fourth centuries B.C. Later, it was used to describe any art form influenced by ancient Greek or Roman examples. Today it is used to describe perfection of form with an emphasis on harmony and unity and restraint of emotion. Such works are usually representational but idealistic.

cloisonné A decorative enameling technique in which thin metal strips are attached to a metal base to outline design areas, or cloisons, which are then filled with enamels and fired.

closure The tendency to complete partial forms or shapes by seeing lines that do not exist.

collage A two-dimensional composition made by gluing various materials such as paper, fabric, etc., on a flat, firm surface. Introduced by the Cubist artists Picasso and Braque.

color An element of design with three properties, hue, value and intensity. Also the character of surfaces created by the response of vision to wavelengths of reflected light.

complementary colors Two colors which are directly opposite each other on the color wheel meaning they are in extreme contrast with each other.

composition The act of organizing the elements of an artwork into a harmoniously unified whole.

concept art A style of the 1970's emphasizing the idea behind the work of art rather than the work itself. Artists tried to deemphasize the artwork in favor of the concept to demonstrate that the conception of the work is more important than the product.

construction A sculpture built by connecting several or many parts to one another. The parts may be made of a single material or of a variety of materials. *Number 7: Full Moon* by Richard Lippold (p. 168) is an example.

content The inner meaning or subject matter of an artwork as distinguished from its form.

continuation (viewer movement) A phenomenon that occurs in an artwork when the observer's vision is directed from place to place by lines, edges of shapes, or an arrangement of objects and figures.

contour line Lines that define the outer edges of forms and surfaces within a form such as shapes or wrinkles and folds. Used in contour drawings to suggest depth in addition to height and width.

contrast A principle of design that refers to differences between elements such as color, texture, value, and shape. A painting might have bright colors contrasted with dull or angular shapes contrasted with round ones.

cool colors Those colors in which blue is dominant found on the right side of the color wheel.

corbeled arch An arch constructed from an overlapping arrangement of stones, each layer projecting a bit beyond the row beneath it, and held in place by the pressure of the stones against one another.

Corinthian One of the classical styles of ancient Greek architecture featuring tall, slender columns topped with ornate capitals.

crafts Works of art that may be expressive, but generally have utilitarian purposes. This includes fiber arts, ceramics, metalsmithing, fabrics, furniture, basketry, etc.

crosshatching Shading created by crossed parallel lines.

cross vault The intersecting and joining of two barrel vaults at right angles.

Cubism A twentieth century art movement developed mainly by Picasso and Braque in which the subject matter is broken up, analyzed and reassembled in an abstract form, emphasizing geometric shapes.

culture The concepts, habits, skills, art, institutions, beliefs, traits, etc., of a given people in a given period; civilization.

descriptive lines Lines created with a variety of tools; can be outlines, contour lines, single lines or hatching.

design The plan the artist uses to organize the art elements (line, shape, form, space, etc.) in a work of art to achieve a unified composition.

dome A beehive shaped vault or ceiling over a circular opening.

dominance A concept of design which suggests that one element, or a combination of elements, attracts more attention than anything else in a composition. The dominant element(s) is usually a focal point in a composition and contributes to unity by suggesting that other elements are subordinate to it.

Doric The earliest of the classical styles of ancient Greek architecture, characterized by columns that have no base, and topped by simple, undecorated capitals.

earthenware Ceramic ware that is made from natural clay. It is soft, porous and fired at low temperatures.

elements of design Space, line, shape, form, color, value and texture. The tools the artist works with to create an artwork according to the principles of design.

ellipse An oval shape produced by drawing an elongated circle so that it appears to be viewed from an angle. A foreshortened circle that is longer in one dimension than it is in the other.

emulsion A liquid in which droplets of a second liquid are suspended until painted on a surface where they dry and bond together.

engraving A technique in which a design is incised in a plate of metal, wood or plastic. A print is then made from the plate.

etching A technique in which a metal plate covered with an acid-resistant coating is incised by needle scratches. The plate is then immersed in acid and a print is made from the plate.

Expressionism An art movement developed at the end of the nineteenth and the beginning of the twentieth century in Germany. This style emphasized the expression of the artist's emotions through the use of strong color, exploitation of media and the use of suggestive and symbolic imagery.

eye level A horizontally drawn line that is even with the viewer's eye. In landscape scenes, it can be the actual horizon line, but can also be drawn in still life.

façade The front of a building. The façade accents the entrance and usually prepares the viewer for the architectural style inside.

Fauvism An early twentieth century style of painting developed in France. The artists, led by Matisse, used brilliant and explosive color to express the inner quality of their subjects rather than how they appeared in nature. They were called Fauves, or "Wild Beasts" because critics thought they used colors in a violent uncontrolled way.

figure-ground The perceptual tendency to divide visual patterns into two kinds of shapes with the figure(s) appearing to be on top of, and surrounded by, the ground. In the pictorial arts, the relationship between images and the background. Figure and ground are often referred to as positive shape and negative shape.

foreground The area of a picture that appears to be closest to the viewer.

foreshortening A method of applying perspective to an object or figure so that it seems to recede in space by shortening the depth dimension, making the form appear three-dimensional.

form An element of design that appears threedimensional and encloses volume, such as a cube, sphere, pyramid or cylinder. The term may also refer to the characteristics of an artwork's visual elements (lines, color, textures, etc.) as distinguished from its subject matter.

frame construction A method of construction in which a skeleton of studs and joists is erected as in a new house. An exterior of wood, brick, metal or plaster is added.

fresco A method of mural painting in which pigments are applied to a thin layer of wet plaster so that they will be absorbed.

Futurism A style of art originating in Italy during the early twentieth century that emphasized representation of a dynamic, machine-powered world.

genre A type of localized art that depicts realistic scenes or events from everyday life.

geometric shapes (rectilinear) Mechanical, humanmade shapes such as squares, triangles, circles, etc. Geometric shapes have regular edges as opposed to the irregular edges of organic shapes.

glaze A thin coating of minerals which gives the surface glass-like quality. Used in painting and ceramics.

Gothic A style in European art and architecture that prevailed from the twelfth through the fifteenth century. Gothic architecture, specifically in cathedrals, was characterized by pointed arches, spires, flying buttresses and cross vaults.

gouache A form of water-soluble paint used to create opacity.

graphic art The art of printmaking in any form. In commercial art, advertising, book and magazine illustration, cartoons and signs, etc., for commercial purposes.

ground The treated surface on which a painting or drawing is made. A coating, such as priming or sizing is used to prepare a support (i.e., bare canvas or wood) for a painting.

harmony A condition in which the elements of an artwork appear to fit well together.

hatching Shading using closely spaced, parallel lines used to suggest light and shadow.

hieroglyph A form of ancient writing in which pictures or symbols are used to represent sounds, words or ideas.

hue The property of color that distinguishes one gradation from another and gives it its name.

humanism Devotion to human concerns; the study of humanity. This philosophy emerged during the Italian Renaissance characterized by a renewed interest in the art and literature of Classical Greece.

implied line Lines that are indicated indirectly in artworks at edges where two shapes meet, where a form ends and the space around it begins, or by positioning several objects or figures in a row.

Impressionism The first of the Modern art movements developed in France during the second half of the nineteenth century which emphasized the momentary effects of light on color in nature.

intaglio A technique of printmaking where lines and areas are etched, engraved or scratched beneath the surface of a metal or plastic plate. Ink is then transferred from the plate onto paper.

intensity The degree or purity, saturation or strength of a color.

intermediate colors Colors produced by mixing a primary color and the adjacent secondary color on the color wheel. (For example, yellow and green for yellow-green.) They are also made by mixing unequal amounts of two primaries. (For example, adding more yellow to a combination of yellow and blue produces yellow-green.)

Ionic Classical Greek architecture characterized by slender, elegant columns with spiral device capitals and fluted shafts.

isometric perspective A method of applying perspective by drawing the height, width and depth of an object or figure on the same scale at equal angles of 120° with one another. Planes recede on the diagonal, but the parallel lines along edges remain parallel rather than converging as in linear perspective.

kiln A furnace capable of controlled high temperatures used to fire ceramic ware and sculpture.

kinetic art Any art construction that contains moving elements which can be set in motion by the action of gravity, air currents, motors, springs or magnets.

line An element of art which is used to define space, contours and outlines, or suggest mass and volume. It may be a continuous mark made on a surface with a pointed tool or implied by the edges of shapes and forms.

line of sight Implied lines suggested by the direction in which figures in a picture are looking, or from the observer's eye to the object being looked at.

linear perspective A technique of creating the illusion of depth on a flat surface. All parallel lines receding into the distance are drawn to converge at one or more vanishing points on the horizon line.

lithography A method of printing from a flat stone or metal plate. A drawing is made on the stone or plate with a greasy crayon and chemically treated so that only the greasy drawing will hold ink while the remaining surface resists it. A print is then made from the plate.

lost-wax process (cire purdue) A method of casting metal in which a mold is lined with wax, filled with a solid core of heat resistant materials (vestment) and heated to melt the wax leaving a thin cavity between mold and core into which metal is poured.

low relief (bas relief) Sculpture that projects slightly from the surface.

Mannerism A sixteenth century European art style that rejected the calm balance of High Renaissance art in favor of emotion, distortion of the figure, exaggerated perspective views and crisp treatment of light and shadow

masonry A medium of architecture consisting of stone or brick.

mastaba A low, rectangular Egyptian tomb made of mud brick with sloping sides and a flat top.

medieval Pertaining to the Middle Ages—the period of European history between ancient times and the Renaissance (ca. 500 A.D. to 1450 A.D.).

medium (pl. media) the materials used to create an artwork such as oil, watercolor, etc., or a category of art, such as drawing, painting or sculpture.

minaret A high, slender tower attached to a Moslem mosque, with balconies from which a crier calls the people to prayer.

Minimal art A twentieth century style that stressed reducing an artwork to minimal colors, simple geometric forms, lines and textures.

mobile A kinetic sculpture, invented by Alexander Calder in 1932, constructed of shapes that are balanced and arranged on wire arms and suspended from above so as to move freely in air currents.

mold A hollow container that produces a cast by giving its form to a substance (molten metal, plastic or plaster) placed within it and allowed to harden.

monochromatic One color which is modified by changing the values and saturation of the hue by additions of black or white.

mosaic A mural technique formed by placing colored pieces of marble or glass (tesserae), small stones or ceramic tiles in a layer of adhesive material.

mosque A Moslem house of worship.

movement A principle of design associated with rhythm, referring to the arrangement of parts in an artwork to create a sense of motion to the viewer's eye through the work.

mural A large design or picture created directly on the wall or ceiling.

negative space The space not occupied by an object or figure but circulating in and around it, contributing to the total effect of the composition.

Neoclassicism ("New Classicism") A style of art in the nineteenth century in which artists and critics sought inspiration from the classical art of ancient Greece and Rome and imitated its themes, simplicity, order and balance.

neutral colors Colors not associated with any hue such as black, white and gray and are neither warm nor cool. Also colors which have been "grayed" or reduced in saturation by mixing them with a neutral or complementary color.

one-point perspective A way to show three-dimensional objects on a two-dimensional surface, using one vanishing point. One object faces the viewer; the lines defining other objects in the artwork recede at an angle to a single vanishing point on the horizon line. (see *perspective*)

Op art A twentieth century style in which artists sought to create an impression of movement by means of optical illusion.

optical movement An illusion of movement, or implied movement caused by the response of the eye to lines, shapes and colors arranged in artworks. (see *Op art*)

organic shapes (bimorphic) Free forms, or shapes and forms that represent living things having irregular edges, as distinguished from the regular edges of geometric shapes.

pan In filmmaking, to pivot sideways from a stationary position.

papier mâché A technique of creating threedimensional or relief sculpture by molding strips of paper soaked in glue or paste.

pastel A chalky, colored crayon consisting of pigment and adhesive gum. Also paintings done with such crayons.

patina The surface coloration on metal caused by natural oxidation. This effect can also be produced by the application of heat, chemicals and polishing agents.

performance art Works of a theatrical nature performed by the artist before an audience. A performance may involve props, lights, sound, dialogue, etc.

perspective A method by which artists depict threedimensional space and objects on a two-dimensional surface such as paper, canvas or cardboard.

picture plane The imaginary flat surface which the artist uses as a frame of reference to create the illusion of forms in three-dimensional space through the use of perspective.

piece mold A mold with sections completely free of undercuts. It may consist of two or more pieces and is generally made from plaster.

pigment A powdered coloring material for paint, crayons, chalks and ink.

plane A flat, two-dimensional surface.

planographic print Prints made from a flat surface area on which ink is placed. The lithograph is planographic as are monoprints made from ink spread on a flat, nonporous surface.

Pop art An art style, also known as neo-Dada, developed in the 1950's. Pop artists depicted and satirized popular culture such as mass media symbols, comic strips, fast foods, billboards and brand name products.

porcelain Ceramic ware made from a specially prepared, fine white clay that fires at the highest temperatures. Porcelain is hard, translucent, thin walled and rings when struck.

positive space The enclosed areas or objects in an artwork. They may suggest recognizable objects or nonrepresentational shapes.

post and lintel A method of construction in which two vertical members (posts) support a horizontal member (lintel) to create a covered space.

Post Impressionism A style developed in the 1880's in France in reaction to Impressionism. It included artists such as Cezanne, Seurat, Gauguin and Van Gogh. The first two artists explored the formal structure of art while the other two championed the expression of personal feelings.

pottery Ceramic ware made of clay and hardened by firing at low temperatures.

primary colors The three basic colors, red, yellow and blue, from which it is possible to mix all other colors. The primaries cannot be produced by mixing pigments.

principles of design Balance, emphasis, rhythm, movement, repetition, contrast and unity. The methods or techniques that artists use to organize or design artworks by controlling and ordering the elements of design.

proximity The placement of objects very near to each other to make them look related.

radial balance A composition based on a circle with the design radiating from a central point.

Realism A mid-nineteenth century style in which artists turned to painting familiar scenes and events as they actually appeared in nature in the belief that subject matter should be shown true to life, without stylization or idealization as in Neoclassicism and Romanticism.

relief A type of sculpture in which forms project from a background. It is classified according to the degree in which it is raised from the surface: high relief, low relief, etc.

Renaissance A period in Western history (ca. 1400–1600 marking a "rebirth" of cultural awareness and learning, founded largely on a revival of Classical art. It began in Italy and spread to all of western Europe.

repoussé A metalworking process of hammering or pressing sheet metal into relief on one side to create shapes or patterns on the other side.

rhythm A principle of design that refers to ways of combining elements to produce the appearance of movement in an artwork. It may be achieved through repetition, alternation or progression of an element.

ribbed vault A vault in which there is a framework of ribs or arches under the intersections of the vaulting sections.

Rococo An eighteenth century style of art and interior decoration which emphasized portraying the carefree life of the aristocracy. Love and romance were portrayed rather than historical or religious subjects.

Romanticism A style of art that flourished from the middle of the eighteenth century and continued well into the nineteenth century. Romanticism emphasized personal emotions, dramatic action and exotic settings using literary and historical subject matter.

saturation The purity, vividness or intensity of a color.

sculpture Three-dimensional forms (sculpture in the round) or forms in relief created by carving, assembly or modeling.

secco A mural technique created by painting on a dried lime-plaster wall with pigment ground in casein.

secondary colors Colors that result from a mixture of two primary colors. On the twelve-color wheel, orange, green and violet.

serigraphy (silk screen printmaking) A technique of printmaking in which stencils are used on porous silk or polyester material. The paint is brushed over the screen and the color penetrates the unmasked areas.

sgraffito A method of decorating a surface such as clay, plaster or glass, by scratching through a surface layer to expose a different color underneath.

shading Variations in value to suggest form, volume and depth in artworks.

shape An element of art. An enclosed space defined by other art elements such as line, color and texture.

shape constancy The tendency to see the shape of a three-dimensional object as unchanging regardless of any change in position or angle from which it is viewed.

simulated texture An artist may use color and value contrast to give a painting or drawing the *appearance* of texture as distinguished from the texture of the artwork itself.

size constancy The tendency to see the size of an object as unchanging regardless of the distance between the viewer and the object.

space An element of art that indicates areas between, around, above, below or within something.

split complementary On the color wheel, a hue which is combined with hues on either side of its complement.

stabile A term adopted by Alexander Calder to identify standing constructions that emphasize space, similar to the mobile, but do not have moving parts.

stoneware Ceramic ware made from clay that is fired at a relatively high temperature (2,200°F). It is hard, and nonporous.

storyboard In filmmaking, a series of pictures that resemble comic strips, corresponding to a sequence. Each illustration represents a shot.

Stupa A large, mound-shaped Buddhist shrine.

style The identifying characteristics of the artwork of an individual, a group of artists, a period of time or an entire society.

symmetrical balance The organization of the parts of a composition so that one side duplicates or mirrors the other.

tempera A technique of painting in which the water-base paint is mixed or "tempered" with egg yolk.

tesserae The small cubes, usually pieces of glass or clay, used in making mosaics.

texture The surface quality of an artwork usually perceived through the sense of touch. However, texture can also be implied; perceived visually though not felt through touch. (see *simulated texture*)

three-dimensional Having height, width, and depth.

tint A lighter value of a hue made by adding a small amount of another color to it.

tilt In filmmaking, to pivot up and down from a stationary position.

track In filmmaking, to move or follow an action.

trapezoid A shape with four angles and four sides only two of which are parallel.

triadic color scheme Any three colors equidistant on the color wheel.

two-dimensional Having height and width.

two-point perspective A way to show three-dimensional objects on a two-dimensional surface, using two vanishing points and two sets of converging lines to represent forms. These forms are seen from an angle and have two receding sides. Two dimensions appear to recede: width and depth. (see *perspective*)

Ukiyo-e ("the art of the floating world") Japanese art which centered around the district of Edo and popular culture. Commonly produced in woodcuts.

unity A principle of design related to the sense of wholeness which results from the successful combination of the component elements of an artwork.

value An element of design concerned with the degree of lightness of colors. Darker colors are lower in value.

vanishing point A point on the eye-level line, toward which parallel lines are made to recede and meet in perspective drawing.

variety A principle of design concerned with the inclusion of differences in the elements of a composition to offset unity and make the work more interesting.

vault An arched roof or covering made of brick, stone or concrete. (see *barrel vault* and *cross vault*)

vehicle A liquid binding agent in paint such as water, oil, or egg yolk which allows the paint to adhere to the painting surface.

warm colors Those hues in which yellow and red are dominant located on the left side of the color wheel.

wash A transparent layer of color applied to a surface allowing underlying lines, shapes and colors to show through. Watercolor or ink that is diluted with water to make it lighter in value and more transparent.

waste mold A plaster mold from which one cast is taken. The mold is formed around a clay model in two or three removable parts which are reassembled and filled with liquid plaster that is allowed to harden. The mold is broken away (wasted) to reveal the cast.

woodcut A technique of relief printmaking in which a design is cut into a block of plank wood with knives and gouges leaving raised shapes to receive ink. A print is then made from the block.

wood engraving A technique of relief printmaking in which a design is cut into the end grain of a wooden block with gravers like those used for metal plates. Wood engravings contain more detail than woodcuts.

zoom In filmmaking, to make an image appear nearer or farther by means of a zoom lens.

Bibliography

Part I Introduction

- Blocker, H. Gene. Philosophy of Art. NY: Charles Scribner's Sons, 1979.
- Hobbs, Jack A. Art in Context, 4th ed. San Diego, CA: Harcourt Brace Jovanovich, 1990.

Part II What to Look For

- Bobker, Lee R. *Elements of Film*, 3rd ed. NY: Harcourt Brace Jovanovich, 1979.
- Gatto, Joseph, Porter, Albert and Selleck, Jack. Exploring Visual Design, 2nd ed. Worcester, MA: Davis Publications, Inc., 1987.
- Goldstein, Ernest, Katz, Theodore, Kowalchuk, Jo and Saunders, Robert. *Understanding and Creating Art*. Dallas, TX: Garrard Publishing, 1986.
- Hobbs, Jack A. Art in Context, 4th ed. San Diego, CA: Harcourt Brace Jovanovich, 1990.
- Lauer, David A. Design Basics, 2nd ed. NY: Holt, Rinehart and Winston, 1985.
- Richardson, John A., Coleman, Floyd W., and Smith, Michael J. Basic Design: Systems, Elements, Applications. Englewood Cliffs, NJ: Prentice-Hall, Inc., 1987.
- Stoops, Jack and Samuelson, Jerry. Design Dialogue, 2nd ed. Worcester, MA: Davis Publications, Inc., 1990.
- Zelanski, Paul and Fisher, Mary. *The Art of Seeing*. Englewood Cliffs, NJ: Prentice-Hall, Inc., 1988.

Part III How Is It Organized?

- Gatto, Joseph, Porter, Albert and Selleck, Jack. Exploring Visual Design, 2nd ed. Worcester, MA: Davis Publications, Inc., 1987.
- Hobbs, Jack A. Art in Context, 4th ed. San Diego, CA: Harcourt Brace Jovanovich, 1990.
- Lauer, David A. Design Basics, 2nd ed. NY: Holt, Rinehart and Winston, 1985.
- Stoops, Jack and Samuelson, Jerry. *Design Dialogue*, 2nd ed. Worcester, MA: Davis Publications, Inc., 1990.

Part IV What Is It Made Of?

Bobker, Lee R. Elements of Film, 3rd ed. NY: Harcourt Brace Jovanovich, 1979.

- Bontemps, Arna Alexander, editor. Forever Free: Art by African-American Women 1862–1980. Alexandria, VA: Stephenson, Inc., 1981.
- Brommer, Gerald. Exploring Drawing. Worcester, MA: Davis Publications, Inc., 1988.
- Brommer, Gerald and Gatto, Joseph. *Careers in Art: An Illustrated Guide.* Worcester, MA: Davis Publications, Inc., 1984.
- Brommer, Gerald and Kinne, Nancy. Exploring Painting. Worcester, MA: Davis Publications, Inc., 1988.
- Davis, Virginia. Crafts: A Basic Survey. Dubuque, IA: Wm. C. Brown, 1088.
- Fonvielle-Bontemps, Jacqueline. Choosing: An Exhibit of Changing Perspectives in Modern Art and Art Criticism by Black Americans, 1925–1985. Washington, DC: Museum Press, 1985.
- Kingman, D. and Kingman, H.K. *Dong Kingman Watercolors*. NY: Watson Guptill, 1980.
- Mayer, Barbara. Contemporary American Craft Art: A Collector's Guide. Layton, UT: Gibbs Smith Publishers, 1087.
- Mendelowitz, Daniel M. *Drawing*. Stanford, CA: Stanford University Press, 1980.
- Smith, Paul J. and Lucie-Smith, Edward. Craft Today: Poetry of the Physical. NY: American Craft Museum, 1988.
- Sprintzen, Alice. Crafts: Contemporary Design and Technique. Worcester, MA: Davis Publications, Inc., 1987.
- Williams, Arthur. Sculpture: Technique, Form and Content. Worcester, MA: Davis Publications, Inc., 1989.

Part V What Is It Saying?

- Aldridge, J.L., editor. The Western Art of Charles M. Russell. NY: Ballantine, 1988.
- Brommer, Gerald F. *Discovering Art History*, 2nd ed. Worcester, MA: Davis Publications, Inc., 1988.
- De la Croix, Horst and Tansey, Richard. Gardner's Art Through the Ages, 8th ed. NY: Harcourt Brace Jovanovich, 1986.
- Emmerich, Andre. Art Before Columbus. NY: Simon and Schuster, 1983.
- Harris, Ann S. Women Artists: 1550–1950. NY: Alfred A. Knopf, Inc., 1977.

Hobbs, Jack A. and Duncan, Robert L. Arts, Ideas and Civilization. Englewood Cliffs, NJ: Prentice-Hall, Inc., 1989.

Huntington, Susan L. and Huntington, John C. The Art of Ancient India: Buddhist, Hindu, Jain. NY: Weatherhill, 1985.

Janson, H.W. History of Art, 3rd ed. NY: Harry N. Abrams, Inc., 1986.

Nuttgens, Patrick. The Story of Architecture. Englewood Cliffs, NJ: Prentice-Hall, Inc., 1984.

Rice, David T. Islamic Painting. NY: Columbia University Press, 1972.

Sear, Frank, Roman Architecture. Ithaca, NY: Cornell University Press,

Willett, Frank. African Art. London: Thames and Hudson, 1985.

Part VI In the Final Analysis

Ebert, Roger. Roger Ebert's Movie Home Companion. Kansas City, KS: Andrews and McMeel, 1989.

Feldman, Edmund B. Varieties of Visual Experience. Englewood Cliffs, NJ: Prentice-Hall, Inc., 1987.

Hobbs, Jack A. Art in Context, 4th ed. San Diego, CA: Harcourt Brace Jovanovich, 1990.

Paul Cézanne, Still Life with Apples and Peaches, ca. 1905. Oil on canvas, $32" \times 39\%"$ (81 × 101 cm). National Gallery of Art, Washington, DC (Gift of Eugene and Agnes Meyer).

Index

A-101 (Tadasky), 125, 126, 302 Abstract Art, 35, 88, 301-302 Abstract Expressionism, 300-301 abstract lines, 35 Acoma Pueblo Water Jar, 239 Acropolis (Greece), 251, 253 acrylic paint, 141 actual movement, 102-103 Adams, Ansel, Half Dome, Merced River, Winter Yosemite Valley, 149 adobe brick, 239 Adoration of the Magi, The (Gentile da Fabriano), 138, 139 Adoration of the Shepherds (Rembrandt van Rijn), 276, 277 advertising agency art director, advertising photographer, 197 aerial perspective, 86 aesthetic experience, 12-14 African art, 230-234 Aguilar, José Roberto, The Brazilian Myth (O Mito Brasileiro), 37 Akroterion (Graves), 304 Albers, Joseph, Homage to the Square: Glow, 4, 5, 7, 16, 17, Alebrijes (Linares, Linares-Vargas, Linares-Vargas), 167 Alhambra, the (Islamic), 227-228 alternate repetition, 121, 122 American Gothic (Wood), 25, 114, 115, 205 American Indian art, 4, 5, 14, 15, 16, 125, 238-242 Amiens Cathedral (Gothic), 264, 265 analogous color, 68-69 analysis, 110-115, 201, 308, 312, 313 Analytical Cubism, 294 Anasazi art, 238-239 Anderson, Ron, The Killing of a '69 XR-7, 4, 5, 8 Angkor Thom, 159, 213 Animal Caricatures (Sojo), 220, 221, 223 animation, 153 animation artist, 195 approximate symmetry, 124

aquatint, 146 arabesque, 228 Ardabil Carpet, The (Islamic), 228, 229, 241 Arabs Skirmishing in the Mountains (Delacroix), 282, 283 arcade, 256 Arch, The (Calder), 49 arch, 227, 237, 255, 256, 263 archaeologist, 6 architect, 187 architectural renderer, 187 architecture: careers in, 187-188 modern, 288, 289, 298-299, 303, 304-305 non-Western, 219-220, 230, 231 Western, 252-253, 254, 255-257, 263-267, 273 Aronson, David, Virtuoso, 165 art director, 189, 195 art educators, 195 art historian, 195 art history, 205, 206-305 art magazines, 310 Artist's Bedroom at Arles, The (Gogh), 71, 286 Artist's Studio, The (Subleyras), 2, 3 Assemblage, 169-170, 172, 302 asymmetrical balance, 124 Athena Lemnia (Phidias), 251, 252, 254, 267 Attitudes of Animals in Motions (Muybridge), 103 Aztec art, 236-237, 238 Aztec Calendar Stone, 237

background, 80
balance, 116, 122–126
Baldessari, John, Cremation
Piece, 157, 302
balloon-frame, 289
Bamboo (Wu Chen), 30
Banjo Lesson, The (Tanner), 58, 59
Baptism in Kansas (Curry), 120, 125, 300
Bare Willows and Distant Mountains (Ma Yuan), 86, 87, 217–218

Barlach, Ernst, The Vision, 160-161, 291 Baroque art, 275-279, 280 barrel vault, 256 Bath, The (Cassatt), 46, 47, 285, Bathing at Asnières (Seurat), 116, 117, 119-120, 122, 125-126, 286, Bauhaus, 298-299 Bayon temple (Angkor Thom), Bedroom at Arles, The (Gogh), 70, 286 Bellows, George, Stag at Sharkey's, 99, 141 Benin art, 233 Beuys, Joseph, 8, 11, 15 Coyote - I Like America and America Likes Me, 4, 5, 9, 14, 157, 174, 302 Bingham, George Caleb, Fur Traders Descending the Missouri, 86 biomorphic shape / form, 50, 55 black-on-black pottery, 240 Black Painting (Reinhardt), 126, 127 Blaue Reiter, Der. 200, 202 Blue Hole, Little Miami River (Duncanson), 4, 5, 16 Boccioni, Umberto, Unique Forms of Continuity in Space, 100, 294 Bodhisattva (China), 216-217 Bohnett, Barbara, Joy Inside My Tears, 179 Bonheur, Rosa, Gathering for the Hunt, 283, 285 Borglum, George, The Presidents (Mount Rushmore), 160 boundaries, of space, 75 Bouts, Dirk, The Last Supper, 45, 80, 81, 82 Braids (Wyeth), 30, 138, 139 Braque, Georges, 155, 294, 302 The Table, 296 Violin and Palette, 294 Brazilian Myth, The (O Mito Brasileiro) (Aguilar), 37 broken color, 285

Brooklyn Bridge (Stella), 294, 295 Broulé Sioux shirt, 4, 5, 14, 15, 16, 242 Brücke, Die, 290, 291 Brunelleschi, Filippo: Florence Cathedral, 267 Pazzi Chapel, 266-267 Bullock, Wynn, Leaves and Cobwebs, 26 Burchfield, Charles, Hemlock in November, 314, 315, 317, 318, 319 Burial at Ornans (Courbet), 284, Calder, Alexander, 76, 78, 102 The Arch, 49 Spring Blossoms, 110, 302 calligraphy, 30 Calvaryman with Horse (China), came (stained glass), 184 Camp, Sokari Douglas, 203 Church Ede, 203, 230 Canal (Frankenthaler), 141 Caniff, Milton, Terry and the Pirates, 103-104, 106 canvas, 141 careers, in art, 186-187 cartoonists, 193-194 carving, 160-161 Cassandre, A.A., Harper's Bazaar magazine cover, 42 Cassatt, Mary, 46 The Bath, 46, 47, 285, 286 cast, 162 Castillo, El (Mayan), 237 casting, 162-164 Catchings, Yvonne Parks, The Detroit Riot, 156 Cathedral (Pollack), 301 Catlett, Elizabeth, 145 Mother and Child #2, 33, 35 The Survivor, 144 Catlin, George, The White Cloud, Head Chief of the Iowas, cave paintings, 4, 5, 11, 134, 244,

Centaur Drawn with Light, A-

Pablo Picasso at the Madoura

Pottery in Vallauris, France

(Mili), 27

ceramics, 7-8 pottery, 175-176, 218, 240 sculpture, 165-167 Cezanne, Paul, Still Life with Apples and Peaches, 286, 333 Chagall, Marc, I and the Village, chalk, 136-137 Charlie Brown (Schulz), 308 Charlie Brown and Snoopy (Schulz), 28 Chartres Cathedral (Gothic), 263 Chen, Xiaowen, Todd, 146 chiaroscuro, 60 Chicago, Judy, Virginia Woolf, Chicago School, 289, 298, 299, Chicago Tribune Tower (Hood and Howells), 298 Chien (Feltner), 37 Chinatown, San Francisco (Kingman), 137 Chinese art, 86, 214-218 Chirico, Giorgio de, The Mystery and Melancholy of a Street, 206 Christo. Wrapped Coast, One Million Square Feet, Little Bay, Australia, 4, 5, 8, 15, 157, 174, 302, 321 Wrapped Islands, 174 Church Ede (Camp), 203, 230 Circle Limit IV (Escher), 40, 41 City Faces (Ono), 152 City of Chicago (Grooms), 79 cloisonné, 259 closed form/shape, 50, 52, 55 closeup, 90 closure, 34-35 Colette, Pectoral #6, 178, 179 collage, 155-156, 172, 294 color, 62-72, 88 Collar and Bracelet (Herbst), 179 colored chalk, 136-137 Colosseum (Roman), 255, 256 comic strip art, 23, 28, 103-104 commercial art, 17 complementary colors, 63, 64, 68 composition, 113, 116 Composition in White, Black and Red (Mondrian), 80, 141, 294 computer art, 152-153 computer graphic designer, 190 Concept Art, 157, 302 Connoisseurs (Daumier), 312 construction, 168-172 contemporary art, 7-9 context, 38

Continual Mobile. Continual Light (Le Parc), 102-103 continuation, 117 contour lines, 29 converge (perspective), 82 cool colors, 60 corbeled arch, 237 Corbusier, Le, 303, 304 Notre-Dame-du-Haut Chapel, 303 Unité d'Habitation, 302, 303 Villa Savove, 200 Corinthian order, 254 Cornell, Joseph, Object ("Roses des Vents"), 119, 126, 302 corporate art director, 189, 190 Country School, The (Homer), 83, 90 Courbet, Gustave, Burial at Ornans, 284, 285 Cow with the Subtile Nose, The (Dubuffet), 94-95 Coyote - I Like America and America Likes Me (Beuys), 4, 5, 9, 14, 157, 174, 302 crafts, 196, 228, 288 Cravat (Frankenthaler), 67 Creation of the Sun and Moon (Michelangelo), 272, 273 Cremation Piece (Baldessari), 157, 302 Cretian art, 175 criticism, 308-311 critical method, 312-319 cross vault, 256 crosshatching, 31, 60 Crucifixion (Gothic), 265 Cruz, Emilio, Past Pastures, 140, Crystal Palace (Paxton), 288, Cubi XVII (Smith), 172, 294

Dada, 297, 302
Dali, Salvador:

Mae West, 124, 125, 297
The Persistence of Memory, 297
Dan-Ngere art, 233–234
dark (value), 57
Daumier, Honore, Connoisseurs, 312
David, Jacques Louis, The Oath of The Horatii, 280–281, 285
David, The (Michelangelo), 308
Death Seizing a Woman
(Kollwitz), 146, 147, 291
Delacroix, Eugene, Arabs

Cubism, 292, 294, 296, 300

Curry, John Steuart, Baptism in

Current (Riley), 102, 302

Kansas, 120, 125, 300

Skirmishing in the Mountains, Demoiselles d'Avignon, Les (Picasso), 292, 293 Demolition of St. James Hall, 136 department store display designer, 189 description of art, 20, 22-24, 113, 201, 308, 312-313 descriptive lines, 28-31 Detroit Industry (Rivera), 142-143 Detroit Riot, The (Catchings), 156 Diner, The (Segal), 174, 302 DiPreta, Rex Morgan, M.D., 23 direction of lines, 38 Discobolus (Myron), 252, 254 display designer, 189 documented art, 156-157 Dogon art, 230-232, 233, 239 dome, 256 dominance, 116, 119-120 Domenèch i Montaner, Llúis, Palace of Catalan Music (Palau de la Musica Catalana), 68 Donatello, St. Mark, 267, 268, Doric order, 253 Dr. J. Robert Oppenbeimer (Shahn), 29, 35 drawing, 134-137 Drugstore (Estes), 112 Dubuffet, Jean, The Cow with the Subtile Nose, 94-95 Duchamp, Marcel, Fountain, Duncanson, Robert S., Blue Hole, Little Miami River, 4, 5, Dürer, Albrecht, The Riders on the Four Horses from the Apocalypse, 144

earth art, 172 East Building, National Gallery of Art (Pei), 76 eclectic art styles, 298, 304, 305 Edetta (Vasarely), 102 edges, 32-33 editorial illustrator, 193 Egyptian art, 160, 182, 202-204, 205, 246-249, 251 elements, of design, 24 Embryo in the Womb (Leonardo da Vinci), 270 Emery, Roth and Sons, Selegie Road Commercial Center, Emperor Justinian and Attendants (Byzantine), 143 enamel, 179

engraving, 146

Environmental Art, 157, 172–174, 302
Escher, M.C., 41
Circle Limit, IV, 40, 41
Espada, Ibsen, El Yunque, 37
Estes, Richard:
Drugstore, 112
Nedick's, 120, 302
etching, 146
evaluation, 308, 312, 313
exhibit designer, 189

Facet Cubism, 294 Falling Shoestring Potatoes (Oldenburg), 101, 182, 302 fashion designer, 193 fashion illustrator, 193 fashion photographer, 196 Fauves, 290, 292 Feltner, James, Chien, 37 Ferrari, Marco, 192 Festival Form (Wood), 97, 98 fiber arts, 179, 180, 228, 229, 241 Field Rotation (Miss), 172, 173, figure/ground, 40 film, 104-106, 150, 195, 309 fine art, 16-17 fine artists, 196 Florence Cathedral (Brunelleschi), 267 Flowering Apple Tree (Mondrian), 317-318 Flowering Swamp (Hofmann), 88, 89, 301 Flute Player (Benin), 233 flying buttress, 263 focal length, 148 folk art, 17, 147 Football Player (Hanson), 164, Foreign Office Building (Brazil), foreshortening, 44, 45, 46, 48, 80, 81, 246 form, 43-49, 50-55 formal design, 77 Forum (Roman), 255 Fountain (Duchamp), 297 Four Sleepers, The (Mokuan), 34 Fragonard, Jean Honore, The Swing, 279-280 frame construction, 288, 289 framing, 90-91 Frankenthaler, Helen: Canal, 141 Cravat, 67 Frankish ornaments, 258, 259 fresco, 142-143 Frey, Viola, Leaning Man, III, Freya (Sugarman), 168

Fritzi (Klee), 135 Frontispiece to "Kirby's Perspective" (Hogarth), 85 Fur Traders Descending the Missouri (Bingham), 86 furniture designer, 193

Gabo, Naum, Linear Construction, 78 Gandhara Buddha in Contemplation (India), 209, 217 Garby, Terry, 184 Gare Saint-Lazare (Manet), 284-285 Gare St. Lazare, Paris, The (Monet), 74 Gathering for the Hunt (Bonheur), 283, 285 Gauguin, Paul, The Vision After the Sermon, 286, 287 gel medium, 141 genre, 278 Gentile da Fabriano, The Adoration of the Magi, 138, 139 geometric shape/form, 50, 55 George Washington (Greenough), 130, 132 George Washington at the Battle of Princeton (Peale), 130, 131, German Expressionism, 290-292, 300

German Pavilion at the International Exhibition, Barcelona, Spain (Mies van der Rohe), 299 gesso, 141

gesso, 141 Ghiberti, Lorenzo, *The Story of Jacob and Esau*, 159 Giacometti, Alberto, *Man Pointing*, 132, 133 Giacomo della Porta, St. Peter's Basilica, 272

Glaser, Milton, 189 glass, 182–184 Glass Bottle Shaped I

Glass Bottle Shaped Like a Fish (Egyptian), 182 glaze, 141, 165

giaze, 141, 105

God Separating Light from Darkness (Michelangelo), 56, 57

Gogh, Vincent Van, 70, 71, 286, 291

The Artist's Bedroom at Arles, 71, 286

The Bedroom at Arles, 70, 286 Grove of Cypresses, 39 Pine Trees with Setting Sun,

Going Home (Lawrence), 122, 123, 124

318-319

Cock's Comb, 300
Gothic art, 263–265, 267, 275
graphic designer, 190
Graves, Michael, San Juan
Capistrano Regional Library,
77
Graves, Nancy, Akroterion, 304
Great Pyramids of Gizeh

Gorky, Arshile, The Liver is the

(Egypt), 248, 249 Great Rock of Inner Seeking (Noguchi), 54, 55 Great Wave, The (Hokusai), 287

Greek art, 250, 251–253 Greenough, Horatio, *George Washington*, 130, 132

Grenouillère, La (Monet), 285-286

Grooms, Red, 79, 172 City of Chicago, 79

Ruckus Manhattan, 79 Ruckus Rodeo, 70, 172, 173, 302

Gropius, Walter, Shop Block,

Grove of Cypresses (Gogh), 39 gum arabic, 137

H.R.H. Briefcase (Levine), 4, 5, 7, 11, 302 Haida chest, 242 Half Dome, Merced River, Winter Yosemite Valley (Adams), 149

Hall of Bulls (Lascaux), 134, 244,

Hanson, Duane, Football Player, 164, 167, 302

happenings, 174

Hardouin-Mansart, Jules, Versailles Palace, 276

Harkness, Edward, 176

Harper's Bazaar magazine cover

(Cassandre), 42 hatching, 31, 60, 136 *Heki* (Tanahashi), 36

Hemlock in November (Burchfield), 314, 315, 317, 318, 319

Hepworth, Barbara, *Pendour*, 78

Herbst, Gerhardt, Collar and Bracelet, 170

hieroglyphics, 246, 247 high placement, 81

high relief, 159

High Renaissance art, 268–273,

Hiroshige, Ichiyusai, *Obasbi*, *Sudden Shower at Atake*, 223 *Hisamatsu* (Shin'cihi), 136 Hockney, David, *Untitled*, 153

Hofmann, Hans, Flowering Swamp, 88, 89, 301 Hogarth, William, Frontispiece to "Kirby's Perspective", 85 Hohulin, Sam, 192

Hokusai, The Great Wave, 287 Homage to the Square: Glow

(Albers), 4, 5, 7, 16, 17, 301 Homer, Winslow, *The Country School*, 83, 90

Hooch, Pieter de, Mother and Child, 278

Hood and Howells, Chicago Tribune Tower, 298

Hopi art, 239

Hopper, Edward, *House by the*Railroad, 50, 51, 52, 61, 141
Horyu-ji Temple (Japan), 219,

House by the Railroad (Hopper), 50, 51, 52, 61, 141

hue, 62-63, 66, 67 humanism, 251, 265

numanism, 251, 205

I and the Village (Chagall), 294 Ice Age art, 245–246, 249 idealism, 251, 252 idolatry, 228 Ife art, 232–233, 235

Illinois Landscape #14 (Stefl), 316–317 illustration, 193–194, 228

illustration photographer, 197
Implications (Sauer), 180
implied lines, 32–35

implied movement, 98–101 Impressionism, 22, 46, 285–286 Incap art, 225, 238

Incan art, 235, 238 India ink, 136

Indian art, 207-211

Indiana, Robert, *The X-5*, 124, 126

individual lines, 30 individualism, 206 industrial design careers,

192-193

informal design, 77

Ingres, Jean Auguste-Dominique, Portrait of a Young

Man, 31 ink washes, 136

intaglio prints, 146 intensity, 63, 64–65, 66

interior designer, 188 intermediate colors, 63

intermediate colors, 63 interpretation, 200–205, 308,

312, 313 interstices, 146

Ise Shrine (Japan), 219 Islamic art, 29, 35, 224–230

Japanese art, 33, 35, 75, 219–223, 286

Jefferson, Thomas, Virginia State Capitol, 281 jewelry, 177–179 Joiner, John, 196 Jones, Willi Posey, 118 Joy Inside My Tears (Bohnett), 179 Judd, Donald, Untitled, 111, 302

Kandarya Mahadeva Temple (India), 210, 227

Kandinsky, Wassily, 292, 298 Sketch 1 for "Composition VII," 291, 292, 298

Katsura (Stella), 170, 302

keystone, 256

Killing of a '69 XR-7, The (Anderson), 4, 5, 8

kiln, 163

kinetic art, 102, 172

Kingman, Dong, Chinatown,

San Francisco, 137 Klee, Felix, Fritzi, 135

Knoblock, Keith, *Lincoln*, 162–163

Kollwitz, Käthe:

Death Seizing a Woman, 146,

Self-Portrait with a Pencil, 135 Konchi-in Temple (Japan), 75 Krentzin, Earl, *Truck*, 178, 179 Kubota, Shigeko, *River*, 151

Lake Shore Drive Apartment Houses (Mies van der Rohe), 302, 303

land art, 172

landscape architect, 188 Landscape (Sesshu), 222, 223

Lange, Dorothea, Migrant Mother, Nipomo, California,

Langobardic ornament, 258, 259 Lascaux, Hall of Bulls, 134, 244 Last Supper, The (Bouts), 45, 80, 81, 82

Last Supper, The (Leonardo da Vinci), 268, 269, 270-271

Lawrence, Jacob, *Going Home*, 122, 123, 124

Layla and Majnun at School (Islamic), 225

Leeper, Doris, *Untitled*, 55, 78 Le Parc, Julio, *Continual*

Mobile, Continual Light, 102–103

Liver is the Cock's Comb, The (Gorky), 300

load-carrying construction, 289 Longborn Steer, Western Series, American Predella #6 (Nice),

94, 302

lost-wax bronze casting, 162-163 low placement, 81 low relief, 159 Luncheon of the Boating Party (Renoir), 20, 21, 32, 35, 55, 58, 91, 107, 141, 201, 202, 285, 308 lunettes, 272 Ma Yuan, Bare Willows and Distant Mountains, 86, 87, Machu Picchu (Incan), 235 macramé, 180 Madeleine, La (Medieval), 2, 61, Madeleine, La (Vignon), 281 Mademoiselle Charlotte du Val d'Ognes, 61, 141 Mae West (Dali), 124, 125, 297 Maison Caree (Roman), 254, 281 Malone, Tom, 175 Man Pointing (Giacometti), 132, 133 Manet, Edouard, 286, 288 Gare Saint-Lazare, 284-285 Oysters, 95, 96 Maria Bowl (Martinez), 240 Marisol, 171 Women and Dog, 170, 302 Martin Luther King (Ringgold), 118 Martinez, Julian, 240 Martinez, Maria, 240 Martinez, Popovi Da, 240 Masaccio, The Tribute Money, 268, 270, 288 masks, 177, 233 Masks (Nolde), 291 masonry, 209, 256, 289 Massacre of the Innocents (Rubens), 276, 277 Mastabas (Egypt), 249 Matisse, Henri, 292, 305 The Red Room, 290, 298 matte finish, 93 Mayan art, 237, 238 meaning, of artworks, 200-205 media, 130-133 for three-dimensional art, 130, 158-185 for two-dimensional art, 130, 134-157 medical illustrator, 193 Medieval art, 259-265, 266 medium, 130 Mesa Verde (Pueblo Indian), 239 Meso-American art, 236-237 metal construction, 171-172 metalworking, 177, 179 Michelangelo: Creation of the Sun and Moon,

272, 273

Michelangelo (cont.) The David, 308 God Separating Light from Darkness, 56, 57 Moses, 271, 272, 273 The Pietà, 96, 271 Sistine Chapel, 271-273, 275 St. Peter's Basilica, 272 Mies van der Rohe, Ludwig, 303, 304 German Pavilion at the International Exhibition, Barcelona, Spain, 299 Lake Shore Drive Apartment Houses, 302, 303 Migrant Mother, Nipomo, California (Lange), 93 Mili, Gjon, A Centaur Drawn with Light - Pablo Picasso at the Madoura Pottery in Vallauris, France, 27 Mill, The (Rembrandt van Rijn), 50, 51, 52, 61, 141, 278 minaret, 226-227 Minkowitz, Norma, Passage to Nowhere, 159 Miss, Mary, Field Rotation, 172, 173, 302 mixed media, 151 mobiles, 102 Moche art, 235 modeling, 165-167 modeling paste, 141 Modern art, 290-305 Modersohn-Becker, Paula, 305 Old Peasant Woman Praying, Mohenjo-Daro (India), 207-208 Mokuan, The Four Sleepers, 34 Mondrian, Piet, 298-299 Composition in White, Black and Red, 80, 141, 294 Flowering Apple Tree, 317-318 Monet, Claude, 22, 286, 288 The Gare St. Lazare, Paris, 74 La Grenouillère, 285-286 Waterloo Bridge, 86, 122, 285 monochromatic colors, 64, 69, monochromatic drawing, 134-136 Monogram (Rauschenberg), 4, 5, 9, 11, 14, 155, 302 Moore, Charles, Piazza dItalia, Moore, Henry, Reclining Nude, 160, 161 mosaic, 143 Moses, (Michelangelo), 271, 272,

Mosque (Cordova), 226, 227

Mosque (Mutawakkil), 226

Mother and Child (Hooch), 278

Mother and Child (Rivera), 29 Mother and Child #2 (Catlett), 33, 35 Mount Rushmore, The Presidents (Borglum), 160 Move Move Mann (Richard), movement, 38, 75, 98-107, 116, 121-122 Munch, Edvard, The Scream, 121, 286 murals, 142 mutoscope, 150 Mycenae funeral mask, 177 Mycerinus and His Queen (Egyptian), 160, 248 Myron, Discobolus, 252, 254 Mystery and Melancholy of a Street, The (Chirico), 296 Mystic Circle (Sri Yantra), 12 National Gallery of Art (Wash-

ington, D.C.), 76, 281 Nature (Thompson), 186 Navajo art, 241 Nazca mantle (Pre-Columbian), Nedick's (Estes), 120, 302 negative shape, 40 negative space, 80 Neoclassical art, 280, 283, 284 Neo-Dada, 302, 304 neutral colors, 64 Nevelson, Louise, Sky Cathedral, 169, 302 Newton's Color Wheel, 62 Nice, Don, Longborn Steer, Western Series, American Predella #6, 94, 302 Nigrosh, Leon, 176 Nixon as The Godfather (Levine), Noguchi, Isamu, Great Rock of Inner Seeking, 54, 55 Nolde, Emil, Masks, 291 non-load-carrying construction, non-Western art, 206-243 nonwoven fiber forms, 180 North by Northwest (film), 98 North Syrian female figure, 162 Northwest Coast Indian art, Notre-Dame-du-Haut Chapel (Le Corbusier), 303 Number 7: Full Moon (Lippold),

Oath of the Horatii, The (David), 280–281, 285 Object ("Roses des Ventes") (Cornell), 119, 126, 302

168, 302

Oblique Progression (Pereira), 88, Obashi, Sudden Shower at Atake (Hiroshige), 223 oil painting, 141, 200 Old Guitarist, The (Picasso), 69, Old Peasant Woman Praying (Mondersohn-Becker), 291 Oldenburg, Claes, 101 Falling Shoestring Potatoes, 101, 182, 302 Spoon Bridge and Cherry, 101 Olmec art, 236 Oloyede, Senabu, 80 100 Cans (Warhol), 119, 121, 126 one-point perspective, 82, 83 Oni of Ife, 232 Ono, Hiromi, City Faces, 152 Op Art, 102 opaque, 136 open form/shape, 50, 52, 55 optical mixing, 31 optical movement, 102 organic shape/form, 50, 55 Our Lady of All Protections (Stankiewicz), 171 outdoor advertising, 191 outlines, 28 overlapping, 81 Oysters (Manet), 95, 96

package designer, 192 Paik, Nam June, 151 painting, 137-143 Palace of Catalan Music (Palau de la Musica Catalana) (Domenèch i Montaner), 68 Palatine Chapel (Medieval), Pantheon (Roman), 257, 266, papier mâché, 165, 167 papyrus, 135, 249 Parking Garage, The (Segal), 164, 167 Parthenon (Greece), 251, 252-253, 256 Passage to Nowhere (Minkowitz), 150 Past Pastures (Cruz), 140, 141 pastels, 136-137 Pastoral Scene (Tsinahjinnie), Paxton, Joseph, Crystal Palace, 288, 289 Pazzi Chapel (Brunelleschi), 266-267 Peale, Charles Wilson, George Washington at the Battle of Princeton, 130, 131, 132 Pectoral #6 (Colette), 178, 179

Pei, I.M., East Building, National Gallery of Art, 76 pencil, 135 Pendour (Hepworth), 78 Peplos Kore (Greece), 250, 251 Pereira, Irene Rice, Oblique Progression, 88, 301 Performance Art, 8, 9, 302 Persistence of Memory, The (Dali), 297 perspective, 82-85, 86 Phidias, Athena Lemnia, 251, 252, 254, 267 philosophy of art, 10-17 photography, 147-149, 196-197 photojournalist, 196-197 Piazza d'Italia (Moore), 305 Picasso, Pablo, 155, 292, 294, 302, 305 Les Demoiselles d'Avignon, 292, The Old Guitarist, 69, 292 Still Life with Chair Caning, 155-156, 294 Three Musicians, 42, 43, 296 A Woman in White, 61, 296 picture plane, 80 Pietà, The (Michelangelo), 96, pigment, 62, 137 Pine Trees (Tohaku), 52-53, 223 Pine Trees with Setting Sun (Gogh), 318-319 Plains Native American art, 4, 5, 14, 15, 16, 242 planographic prints, 146-147 plaster/plastic casting, 164 Pluralism, 301, 304 pointed arch, 263 Pollack, Jackson, 300-301 Cathedral, 301 polyester resin, 164 Pomo Storage Basket, 125 Pompeii, 254, 255 Pont du Gard (Roman), 255 Pop Art, 302, 304 Pope, John Russell, West Building, National Gallery of Art, 76, 281 Portly Courtier, A (Persian), 29, Portrait (Trilling), 182 Portrait Jar (Moche), 235 Portrait of a Young Man (Ingres), 31 Portrait of Confucius (Chinese), portrait photographer, 197 positive shape, 40 post-and-lintel construction, 210, 254, 255, 256 Post Impressionism, 286, 289

Post-Modern Art, 304-305 Preacher (White), 46 Pre-Columbian art, 124, 234-237 Presidents, The (Mount Rushmore) (Borglum), 160 primary colors, 63 principles of design, 116-127 printing plate, 143 printmaking, 143-147 product designer, 192 progressive repetition, 121, 122 proportion, 233 proximity, 117 Pueblo Native American art, 239, 240, 241 Pyramid of Quetzalcoatl (Teotihuacán), 236

qibla, 226

radial balance, 125 radial design, 120 Ramses II (Egypt), 247 Ramsey, Steve, 183 Ranganathaswanny Temple (India), 206 Raphael, School of Athens, 268, 269, 271 Rauschenberg, Robert, Monogram, 4, 5, 9, 11, 14, 155, Realism, 283, 284-285, 296, 302, Reclining Nude (Moore), 160, 161 record jacket designer, 191 rectilinear shape/form, 50, 55 Red Room, The (Matisse), 290, 298 Regionalism, 300 registers, 202 reincarnation, 208 Reinhardt, Ad, Black Painting, 126, 127 relics, 6, 262 relief prints, 144 Rembrandt van Rijn, 278-279 Adoration of the Shepherds, 276, The Mill, 50, 51, 52, 61, 141, 278 Renaissance art, 265-273, 275 Renoir, Pierre Auguste, 22 Luncheon of the Boating Party, 20, 21, 22, 23, 32, 35, 55, 58, 91, 107, 141, 201, 202, 285, 308 repetition, 121, 122 repoussé, 177 retarders, 141 reverse perspective, 220 Rex Morgan, M.D. (DiPreta), 23 rhythm, 116, 121-122 ribbed vaulting, 263

Richard, Pierre, Move Move Mann, 167 Riders on the Four Horses from the Apocalypse, The (Dürer), Riley, Bridget, Current, 102, 302 Ringgold, Faith, 118 Lena, 118 Martin Luther King, 118 River (Kubota), 151 Rivera, Diego: Detroit Industry, 142-143 Mother and Child, 29 Robie House (Wright), 298 Rococo art, 279-280 Rodin, Auguste, The Thinker, 158, 159 Roman art, 254-257, 281 Romanticism, 283, 284 round arch, 256 Rubens, Peter Paul, 279 Massacre of the Innocents, 276, Ruckus Manhattan (Grooms), Ruckus Rodeo (Grooms), 79, 172, 173, 302 Russell, Charles: The Toll Collectors, 200. 201-202, 204, 217, 308 Wild Meat for Wild Men, 202

Saar, Betye, Wizard, 154, 155 San Juan Capistrano Regional Library (Graves), 77 saturation, 63, 64-65, 66 Sauer, Jane, Implications, 180 Scherr, Mary Ann, Waist Watcher Monitor Belt Buckle, 178, 179 School of Athens (Raphael), 268, 269, 271 Schulz, Charles M.: Charlie Brown, 308 Charlie Brown and Snoopy, 28 Scream, The (Munch), 121, 286 sculpto-pictorama, 79 sculpture, 159-172 seals (India), 207 Sears Tower (Skidmore, Owings and Merrill), 33, 35, Seated Buddha Preaching the First Sermon (India), 209, Seated Man and Woman, 231 secco, 142 secondary colors, 63

Segal, George:

The Diner, 174, 302

Selegie Road Commercial

The Parking Garage, 164, 167

Center (Emery, Roth and Sons), 187 Self-Portrait (Wood), 115 Self-Portrait with a Pencil (Kollwitz), 135 sequence, 103-106 Sesshu, Landscape, 222, 223 Seurat, Georges, Bathing at Asnières, 116, 117, 119-120, 122, 125-126, 286, 308 shades, 64 shading, 31, 60, 61, 80, 81 Shahn, Ben, Dr. J. Robert Oppenbeimer, 29, 35 shape, 40-43, 50-55 of lines, 38 Shin'cihi, Hisamatsu, 136 Siva, King of Dancers, Performing the Nataraja (Tamilnada), 210, 211 Shoin, The (Japan), 33, 35 Shop Block (Gropius), 298 signage, 191 silk screen, 147 silk screen printer, 190 similarity, 117 simulated texture, 94 Sisley, Alfred, 22 Sistine Chapel (Michelangelo), 271-273, 275 size, 48, 80, 81 Sketch 1 for "Composition VII" (Kandinsky), 291, 292, 298 Skidmore, Owings and Merrill, Sears Tower, 33, 35, 303 Sky Cathedral (Nevelson), 169, Skylit Solar Court (Albany), 188 skyscraper, 289 Smith, David, Cubi XVII, 172, Smithson, Robert, Spiral Jetty, 172, 173 soft sculpture, 182 Sojo, Toba, animal caricatures, 220, 221, 223 South American art, 235 Southeast Asian art, 159, 212-213, 227 Southwest Native American art, 238-239, 241 space, 74-91, 98 spectrum, 62 sphere, 44 Spiral Jetty (Smithson), 172, 173 split complementary colors, 68 Spoon Bridge and Cherry (Oldenburg), 101 Spring Blossoms (Calder), 110 Stag at Sharkey's (Bellows), 99, 141 stained canvas, 141

stained glass, 184, 265 Standing Buffalo (Font-du-Gaume), 246 Stankiewicz, Richard, Our Lady of All Protections, 171 Stanton, Cynthia, A Wild and Wicked Sky near Remus, Michigan, 57 Star Wars (film), 104-106, 150 Stefl, Robert, Illinois Landscape #14, 316-317 Stella, Frank, Katsura, 170, 302 Stella, Joseph, Brooklyn Bridge, 294, 295 Still Life with Apples and Peaches (Cézanne), 286 Strill Life with Chair Caning (Picasso), 155-156, 294 Story of Jacob and Esau, The (Ghiberti), 159 storyboard, 106 storyboard illustrator, 195 St. Ignatius Loyola engraving, 274, 275 St. Mark (Donatello), 267, 268, 288 St. Peter's Basilica (Michelangelo and Giacomo della Porta), 272 St. Sernin (Medieval church), 262, 265 studio art instructor, 195 Study of a Tree (Leonardo da Vinci), 39 Stupa (Java), 212, 213, 227 Stupa I (India), 208-209, 210 Subleyras, Pierre, The Artist's Studio, 2, 3 Sugarman, George, Freya, 168 Sullivan, Louis, 298, 299 Wainwright Building, 289 support (painting), 137 surface treatment, 93-97 Surrealism, 296-297 Survivor, The (Catlett), 144 Sutton-hoo Helmet, 258, 259 Swing, The (Fragonard), 279-280 symbols, 27 symmetrical balance, 124 Synthetic Cubism, 294, 296

Table, The (Braque), 296
tableau, 171
tactile sense, 93
Tadasky, A-101, 125, 126, 302
Tamilnada, Siva, King of
Dancers, Performing the
Nataraja, 210, 211
Tanahashi, Kazuaki, Heki, 36
Tanner, Henry O., The Banjo
Lesson, 58, 59

technical illustrator, 194 telephoto lens, 148 television graphic artist, 195 tempera, 138 Temple Guardian (Japan), 220, tensile strength, 256 Teotihuacán art, 236, 237 Terra Cotta Grave Figure (China), 204, 205, 217 Terry and the Pirates (Caniff), 103-104, 106 tesserae, 143 texture, 93-97 Thinker, The (Rodin), 158, 159 Thompson, Bradbury, Nature, three-dimensional art, 49, 76-78, 130, 158-185 Three Musicians (Picasso), 42, 43, 296 tints, 64 Tlingit art, 241-242 Todd, (Chen), 146 Tohaku, Hasegawa, Pine Trees, 52-53, 223 Toll Collectors, The (Russell), 200, 201-202, 204, 217, 308 Toltec art, 236, 237, 238 Tomb of Ti Saqqara (Egypt), 202-204, 205, 249 Totem Pole (Tlingit), 241-242 toy designer, 193 translucent, 136 Trent's Jacket (Levine), 96, 97, triad colors, 67 Tribute Money, The (Masaccio), 268, 270, 288 Tri-Color Arch (Zeister), 180, 181 Trilling, Jo Ellen, Portrait, 182 Truck (Krentzin), 178, 179 Tsinahjinnie, Andrew, Pastoral Scene, 88 tusche, 147 Twentieth Century art, 290two-dimensional art, 130, 134-157 two-point perspective, 82 Two Warriors Fighting in a Landscape (Islamic), 228

ukiyo-e, 223, 286 Underglaze Porcelain Jug (Chinese), 218 Unique Forms of Continuity in Space (Boccioni), 100, 294 Unité d'Habitation (Le Corbusier), 302, 303 unity, 116, 117 Untitled (Hockney), 152, 153 Untitled (Judd), 111, 302 Untitled (Leeper), 55, 78

value, 57-61, 64, 66, 135 Van Allsburg, Chris, 193 van Oosterwyck, Maria, Vanitas, 278, 279 Vandenberge, Peter, Zwartman, 166 vanishing point, 82, 83 Vanitas (van Oosterwyck), 278, variety, 116, 119 Vasarely, Victor, Edetta, 102 Vau. Louis Le, Versailles Palace, 276 vault, 256, 263 Venus of Willendorf, 160, 245 Versailles Palace (Hardouin-Mansart and Vau), 276 video art, 151 Vignon, Pierre-Alexandre, La Madeleine, 281 Villa Savoye (Le Corbusier), Violin and Palette (Braque), 294 Virginia State Capitol (Jefferson), 281 Virginia Woolf (Chicago), 111 Virtuoso (Aronson), 165 Vision, The (Barlach), 160-161, Vision After the Sermon, The (Gauguin), 286, 287 volume, of space, 75

Wainwright Building (Sullivan), Waist Watcher Monitor Belt Buckle (Scherr), 178, 179 Warhol, Andy, 100 Cans, 119, 121, 126 warm colors, 60 watercolor, 137 Waterloo Bridge (Monet), 86, 122, 285 weight shift, 251 West Building, National Gallery of Art (Pope), 76, 281 Western Art, 244-305 Whaam! (Lichtenstein), 4, 5, 7, White, Charles, Preacher, 46 White Cloud, The, Head Chief of the Iowas (Catlin), 242, 243 wide-angle lens, 148 Wild and Wicked Sky near Remus, Michigan, A (Stanton), 57 Wild Meat for Wild Men

(Russell), 202

Wizard (Saar), 154, 155 Woman in White, A (Picasso), 61, 296 Women and Dog (Marisol), 170, Wood, Grant, 115 American Gothic, 25, 114, 115, 205 Self-Portrait, 115 Wood, Viola M., Festival Form, 97, 98 woodcut, 143 woven fiber forms, 179 Wrapped Coast, One Million Square Feet, Little Bay, Australia (Christo), 4, 5, 8, 15, 157, 174, 302, 321 Wrapped Islands (Christo), 174 Wright, Frank Lloyd, 299 Robie House, 298 Wright, M., 341 Wu Chen, Bamboo, 30 Wyeth, Andrew, Braids, 30, 138,

X-5, The (Indiana), 124, 126

Yunque, El (Espada), 37

Zeisler, Claire, *Tri-Color Arch*, 180, 181 zoom lens, 104, 149 Zuni art, 239 *Zwartman* (Vandenberge), 166

Acknowledgements

We wish to extend our appreciation to the graduate and undergraduate students at Illinois State University who contributed their time, talent and expertise to this project: to Barbara Caldwell who contributed numerous multicultural suggestions as well as photographs; to Jayne Craig who wrote many of the picture captions; to Linda Willis-Fisher who contributed to the teacher's manual; and to the members of Dr. Salome's classes who permitted us to use their artwork for the "Challenges." We wish to acknowledge those whose counsel we sought while compiling the text: Kent Anderson, David Baker, Laura Chapman, Robert Daugherty, Michael Hagenbuck, Connie Newton, and Ronald Silverman. Finally we wish to thank the following: Nancy Dutting, Claire Golding, Victoria Hughes, and particularly Wyatt Wade whose combination of creativity, pep talk, and patience saw us through every stage of the project.

M. Wright, Loudon Ridge, 1986. Oil on canvas, 50 '' \times 46 '' (127 \times 117 cm).